Sports Illustrated Sports Illustrated Sports Illustrated
Sports Illustrated Sports Illustrated
strated Sports Illustrated Sports Illustrated
Sports Illustrated Sports Illustrated Sport
strated Sports Illustrated Sports Illustrated
Sports Illustrated Sports Illustrated Sport
strated Sports Illustrated Sports Illustrated
Sports Illustrated Sports Illustrated Sport
strated Sports Illustrated Sports Illustrated
Sports Illustrated Sports Illustrated Sport
strated Sports Illustrated Sports Illustrated
Sports Illustrated Sports Illustrated Sport
strated Sports Illustrated Sports Illustrated
Sports Illustrated Sports Illustrated Sport
strated Sports Illustrated Sports Illustrated
Sports Illustrated Sports Illustrated Sport
strated Sports Illustrated Sports Illustrated
Sports Illustrated Sports Illustrated Sports

Sports Illustrated

THE BOSTON CELTICS AT 75

CELEBRATING THE HISTORY OF CELTICS BASKETBALL

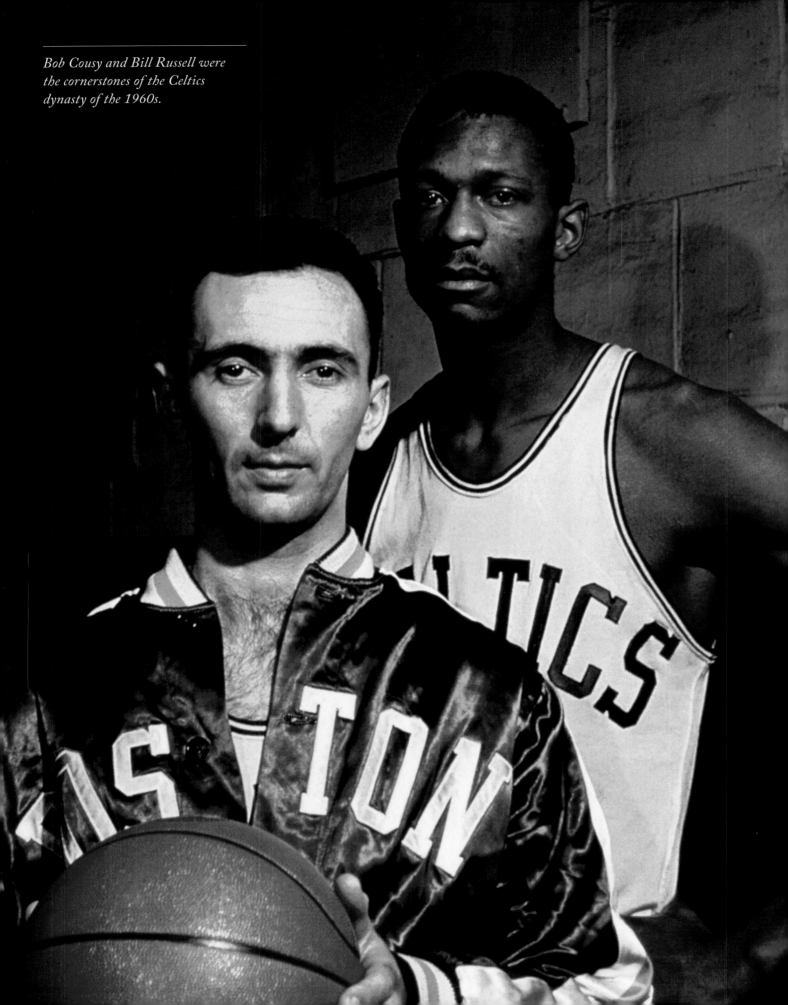

Bob Cousy and Bill Russell were the cornerstones of the Celtics dynasty of the 1960s.

CONTENTS

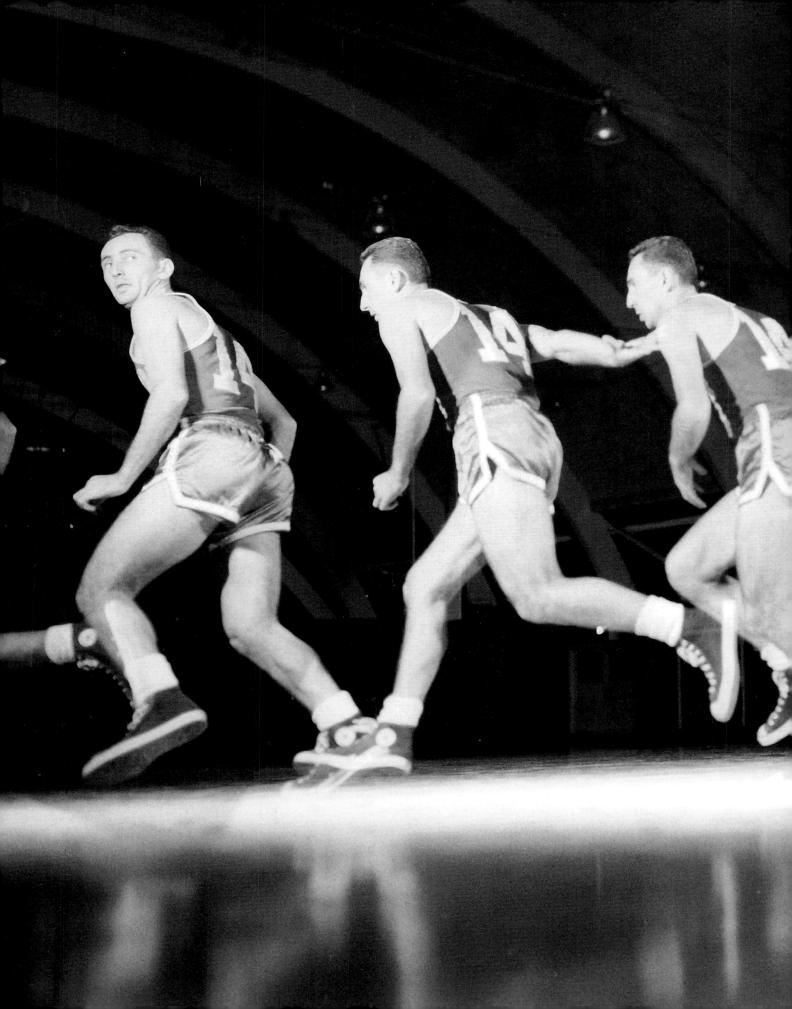

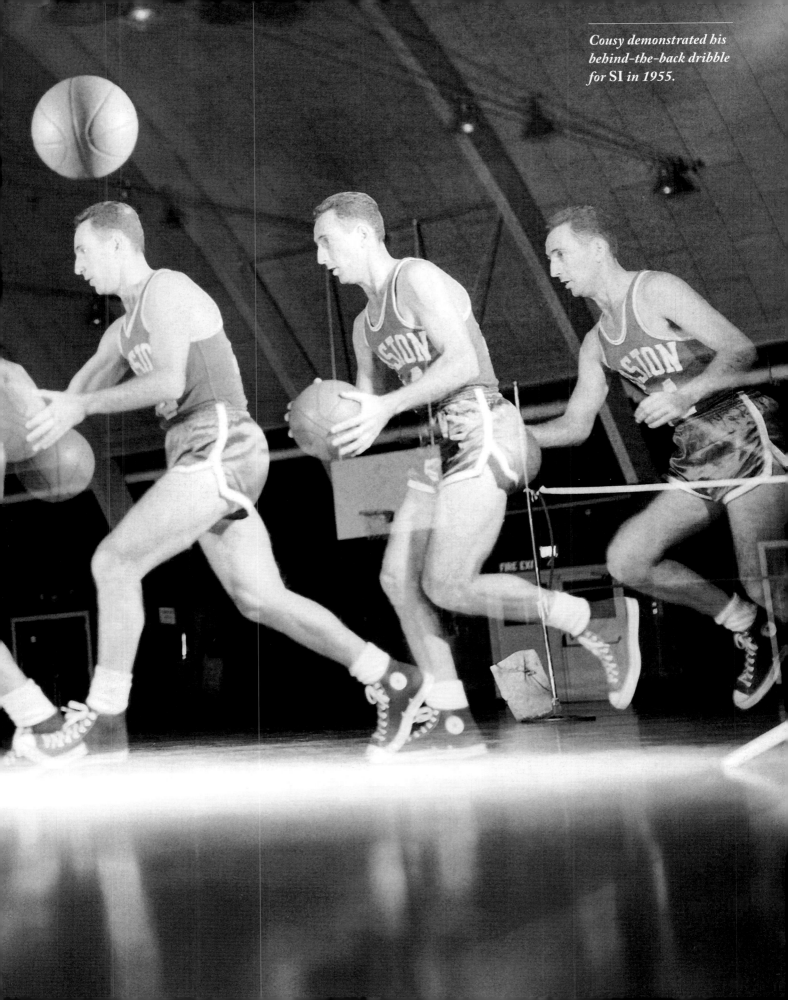

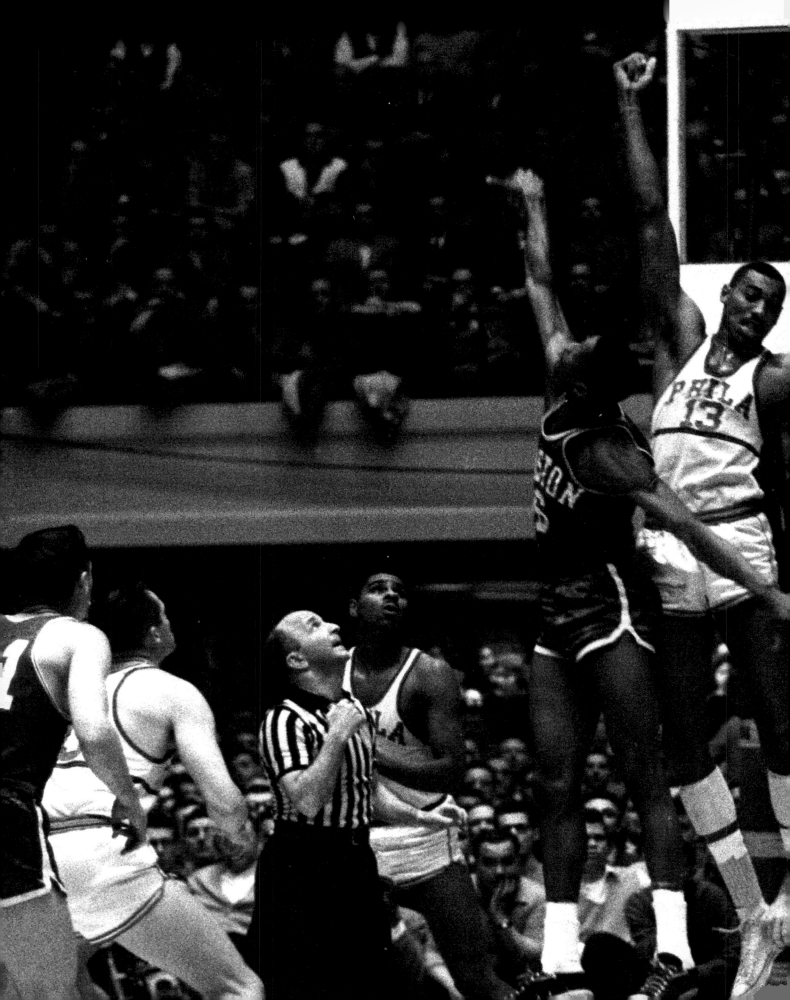

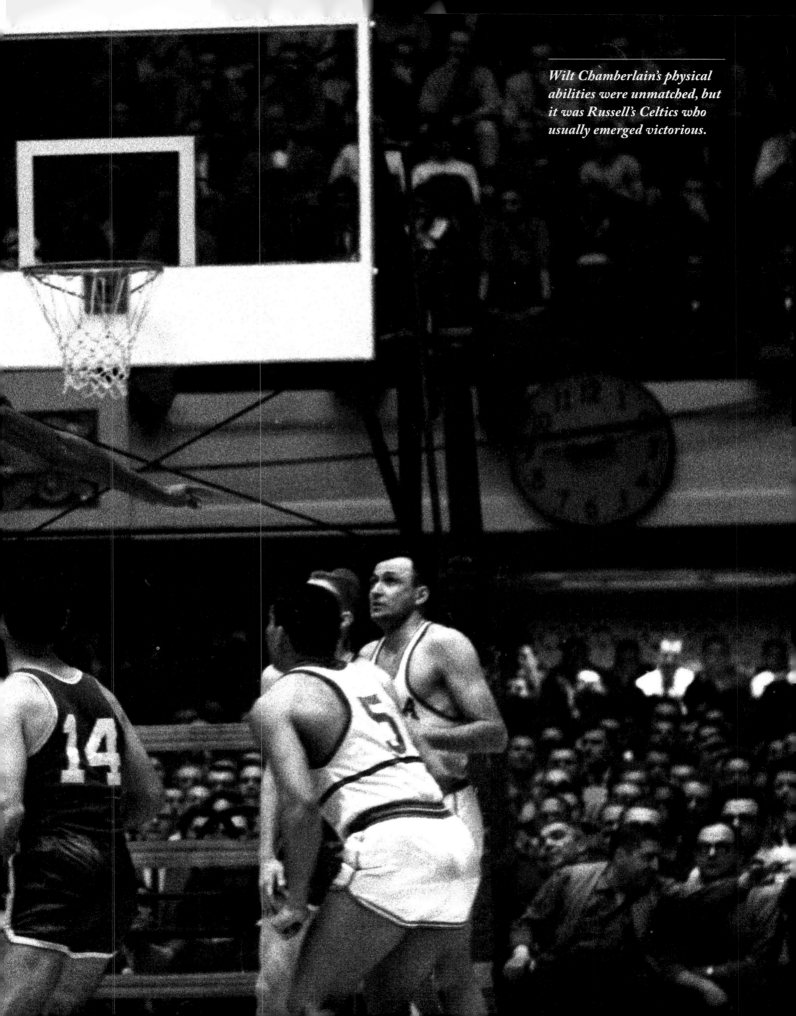

Wilt Chamberlain's physical abilities were unmatched, but it was Russell's Celtics who usually emerged victorious.

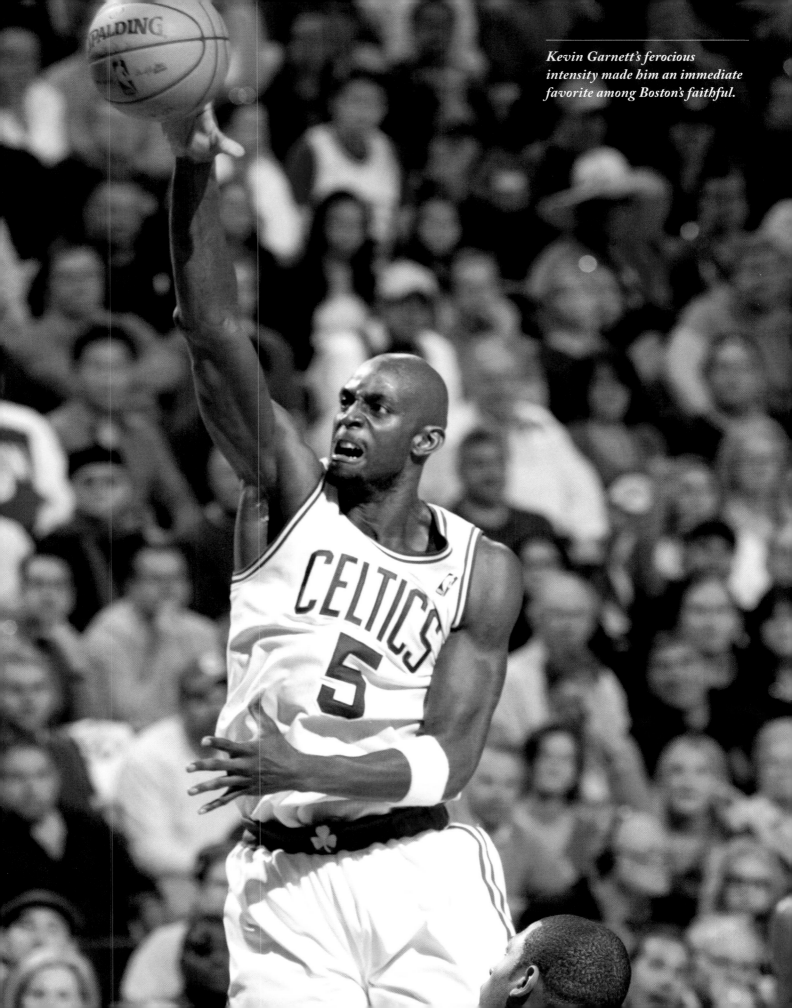

Kevin Garnett's ferocious intensity made him an immediate favorite among Boston's faithful.

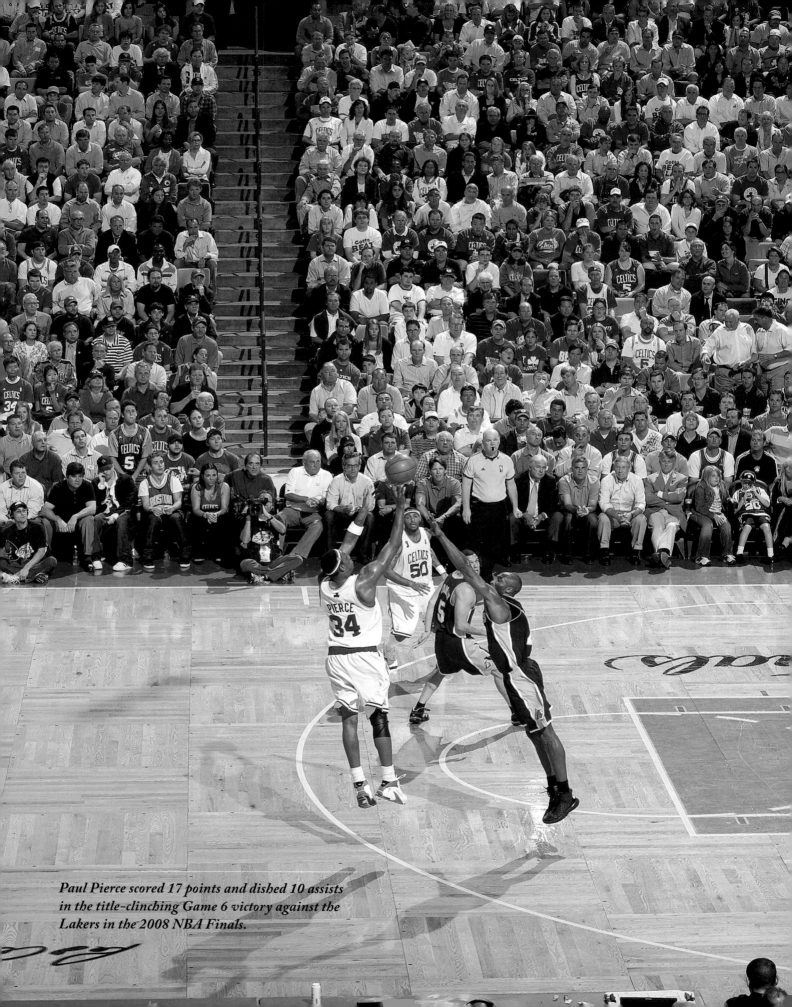

Paul Pierce scored 17 points and dished 10 assists in the title-clinching Game 6 victory against the Lakers in the 2008 NBA Finals.

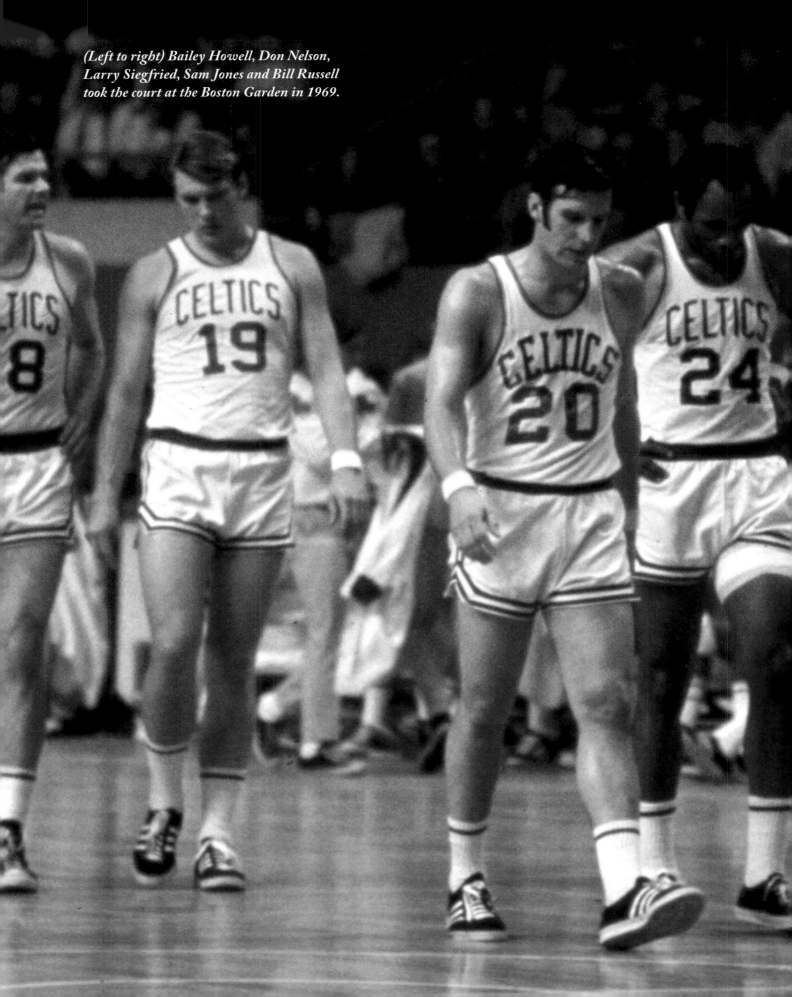

(Left to right) Bailey Howell, Don Nelson, Larry Siegfried, Sam Jones and Bill Russell took the court at the Boston Garden in 1969.

THE PLAYERS

Since their founding as a charter member of the NBA, a succession of stars helped turn the Celtics into one of the league's premier franchises

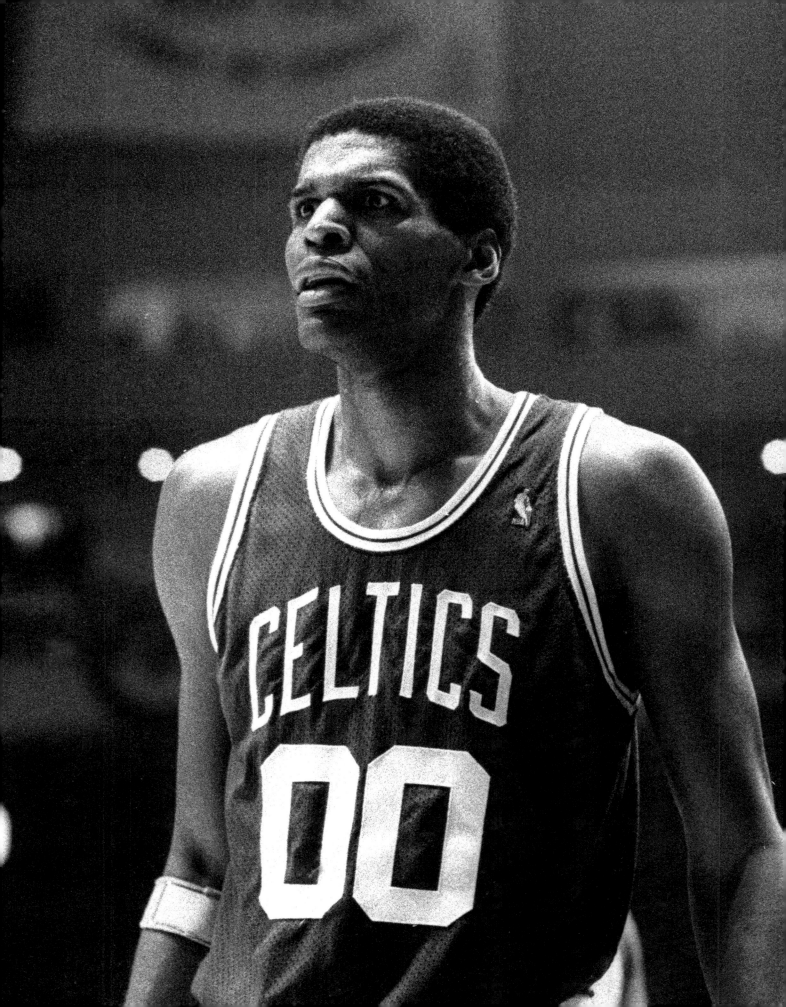

ROBERT PARISH

» **Center 1980–1994**

» **Four-time NBA champion**

» **Nine-time NBA All-Star**

The Boston Celtics had already won 13 NBA championships by the time Robert Parish arrived in 1980 from the Golden State Warriors, but the seven-footer—along with Kevin McHale and Larry Bird—returned them to their lofty perch, leading the team to three titles in six seasons. Parish earned nine All-Star selections and finished second in MVP voting to Bird in 1981–82. Even after the glory days of Boston's first "Big Three," Parish remained productive, appearing in more games than any other NBA player, including 1,106 for Boston, second only to John Havlicek.

Prior to the 1980 NBA draft, the Celtics dealt the top overall pick and an additional first-round selection to the Warriors for Parish and the Warriors' first-round pick, with which Boston chose Kevin McHale.

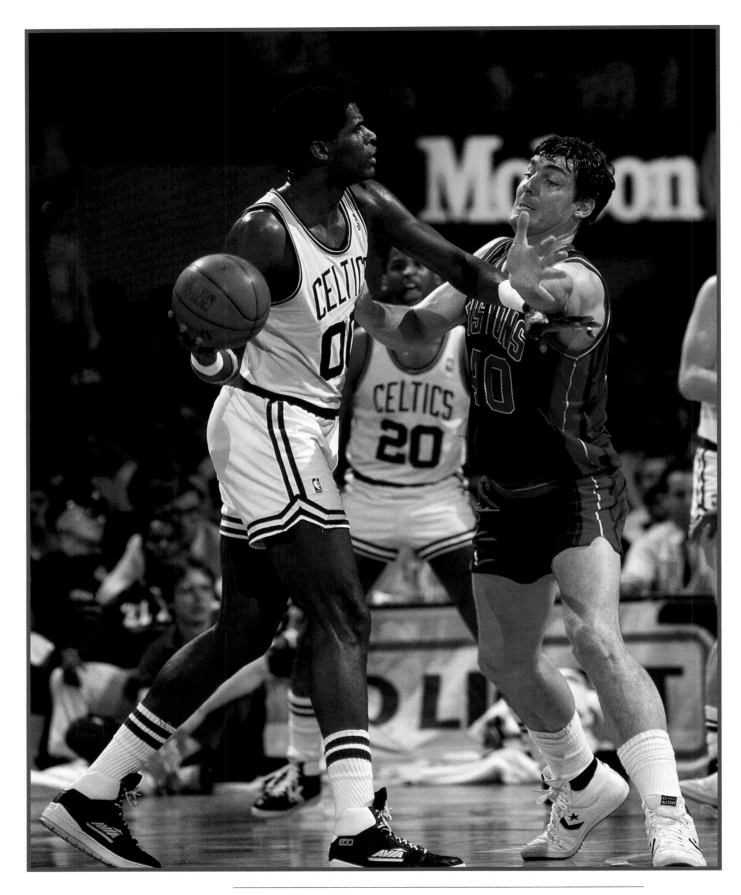

Parish manned the pivot for the Celtics throughout the 1980s, taking on rivals as varied as Detroit's Bill Laimbeer (above) and Los Angeles's Kareem Abdul-Jabbar (right).

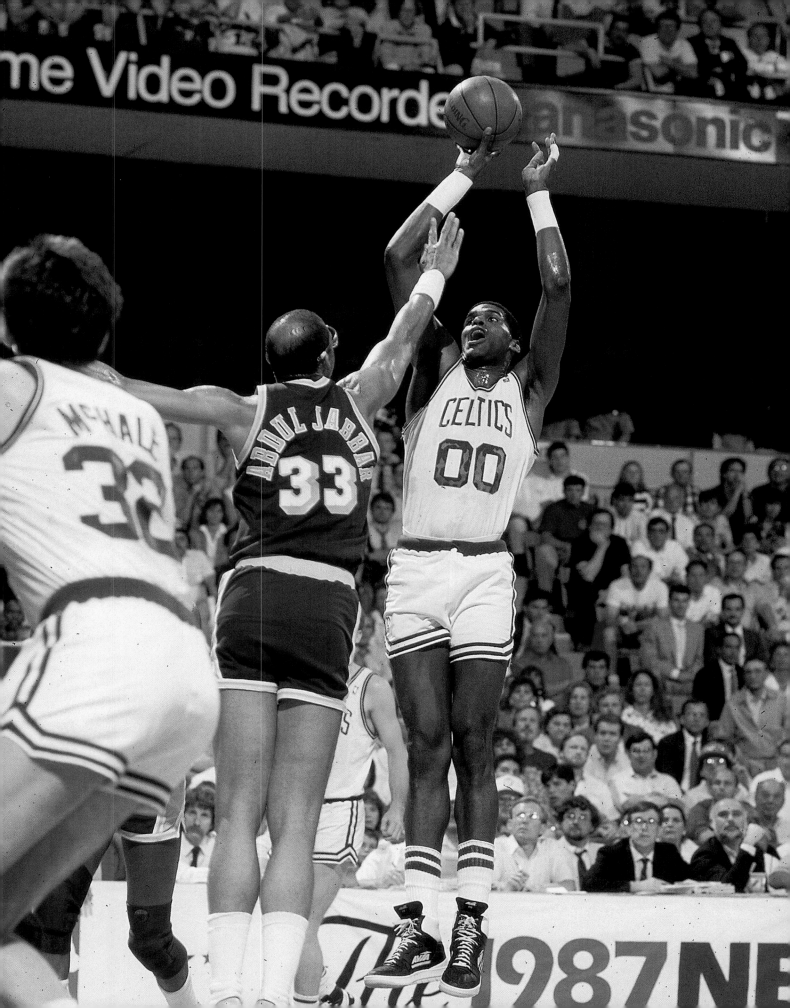

DENNIS JOHNSON

- » **Guard 1983–1990**
- » **Three-time NBA champion**
- » **Five-time NBA All-Star**

When he declared for the 1976 NBA draft, Dennis Johnson wasn't sure he'd hear his name called; Johnson warmed the bench in high school and was thrown off his junior college team three times. But when Seattle selected Johnson 29th in 1976, he rewarded the team in 1979 with their only NBA championship, earning Finals MVP honors. When the Celtics needed to beef up their backcourt in 1983, GM Red Auerbach traded for Johnson, who changed his game to become the playmaking point guard Boston needed. Shutting down Magic Johnson in the 1984 Finals and a buzzer-beater to win Game 4 of the 1985 Finals, along with two titles, sealed Johnson's place in Celtics history. Johnson suffered a fatal heart attack in 2007 at 52 and was posthumously inducted into the Basketball Hall of Fame.

Johnson's steady play in the backcourt allowed the Celtics' other stars to shine.

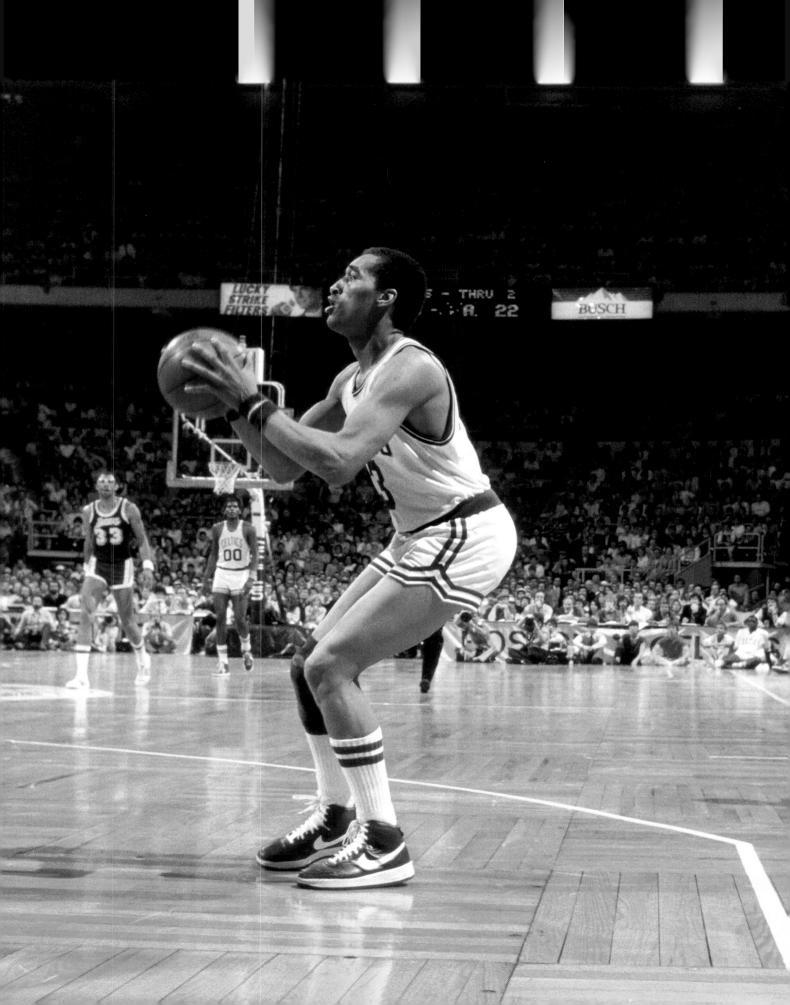

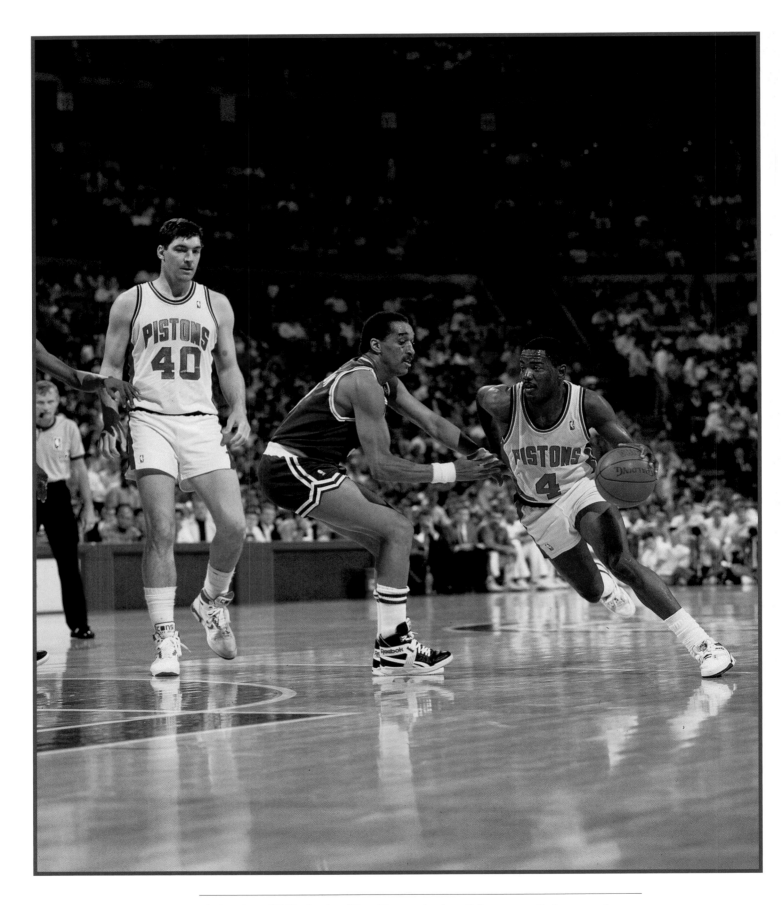

A six-time All-Defensive First Team selection, Johnson excelled at covering smaller guards such as the Pistons' Joe Dumars (above) and taller players such as the Lakers' Magic Johnson (right).

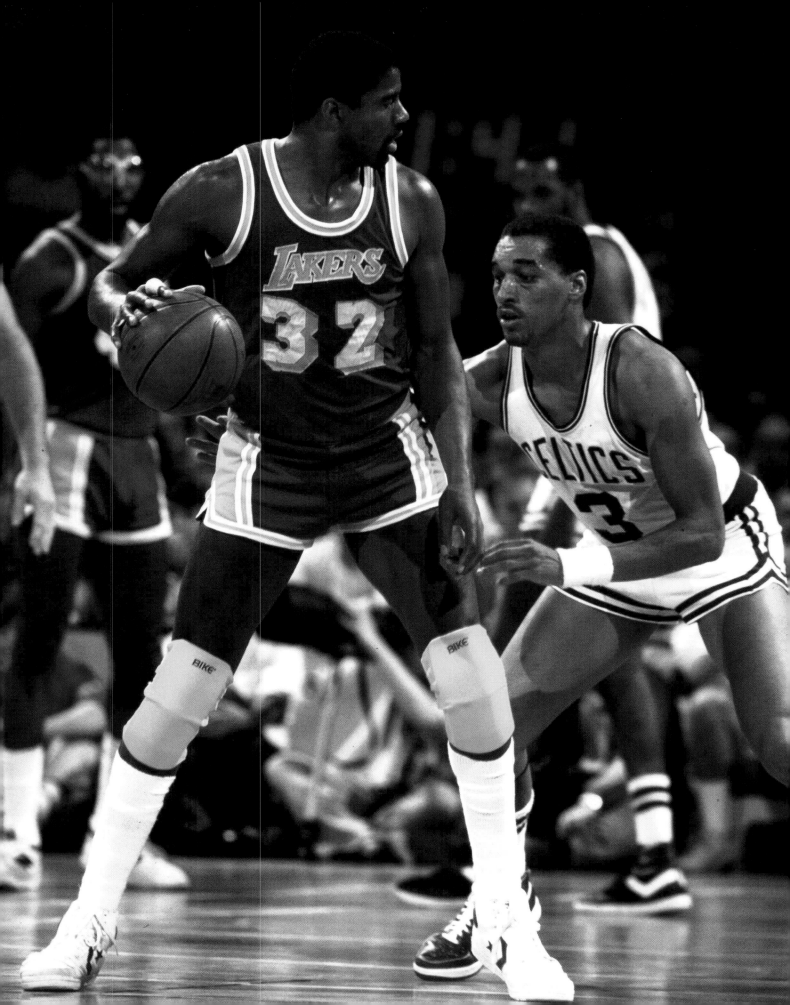

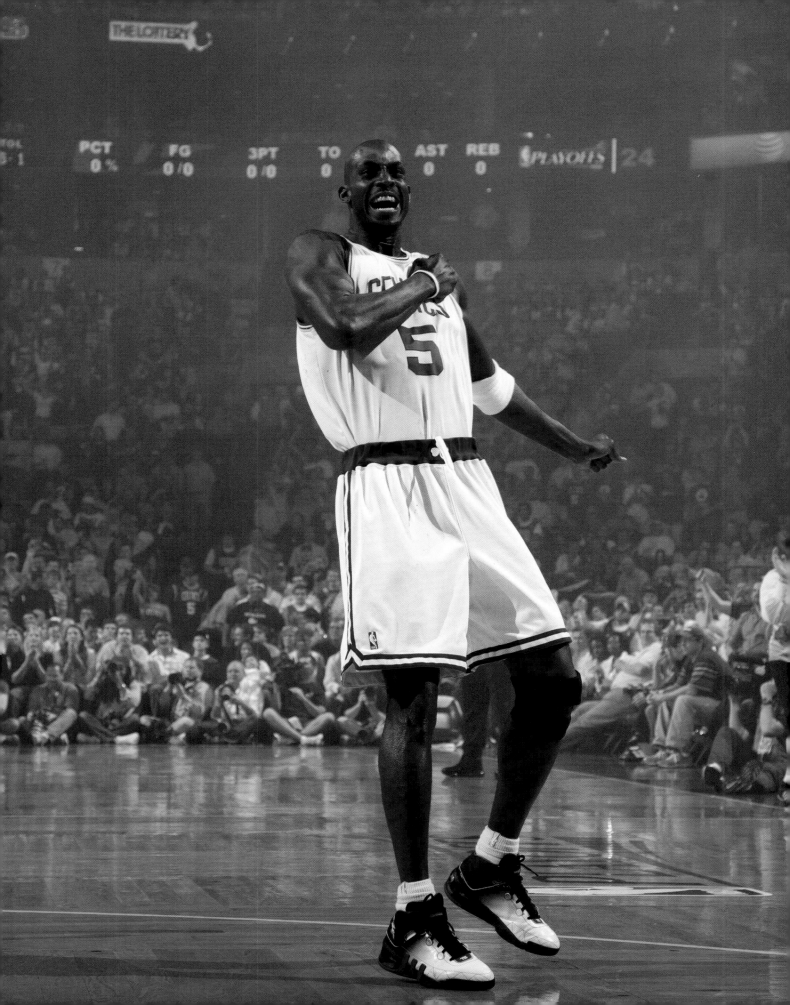

KEVIN GARNETT

» **Forward 2007–2013**

» **NBA Champion 2008**

» **15-time NBA All-Star**

The Celtics had to pay a premium to acquire Kevin Garnett in 2007, sending Minnesota five players and two draft picks. No one would argue Garnett wasn't worth it. Celebrated for his versatility, Garnett is one of only five players to be named MVP and Defensive Player of the Year, the latter in the same season the new "Big Three" of Garnett, Paul Pierce and Ray Allen led the Celtics to their first NBA championship in 22 years. Despite losing during a return trip to the NBA Finals in 2009–10, KG endeared himself to Boston forever with his passion and intensity—not to mention his smooth jumper. The Celtics announced plans to retire his No. 5 during the 2021–22 season.

Garnett's arrival in Boston in 2007 marked a new era in Celtics history.

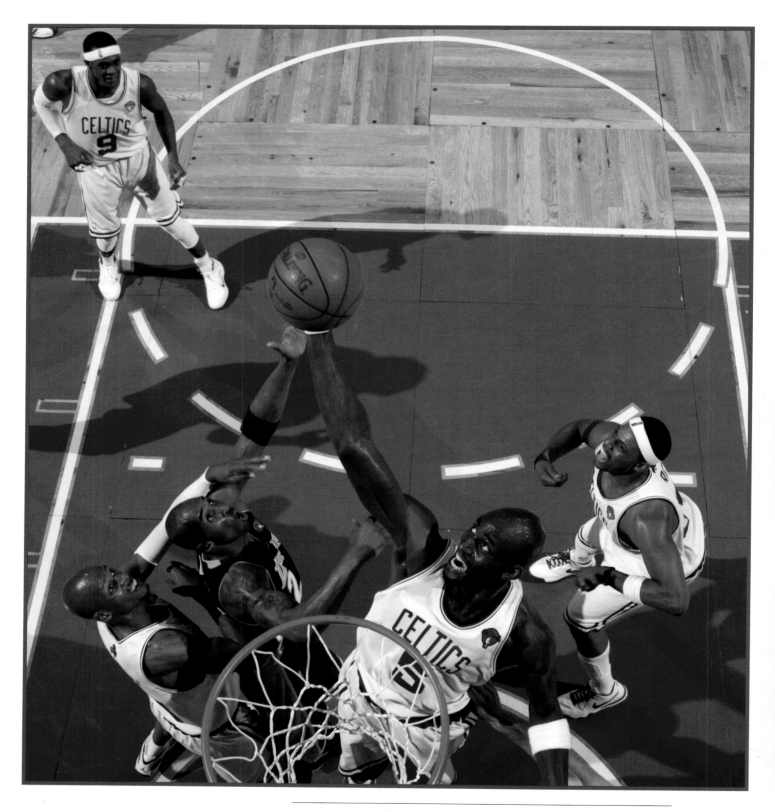

Part of Boston's "Big Three," in 2008 Garnett led the Celtics back
to the Finals for the first time in 22 years, where they met their
long-time rivals, the Los Angeles Lakers. Boston won the series in
six games for its 17th championship, and the first for Garnett.

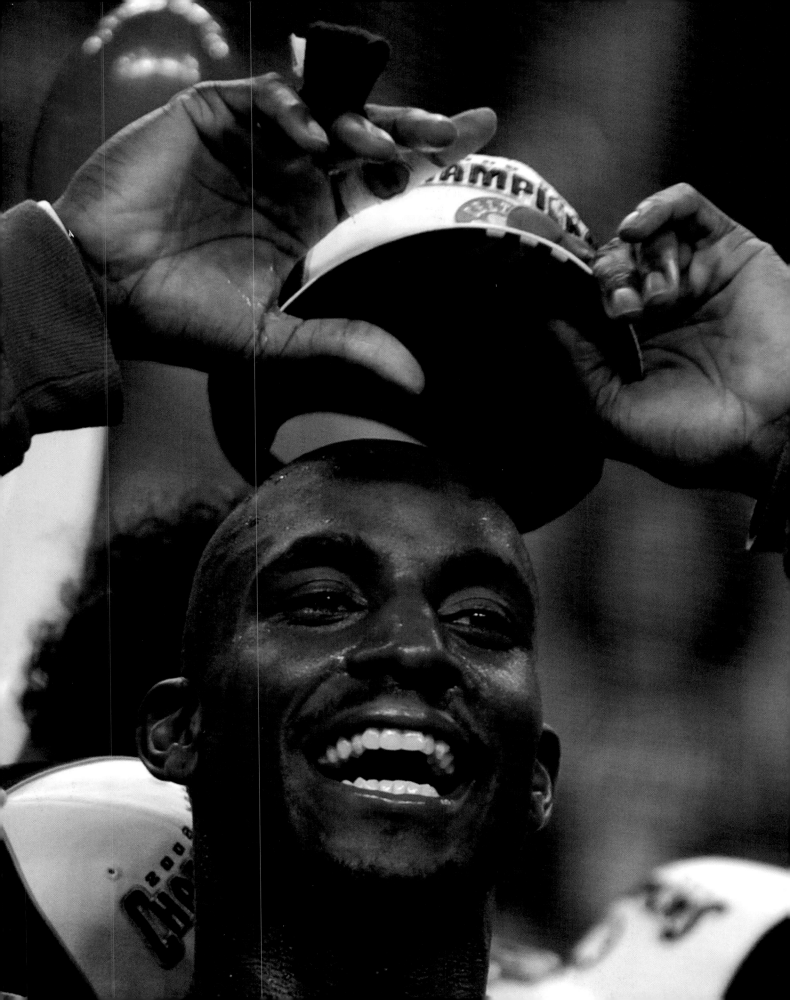

BILL RUSSELL

» **Center 1956–1969**

» **11-time NBA champion**

» **Five-time NBA MVP**

Bill Russell's revolutionary defensive style and rebounding prowess characterized his 13-year career, the entirety of which he played in Boston. The 12-time All-Star was the linchpin of the Celtics dynasty in the 1960s, when his team-first mentality and pioneering defense made the Celtics almost unbeatable. Russell's astonishing 11 NBA championships are tied for the most by an athlete in a North American sports league. He is one of only four players to be named to the NBA 25th, 35th and 50th Anniversary Teams. As important as his on-court contributions was the significance of Russell becoming one of the NBA's first Black superstars. Later, as player-coach for the Celtics, Russell became the first Black coach in a major U.S. professional sports league.

One of the greatest players in NBA history, Russell was an icon on and off the court.

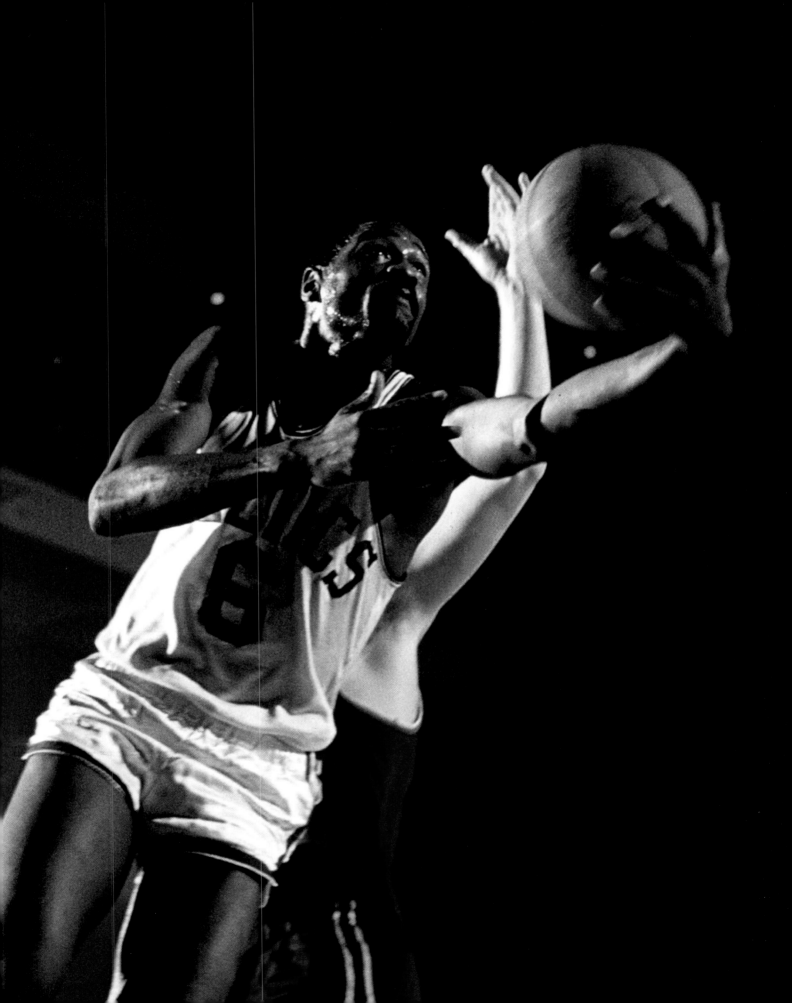

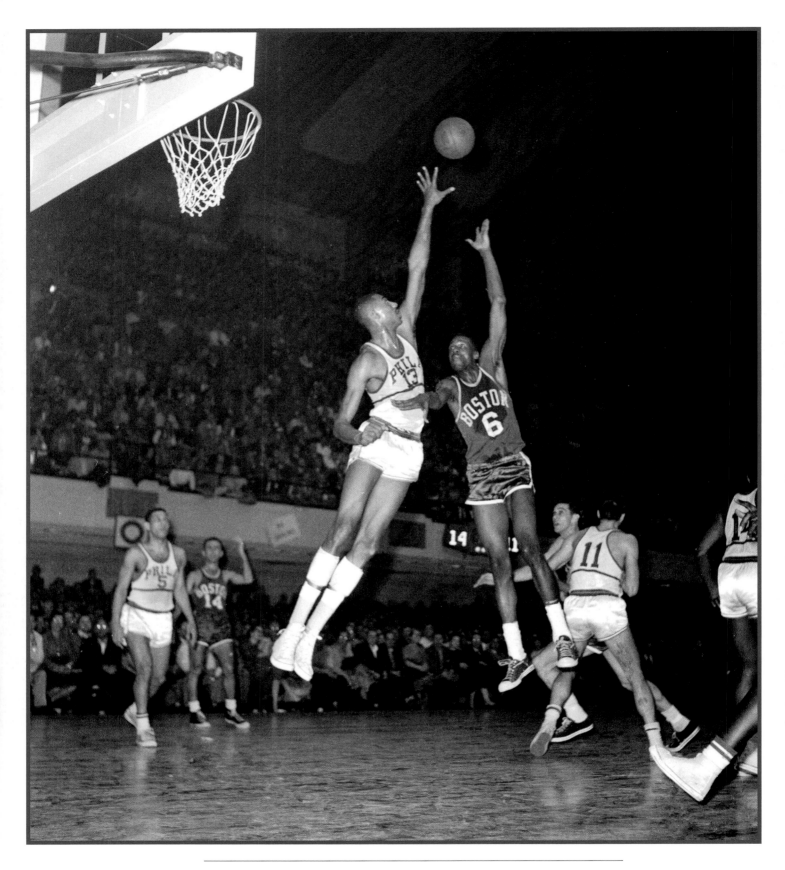

The rivalry between Russell and Chamberlain dominated the NBA throughout the 1960s. In eight playoff series between Boston and Chamberlain's teams, the Celtics' center led his side to seven victories.

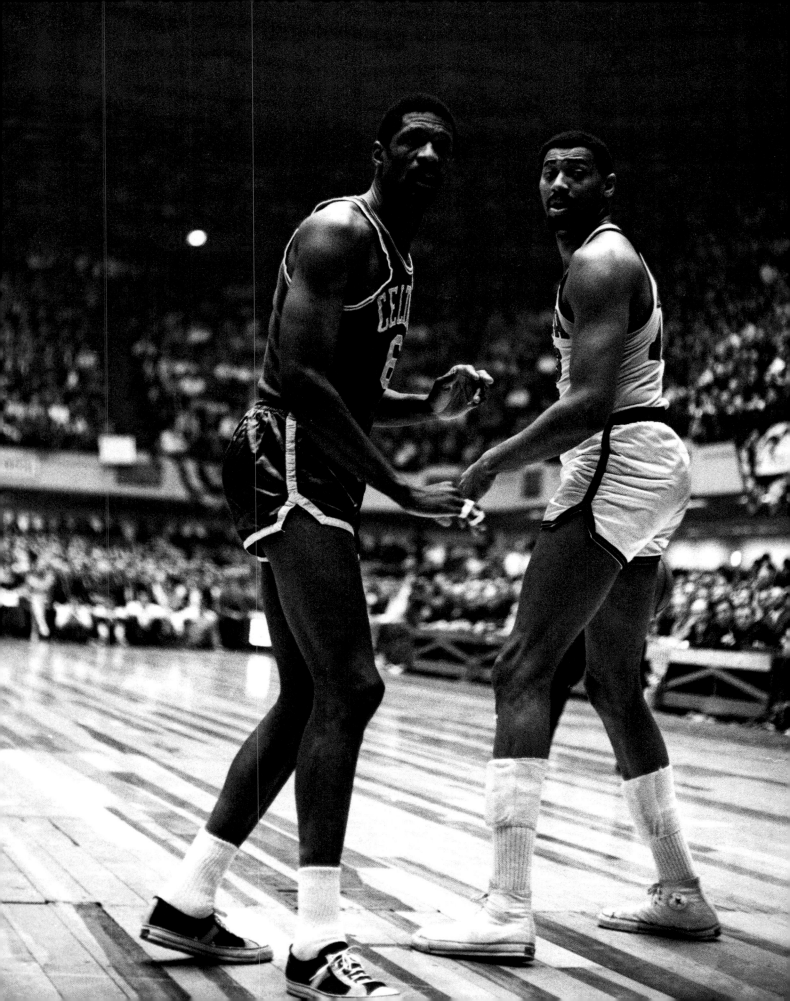

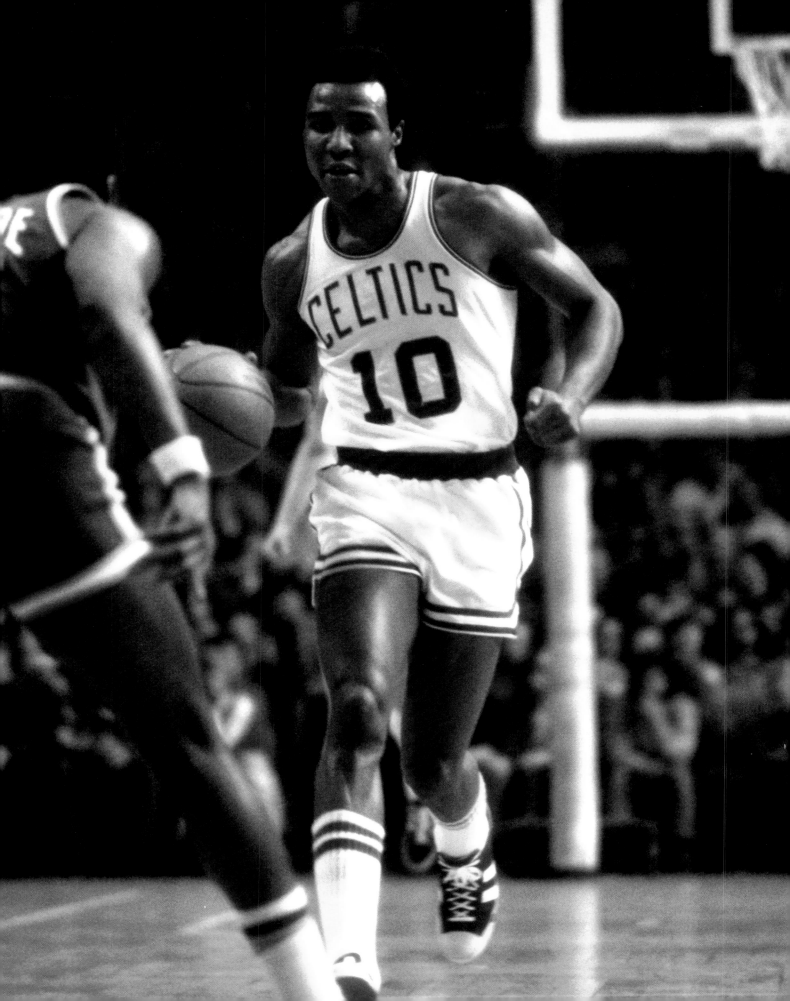

JO JO WHITE

» **Guard 1969–1979**

» **Two-time NBA champion**

» **Seven-time NBA All-Star**

When Jo Jo White was drafted by the Celtics in 1969, he thought he was joining a perennial contender, fresh off its 11th championship in 13 years. By the time he reported to training camp, player-coach Bill Russell and shooting guard Sam Jones had retired, and the dynastic Celtics were soon humbled by their first losing season in 20 years. Anchoring the team at point guard, White led the Celtics back to a title in 1974. White's career was highlighted by his 33-point, nine-assist night in Boston's triple-overtime win over Phoenix in Game 5 of the 1976 Finals, a series in which he earned MVP honors. White died from complications from dementia in 2018 at age 71, having served as the Celtics' director of special projects for 18 years.

In White's rookie season, the Celtics suffered their first losing campaign since 1950. Their new point guard would soon lead them back to a championship.

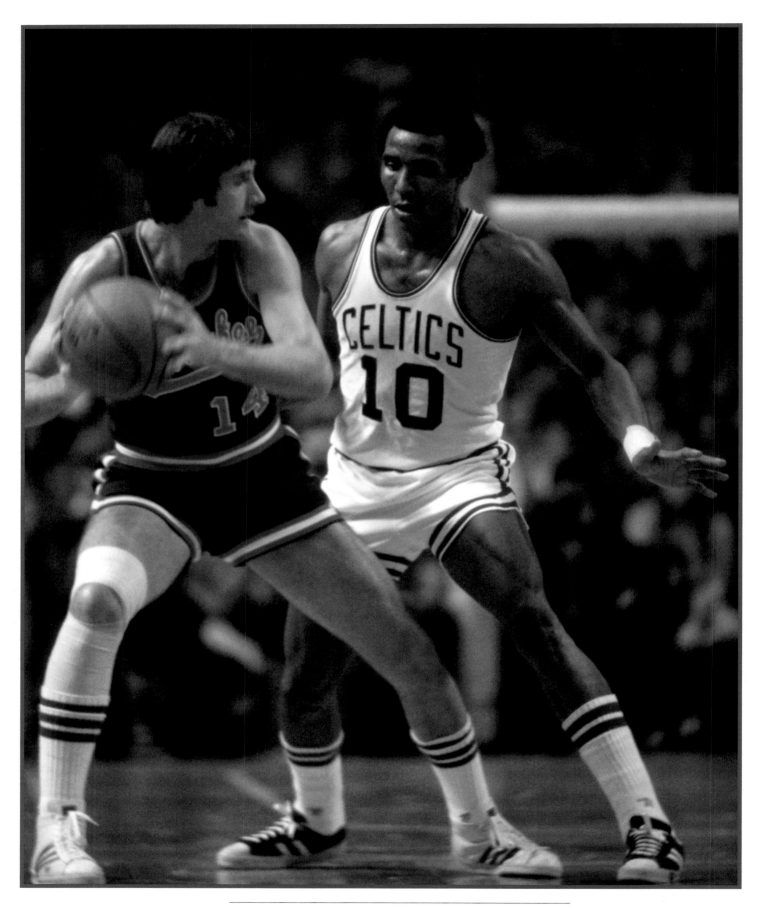

*An iron man who played hard on both ends of the court,
White set a franchise record by playing in 488 consecutive
games between 1972 and 1978.*

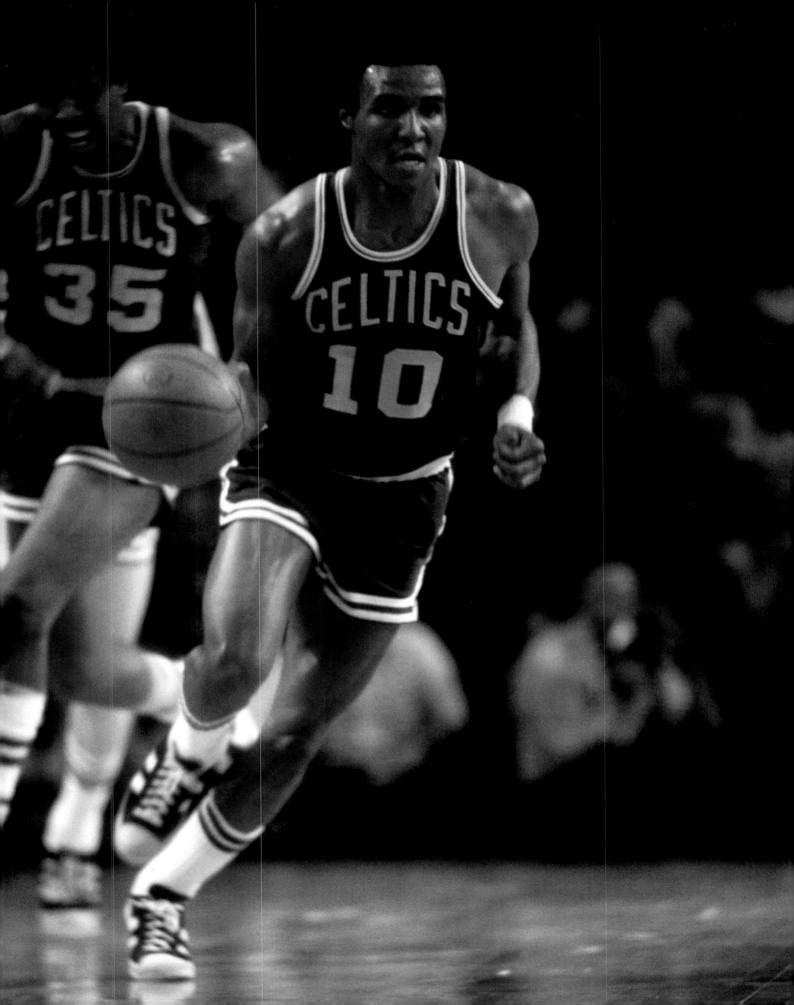

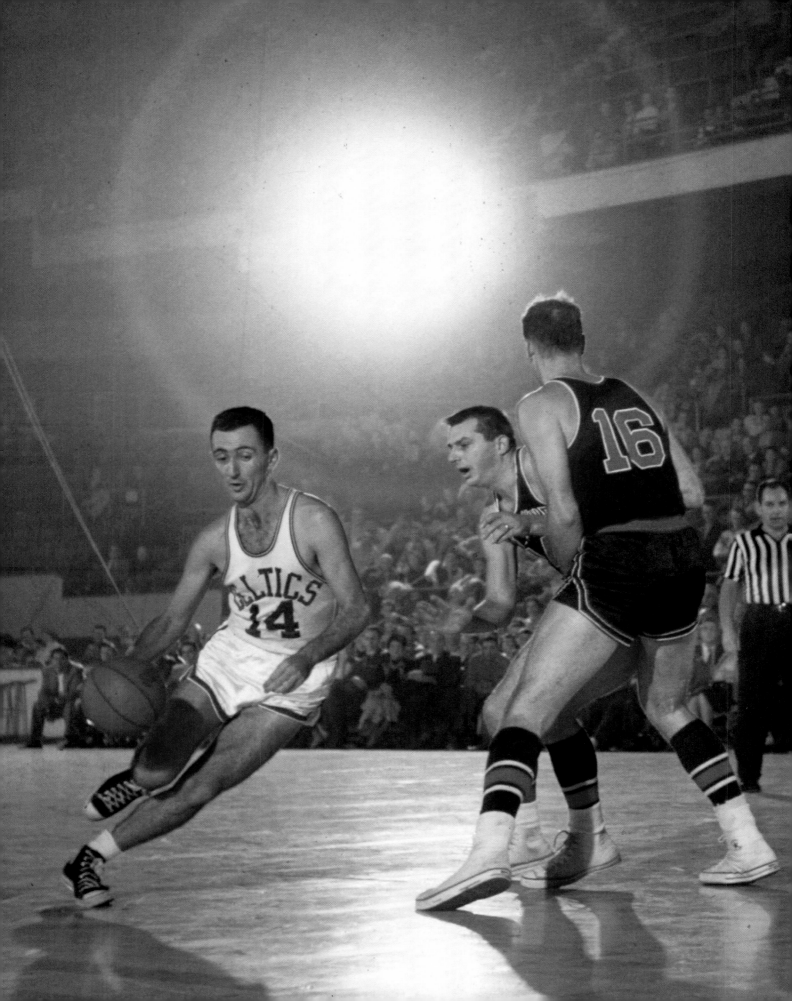

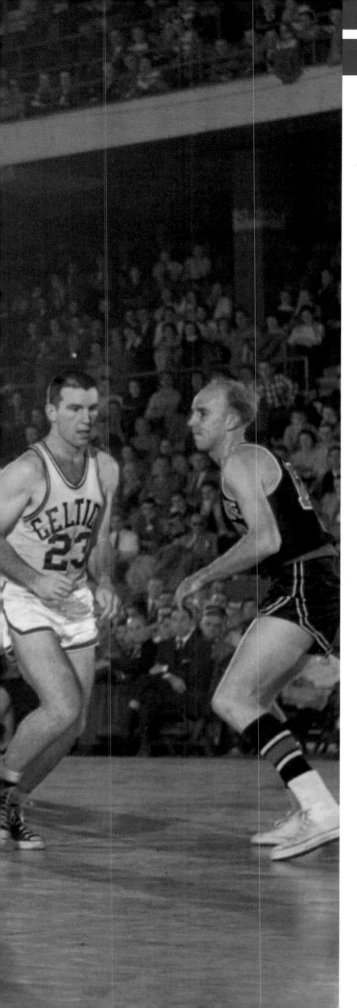

BOB COUSY

» **Guard 1950–1963**

» **Six-time NBA champion**

» **13-time NBA All-Star**

The Celtics had the chance to select Bob Cousy with the first pick in the 1950 NBA draft. They passed. Instead, the Tri-Cities Blackhawks drafted Cousy third overall and traded him to the Chicago Stags—who promptly folded. Cousy's name was placed in a hat along with Chicago's two other top players, and Boston drew Cousy in the dispersal draft. The team that didn't want Cousy in the first place soon wondered what it ever did without him, as he quickly developed into the league's top point guard. Named league MVP in 1957, Cousy's flashy play—punctuated by behind-the-back and no-look passes—was years ahead of its time. The "Houdini of the Hardwood" led the Celtics to six NBA championships during his 13 seasons in Boston.

In much the same way Russell revolutionized basketball defense, Cousy redefined what a point guard could be on offense.

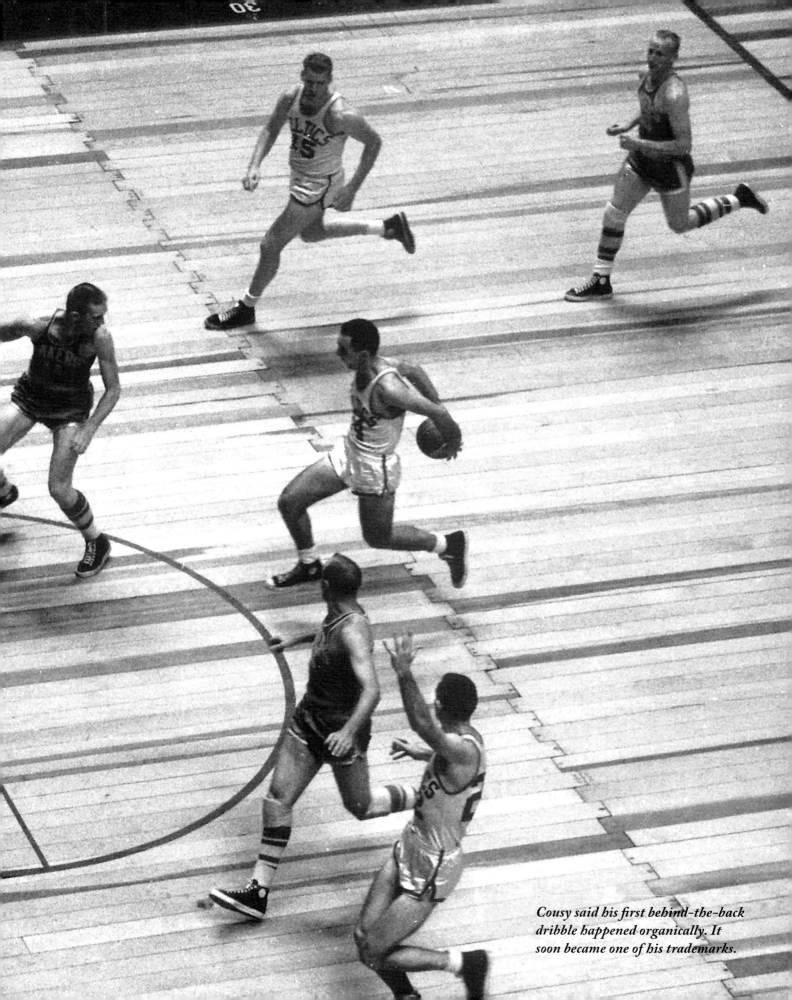

Cousy said his first behind-the-back dribble happened organically. It soon became one of his trademarks.

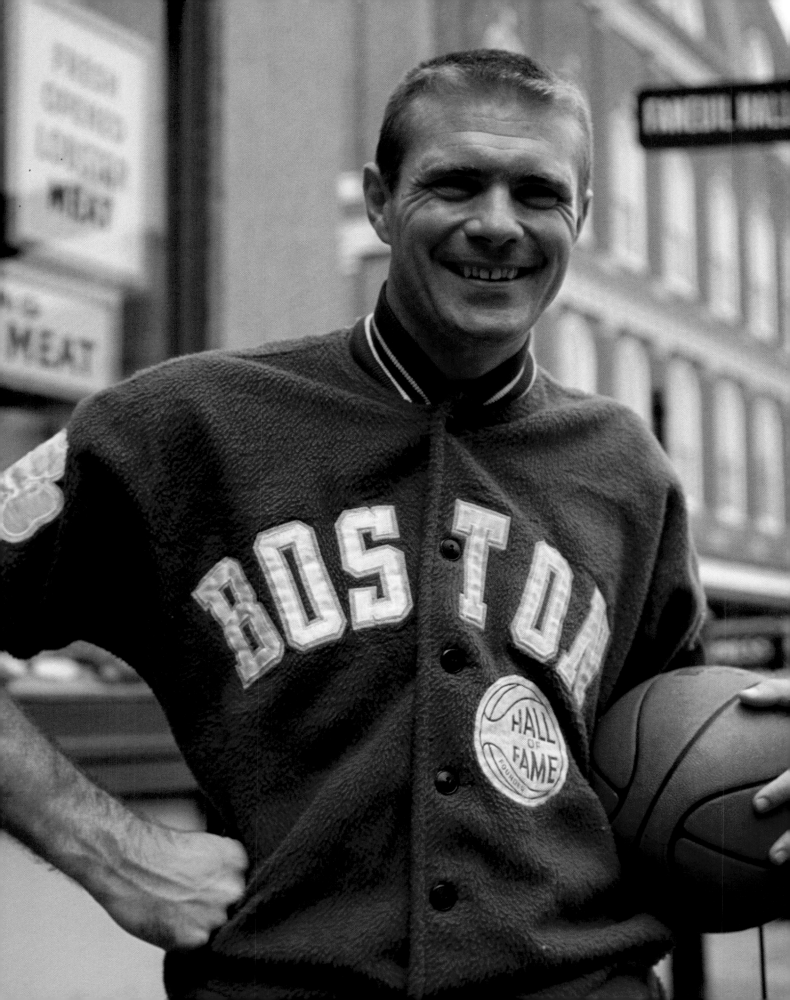

TOM HEINSOHN

» **Forward 1956–1965**

» **Eight-time NBA champion**

» **Six-time NBA All-Star**

Boston coach Red Auerbach had doubts Tom Heinsohn would make the team after being selected in the 1956 NBA draft. Heinsohn responded by winning the league's Rookie of the Year award, averaging 16.2 points per game as the Celtics won their first NBA championship. In Heinsohn's nine years in Boston, the Celtics won eight titles—and when he became coach in 1969, they won two more. When his career on the court was over, "Mr. Celtic" moved to the booth and broadcasted the team's games for more than 30 years. The only person to have been with Boston for all 17 of its championships, Heinsohn died in November 2020 at age 86.

Few figures are as identified with a single franchise as Heinsohn is with the Boston Celtics.

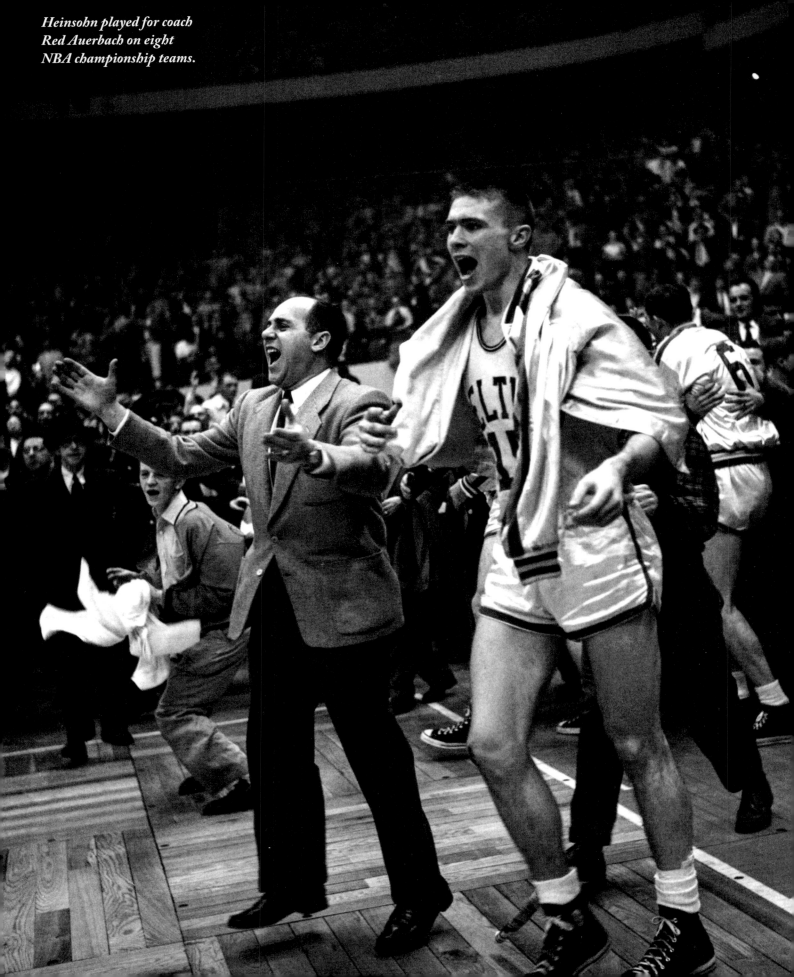

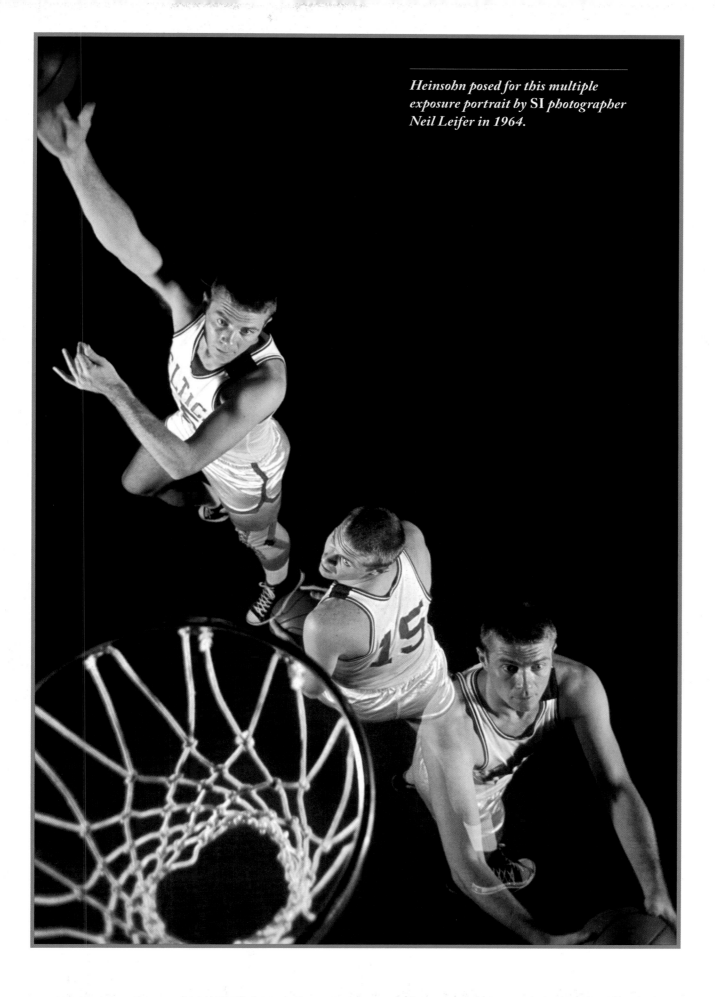

Heinsohn posed for this multiple exposure portrait by SI photographer Neil Leifer in 1964.

SATCH SANDERS

» **Forward 1960–1973**

» **Eight-time NBA champion**

» **Basketball Hall of Fame 2011 (contributor)**

Like his teammate Tom Heinsohn, Tom "Satch" Sanders spent his entire NBA playing and coaching careers with the Celtics. The team's top selection in the 1960 NBA draft, Sanders was an integral part of eight NBA championship teams in Boston; only teammates Bill Russell and Sam Jones amassed more titles as players. Never asked to be a prolific scorer by coach Red Auerbach, Sanders made his living as one of the NBA's great defensive forwards. His light 6'6", 210-pound frame belied his ability to shut down opponents' top scorers. As important as his contributions on the court was his advocacy for players; Sanders founded the rookie transition program in 1986 and was instrumental in the creation of the NBA's player programs department.

Known mostly for his defensive prowess, Sanders remains 15th on the Celtics' all-time career scoring list.

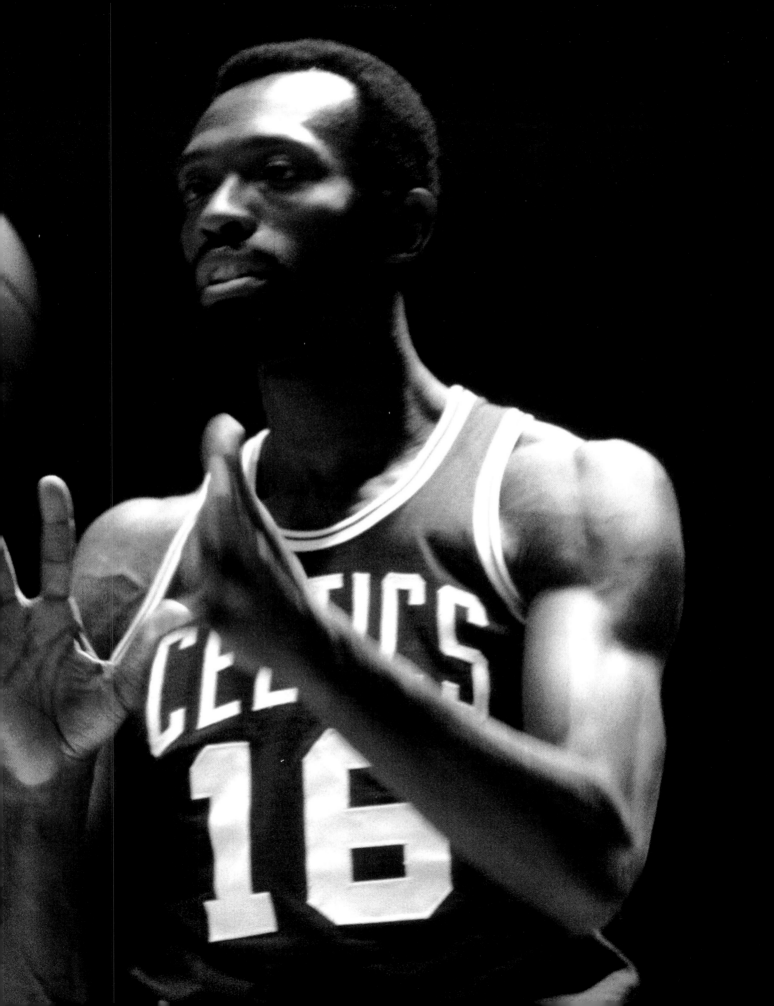

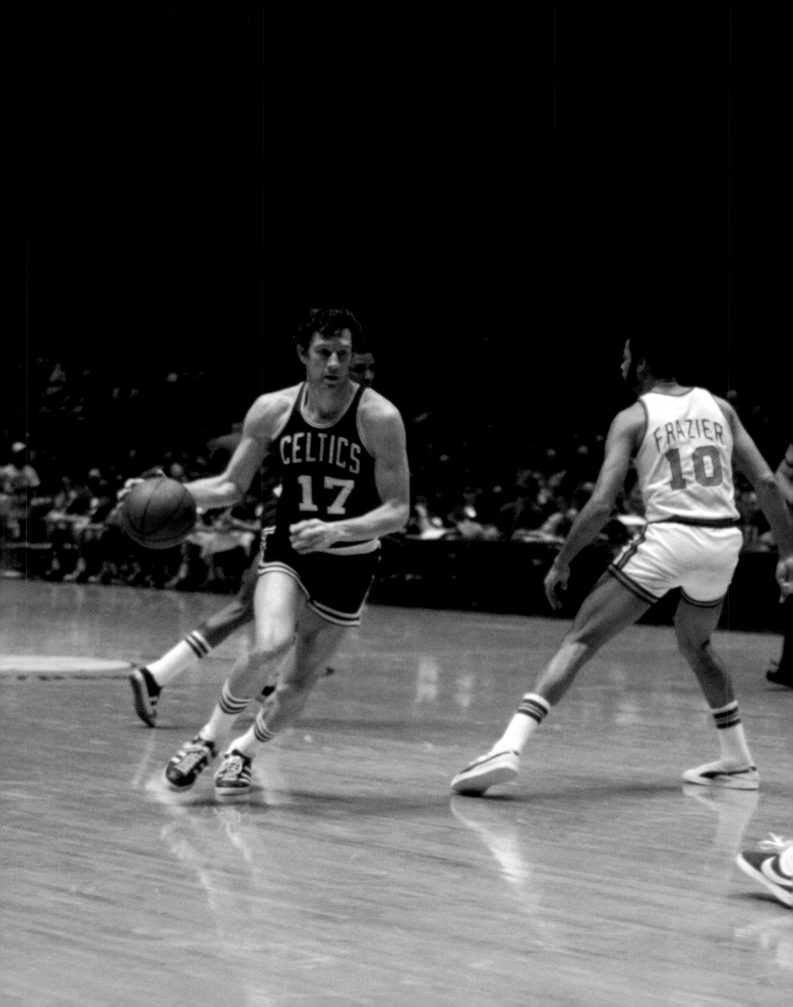

JOHN HAVLICEK

- » **Forward 1962–1978**
- » **Eight-time NBA champion**
- » **13-time NBA All-Star**

It's unlikely any player will ever catch John Havlicek as the Celtics' all-time scoring leader; "Hondo" also leads the franchise in regular-season games played (1,270) and minutes played (46,471) as he racked up 26,395 career points. The player coach Red Auerbach described as the "guts of the team" won six NBA championships during the 1960s dynasty and, after the rebuild, captained the team to two more in 1974—earning the Finals MVP award—and '76. In perhaps his most memorable moment, Havlicek's steal against Philadelphia in Game 7 of the 1965 Eastern Division finals was immortalized by broadcaster Johnny Most's "Havlicek stole the ball!" call. Suffering from Parkinson's disease late in life, Havlicek died in 2019 at age 79.

Celtics teammate Bill Russell said Havlicek was "the best all-around player I ever saw."

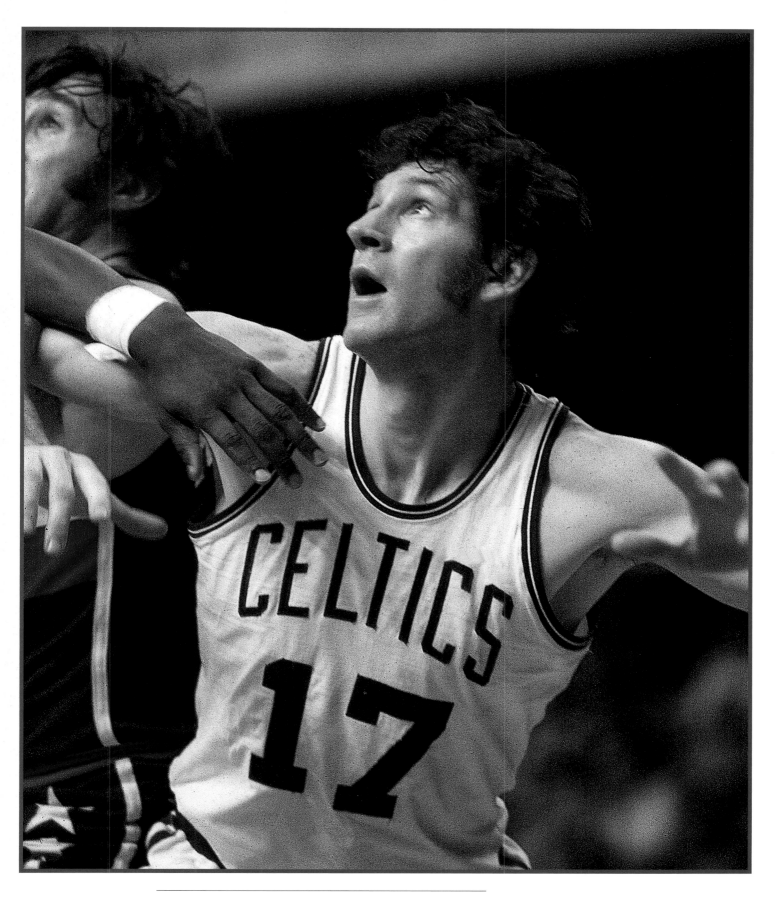

Despite being seen as a "tweener" at 6'5", no Celtic played more games than Havlicek in franchise history, and only four players have collected more career rebounds.

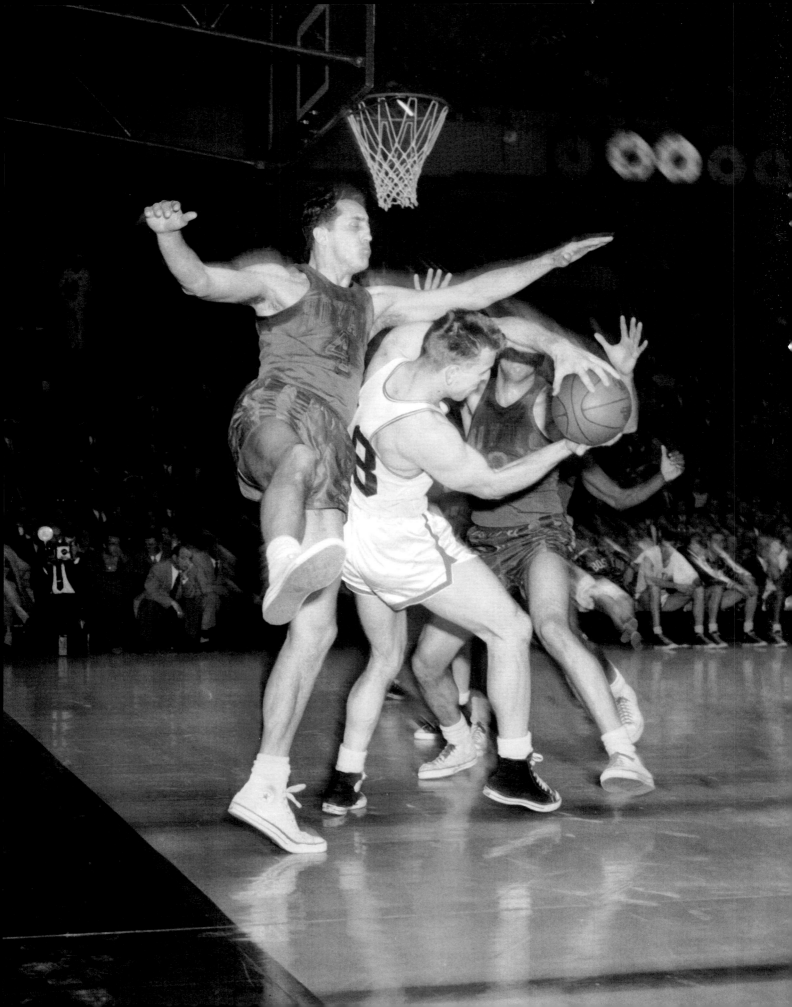

JIM LOSCUTOFF

» **Forward 1955–1964**

» **Seven-time NBA champion**

» **Boston "LOSCY" jersey retired 1964**

Jim "Loscy" Loscutoff played all of his nine NBA seasons in Boston, seven of which ended in NBA titles. An accomplished rebounder at the University of Oregon, as a rookie Loscutoff set a Celtics record for rebounds in a game, with 26. Loscutoff's value in Boston came not in points scored but in his hard-hitting enforcer role, which he embraced with aplomb. When Boston wanted to honor Loscutoff by retiring his No. 18 jersey, he expressed his wishes for it to be worn by future Celtics; it would eventually be retired for Dave Cowens. Loscy died in 2015 at the age of 85, but his nickname remains forever suspended in the rafters of the Garden.

A tenacious rebounder, Loscutoff held onto this ball against the Rochester Royals in 1956.

DAVE COWENS

- » **Center 1970–1980**
- » **Two-time NBA champion**
- » **NBA MVP 1973**

Bridging the gap between Bill Russell's Celtics of the 1960s and Larry Bird's teams of the 1980s, Dave Cowens starred for two Boston championship teams in the 1970s. The fourth overall pick of the 1970 NBA draft, Cowens won the Rookie of the Year award after averaging 17 points and 15 rebounds per game. He won the league's MVP award in 1973, then led the Celtics to a Finals victory over Milwaukee the following season for Boston's 12th championship. Cowens and the Celtics repeated the feat in 1976, defeating Phoenix in six games. Named one of the 50 greatest players in NBA history in 1996, Cowens remains third on the Celtics' all-time rebounding list, behind Bill Russell and Robert Parish.

Cowens followed Bill Russell in the Celtics' line of great centers, and led the team to two NBA titles.

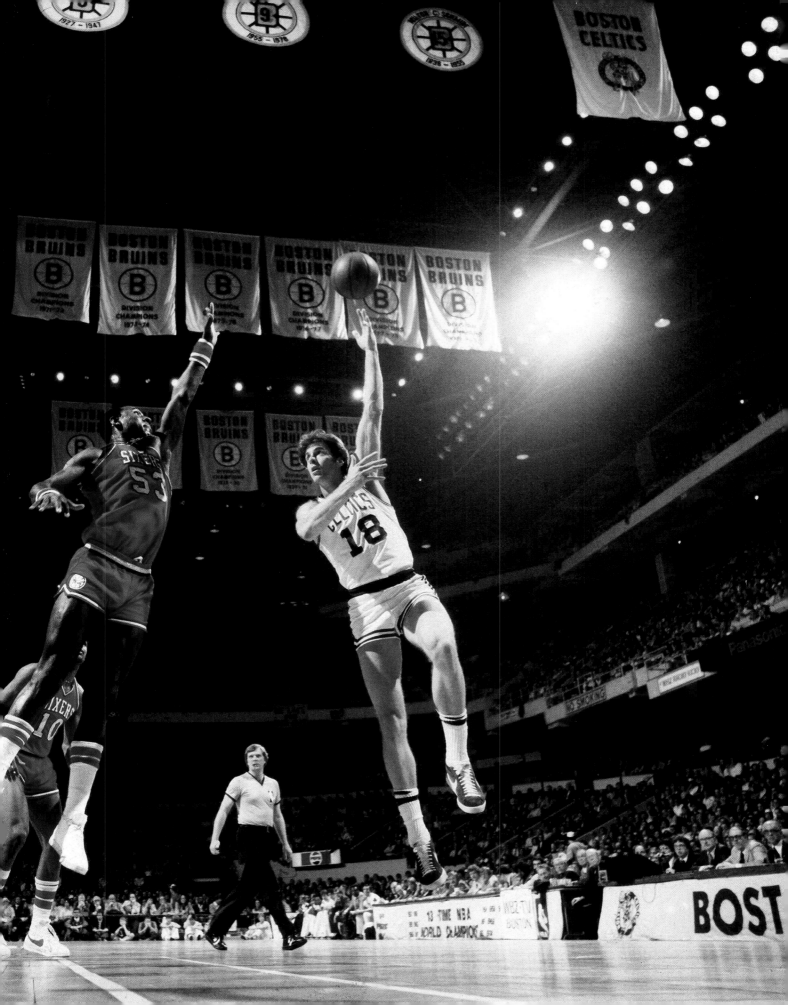

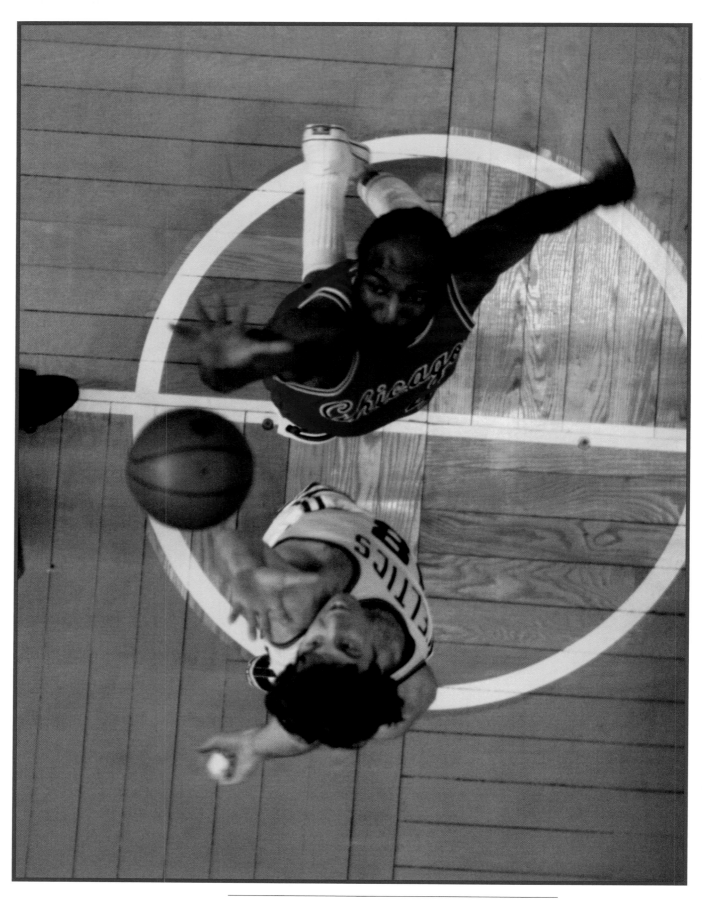

*Cowens had the size to jump center and the offensive skills
to score more than 13,000 career points.*

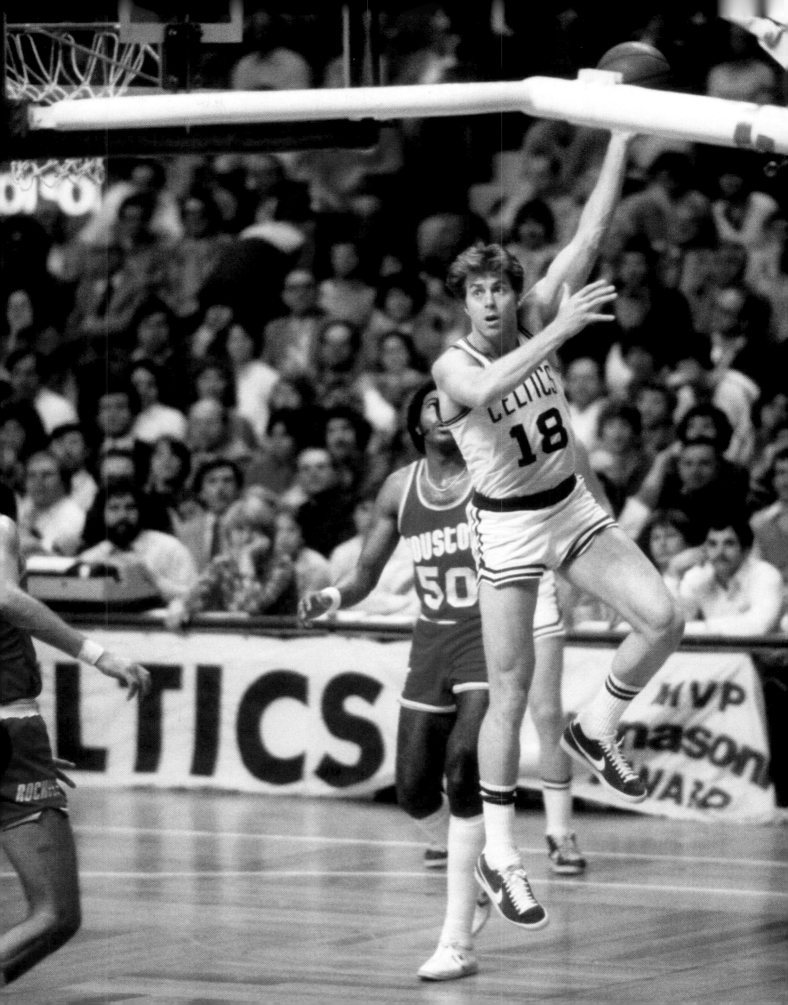

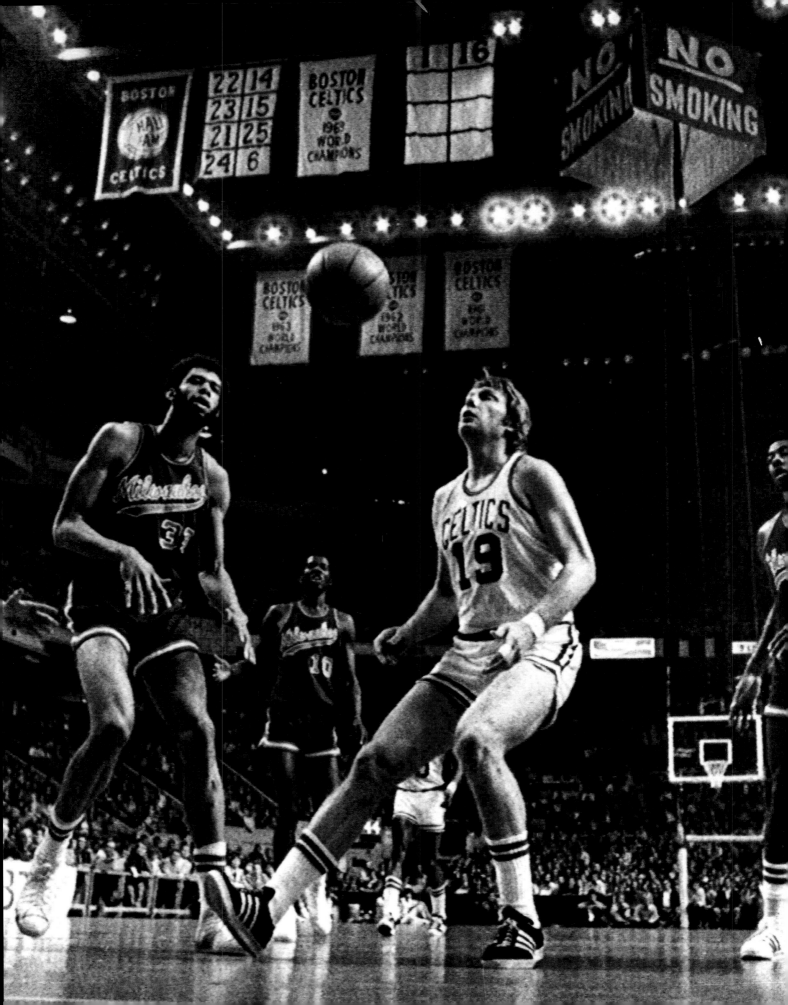

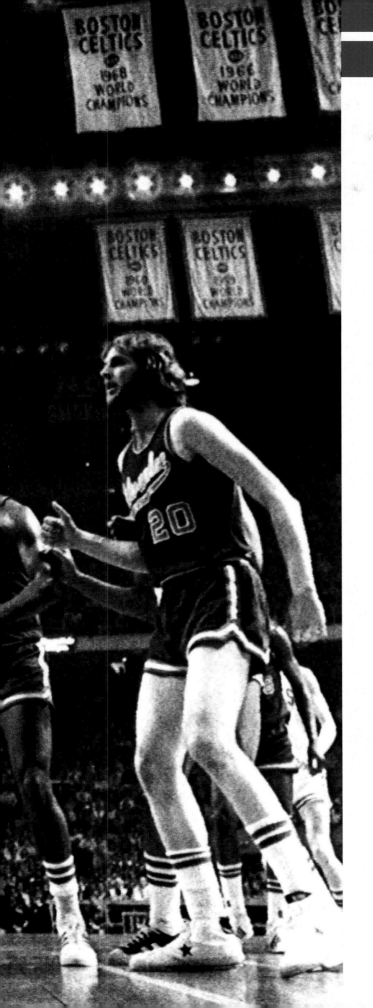

DON NELSON

» **Forward 1965–1976**

» **Five-time NBA champion**

» **Basketball Hall of Fame 2012 (coach)**

After Don Nelson left the University of Iowa as the program's all-time leading scorer, the All-American played one season for the Chicago Zephyrs before being claimed on waivers by the Los Angeles Lakers, with whom he would face the Celtics in the 1965 NBA Finals in a losing effort. The next season, Nelson signed with the Celtics as a free agent and found himself on the winning side when the two teams met again in the Finals. Nelson averaged double figures in points in 11 of his 13 seasons, during which time the Celtics would enjoy four more championships, in 1968, '69, '74 and '76. His last season as a player was 1975–76, and the Celtics retired his No. 19 two years later.

Nelson was part of a Boston team that beat Milwaukee for the NBA championship in 1974, the forward's fourth title as a Celtic.

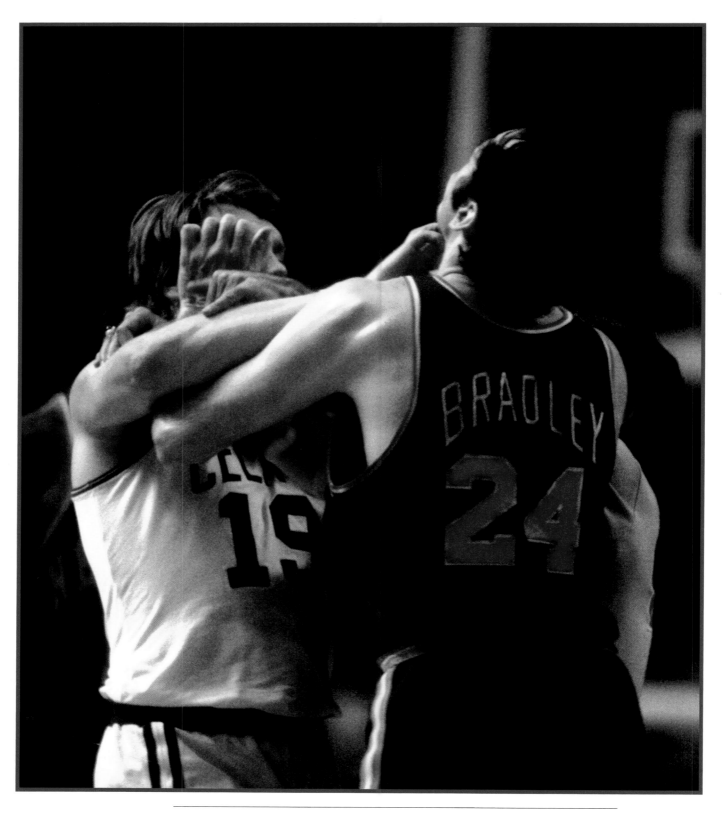

Nelson almost came to blows against the Knicks' Bill Bradley in 1973 (above). In 1976, Nelson helped the Celtics win yet another championship, this time at the expense of the Phoenix Suns (right).

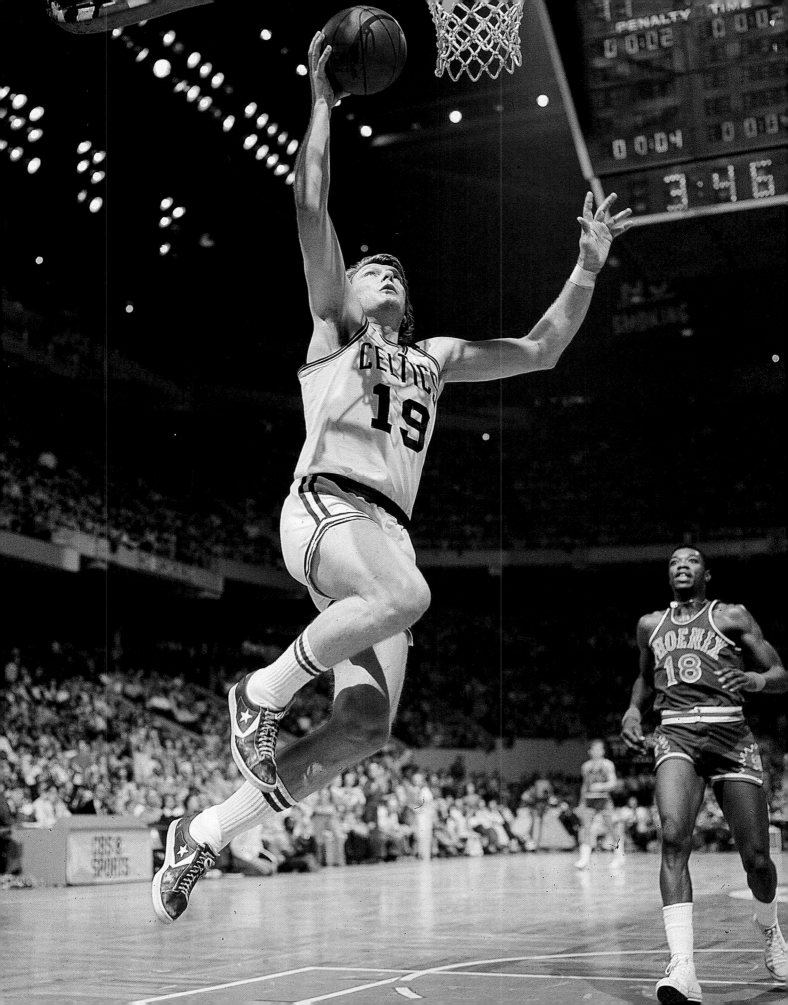

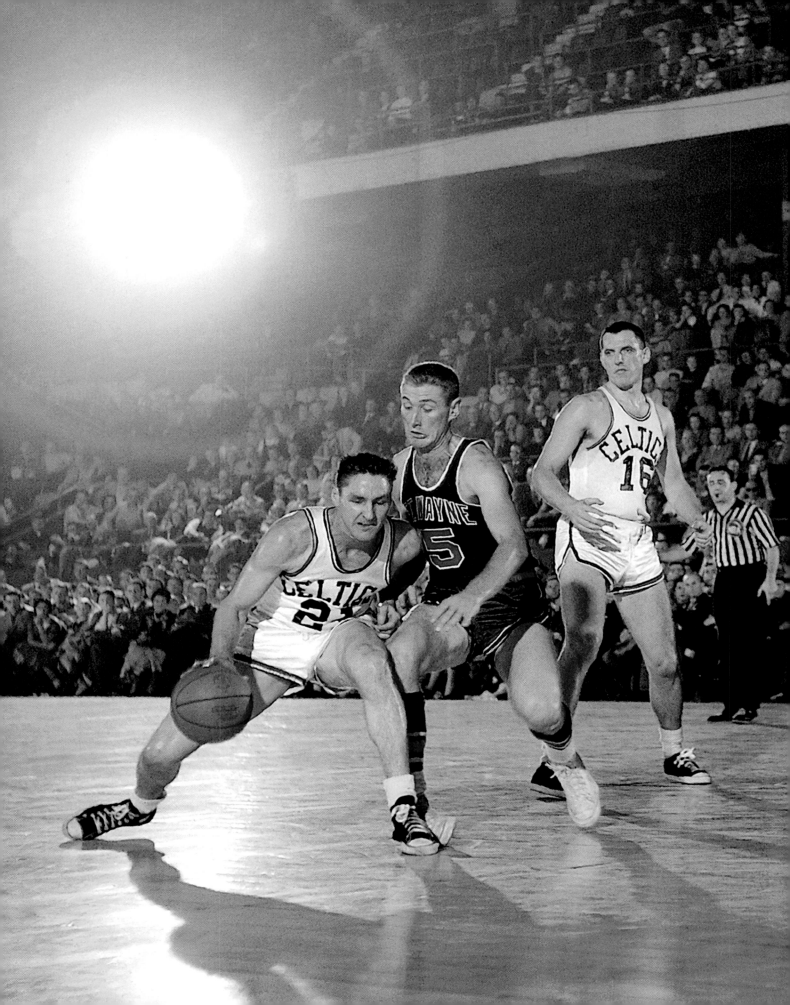

BILL SHARMAN

» **Guard 1951–1961**

» **Four-time NBA champion**

» **Eight-time NBA All-Star**

Forming one of the game's great backcourt tandems with Bob Cousy, Bill Sharman played 680 games in 10 seasons with the Celtics, averaging 18.1 points per game. He played on four of Boston's eight consecutive title teams before retiring following the 1960–61 season. Sharman then began a second career as a coach and executive, guiding the Lakers to their first title in Los Angeles in 1971–72. He is one of only five players, including teammate Bill Russell, to be inducted into the Basketball Hall of Fame as a player and coach. He is credited with several innovations, including the development of the modern jump shot and the shootaround, that endure in today's NBA. The Celtics retired his No. 21 in 1966.

Less heralded than his backcourt mate Bob Cousy, Sharman would go on to become the first man in North American professional sports to win a title as a player, coach and executive.

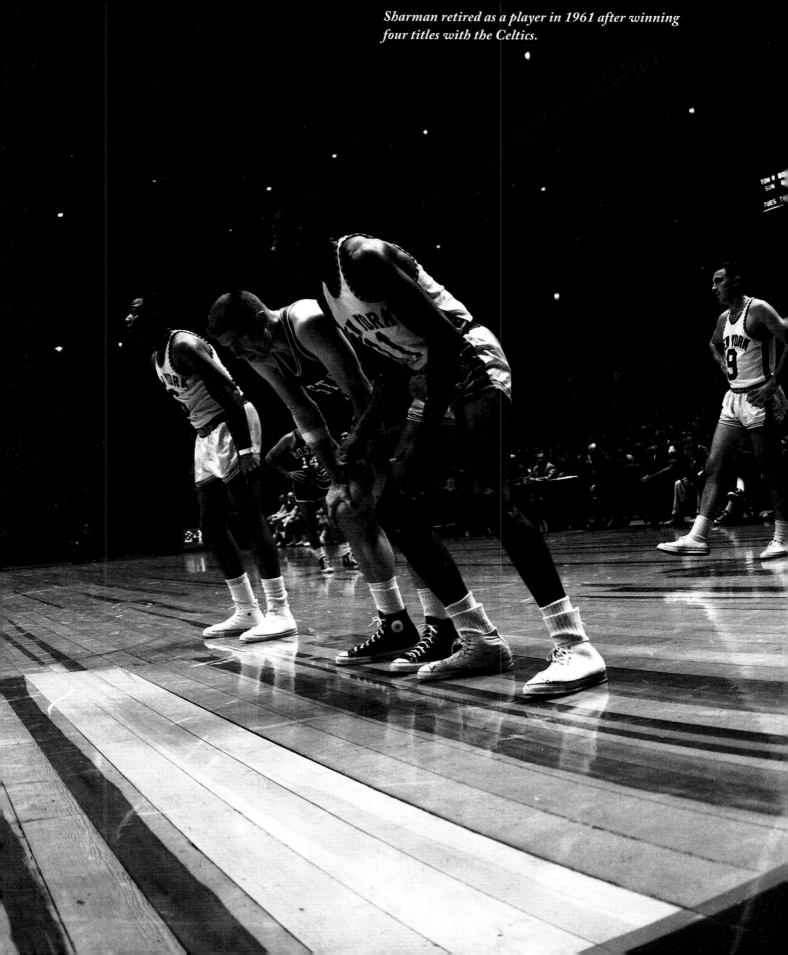

ED MACAULEY

- » **Center 1950–1956**
- » **NBA champion 1958**
- » **Seven-time NBA All-Star**

Ed Macauley's name isn't mentioned as often in Celtics lore as those of Larry Bird or John Havlicek, but there's no question he was one of the NBA's biggest stars in his era. One of the few players to have his jersey retired by the Celtics who didn't win a title with the team, "Easy Ed" was nevertheless dominant in his day; he is the only Celtics player to ever finish in the top 10 in the NBA in points per game, rebounds per game and assists per game. Macauley, even in coverage of his death in 2011, is most often referenced as one of the players traded to St. Louis in exchange for the chance to draft Bill Russell. But before Boston had ever won an NBA championship, Macauley was tearing up the parquet floor.

Macauley starred for Boston at center for six seasons, then was replaced by the greatest center in team history.

FRANK RAMSEY

» **Forward 1954–1964**

» **Seven-time NBA champion**

» **Basketball Hall of Fame 1981**

A standout on Adolph Rupp's championship Kentucky squad in 1951, Frank Ramsey spent his rookie season with the Celtics before completing a year of military service. When he returned to the court in 1956–57, he won the first of his seven championships with the team, including six straight between 1959 and 1964. On paper, his best statistical season was 1957–58, when he averaged 16.5 points and 7.3 rebounds per game; it was also the only season Boston did not win the title following his return from the Army. The sixth man role that fellow Celtics John Havlicek and Kevin McHale would continue to develop in the NBA originated with Ramsey, a player coach Red Auerbach wanted in the lineup in the final minutes of close games.

Though talented and productive enough to start for the Celtics, Ramsey instead became the first in a line of accomplished bench players.

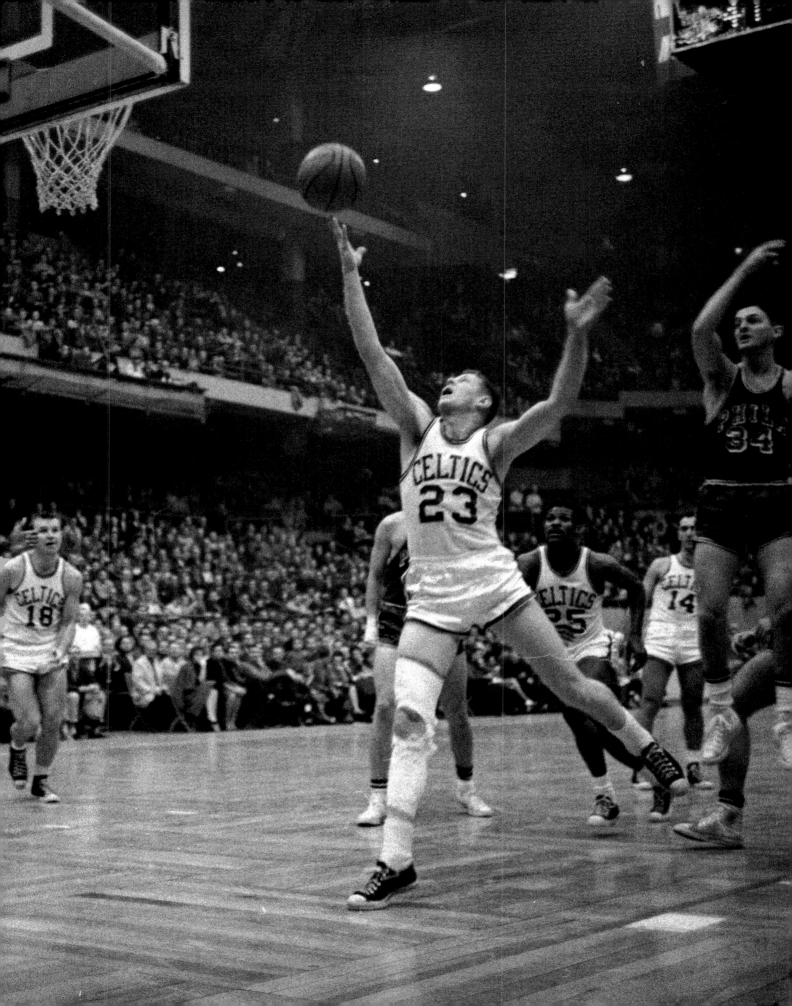

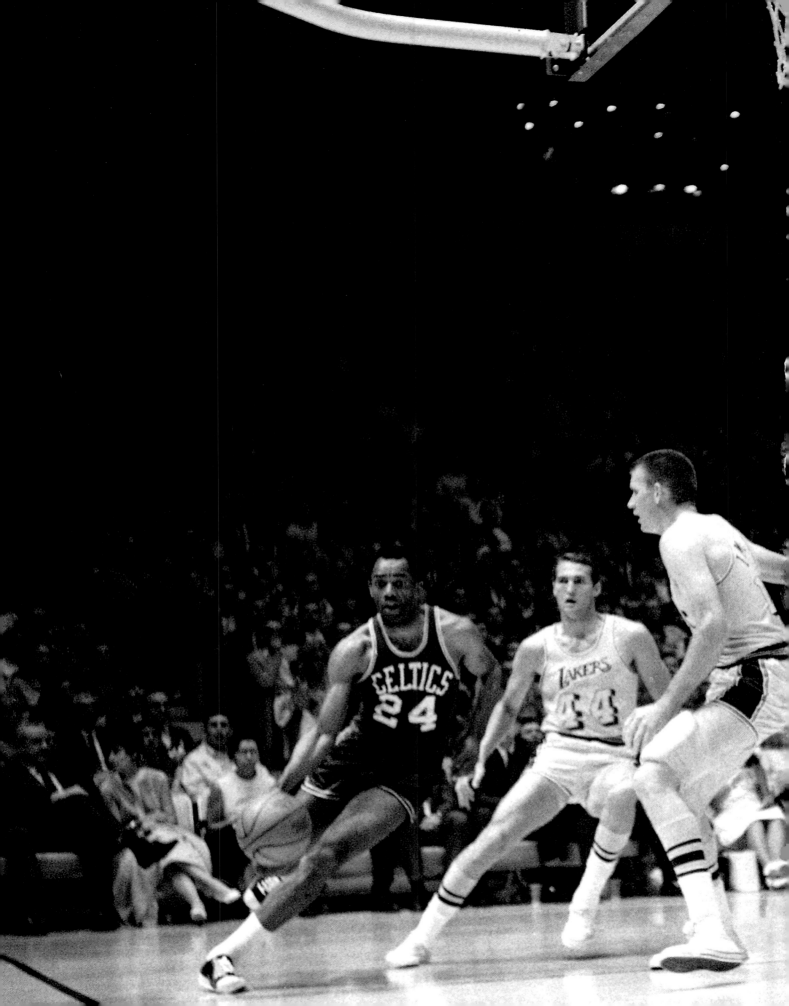

SAM JONES

» **Guard 1957–1969**

» **10-time NBA champion**

» **Five-time NBA All-Star**

Another player who spent his entire career with the Celtics, Sam Jones has the second most NBA championships of any player, with 10; only Celtics teammate Bill Russell (11) has more. Jones, Russell and K.C. Jones are the only Celtics to have been in Boston for the team's eight straight titles (1959–1966). One of the best shooting guards of his era—earning him the nickname "The Shooter"—Jones's numerous game-winning shots inspired another moniker, in "Mr. Clutch." Racking up more than 15,000 points in his 12-year tenure, he still ranks seventh among the Celtics' all-time points leaders.

Jones led the Celtics in scoring three times during his 12 seasons in Boston.

K.C. JONES

» **Guard 1958–1967**

» **Eight-time NBA champion**

» **Basketball Hall of Fame 1989**

One half of the "Jones Boys" along with Celtics teammate Sam Jones, point guard K.C. Jones won eight NBA championships as a player in Boston between 1959 and 1966. As an assistant coach, he helped lead the team to another title in 1981, and then added two more as head coach in 1984 and 1986. Jones and University of San Francisco teammate Bill Russell led the Dons to NCAA championships in 1955 and 1956 before teaming up again for the eight consecutive Celtics titles. The play that would become the alley-oop originated with Jones and Russell, and they are among the eight players to ever win an NCAA championship, an NBA championship and an Olympic gold medal. Jones, who suffered from Alzheimer's disease, died in December 2020 at 88.

Long before he led them to championships as a coach, K.C. Jones won eight titles with the Celtics as a player.

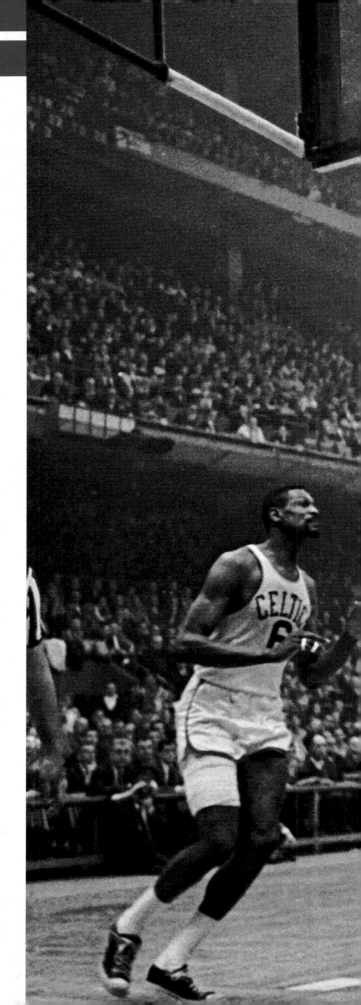

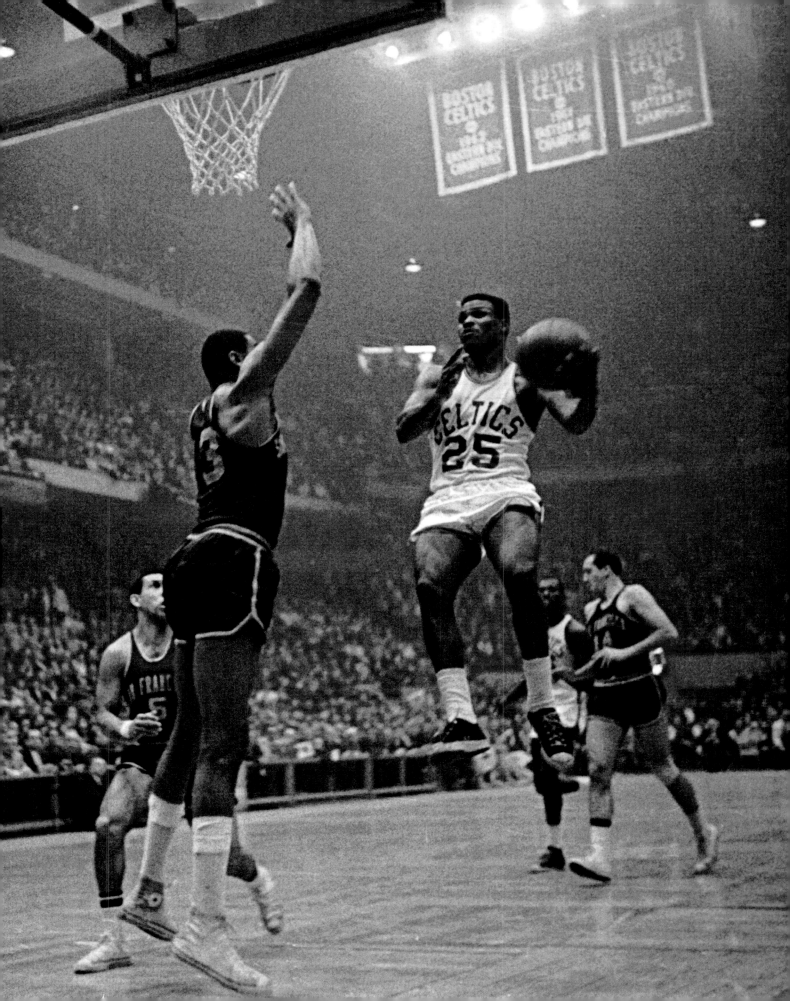

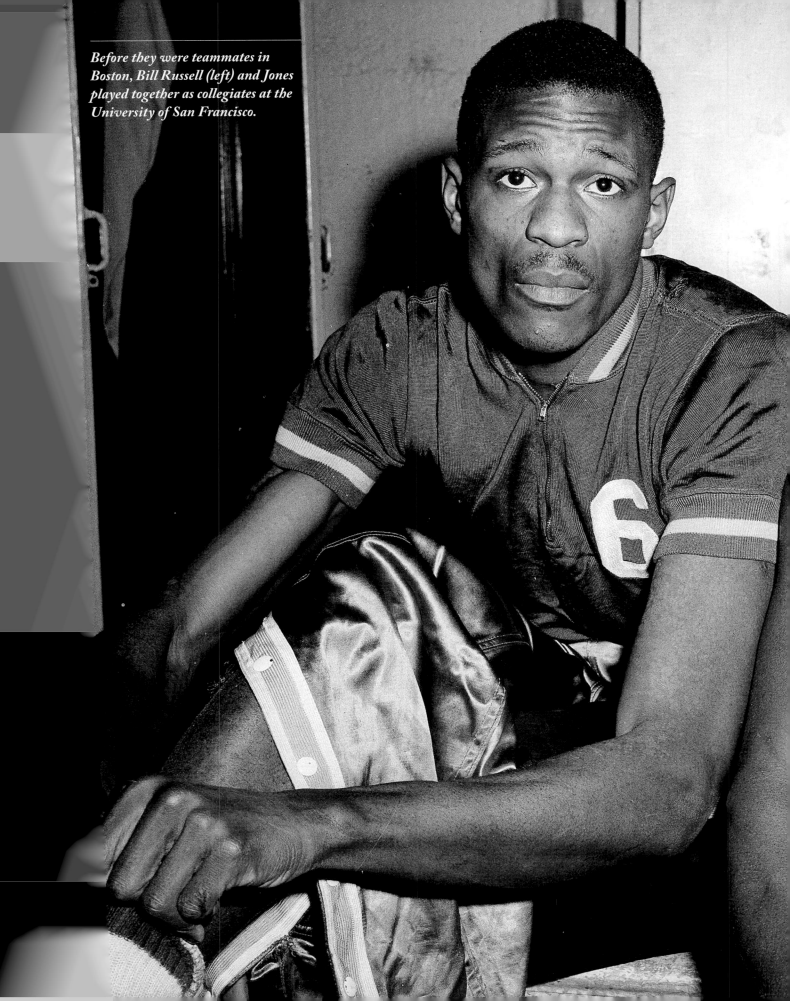

Before they were teammates in Boston, Bill Russell (left) and Jones played together as collegiates at the University of San Francisco.

CEDRIC MAXWELL

» **Forward 1977–1985**

» **Two-time NBA champion**

» **NBA Finals MVP 1981**

Cedric Maxwell's first season as a Celtics starter (and second overall) was forgettable—the team finished 29-53 and missed the playoffs for the first time in seven years. But Maxwell was a bright spot, averaging 19 points and 9.9 rebounds per game. In 1979–80, Larry Bird joined the team, and Boston began its ascent. With Maxwell, Bird, Robert Parish and Kevin McHale in the frontcourt, the Celtics won the title in 1981, where Maxwell was named Finals MVP. His playoff prowess continued in 1984, when he scored 24 points against the Los Angeles Lakers in Game 7, leading the Celtics to another title. Since 2001, Maxwell has announced Celtics games on WBZ-FM in Boston. The Celtics retired Maxwell's No. 31 jersey in 2003.

Maxwell averaged 13.7 points per game over eight seasons in Boston.

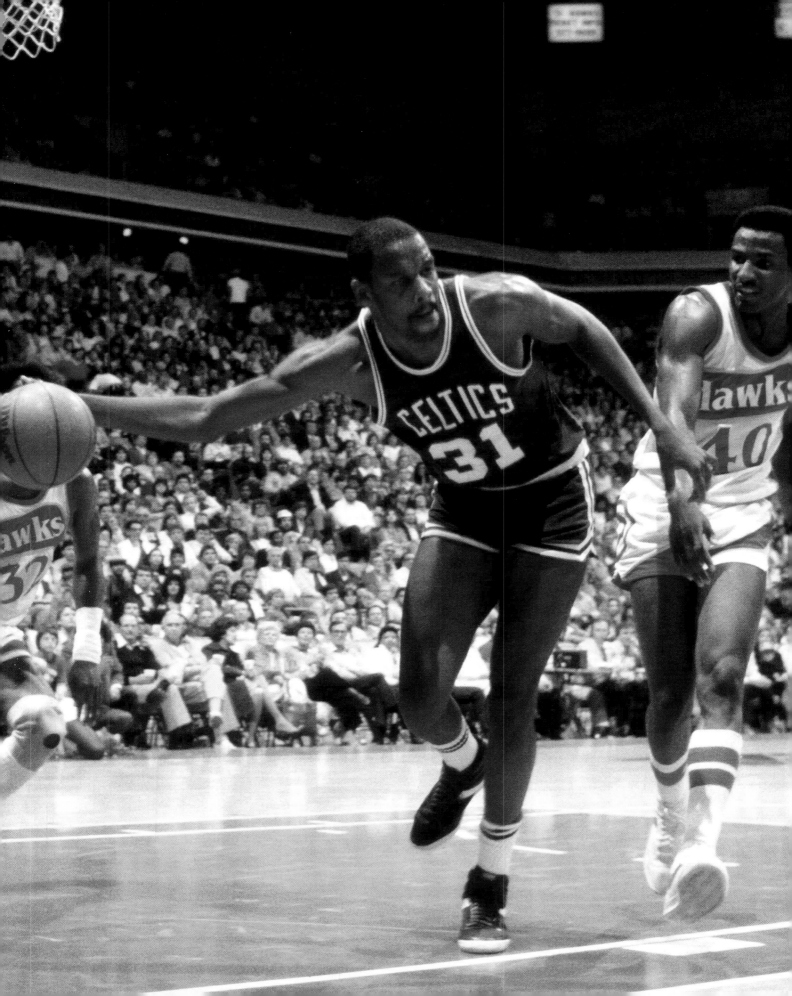

KEVIN McHALE

- » **Forward 1980–1993**
- » **Three-time NBA champion**
- » **Seven-time NBA All-Star**

Kevin McHale played his entire NBA career for the Celtics, joining Larry Bird and Robert Parish to form Boston's original "Big Three." Following in the footsteps of former Celtic Frank Ramsey, McHale came off the bench for the first five years of his tenure in Boston and won the NBA Sixth Man of the Year award twice, in 1984 and 1985. A standout on offense and defense alike, McHale averaged 17.9 points and 7.3 rebounds in 971 regular-season games and was a six-time selection to the NBA All-Defensive First or Second Teams. Despite often battling injuries, McHale played more games for the Celtics than Bill Russell, Bob Cousy and Bird. Boston retired his No. 32 jersey in 1994 and two years later, McHale was named to the NBA's 50th anniversary team.

McHale was the Celtics' leading scorer in the 1985 NBA Finals against the Lakers, averaging 26 points per game.

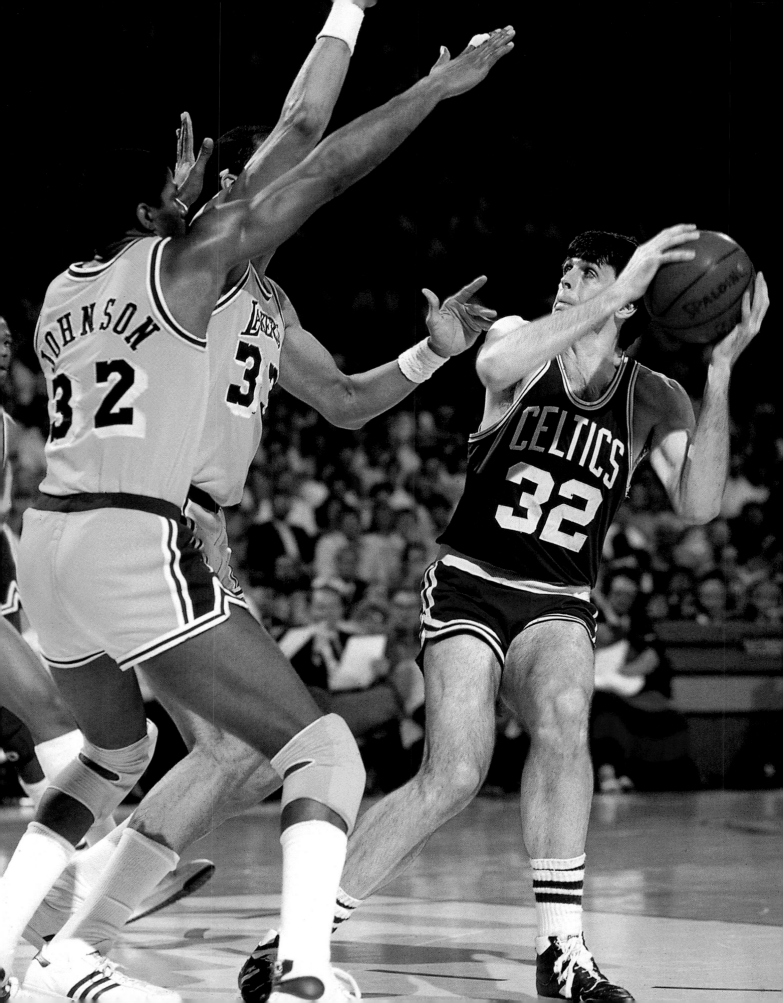

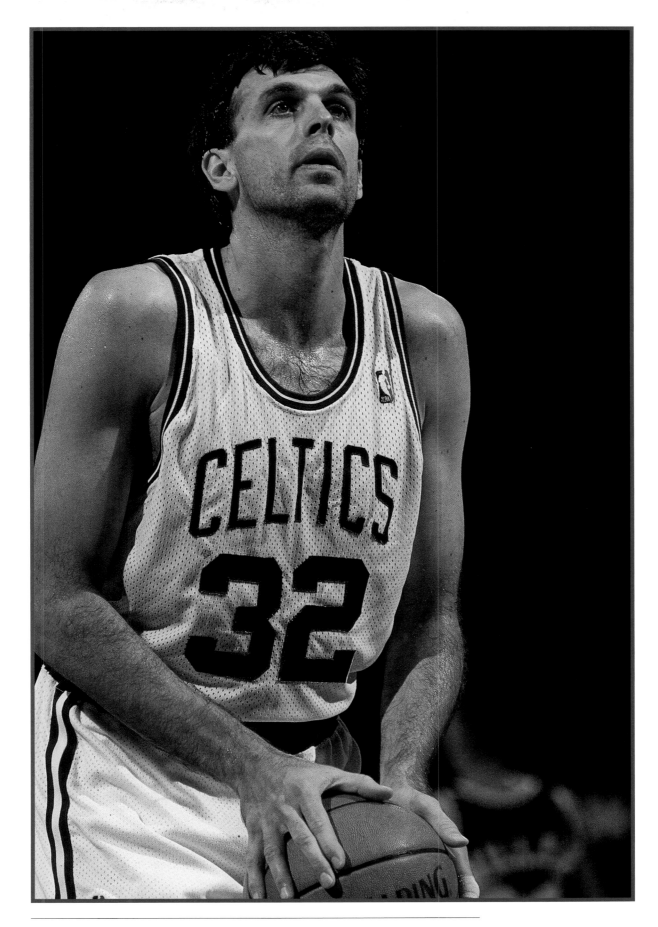

McHale is fifth in Celtics history in career free throws made and attempted.

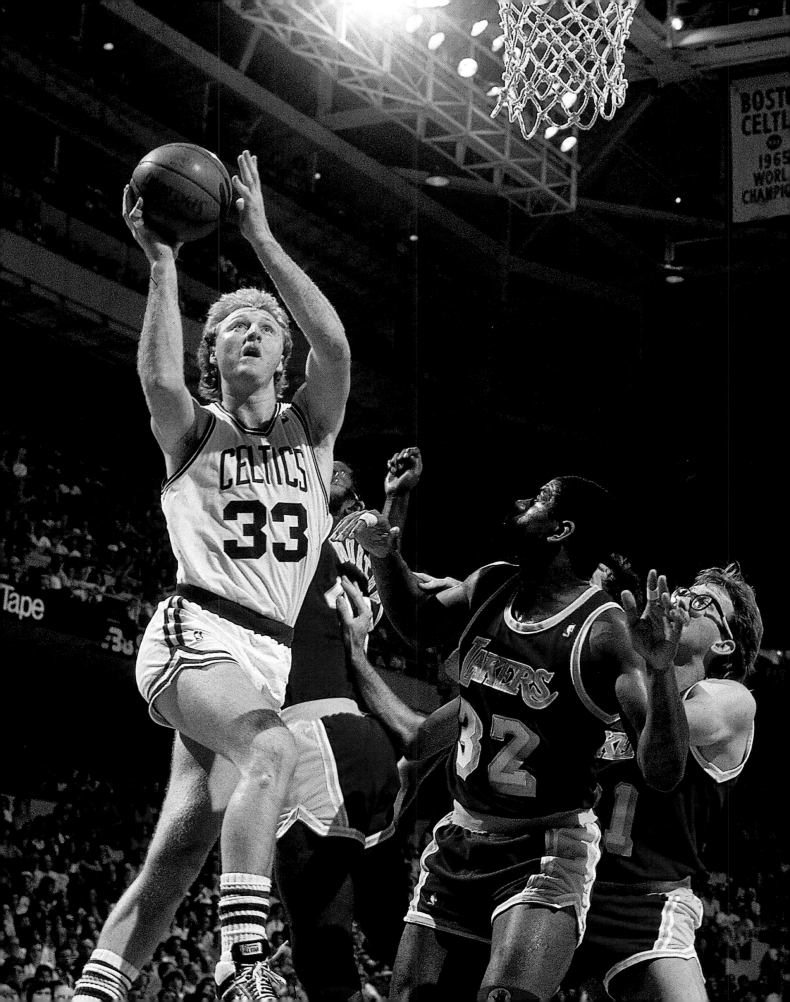

LARRY BIRD

- » **Forward 1979–1992**
- » **Three-time NBA champion**
- » **Three-time NBA MVP**

In his 13-year NBA career, Larry Bird led the Celtics to five NBA Finals and three titles, twice earning NBA Finals MVP honors. After the Celtics had missed the playoffs for two consecutive seasons, Bird helped lead the team to the Eastern Conference finals in his rookie season. His on-court rivalry with the Lakers' Magic Johnson is often credited with revitalizing the NBA. Bird is the only forward in NBA history to win NBA MVP three consecutive times (1984–86). "Larry Legend" earned almost every accolade imaginable both on and off the court; he remains the only person in league history to earn Rookie of the Year, NBA MVP, NBA Finals MVP, All-Star MVP, Coach of the Year and Executive of the Year honors.

Bird's battles against Magic Johnson and the Lakers dominated the NBA throughout the 1980s.

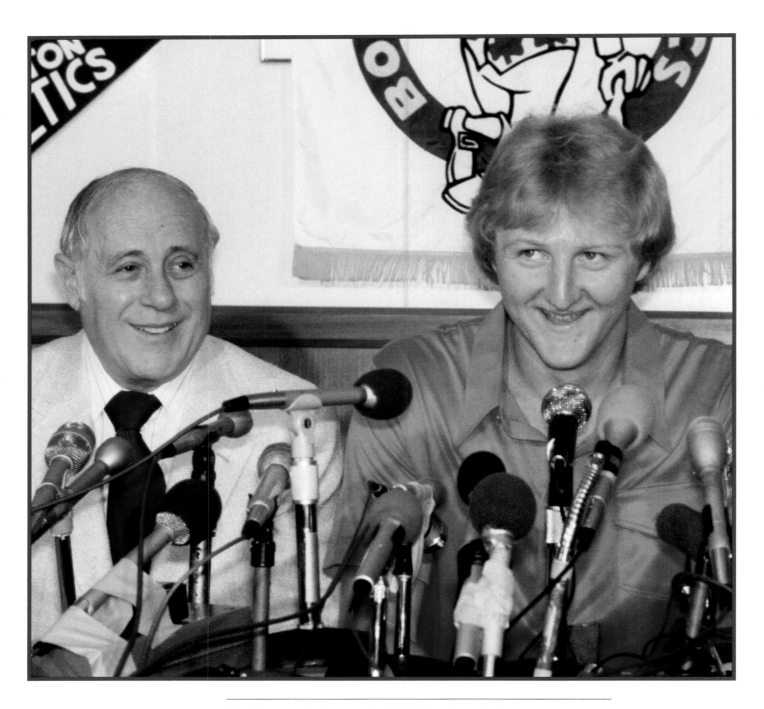

Bird's arrival in Boston in 1979 (above) marked a new era in Celtics history. Soon he was pitting his skills against superstars such as Julius Erving (right).

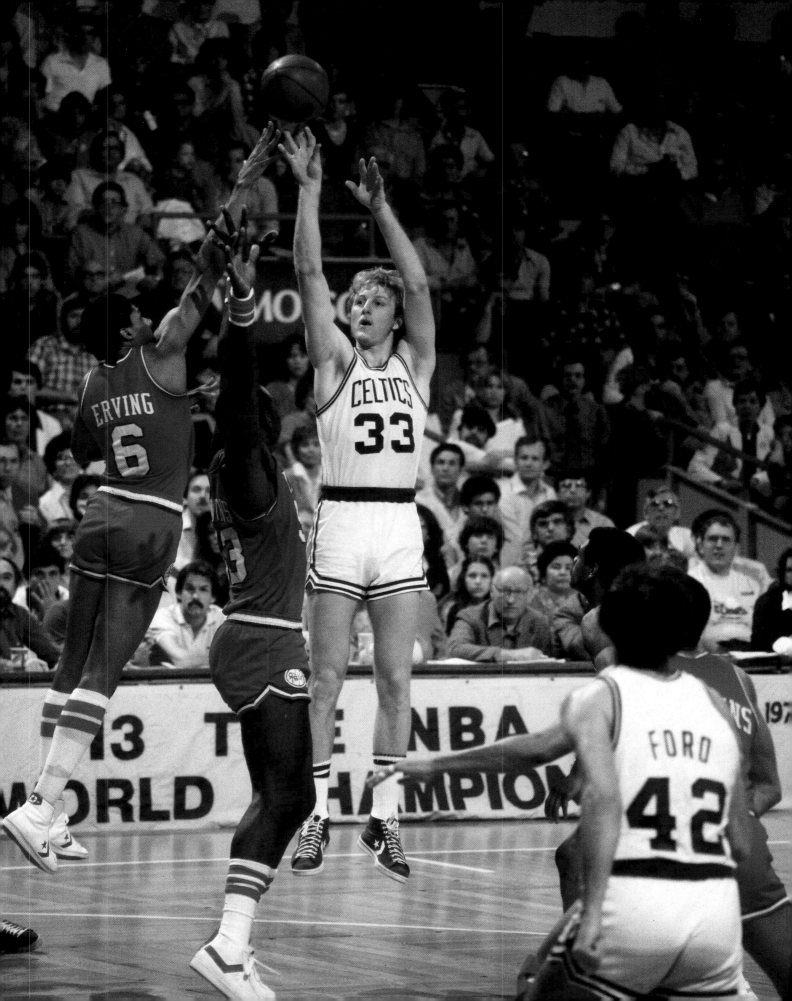

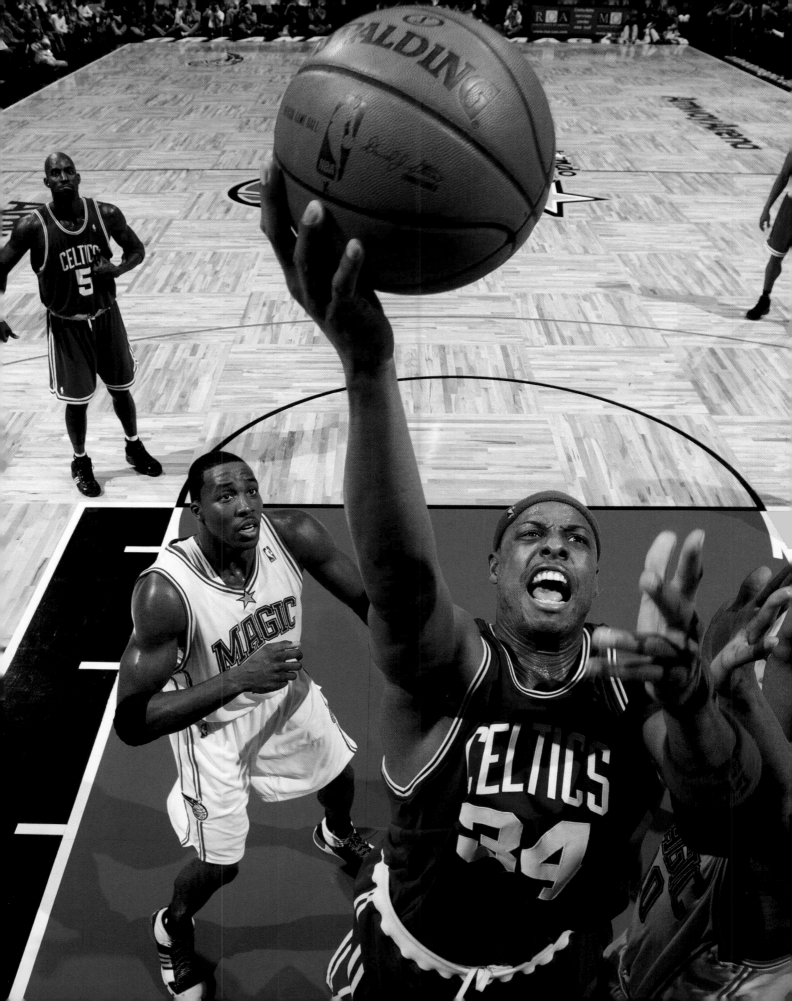

PAUL PIERCE

» **Forward 1998–2013**

» **NBA champion 2008**

» **10-time NBA All-Star**

Paul Pierce spent the first 15 years of his NBA career in Boston, and once paired up with Kevin Garnett and Ray Allen, the Celtics' new "Big Three" brought Boston its first NBA championship in 22 years in 2008. Pierce, who put up 22 points a night over the six-game series, was named NBA Finals MVP. "The Truth" is one of only three Celtics to have scored more than 20,000 career points, and he is the only player in the franchise's top 10 to have played in the 2000s. In 2017, Boston signed Pierce to a contract that enabled him to retire a Celtic. The team raised his No. 34 jersey to the TD Garden rafters the following year.

After years of struggle, Pierce brought an NBA title back to Boston in 2008.

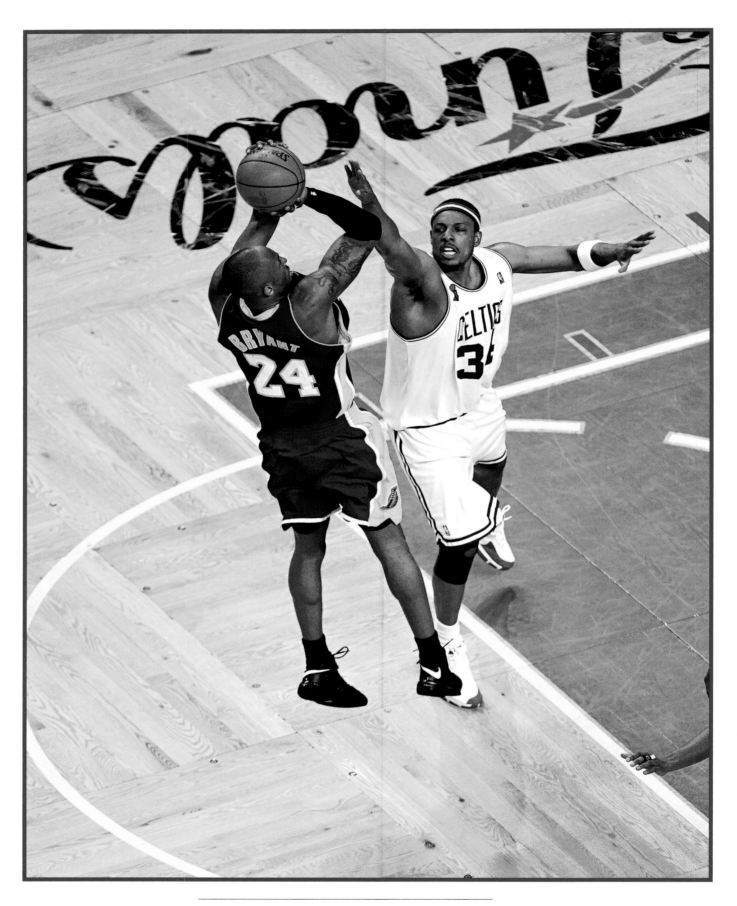

Pierce demanded the chance to guard the Lakers'
Kobe Bryant (above). In the end, Pierce and the
Celtics were victorious (right).

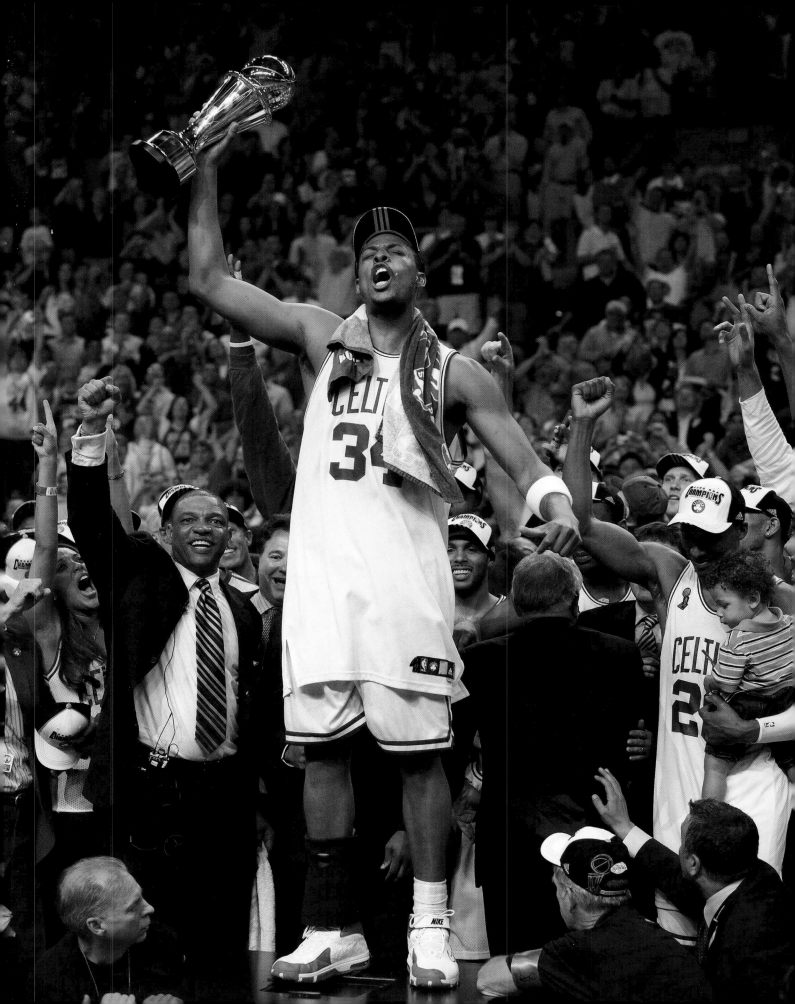

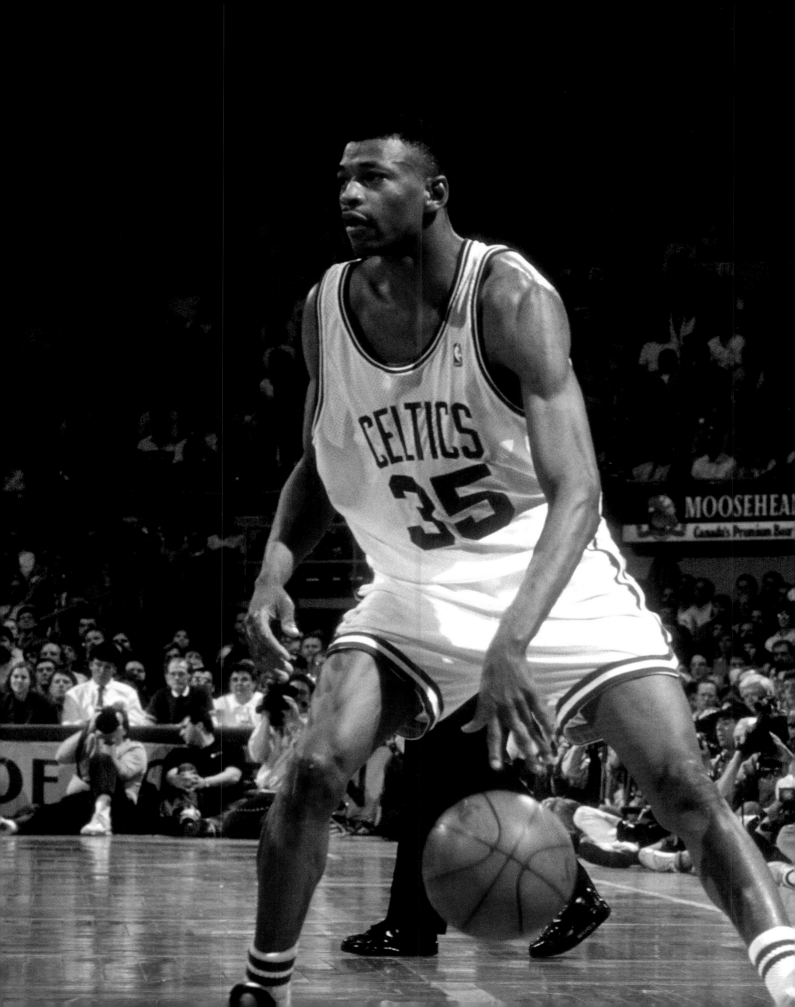

REGGIE LEWIS

» **Forward 1987–1993**

» **NBA All-Star 1992**

» **Boston #35 jersey retired 1995**

Another player who spent his entire professional career in Boston, Reggie Lewis joined the Celtics in 1987 to support the veteran "Big Three" of Larry Bird, Kevin McHale and Robert Parish. In his second season, an injury to Bird created an opportunity for Lewis, who averaged 18.5 points per game while playing more than 30 minutes per night. In the 1993 playoffs, Lewis suddenly collapsed on the court. Three months later, at 27, Lewis suffered sudden cardiac death during an off-season practice, with his death attributed to hypertrophic cardiomyopathy. The Celtics retired his No. 35 in 1995, making him and Ed Macauley the only Celtics to have their numbers retired without winning a title in Boston.

Lewis played only six seasons for the Celtics before his life was tragically cut short.

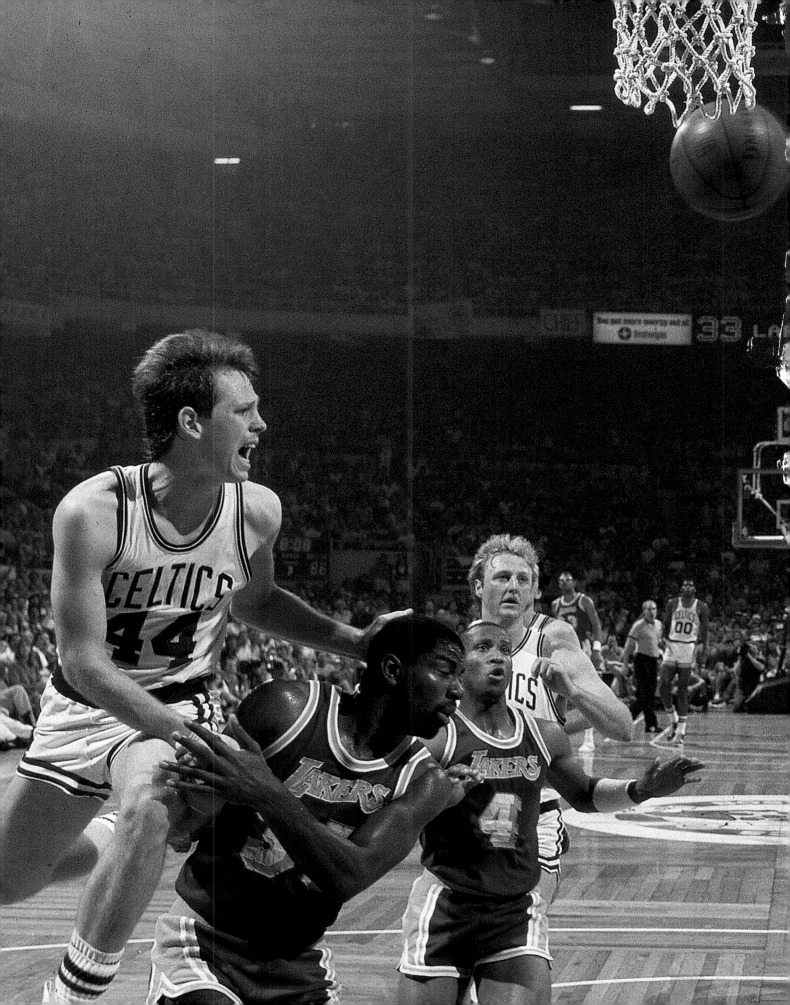

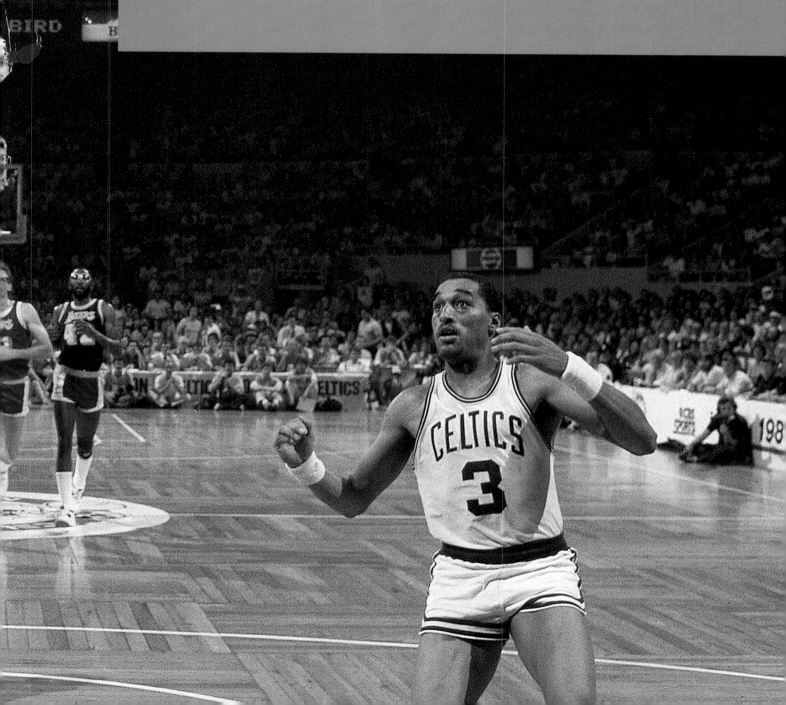

THE STORIES

The Celtics' history is a rich one, filled with great characters and memorable games. Sports Illustrated has written about it extensively over the years

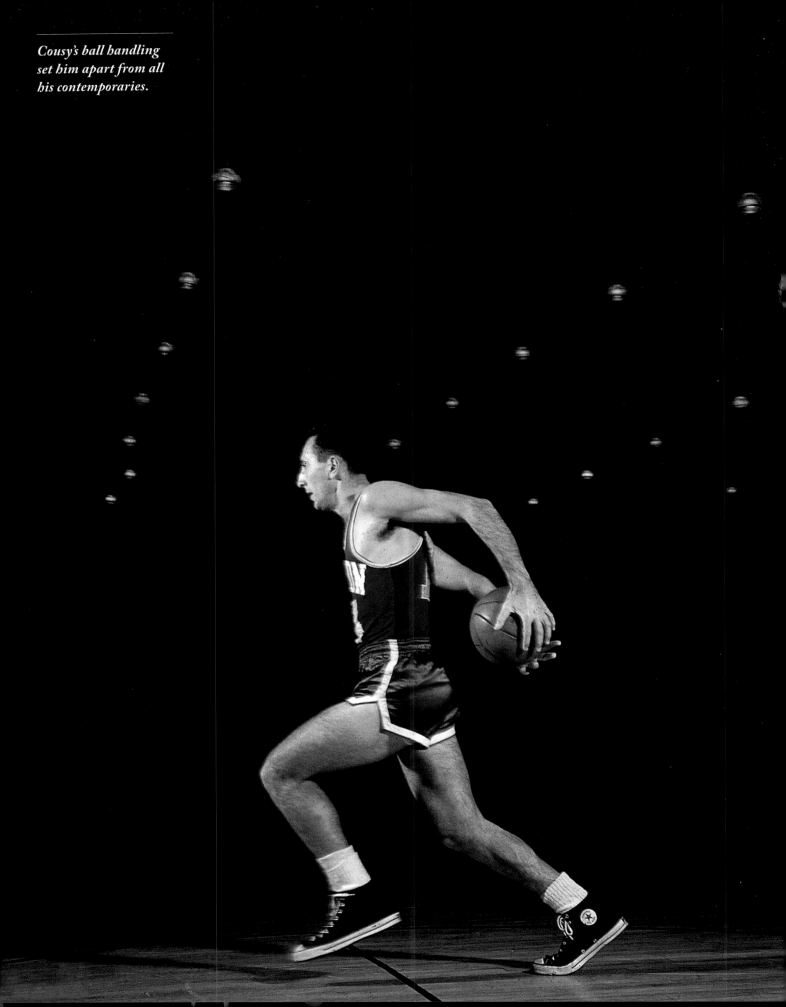

Cousy's ball handling set him apart from all his contemporaries.

BOB COUSY: BASKETBALL'S CREATIVE GENIUS

All imagination and agility, the great Celtic star is leading the youngest of the major games out of its periodic wildernesses BY HERBERT WARREN WIND

WITH THE SCORE TIED 57-57 AND ABOUT 10 SECONDS TO GO IN THE HOLY CROSS-LOYOLA OF CHICAGO game in 1949, Bob Cousy of Holy Cross was fed the ball and drove hard for the basket, hoping to get a half step ahead of his man and get off a fairly close-in shot, preferably a layup, with his right hand. He never got that half step ahead. The man guarding him, Ralph Klaerich, had held Cousy scoreless from the floor during the entire second half and was right with him again this time.

If anything, Klaerich was a fraction of a step in front of Cousy, overplaying him to his right side as he had been doing with remarkable success, ready to block any shot Cousy might try to make as he finished his dribble.

This time, however, Cousy finished his dribble somewhat differently than Klaerich—or, for that matter, Cousy—was expecting. Realizing that the only way he could get free for a shot was somehow to get to Klaerich's right (his left), Cousy, hearkening to some distant drum, reached behind his back with his right hand and slapped the ball to the floor, found the ball with his left hand as it came up on the bounce to his left side, and then, without a break in his stride or dribble, drove to the left (yards away from the flabbergasted Klaerich), leaped into the air and sank a florid left-hander that won the game. "There was some talk at the time that I had been practicing that behind-the-back dribble and had only been waiting for the proper occasion to use it," Cousy recently recalled. "The fact of

the matter is that I had never even thought of such a maneuver until the moment the situation forced me into it. It was purely and simply one of those cases when necessity is the mother of invention. I was absolutely amazed myself at what I had done. It was only much later that I began to practice it so that I could make it a reliable part of my repertoire."

A person of abundant imagination, Cousy over the years has enlarged and refined his ball-handling techniques to the point where today no oldtimer remembers his equal and no contemporary player can touch him. To begin with, he is unanimously regarded as the game's most accomplished dribbler. The one man who might be compared with him, the old Globetrotter alumnus, Marques Haynes, honestly cannot be, since Cousy works against—and confounds—bona fide opposition in the National Basketball Association while Haynes operates on an exhibition tour with a well-drilled "opponent" helping him to display his remarkable wares. Much the same difference applies to any comparison of Cousy and Goose Tatum, whose humor and ball handling made the Globetrotters one of the most gratifying vaudeville acts since Fink's Mules. Performed at the breakneck speed with which the pro game is played, Cousy's thesaurus now includes (along with his behind-the-back dribble, the pass-off-the-dribble, the reverse dribble and other plain and fancy locomotion) such exclusive Cousyisms as the behind-the-back transfer (in which he shifts the ball from his right hand to his left and then lays up a left-hander, all this while afloat in the air), the twice-around pass (in which he swings the ball around his back once and then passes it off to a teammate as he takes it around a second time, all this, of course, while in the air) and several variations on these themes which he resorts to when the situation calls

for them. This virtuosity has won for Cousy such sobriquets as "The Mobile Magician" and "The Houdini of the Hardwood" as well as the highest salary of any player in the NBA. He receives about $20,000 a year from the Boston Celtics, and in a world where few basketball players as yet get a slurp of the subsidiary gravy, he has been able to augment his income considerably by running clinics and by endorsing a chewing gum, a breakfast food, a toothpaste, a seamless basketball and a Canadian sneaker. Far from resenting Cousy's fiscal eminence, his teammates and rivals are extremely happy about it for there is absolute agreement that, since the retirement of George Mikan, Cousy, as pro basketball's greatest attraction, has almost singlehandedly been carrying the league to a prosperity it could never otherwise enjoy.

It is always a little misleading to talk about the astonishing things Bob Cousy can do with a basketball because it tends to distort a true appreciation of his genius for the game. Though you are apt to forget it some nights when a poorly played contest seems to consist almost entirely of tall men shooting from outside and taller men battling lugubriously under the basket, basketball, good basketball, is a game of movement. As in hockey, rugby, soccer, polo, lacrosse, and other kindred games where two opposing teams try to gain possession of the ball and advance it toward the enemy's goal for a scoring shot, the really gifted players are not necessarily the high-scoring specialists but the men with an instinctive sense of how to build a play—the man without the ball who knows how to cut free from the opponent covering him, and, even more important, the man with the ball who can "feel" how an offensive maneuver can develop, who can instantly spot a man who breaks free, and who can zip the ball over to him at the right split second. Without this latter breed—the

playmakers—basketball, or any other goal-to-goal game, can degenerate into a rather ragged race up and down the playing field.

Cousy's greatness lies in the fact that he is fundamentally a playmaker and that his legerdemain, far from being empty show-boating, is functional, solid basketball. Equipped with a fine sense of pattern, superb reflexes, he also has peripheral vision which enables him to see not only the men in front of him but a full 180° angle of the action. Thus, like nobody else in the game—unless it be Dick McGuire of the Knicks on one of his outlandish hot nights—Cousy can open up a seemingly clogged court by appearing to focus in one direction, simultaneously spotting a seemingly unreachable teammate in another area, and quickly turning him into a scoring threat with a whiplash pass. There is implicit deception in Cousy's straight basketball, which is the secret of any great player's success, and it is only in those exceptional circumstances when extra measures pay off soundly that he resorts to his really fancy stuff.

Well aware that his feats of manipulation draw the crowds and help to keep the league healthy, Cousy will flash a few of his special effects near the end of a game in which the outcome is already surely decided, if he previously has not had a chance to use them. Aside from this, he is all function. There has been only one occasion, for example, when he has deliberately trotted out a little of the old razzle-dazzle to show up an opposing player.

This occurred a few years back in one of those high-pitched battles between the Celtics and the Knicks. Sweetwater Clifton of the Knicks, who can handle the ball with his enormous hands as if it were the size of a grapefruit, had been, as Cousy saw it, indulging himself far too prodigally in exhibiting his artistry and appeared much more concerned with making the Celtics look foolish than in playing basketball. This

aroused Cousy's French. The next time he got the ball, he dribbled straight up to Clifton. Looking Sweets right in the eye, he wound up as if he were going to boom a big overhand pass directly at him. As he brought the ball over his shoulder, however, Cousy let it roll down his back, where he caught it with his left hand, and, completing that big windmill thrust with his empty right hand, stuck it out towards Sweets in the gesture of "shake hands." It brought down the house.

"It was an old Globetrotter trick I'd seen them use and had practiced for my own benefit a couple of times," Cousy explained not long ago. "I shouldn't have done it but I was awfully sore at the time. Naturally the newspapers played it up that there was a feud between me and Clifton. The next time we played New York I looked Clifton up and told him I was sorry about the incident, for I was. Clifton isn't a wiseguy. He's a helluva nice guy. I should have taken that into account at the time."

Even when he was a collegian, Robert Joseph Cousy's ability was so conspicuous that Adolph Rupp, the unquiet coach of Kentucky, acclaimed him "the greatest offensive player in the country." This is a tribute indeed when you consider that Rupp views it as only a little short of treason to find anything or anybody worthy of his praise except Happy Chandler, bourbon whisky, his own basketball teams and other strictly Bluegrass products.

THE GREATEST IN HISTORY

Today, 27 years old, a discernibly improved player in this his sixth season as a pro, Cousy is regarded by most experts as nothing less than the greatest all-round player in the 64-year history of basketball. "I've seen many great ones since I began fooling around with a ball in 1912," Joe Lapchick, a stalwart on the famous old New York Celtics and

presently the coach of the Knickerbockers, reflected recently. "I've seen Johnny Beckman, Nat Holman, that wonderful player Hank Luisetti, Bob Davies, George Mikan, the best of the big men—to name just a few. Bob Cousy, though, is the best I've ever seen. He does so many things. It's so hard to say that Cousy can think in the air or that Cousy does this or that. Cousy does everything. He's regularly one of the league's top five scorers. When a guy's a scorer, you usually don't expect him to be a leader in the other departments. One talent generally suffers from another. Bob, however, has been a top leader in assists for the last five seasons. He's become a very capable defensive player, a tremendous pass stealer."

Lapchick paused to find words to sum up his panegyric. "I was just thinking of the games we've played against Cousy," he resumed with a bittersweet look in his eyes. "He always shows you something new, something you've never seen before. Any mistake against him and you pay the full price. One step and he's past the defense. He's quick, he's smart, he's tireless, he has spirit and he is probably the best finisher in sports today."

One Celtic-Knick scrap that Lapchick may have been musing on was their meeting on December 10, 1953. The Knicks were leading 93–90 with 30 seconds to go. Since they had possession of the ball, Boston having just scored, and no 24-second rule to contend with in those days, the game to all intents

Cousy was the engine that powered the Celtics dynasty.

and purposes was as good as over. The Knicks knew exactly how they would handle the play coming up to keep Cousy from getting his hands on the ball again. Carl Braun, taking the ball out of bounds, would wait until Dick McGuire cut toward him, carrying Cousy, his man, along with him. Braun would then toss the ball to Harry Gallatin, well behind the spot where Cousy would then be. Braun took the ball, McGuire came tearing along with Cousy, Braun threw the ball to Gallatin—and Cousy intercepted it with a pantherlike whirl. He drove in unimpeded for a basket that cut the Knicks' lead to one point. A moment later, up front on an all-court press, he intercepted a bounce pass. Boston (Cousy) immediately called timeout. When play was resumed, Cousy hooked a pass to his teammate, Ed Macauley. Macauley was fouled before he could get a shot off. He made the foul. The final buzzer sounded: 93 all. In the overtime, in what many critics adjudge the finest exhibition of dribbling they have ever seen, Cousy controlled the ball for just about four of the five minutes of play, killing the clock once Boston was ahead and drawing foul after foul when as many as three Knicks at a time tried desperately to get the ball away from him. Final score: Boston 113, New York 108.

Like any athlete, Cousy has his big nights and his bad nights, though it should be added that most players would gladly settle for a straight diet of his bad ones. As to his greatest

playmakers—basketball, or any other goal-to-goal game, can degenerate into a rather ragged race up and down the playing field.

Cousy's greatness lies in the fact that he is fundamentally a playmaker and that his legerdemain, far from being empty show-boating, is functional, solid basketball. Equipped with a fine sense of pattern, superb reflexes, he also has peripheral vision which enables him to see not only the men in front of him but a full 180° angle of the action. Thus, like nobody else in the game—unless it be Dick McGuire of the Knicks on one of his outlandish hot nights—Cousy can open up a seemingly clogged court by appearing to focus in one direction, simultaneously spotting a seemingly unreachable teammate in another area, and quickly turning him into a scoring threat with a whiplash pass. There is implicit deception in Cousy's straight basketball, which is the secret of any great player's success, and it is only in those exceptional circumstances when extra measures pay off soundly that he resorts to his really fancy stuff.

Well aware that his feats of manipulation draw the crowds and help to keep the league healthy, Cousy will flash a few of his special effects near the end of a game in which the outcome is already surely decided, if he previously has not had a chance to use them. Aside from this, he is all function. There has been only one occasion, for example, when he has deliberately trotted out a little of the old razzle-dazzle to show up an opposing player.

This occurred a few years back in one of those high-pitched battles between the Celtics and the Knicks. Sweetwater Clifton of the Knicks, who can handle the ball with his enormous hands as if it were the size of a grapefruit, had been, as Cousy saw it, indulging himself far too prodigally in exhibiting his artistry and appeared much more concerned with making the Celtics look foolish than in playing basketball. This

aroused Cousy's French. The next time he got the ball, he dribbled straight up to Clifton. Looking Sweets right in the eye, he wound up as if he were going to boom a big overhand pass directly at him. As he brought the ball over his shoulder, however, Cousy let it roll down his back, where he caught it with his left hand, and, completing that big windmill thrust with his empty right hand, stuck it out towards Sweets in the gesture of "shake hands." It brought down the house.

"It was an old Globetrotter trick I'd seen them use and had practiced for my own benefit a couple of times," Cousy explained not long ago. "I shouldn't have done it but I was awfully sore at the time. Naturally the newspapers played it up that there was a feud between me and Clifton. The next time we played New York I looked Clifton up and told him I was sorry about the incident, for I was. Clifton isn't a wiseguy. He's a helluva nice guy. I should have taken that into account at the time."

Even when he was a collegian, Robert Joseph Cousy's ability was so conspicuous that Adolph Rupp, the unquiet coach of Kentucky, acclaimed him "the greatest offensive player in the country." This is a tribute indeed when you consider that Rupp views it as only a little short of treason to find anything or anybody worthy of his praise except Happy Chandler, bourbon whisky, his own basketball teams and other strictly Bluegrass products.

THE GREATEST IN HISTORY

Today, 27 years old, a discernibly improved player in this his sixth season as a pro, Cousy is regarded by most experts as nothing less than the greatest all-round player in the 64-year history of basketball. "I've seen many great ones since I began fooling around with a ball in 1912," Joe Lapchick, a stalwart on the famous old New York Celtics and

presently the coach of the Knickerbockers, reflected recently. "I've seen Johnny Beckman, Nat Holman, that wonderful player Hank Luisetti, Bob Davies, George Mikan, the best of the big men—to name just a few. Bob Cousy, though, is the best I've ever seen. He does so many things. It's so hard to say that Cousy can think in the air or that Cousy does this or that. Cousy does everything. He's regularly one of the league's top five scorers. When a guy's a scorer, you usually don't expect him to be a leader in the other departments. One talent generally suffers from another. Bob, however, has been a top leader in assists for the last five seasons. He's become a very capable defensive player, a tremendous pass stealer."

Lapchick paused to find words to sum up his panegyric. "I was just thinking of the games we've played against Cousy," he resumed with a bittersweet look in his eyes. "He always shows you something new, something you've never seen before. Any mistake against him and you pay the full price. One step and he's past the defense. He's quick, he's smart, he's tireless, he has spirit and he is probably the best finisher in sports today."

One Celtic-Knick scrap that Lapchick may have been musing on was their meeting on December 10, 1953. The Knicks were leading 93–90 with 30 seconds to go. Since they had possession of the ball, Boston having just scored, and no 24-second rule to contend with in those days, the game to all intents

Cousy was the engine that powered the Celtics dynasty.

and purposes was as good as over. The Knicks knew exactly how they would handle the play coming up to keep Cousy from getting his hands on the ball again. Carl Braun, taking the ball out of bounds, would wait until Dick McGuire cut toward him, carrying Cousy, his man, along with him. Braun would then toss the ball to Harry Gallatin, well behind the spot where Cousy would then be. Braun took the ball, McGuire came tearing along with Cousy, Braun threw the ball to Gallatin—and Cousy intercepted it with a pantherlike whirl. He drove in unimpeded for a basket that cut the Knicks' lead to one point. A moment later, up front on an all-court press, he intercepted a bounce pass. Boston (Cousy) immediately called timeout. When play was resumed, Cousy hooked a pass to his teammate, Ed Macauley. Macauley was fouled before he could get a shot off. He made the foul. The final buzzer sounded: 93 all. In the overtime, in what many critics adjudge the finest exhibition of dribbling they have ever seen, Cousy controlled the ball for just about four of the five minutes of play, killing the clock once Boston was ahead and drawing foul after foul when as many as three Knicks at a time tried desperately to get the ball away from him. Final score: Boston 113, New York 108.

Like any athlete, Cousy has his big nights and his bad nights, though it should be added that most players would gladly settle for a straight diet of his bad ones. As to his greatest

game, there is, to be sure, a sizable difference of opinion, the fan's choice depending in the last analysis on which games he has personally seen. A good many, for example, incline to think the high point was his performance in the 1954 East-West All-Star Game where Cousy turned the overtime into a one-man show while scoring 10 of the East's 14 points. (The basketball writers, who had voted Jim Pollard the game's most valuable player at the end of the regulation four quarters, had no other course but to open the polls again and vote the award to Cousy.) Most of Cousy's New England following, however, who idolize him with a clamorous devotion which recalls the great love affair between Les Canadiens' rooters and Maurice Richard, are certain that no basketball player ever turned in a more magnificent job than Cousy did in a first-round playoff against the Syracuse Nationals two winters ago this coming March. Briefly, the tide of battle went something like this: at the end of the regulation four 12-minute periods, the teams were tied 77–77. At the end of the first five-minute overtime, they were still tied, 86 all. At the end of the second overtime, still tied up, 90 all. Syracuse dominated the third overtime and, with time rapidly running out, was out in front by five points. With 13 seconds to go, Cousy got loose for a pretty one-hander; he was fouled on the play and added the foul shot. With five seconds to go, he got the ball at mid-court and let go a long one-handed push-shot. Swish! 99–99. In the fourth overtime Syracuse once again raced off to a five-point lead. Once again Cousy tied it up. Syracuse began to fade then, and with Cousy adding four more foul shots, Boston pulled away to ultimately win 111–105. Cousy's scoring total for the marathon was 50 points—10 field goals and 30 free throws in 32 attempts, still an NBA playoff record. Up to that evening Boston, seven years in the pro league, had been a rather shaky basketball town. Since that game, Boston has been a rabid basketball town—Cousy's performance was as conclusive as that.

LILLIPUTIAN IN A FOREST

In the Brobdingnagian world in which he operates, where a man 6 foot 5 has to look up to a good many of his teammates, Cousy, who stands 6 foot 1½, is one of the few surviving Lilliputians. On the floor, as he darts in and out of the forest of young oaks populating the court, spectators unconsciously begin to think of him as a much smaller man, a mere whippet of say 5 foot 8, or 5 foot 9. It is a shock to them, when they meet him off the court, to find that by conventional or nonbasketball standards their hero is a big fellow who towers over most hockey players and who must slide the front seat of an auto way back to gain sufficient leg room. (In this connection—how environment changes a fellow's height—Cousy's running-mate, Bill Sharman, offers a very amusing case. During the winter, those who watch him tend to peg him in their minds as "Little Bill" Sharman. Comes spring, Sharman switches to baseball—last year he batted .292 with St. Paul in the American Association—and instantly undergoes a metamorphosis. For the next six months he is "Big Bill" Sharman, at 6 foot 2, one of the largest third basemen in organized ball.)

Cousy's weight is as deceptive as his height. Taking in his unobtrusive chest, his sloping shoulders and his long, lean neck, most people guess him at 160 or 165 pounds. He weighs 185. Most of it is in his heavy, powerful thighs and legs, which, as Cousy sees it, are the key to a natural endurance that makes it possible for him to drive up and down a court long after other players in the pink of condition have retreated to the bench for a breather. But, of course, his most valuable physical asset is his hands, with

their very large palms and extraordinarily long fingers, both far out of proportion to the rest of his body. Besides permitting Bob to manipulate a basketball more facilely than most giants can, his hands, when added to his average-length arm for a 6-footer—he takes a 35 shirt sleeve—give him a reach some two inches longer than most men his size and enable him, among other things, to perform that old back magic. One look at Cousy's hands and enthusiasts of other professions, from pianists to golfers, while not arguing that he was wrong to choose a career in basketball, invariably try to persuade him that he could have achieved as much in theirs. Baseball men are particularly saddened when they learn that Cousy played their game until he was 14 and then gave it up to concentrate on basketball. They see in him, when they add his speed, his eye and his catlike reflexes to these enormous mitts, a great shortstop who got away.

When Cousy occasionally succumbs to blandishments that his hands and timing give him the ideal equipment for this or that other sport, the results often exceed the expectation. Two years ago he took up tennis as an off-season conditioner and now plays it so well that he can provide suitable rallying if not playing opposition for Jack Kramer. When he decided to learn how to fish last May, he needed only two hours of practice before he was shooting 30 yards of D-weight line the full 90 feet with the ease of a master caster.

While enjoying his ever-enlarging sphere of proficiencies, Cousy has no regrets whatsoever that the hospitality of circumstances in St. Albans, Long Island, where he grew up, led him to a life of basketball. He loves the game and thinks of it as a great game, well worth anyone's dedication. "To me," he once confided to a friend, "practice was never work. It was and

is time spent at the thing I love the best. It gives me a chance to improvise, to create. Maybe I shouldn't put it on such a high plane," Cousy interrupted himself with a grin. "Anyhow, it does give you a chance to dream up new things and to polish them, and that is one of the reasons why the game has always had such a tremendous appeal for me."

Cousy pours so much of himself into basketball that when he is playing a game his absorption in the business at hand temporarily suffuses the rest of his personality. In the dressing room before a game, his normally expressive dark brown eyes begin to lose their animation and a sort of glaze settles over and begins to tighten his mobile face. He becomes quiet and solemn, and, in fact, somewhat drowsy. Part of this is natural—he has an indecent capacity to relax at hard moments. Part of it is calculated. He wants to play each game up to the hilt and he knows that he is expected to cut loose with some sensational stuff, and a spot of pregame torpor helps him to collect his energy and to shape his concentration. Once on the floor, he changes considerably. A tremendous, burning will to win comes over him. His eyes become narrowed with dourness and his Gallic features take on a Velazquezian gauntness. Except for those moments when he is arguing a point with the referee, Cousy's set poker face never alters for a moment, whether the Celtics are winning or losing, whether he is "hot" or "off," regardless of the score and the period. Coupled with the assurance and the audacity of his style of play, this facial immobility is often misread by anti-Celtic fans as hauteur, and they watch his moves with the grudging admiration that Ben Hogan with his ice-cold, unshatterable poise used to extract from the followers of Snead, Nelson and other golfers.

AN HONEST-TO-GOODNESS CALM

Once a game is over, no matter how high the victory or how galling a defeat, Cousy usually manages to relapse almost instantly into an honest-to-goodness calm, much to the mystification of his teammates, who generally require a much longer period to settle down. It takes Cousy a half hour, nonetheless, before he has the game completely digested. A liveliness then comes back to his eyes, the contours of his face become rounder, and there is a merriment in his remarks and a ready enjoyment of other people.

The more you see Cousy, the more you come to realize that he is a person of honest individuality, as easy to admire off the court as on. He has packed a lot of maturity under his belt for a man of 27. He has a mind of his own, a good one, and an uncommon understanding of the responsibility his position carries along with its privileges. Perhaps the best way to delineate the mosaic of his substantial personality is to describe a piece here, a piece there.

For example, there is Cousy, the citizen of Worcester, his adopted home town and the site of his college, Holy Cross, quietly calling up basketball friends like Carl Braun last summer and organizing a charity game, the proceeds to go to the widows of two Worcester firemen who had lost their lives in a fire. Both had left four children and no insurance. The game raised $4,000.

There is Cousy—you do not learn this from him—deciding to accompany his teammate Chuck Cooper back to New York on the sleeper, after a hotel in Raleigh, N.C., had refused accommodations for Cooper, a Black man from Duquesne. Cousy and Cooper shared an apartment in Boston for three months when Cousy was waiting to move his family into a new house.

There is Cousy, so keyed for really lazy relaxation or all-out action that sports in which the tempo is not continuous are curiously difficult for him to take. At college he fell asleep while watching the first three football games he attended and never went to a game again. Last summer he walked out of a fairly crucial Yankees–Red Sox battle in the sixth inning. "All they did was change pitchers," he explains. "Anyway that was longer than I generally last. Three innings is about my quota."

There is Cousy, aware that there will come a time when his basketball days will be over, realistically planning for the future. Four years ago he became one of the three co-owners of Camp Graylag, a summer camp near Concord, N.H. After the camping season, he now conducts an annual clinic there attended by boys who come from all over the country. Tuition: $100 for the 10-day course. One of his associates in his noncamp ventures is Jack Richards, a Harvard graduate turned song writer. (The current hit song "He" is one of his numbers.) Cousy and Richards met two winters ago when Bob gave a clinic at a settlement house in a tough Cambridge district where Richards spent a lot of his time. "The next summer Jack sent 10 of those boys up to my 10-day clinic at his own expense," Cousy relates. "That impressed me. You don't find many fellows who actually act."

There is Cousy, the head of the Players' Association which he helped form in 1954 and which now has its headquarters in Worcester. It is a very necessary organization, for the NBA, still a young league, numbers among the owners of its teams quite a few promoters who have yet to graduate from the dance-hall era of early pro basketball and who continue to think in terms of the quick buck instead of the big league. While the players' salaries are now pitched at a proper level, the league president, Maurice Podoloff, has much of the time acted as though he were solely responsible to the club owners and

not equally responsible for safeguarding the legitimate interests of the players. With the NBA now a prosperous circuit, most veteran basketball hands consider the Players' Association to be more than justified in its efforts to obtain a reasonable limit to the fatiguing preseason barnstorming tours, small payment fees (like other pro athletes receive) for players who publicize the league through personal and television appearances, concrete steps by the league to improve the quality and uniformity of the still capricious officiating, and other such improvements. As the game's young statesman as well as its outstanding player, Cousy was the logical choice to represent pro basketball at the White House luncheon last July when leaders from all sports met with President Eisenhower

to discuss what sports can contribute in the nation's over-all campaign against juvenile delinquency.

HOOPS ALL OVER THE WORLD

No sport in history caught on like Dr. Naismith's baby. Within a month of the historic first game, girls were playing basketball. (Naismith, by the way, married a member of the first girls' team.) By 1892 the game was being played at the University of Iowa, a year later at Stanford. By the turn of the century, with YMCA men carrying the ball wherever they went, there were hundreds of hoops in South America, China, Japan—all over the world. As it grew, the game changed. Players with a gift for it came up with all kinds of new maneuvers. For example, the

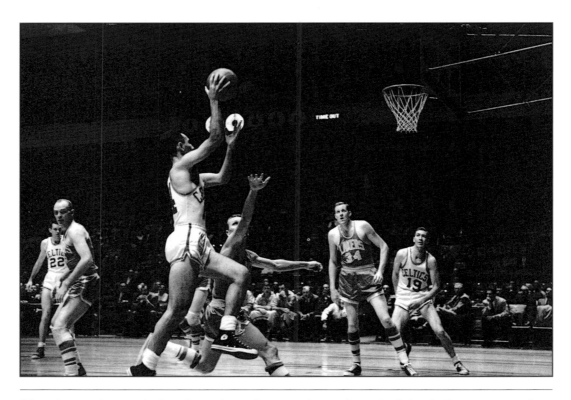

Though more famous for his playmaking, Cousy is also sixth on the Celtics' all-time scoring list.

dribble, first conceived as a defensive aid to help a man stuck with the ball to keep free until he could get off a pass, swiftly was turned by talented dribblers into an element of the attack. And as the game changed, rules had to be added and changed—a rule here to make official some unarguable improvement the players had hit on, such as the rule that the team which did not touch the ball last before it went out of bounds throws it back into play; a rule there to curb certain unanticipated excesses which were hurting the game, like the one limiting the number of fouls a player could commit before being disqualified for the rest of the game. Today, 64 years old, basketball is still in the process of evolution, a game that has not yet found its best expression as has baseball or golf or tennis. It has changed tremendously just over the past 20 years, when the abolition of the center jump and the 10-second backcourt rule and the advent of the fast break so greatly speeded up the game.

But it hasn't all been progress in a neat straight line. Bad trends have been recognized and rules instituted to prevent them, and as often as not the new rules have fostered greater ills than the ones they proposed to cure. There have been periods, many of them, in fact, when the game got itself so fouled up that the elements which had made for its appeal had all but disappeared and what had arisen in their place wasn't basketball at all. A good deal of the trouble, to be sure, has resulted from the unavoidable proposition that in a game where the goals are set 10 feet above the ground, a big man will always have a valuable advantage, and you cannot legislate against height in basketball any more honestly than you can restrict the bulk of the linemen in football. You must deal with it within the spirit of the game.

Up to now, whenever basketball has found itself all snarled up in a jungle of unforeseen developments and unnatural rules, someone has always appeared to lead the game out of the wilderness. Sometimes it has been a wonderful team like the Original Celtics, sometimes a rules committee cleaving to the heart of the matter, and sometimes a single player. In recent years, when the game was coming very close to developing into a race-horse shooting match between men who had developed unstoppable shots and who could do very little else, Bob Cousy, above and beyond anyone else, has blazed the trail back to good basketball. Cousy has, in truth, gone much further: he has opened the road to better basketball. Perhaps no player or coach in the game's history has understood the true breath of basketball as well as he. He has shown, in what has amounted to an enlightened revolution, that basketball offers a hundred and one possibilities of maneuvers no one ever dreamed of before. Reversing your dribble or passing behind your back and so on—those stunts had been done for years, but if you combine those moves with a sense of basketball, then you are going someplace. Increase your repertoire of moves, and the man playing you, by guarding against one, gives you the opening you need to move into another. It is not unlike learning to speak a new language. The larger your vocabulary, the better you will speak it, as long as you are building on a sound foundation.

Bob Cousy has been called a once-in-a-lifetime player. He may prove to be. But from now on the new stars that arise will play like Cousy. You can see his influence in the backyards throughout the country. Where all the kids used to be practicing special shots, you now find them trying to do something with the ball in the style of the master and submitting rather stoically, when the maneuver fails, to that inevitable come-uppance: "Who do you think you are anyway—Cousy?" ●

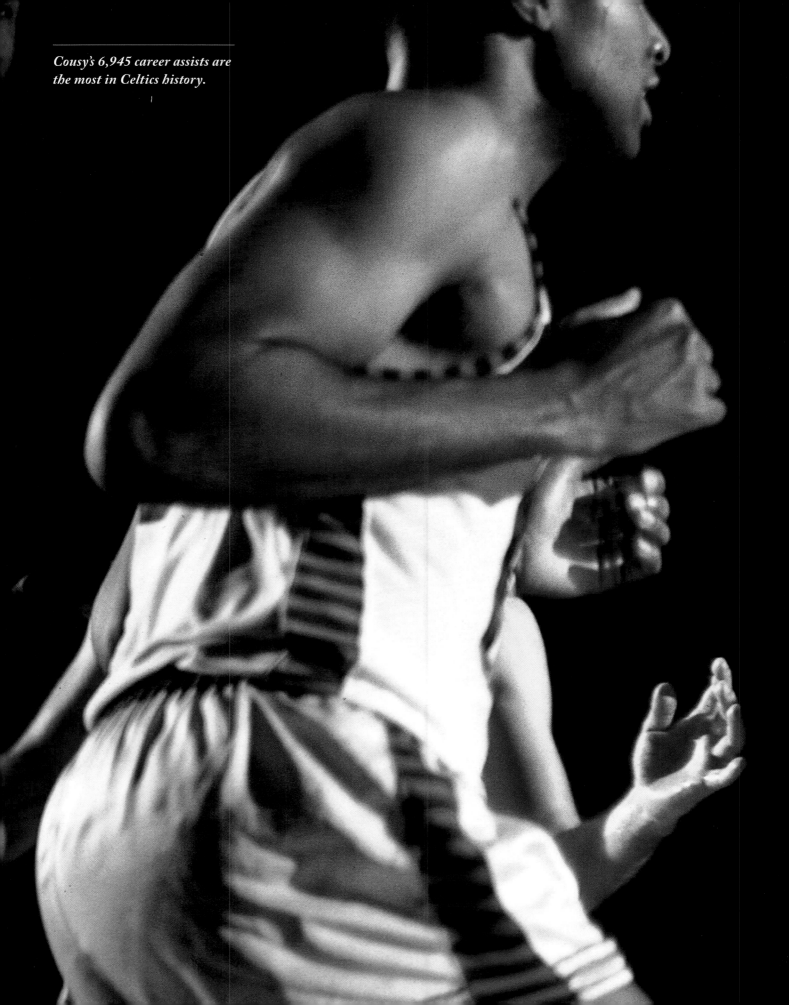

Cousy's 6,945 career assists are the most in Celtics history.

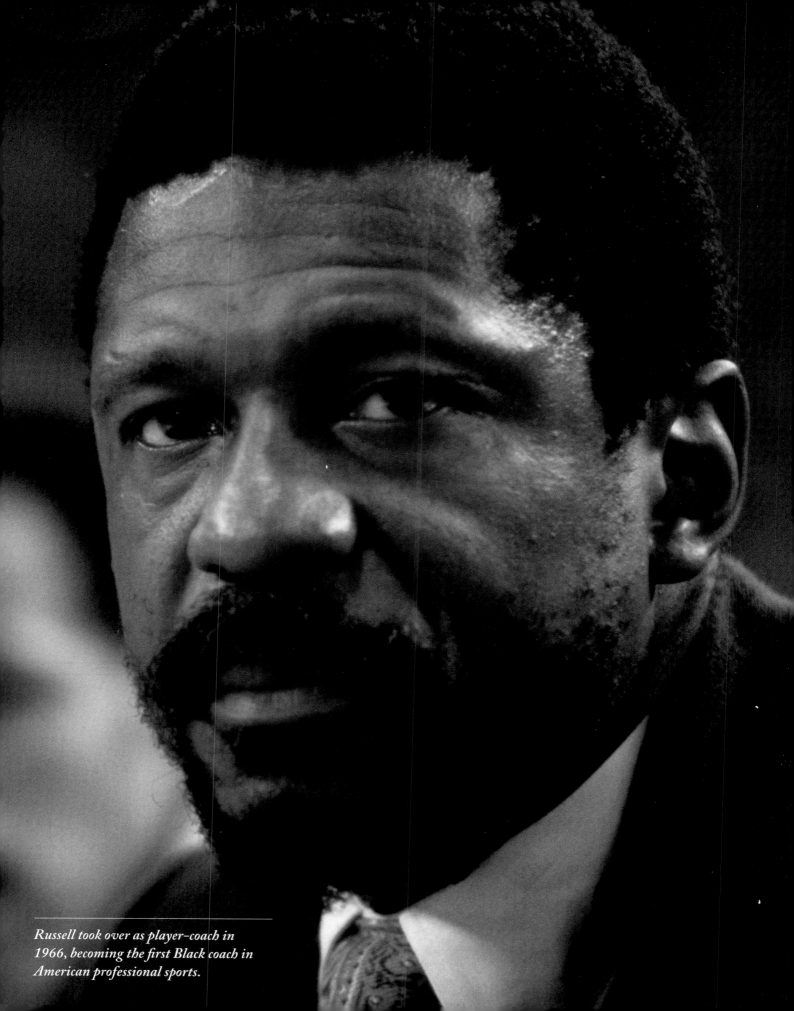

Russell took over as player-coach in 1966, becoming the first Black coach in American professional sports.

REFLECTIONS IN A DIARY

Bill Russell's achievement as coach as well as star of the Boston Celtics earned him SI's *highest accolade: Sportsman of the Year* BY GEORGE PLIMPTON

THE TROPHIES ARE DOWNSTAIRS IN A CELLAR ROOM THAT HAS A COVERED POOL TABLE IN THE MIDDLE, an unstocked bar at one end and posters of Allen Ginsberg and Marlon Brando on the wall. The room is dark and dusty and, unlike most athletes' trophy rooms, apparently little used. Russell says that one day he hopes to devote the floor space to a large electric train system for his children and also for himself. He'd clear everything out for that, including the trophies. These stand in a tall case against one wall—rows of them, mostly yard-high replicas of players poised, right arm up, to shoot one-handed shots with silver basketballs.

They commemorate one of the most remarkable records in sports: 14 years of play at the pinnacle of basketball—two years leading the University of San Francisco to the national championship and then 12 years with the Boston Celtics, leading them to two second-place finishes and 10 world championships.

Russell inserts a key. The heavy glass doors slide on smooth runners. He bends and peers in. He fishes out an Olympic gold medal, as small as a 50-cent piece in his big hands. He won it as a member of the 1956 Olympic basketball team.

His favorite trophy in the case? He points at one of the less towering, one which marks the beginning of his career, a tall silver figure on a white base. He won it in a tournament promoted by the *San Francisco Examiner*, as the Bay Area's Most Promising Young Player. At the time he was 19 years old and a freshman at the University of San Francisco.

He leads the way upstairs. He walks stiffly, bending to get his 6'9" height through doors. Upstairs the house is lively. His wife Rose and the children are there: Jacob, Kenyatta and Buddha, named after Russell's heroes in history. A dog is underfoot: Patches, a boxer, nervous perhaps because Russell dislikes him (he tracks in asthma, Russell says) and whose legs Bill mockingly keeps threatening to break. The living room is tasteful—a grand piano, a mobile hanging from the ceiling, African artifacts (spears and masks on the wall), peacock plumes in a vase and a ceiling-high bookcase crowded with volumes, many by Black leaders and athletes.

A complete set of Hogarth's sketches in bound volumes stretches along the bottom shelf. Russell moves through the room chatting with the children, ducking his head to clear a ceiling lamp on the landing, an instinctive move that he would doubtless make if the room were in pitch darkness.

SAM JONES: Russell was slow settling down in Boston. When I came to the Celtics he'd been with them a year and he had just moved from the Hotel Lenox in the city into a different house out in Reading. There wasn't anything in it for a while except a telephone, a refrigerator and a rocking chair. This one time I was out there—I remember the date, Nov. 2, 1957—Rose was pregnant. Not only that but she was having birth pains there in the living room, rocking back and forth in that rocking chair, and Bill was off somewhere in the only car. I said to her, "Don't do anything. Wait till Bill comes back." I've had five kids since, but I didn't know anything then, so I stood over her and I wrung my hands and she rocked back and forth and I said, "Please, please wait till Bill gets back. He'll know what to do…he can handle anything."

Out in back of the house is a small pale blue swimming pool, emptied, with a carpet of autumn leaves in the bottom, a chair facing the deep end and a bicycle leaning against the shallow-end side. There are seven or eight bird-houses in the yard; Rose Russell, a girl of lively curiosity, is an amateur bird watcher. Russell himself collects phonograph records. He has 4,000, one of which he selects, a big-beat single, and puts on the turntable. The volume is very high. He talks through the sound: "Track was what I was first interested in at college, because the track team had a sweater that buttoned down the front with S.F. on it for San Francisco. The other sports had nothing like that. The first

meet, I went out and jumped 6 feet 7 inches for the sweater."

TOM (SATCH) SANDERS: He's nicely hooked on clothes. Last year it was Nehru jackets and love beads—his kick as an overgrown love-child. This year it's Africa— caftans and sandals. We shake our heads when we consider what he might turn up in next year.

The record comes to an end and Russell puts on another. "Track is really psychic," he says. "There wasn't a guy I jumped against I couldn't beat if I had the chance to talk to him beforehand. I talked to Charlie Dumas and we tied. After that he never talked and he went on to those world records. I recall we had one big meet with 34 jumpers. They wanted to start the bar at 5 foot 8. I said, 'Let's start it at 6 foot 4—let's get rid of all this garbage.' I wore a silk scarf, basketball shoes, a track suit and black glasses. I took off the glasses to jump. I had no trouble that time. I loved track. I was completely loose— never got worried or sick before an event… loose as ashes."

JOHN HAVLICEK: He's a fantastic athlete. He could have been the decathlon champion. He could broad-jump 24 feet. He did the hurdles in 13.4. I've seen him in plays on a basketball court when he not only blocks a shot but controls the ball and feeds it to his forwards, and then he's up at the other end of the court trailing the fast break and if there's a rebound there he is, ready for it. He just might be the fastest man on the Celtics. Last year in the playoffs Archie Clark of the Lakers stole the ball three times and he must have had five steps on Russell and a free lane to the basket. Each time Russell caught him and blocked the shot. Think of that. Think of being on the other team. There's got to be

a funny feeling, going for the basket when Russell's around.

There is an invitation to dinner at a friend's house. Willie Mays is going to be there. In the garage Russell gazes longingly at his Lamborghini sports car, but it is a two-seater and there are too many people to transport. On the way to dinner Russell talks about the defensive skills that are his specialty. "Much of defending is instinctive," he says. "He-is-going-to-shoot, so obviously I-must-do-this. But it's also possible to analyze your reactions in certain situations so you can learn to control what you do— so that it's not an accident anymore. Of course, there are some tricks. If a game is close, two minutes to go, your man's probably going to take his favorite shot. So you can compensate. And then again there's luck. Now, naturally," he adds, beginning his big rackety laugh, "if I was 22 my man wouldn't be having any luck at all."

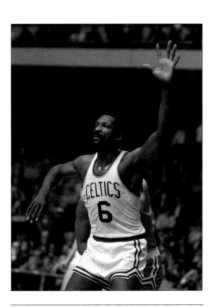

Russell feared losing his competitive age late in his playing career.

"What begins to go— besides the luck?" someone in the car asks.

"You begin to lose the competitive edge. That's the only department—and it's an important one—where I feel any loss. My timing's as good as it ever was. But night after night, test after test, they come to challenge me—it's not unlike being a gunfighter. For the last four or five years I've had this picture of myself as the gunfighter—the guys coming up who say they saw me when they were in the fourth grade and they've watched every move, and practiced them, and how they want to try me. And they keep coming and sometimes I wonder if I still have to prove myself."

JOHN HAVLICEK: He used to throw up all the time before a game, or at halftime—a tremendous sound, almost as loud as his laugh. He doesn't do it much now, except when it's an important game or an important challenge for him—someone like Chamberlain, or someone coming up that everyone's touting. It's a welcome sound, too, because it means he's keyed up for the game, and around the locker room we grin and say, "Man, we're going to be all right tonight."

RED AUERBACH: The first time I saw him play after we landed him for the Celtics was with the 1956 Olympic team against an all-star team in College Park, Md. He was horrible. He was awful. I thought, God, I've traded Ed Macauley and Cliff Hagan for this guy! I sat there with my head in my hands. He came over to see me after the game. He said he wanted to apologize—he'd never played like that. I looked at him and said I hoped he was right because if his play that night was any indication of his ability, then I was a dead pigeon. His first game as a pro wasn't much, either. Harry Gallatin of the Knicks just ate him up. Russell—well, he didn't seem to want to hit anyone. Timid. He'd just been married, and that doesn't do a guy any good. At least on a basketball court. So the next time we

played the Knicks I thought I'd play Russell at corner and let Arnie Risen play center against Gallatin. Russell came to me and said he wanted to try again against Gallatin. Well, what a job he did on Gallatin—maybe the guy got one shot on him, maybe two. Russell destroyed him. That's a word you can use about him—he "destroyed" players. You take Neil Johnston—a good set shot and a great sweeping hook shot, a big long-armed guy who played for Philly and was the leading scorer in the NBA the year before. Russell destroyed him. He destroyed him psychologically as well, so that he practically ran him out of organized basketball. He blocked so many shots that Johnston began throwing his hook farther and farther from the basket. It was ludicrous, and the guys along the bench began to laugh, maybe in relief that they didn't have to worry about such a guy themselves.

Willie Mays has already arrived at the dinner party, looking chilly in a lightweight gray suit. It is a cold autumn day outside. He brightens at Russell's entrance. He stands in front of the fire, bouncing up and down on his toes, and in reply to how he feels and what he thinks about next season he announces he is only going to play 100 baseball games; the schedule is just too exhausting; in fact, maybe he'll limit himself to 80. "Well, 80, yes I should think so," says Russell. "Baseball… really damn brutal. Think of it. You got to get to the ball park at 4 o'clock for a night game. You sit around and shoot some pool. Then you eat a sandwich maybe, and you drink some pop. Then you sit around and do a lot of cussing at each other. Then you pull yourselves together and it's time for some more pool. After a while you get dressed. Out on the field you lounge around the batting cage. Then you go back and lie down and read the day's lineup. Finally you go back out and the game begins. The only people who do anything are the pitchers and catchers. What does everyone else do? Well, they lean forward on their toes

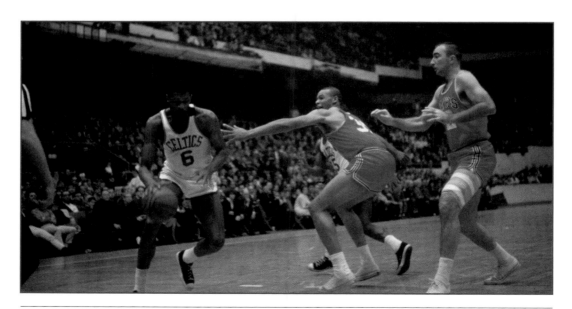

Teammates attested to Russell's incredible athleticism.

and they pound their fists into their gloves! [Russell stands and pounds his fists together.] Sometimes they spit on the ground. Just for a change. When the pitcher gets three men out, everybody walks into the dugout where they hold their chins in their hands. [He holds his chin in his hand.] And what then? They stare out at the field until it's time to go out and start pounding that glove again. It's really brutal."

"Aw, come on," says Mays, bouncing on his toes.

TOM (SATCH) SANDERS: He's a good needler. When I first came to the Celtics I decided we weren't going to get along. In training camp I was going to be mean and hard and cold and I wasn't going to have anything to do with anyone—just concentrate on making the team. Well, that lasted two or three seconds. Russell let loose with that big laugh in this restaurant, and I decided that anyone with that much laughter wasn't anyone to be mean and hard and cold around. So I went over and asked if I could tag along. In his inevitable fashion he turned on me and said no, hell no, certainly not. Well, I thought, I've done it now, I've shown myself up as weak, just when I was going to be mean and hard and cold. I'd better change back fast. But then, just as I was turning away and getting all set to be aloof again, why he said he was only kidding. Well, that's like him. He enjoys surprising people to keep them just a bit off balance. When I do something wrong he says, "You just don't like Boston, do you?"

Mays asks Russell about coaching basketball. "It doesn't seem to me to be all that complicated," Russell says. "I've listened to coaches for so many years. Players react to different stimuli. Some guys you berate; some you praise. If you happen to have a team of guys who need to be yelled at,

well, you yell at them and you hope that your manner's convincing."

"You miss things?" Willie asks. "Playing and coaching at the same time?"

"I miss some things—guys getting tired, certain guys I don't play enough. But I have intelligent players who give me advice. I don't worry. I'm not going to get ulcers coaching. I'm going to give them."

BAILEY HOWELL: There are some advantages to having a player-coach. The great one is that he can inspire you on the floor by example. A coach on the bench can only shout, or maybe send in a substitute. But if things are going badly Russell can take over. He can get a rebound, begin to block shots. By performing on the floor he can pick up the whole team and set it going right.

JOHN HAVLICEK: His first season was rough—we finished second. He called us in to see him at the beginning of his second season—we were down in Puerto Rico on an exhibition tour—and he looked at us, six or seven Celtic veterans, and said that sitting in that room was a century of basketball experience. He wanted our help—he wanted to tap that knowledge. Of course he told us that his would be the final decision. It helped a lot. He told us to criticize him if we felt he warranted it. One of his problems is that after he gets a rebound he sometimes won't come all the way down court with the offense. He has a tendency to go to half-court and watch. If I'm on the bench I'll yell, "Get down there, Russ!" And he'll start, jump a little, you know, and he'll prance on down there, that chin striking out, and that goatee of his accentuating the whole business.

"Hey, when you coming out to the ball park?" Mays asks Russell abruptly. "For batting practice, I mean. We'll fit you out." Mays is full of enthusiasm. "What size are your feet?"

"Fourteen," says Russell.

Mays's enthusiasm is not diminished. "We got fourteens. We got them around somewhere. We'll get you into something."

"I hit batting practice in Dodger Stadium," Russell says. "Mudcat Grant took me out there when he was with the club. I hit the right-field wall."

"The right-field wall!" Mays is aghast. "Why I can't hit that wall." He puts on a pout. "What you talking 'bout?" He begins to stomp around the living room. "What you talking 'bout?"

LARRY SIEGFRIED: As a coach he's not a man of a million words. He's direct and he's precise and it has a great effect. We were down 3–1 to Philly in the playoffs last year and he gave us this little sentence in the dressing room for a pep talk. He said, "We've come so far and I don't want to go home now."

"You play pool?" Mays asks. "You coming out to the house when you're on the Coast? To play pool?" He is very enthusiastic.

"Oh-oh," Russell says. "He's beginning to reel me in."

"Oh man," says Mays. "Don't you gamble none?"

"Always with the wrong person. You ever play golf with Jimmy Brown? One time we're playing and Brown says, 'Hey, I can beat you using one club.' 'What club?' I ask him. Well, that was a mistake. He was reeling me in right there. 'A four-wood,' he says. I ask him, 'You mean you chip and putt and everything with a four-wood?' 'Yes,' he says. He's reeling me in good. Well, I think about it and finally I say O.K. So I get a four on the first hole and so does he. I get a five on the next; so does he. Then I get a three and he does too. Well, I'm one over par after five holes, playing way over

my head, and he's fooling around with that four-wood and he's dead even with me. Well, I can't play up to that cat, so he wins the last four holes and $80."

Mays says he's pleased to know about that, just in case he runs into Jimmy Brown on a golf course; and in the meantime he's ready to take on Russell with just a putter.

Russell looks around the room solemnly. "A den of thieves," he says, and he rocks back and forth with laughter. He stands up. He says goodbye to Mays. He will see him on the Coast. Maybe he will play pool. He is sorry to leave but he has a game the next night.

In the car on the way back someone asks, "Hey, did you really hit the right-field fence at Dodger Stadium?"

Russell laughs. He says, "Maybe not so far as that. But we can't let Willie know."

JOE DE LAURI, the Celtic trainer: He's friendly and easy with those he likes. But the big concern he has is for the Celtics. Nothing else really matters. That's why he seems so cold often to the press and the fans. They're not Celtics. After we won the championship last year he kicked everyone who wasn't a Celtic out of the dressing room—press, photographers, hangers-on, and also this poor guy who was tending a television camera in the locker room who said he had to have permission to leave it untended, pleading to stay, said he was going to lose his job, and it took three or four minutes to get him out. The press was pounding on the door, furious about deadlines and all, and Russell turned around and looked at us and he asked Howell to lead the team in prayer. He knew Bailey was a religious man—it was also his first year on a championship team—and he knew Bailey would appreciate it. Russell's not a religious man himself. Sam Jones said, "You pray?" And Russell said, "Yeah, Sam." ●

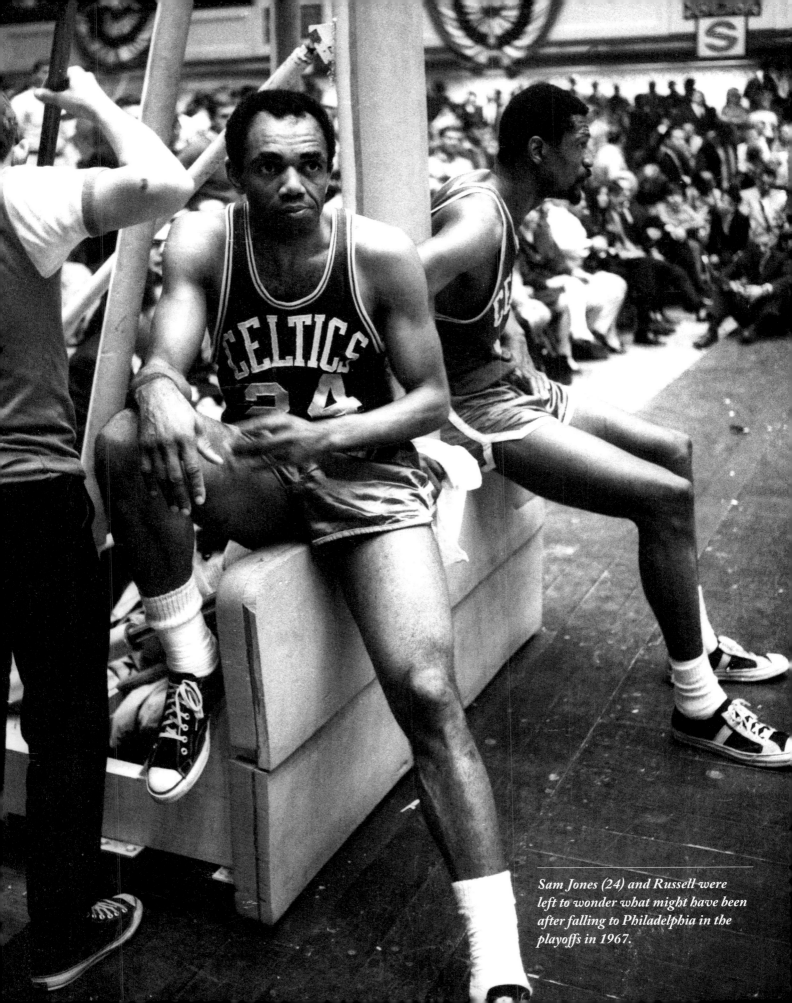

Sam Jones (24) and Russell were left to wonder what might have been after falling to Philadelphia in the playoffs in 1967.

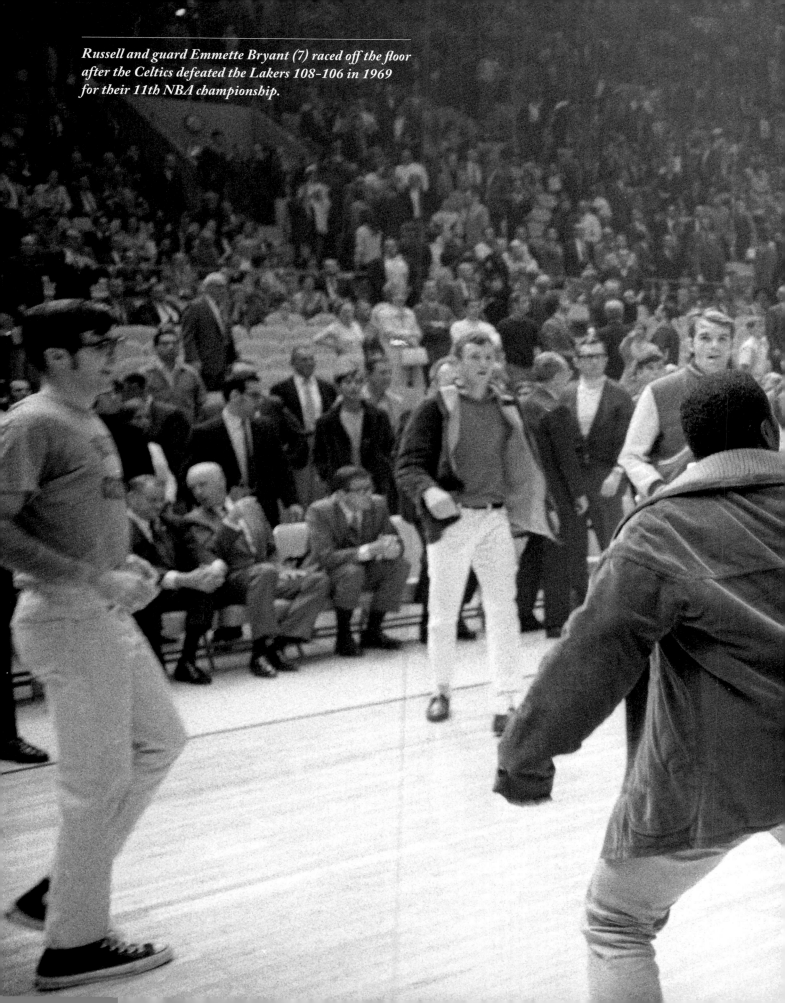

Russell and guard Emmette Bryant (7) raced off the floor after the Celtics defeated the Lakers 108–106 in 1969 for their 11th NBA championship.

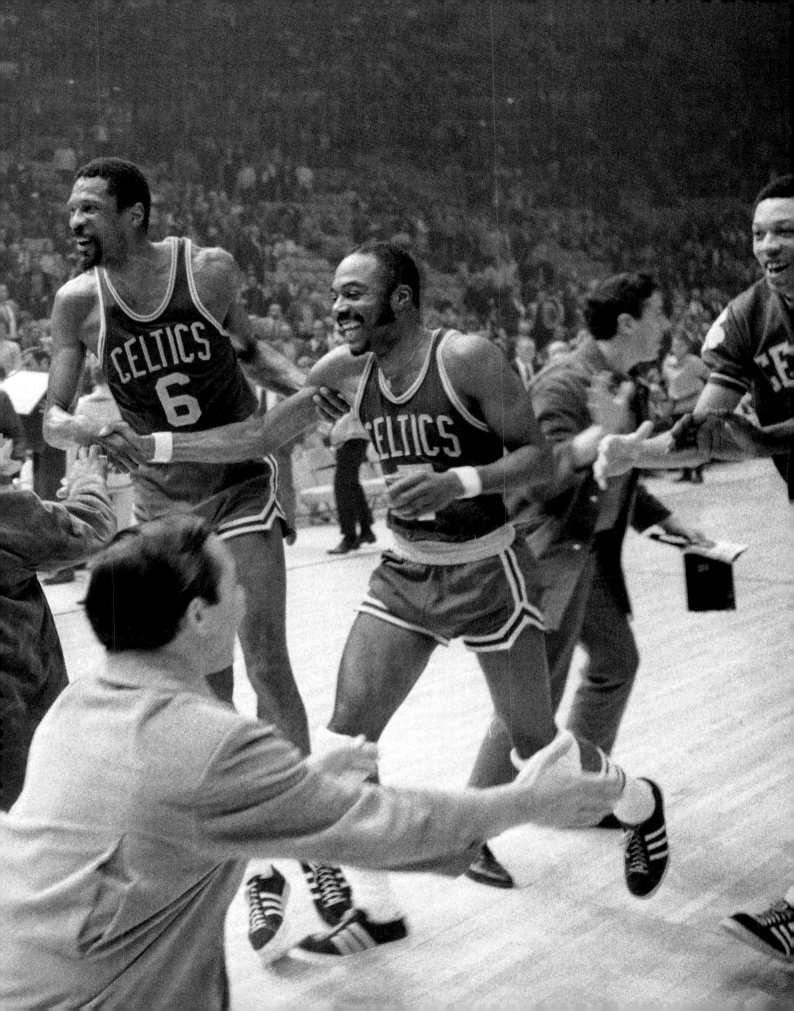

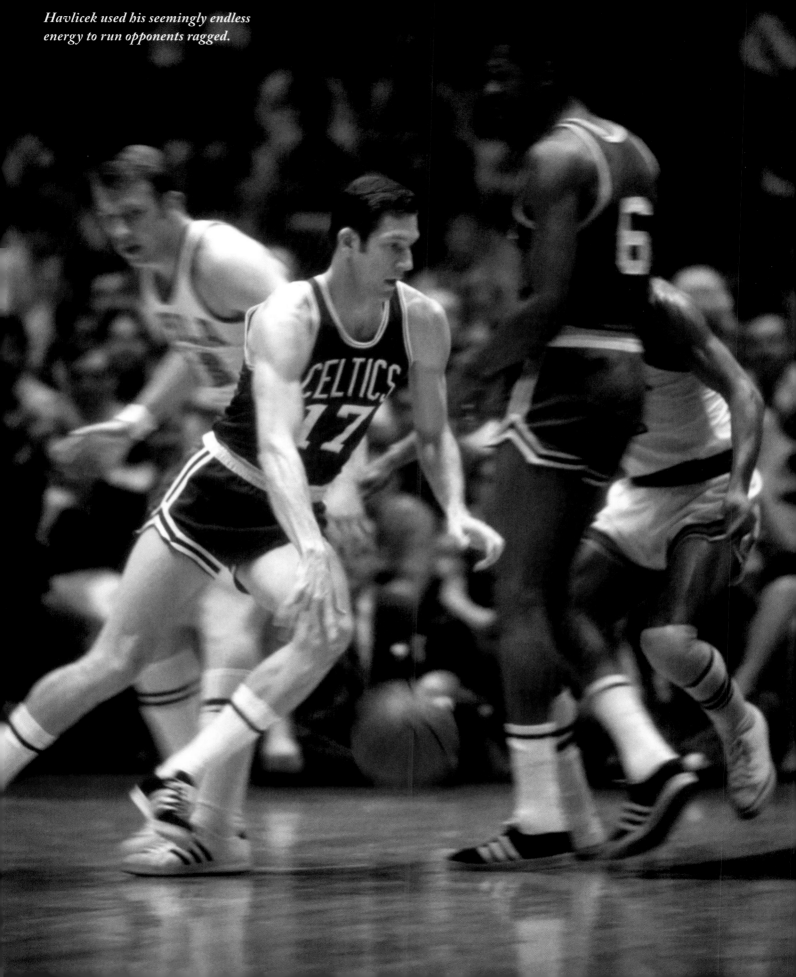

Havlicek used his seemingly endless energy to run opponents ragged.

THE GREEN RUNNING MACHINE

Directing the Celtics attack or harassing a key rival, John Havlicek is live perpetual motion BY JOHN UNDERWOOD

WHEN JOHN HAVLICEK WAS A ROOKIE BOSTON CELTIC, ONE OF THE MOST IMPORTANT SECOND-STRING PLAYERS on the Boston team was Jim Loscutoff, the National Basketball Association equivalent of a middle linebacker. Loscutoff was sometimes called "The Enforcer." In the first scrimmage of that 1962 training camp at Babson Institute in Wellesley, Loscutoff introduced Havlicek to the realities of a noncontact sport.

The more noncontact Havlicek had with Loscutoff, the closer he figured he was coming to the emergency ward at Massachusetts General. Loscutoff outweighed him by 25 pounds, and was not disposed to coddle. The shoe rubber, Havlicek recalls, was screeching on every play.

Rookie Havlicek responded to this intimidation by running. He ran veteran Loscutoff into the floor, as surely as if he were a 10-penny nail. It is a style peculiar to Havlicek and, since it requires the physiology of an Arabian saddle horse, impossible to imitate. Havlicek runs and runs (scoring, rebounding, defending tenaciously, making key passes, setting up plays), and when his opponent begins to go under, he runs some more.

"Hey, you're crazy," panted Loscutoff as they lined up during a free-throw lull. "Nobody runs like that. Slow down."

Havlicek explained that he was not an unreasonable man, and that if he was making Loscutoff look bad, he had a solution.

"Quit pushing me around," he said, "and I'll quit running so hard." The compromise at least saved Loscutoff from an early swoon, but it has not saved the rest of the NBA from Havlicek in these intervening 12 years. Red Auerbach, then the Boston coach and now its president and general manager, remembers that first scrimmage, and having thought, "Oh, have I got something here. Are they going to think I'm smart!"

Smart Red had drafted Havlicek off the Ohio State campus at a time when his Celtic team was a philharmonic of Cousys, Heinsohns, Russells and Joneses. Eventually Red relinquished the baton to Russell, and the blend was altered to include Sanders, Nelson and Howell. Then Russell, too, turned it over, this time to Heinsohn, and the empty chairs were filled by a brassier medley of Cowens, Chaney and Jo Jo White. And always the insatiable Celtics won—well, seven out of 12 NBA championships is almost always—and always there was Havlicek.

Then at an age (34) when he was at last showing some faint signs of breaking into a sweat, Havlicek emerged last winter into total light as the physical, spiritual and appointed leader of the Celtics in their seven-game championship decision over the Milwaukee Bucks. Havlicek was named Most Valuable Player in the series.

The vote was academic. A case could have been made that Havlicek was more like Most Valuable in the Game Today. Or the Best Athlete the NBA has ever had—which would rank him right up there universally because few other sports demand anywhere near as much of an athlete as pro basketball.

Pshaw, you say. How can that be? How can such things be said of a guy who doesn't shoot as well as the best, isn't strong enough to smother a backboard, doesn't have breathtaking speed, can't dribble behind his back and isn't 7 feet tall? How can that be as long as Kareem Abdul-Jabbar is alive and living on the basket rim?

There is no arguing Abdul-Jabbar's preeminence. Basketball is a game divided between centers and other fellows, and the best big man will get the franchise owner's vote. The best centers are called "dominant forces." Abdul-Jabbar, as the reigning dominant force, follows the skyline of George Mikan, Russell and Wilt Chamberlain. But inevitably

he will make way for another. Already there are pretenders: a redhead named Walton in Portland and an adolescent named Moses in Utah. It is only a matter of time.

But it is altogether unlikely that you will ever see another Havlicek. The dimension John Havlicek has brought to basketball is entirely and uniquely his own, and it will probably go with him once he finally winds down. At that time Geoff Petrie of the Portland Trail Blazers would like to have them "take his body apart and see what's in it."

The record books are not conclusive on the subject of Havlicek: 20,814 career points represent an all-time Celtic high, but a lot of guys can put a ball in a basket. Furthermore, Havlicek does not fit any of the grooves: he plays two positions—forward and guard—not just one. Sometimes he plays them alternately during a game, sometimes interchangeably as a fill-in, though it has been a while since he was known as the Celtics' "sixth man."

The 6'5" Havlicek is what is known in the NBA as a "tweener," an in-between-size player, usually too slow for guard and too small for forward. If you have basketball in mind, a tweener is not what you want to grow up to be. Havlicek has managed to breach the definition. His play is fast enough for the guards, big enough for the forwards.

"He is the best all-around player I ever saw," says Bill Russell simply. As a forward "he may be the best in the league right now," says Bill Sharman, the Lakers' coach. "The toughest in the league to cover," says Bullet forward Mike Riordan. As a guard, says Jon McGlocklin of the Bucks, "he's right on your shirt whether you're five feet from the basket or 20. He's harder to get shots on than anybody." "He plays bigger than 6'5"," says Jerry West, late of the Lakers. ("Right," says Havlicek. "I'm actually 6'5½". I think I'm

still growing.") "A road runner," says Laker general manager Pete Newell, "taking you through every ditch, every irrigation canal, barbed-wire fence and cattle guard. You've had a trip over the plains when you've played him for a night."

There are a lot of fine shooters around," says Al Attles, the Warriors' coach, "but when it gets right down to taking that big shot, the one that really means something, they're off in a corner somewhere." "He'll not only take it," says Sam Lacey of the Kings, "he *wants* it."

If you gauged worth by pure skill, a veteran basketball observer believes, "Havlicek would not rate in the top five. But if you were playing for a million bucks, he'd be in the top two." Jerry West, a less practical jurist, says: "Superstar is a bad word. In our league people look at players, watch them dribble between their legs, watch them make spectacular plays, and they say, 'There's a superstar.' Well, John Havlicek *is* a superstar, and most of the others are figments of writers' imaginations."

It would be reassuring for those who become melted butter in his wake to believe that Havlicek is some kind of genetic fluke who grew into a large pair of lungs connected to a long pair of legbones, the whole held together by wire, rubber and whipcord. But in Havlicek's case his particular style was charted by him as surely as if it were a sea voyage. The pivotal moment occurred during his sophomore year at Ohio State, when he was growing in the shadow of Jerry Lucas, just as he would later live in Bill Russell's more encompassing one in Boston.

For the record, Havlicek was born in Martins Ferry in the athlete-rich Ohio Valley, raised on the West Virginia line in rural Lansing, Ohio (pop. 1,000) and schooled in nearby Bridgeport. He was the second son of an immigrant Czechoslovakian butcher,

Frank Havlicek, who, until he died last year, never lost his accent and believed soccer was the only sport. While mother and father tended the Havlicek stores John became a prime item at Bridgeport High, his names—Yunch, Boola, Big John, Mr. Clean— on everyone's lips. He never met a sport he didn't like. In baseball he hit .440, and teammate Phil Niekro, now with the Atlanta Braves, says he would have been a cinch big-leaguer.

As a 6'3", 180-pound quarterback, Havlicek was not only the class of the Bridgeport football team but also most of its size. He could throw a football 80 yards, but never had time to because his guards and tackles weighed 130 pounds. To compensate he got to be so good running the split-T option that twice in one game officials blew the ball dead because they couldn't find it.

Of such stuff legends are made, of course, and responsible people enjoy nurturing them. Red Auerbach says he once asked John how far he could swim, having seen him knifing through a motel pool. Red says John replied, "I don't know, it's just like walking to me." There are similar stories about Havlicek hefting a tennis racket for the first time and winning a class tournament at Ohio State, and about his picking up a foil and performing like Douglas Fairbanks. Havlicek laughs them off. Basketball was his best and true love, and he had no illusions about how he had to play it, even as a high-schooler. "It's true I'm not a shooter," he says, "not the way Sam Jones was or Jon McGlocklin. I never had their touch. I learned to score by taking advantage of every opening." He found early on that when confronted with taller players he could "lean back and throw it up, then run get the rebound and put it in." Sooner or later he always put it in. After Havlicek scored 28 of his team's 31 points in one game, the rival

coach told the Bridgeport coach he knew how to stop Havlicek. "Put three men on him man-to-man, and play the other two in a zone under the basket," he said. "And every time he gets near the ball complain to the referees that they're favoring him."

Old-worlder Frank Havlicek rarely saw John play anything, never having gotten over soccer, but Mrs. Havlicek became a devotee. She harbored a mother's qualms about John playing football, though the football scouts came after him in droves. She found a sympathetic ear in Fred Taylor, the Ohio State basketball coach. Taylor has never been overly fond of what he still calls "oblong ball." "Mrs. Havlicek," he told her, "if you don't want John to play football, then he'll play it over my dead body."

Even that might have been arranged at Ohio State, because Woody Hayes himself wanted Havlicek. John told Hayes he didn't think he could hack basketball, baseball, football and the books, too, and he had a mind to play basketball and baseball. "How do you know until you try?" replied Hayes.

But Woody finally relented, and he told Havlicek he was the kind of boy they wanted at Ohio State "even if you don't play football. So come on, and I won't bother you again." And Hayes didn't, says John. His assistant coaches did. For the next four years they scattered hints like rose petals every time John passed by. Hayes himself was just slightly more subtle. He would introduce

Havlicek brought a football player's mentality with him onto the court.

Havlicek to his football recruits as "the best quarterback in the Big Ten who isn't playing."

The 1960 Ohio State basketball team was the NCAA champion, led primarily by sophomores—Jerry Lucas, Mel Nowell and John Havlicek. It was just before that season began that Havlicek came unilaterally to the conclusion that very likely made his career.

He walked into Coach Taylor's office, as Taylor recalls, and respectfully informed him there was "only one basketball, and you've got plenty of guys who can shoot it. I'm going to make this team on the other end of the floor."

"At the time," says Taylor, "we were trying to sell our kids on defense. Defense is hard to sell, but here was John literally jumping at the chance. I never saw anything like it. And of course I never saw anything like John. By midseason I was usually assigning him to the opposition's best player automatically, whether it was a frontcourt man or a backcourt man."

In his three years, during which Ohio State won one NCAA championship and lost two in the finals, Havlicek drew them all: Lenny Chappel of Wake Forest, Terry Dischinger of Purdue, Cotton Nash of Kentucky. "We even put him on a couple of centers," says Taylor. "He'd get upset if he didn't think he was guarding the best."

And Havlicek himself made a discovery: "I knew from the first time I played this game that the toughest guy to score on was the guy who kept after me all the time, nose-to-nose,

basket-to-basket. The opposite is also true. The toughest guy to defend against is the guy who keeps running. Who never lets up. Never lets you relax. Who sneaks one in on you the first time you drag your feet. I never worried about the physical part, killing myself running or anything like that. I read once where a doctor said you'd pass out before you did any real damage. I never passed out."

Dervishes are an ascetic order, and so are stoics, and Havlicek is one of those, too. Shy, self-disciplining (he punishes himself for athletic failures by running great distances or denying himself Cokes), a noncomplainer. He played hurt, and still does. In a 1973 semifinal series with the Knicks he played three games with a partially separated shoulder, his right arm virtually useless at his side. Against Los Angeles in the 1969 finals he played with an eye swollen shut by an accidental gouging. "I don't think you should mind a little pain if you're paid to play," he says.

In that 1960 NCAA championship he played with a severely cut middle finger on his right (shooting) hand. Taylor remembers a time when John's knee was in such pain from strained ligaments that he finally consented to try an elaborate homemade brace the trainer called an "octopus." When Havlicek appeared on the practice floor his teammates whooped at the contraption, and John retreated to the training room. "I can't wear this thing," he said. "Take it off. It's embarrassing."

Havlicek was also quietly self-effacing about scoring, and Taylor finally suggested that John might want to take a shot himself now and then. He had been averaging no more than six or eight points a game. There followed a game in which Havlicek led the Buckeyes in scoring. When an astonished teammate asked what had gotten into him, Havlicek said, "Coach told me to." In his All-America senior year Havlicek led

Ohio State in scoring seven times. He was voted team captain on all ballots but his own, which he cast for Lucas.

Having played no football at Ohio State, Havlicek was nonetheless drafted by Paul Brown of the Cleveland Browns in the seventh round of 1962. In all, five NFL clubs sent him feeler letters.

Havlicek was drafted by the Celtics, too, in the NBA's first round, but in those days basketball owners were throwing dollar bills around as if they were hatch-covers. The Celtics' original offer was $9,500, with no bonus—"your bonus will be the playoff money," Havlicek was told. Unbeknownst to Havlicek, Taylor called Celtic owner Walter Brown to plead for a better deal. "You college coaches are all alike," said Brown, "always thinking your player is worth more." "Mr. Brown," replied Taylor, "the NBA never had a player worth more than this one."

The offer was raised to $15,000, which equaled that from the Browns, except that the Browns agreed to throw in an Impala convertible. Not having satisfied an itch to try football at a level where the tackles weighed more than 130 pounds, Havlicek gathered up the keys to the convertible and reported to the Cleveland camp.

"On the first day, at the first meal, I loaded up my tray and took a seat by myself," he says. "I wasn't planning on doing much talking anyway, and I'd heard about the things they did to rookies in the NFL. Suddenly I began to hear these barking and growling noises, like they were maybe directed at me. But when I looked up there was this guy with two T-bone steaks on his plate. He was eating them *raw*. I thought, 'Boy, this football is going to be tough.'"

As a 6'5", 205-pound wide receiver, Havlicek was called "The Spear" by the Browns. He ran the 40-yard sprints in

4.6 seconds and, he says, "caught the ball as well as anyone in camp, but the team was loaded with fine receivers—Gary Collins, Bobby Crespino, Ray Renfro. And there was a lot I didn't know about blocking."

Against the Steelers in the second exhibition, at Municipal Stadium, Brown sent Havlicek in. "The crowd gave me a big hand," he says. "They were curious to see if a basketball player could play football. Somehow I made my block, on the cornerback, I think. A perfect block. Jim Brown ran a sweep 48 yards to the Pittsburgh two.

"Somebody in the huddle said, 'O.K., Spear, do it again.' I was feeling pretty good. This time it was an off-tackle play. I lined up looking into the face of Big Daddy Lipscomb.

leadership and inspiration, and their style of play is his style. It is a rare, beautiful thing."

———

Late this summer, before the Celtics opened their training camp, Havlicek was back in Ohio. Early one sunny afternoon, he turned his Jeep Wagoneer out of the drive of the four-bedroom maple-shaded brick house in Wellington Woods, a suburb of Columbus, and headed out for some errand-hopping prior to an afternoon golfing date and an evening banquet to be held in his honor in downtown Columbus. "Actually," he said, "it's for the Children's Hospital. I'm just a reason to get people there." The Jeep had been the automobile of his choice for winning the MVP award. Its mates in the Havlicek garage were a bottle-green Cadillac convertible, an

> Red Auerbach once said, "John Havlicek is what I always thought a Celtic should be."

> John Havlicek, says Jim Washington, is what the Celtics have become. "They are one and the same."

When they peeled everybody off the pile I was the bottom, my shoulder pads twisted around and the part of my helmet that was supposed to be over my ear was jammed against my nose. I said to myself, 'Boy, this football *is* tough.'"

Havlicek was the last receiver to be cut by Brown. "I liked Brown," says Havlicek, "the way he ran things, the way everything was so precise. My kind of coach. He was very nice about it when he let me go. He seemed to know I had something to go to."

Red Auerbach once said, "John Havlicek is what I always thought a Celtic should be." A rival player, Jim Washington of the Hawks, perceives a more spiritual relationship. John Havlicek, says Washington, is what the Celtics have become. "They are one and the same," says Washington. "He gives them

Audi and a Honda Trail 70 that had only 29 miles on it because all he uses it for is to take mini-rides around the neighborhood with his 4-year-old son Chris snuggled against his chest.

"I identify with the Jeep," said Havlicek, turning into Olentangy Road. "You know, I could do this every day the rest of my life—play golf, fish, play tennis. Loaf around in these." He pulled at the striped beach shirt he was wearing with the faded jeans and a scuffed pair of Adidas sneakers without socks. His hair was longer than it used to be, a concession to style, he said, and to his wife's wishes.

He said it had not been that difficult to adjust his son-of-a-butcher's tastes to his conspicuous success (his salary alone, as the highest-paid Celtic, is $200,000-plus). "We

do not try to run up a lot of material things," he said. The Havlicek homes in Ohio and in suburban Melrose outside Boston are tidy and attractive, but not pretentious; no swimming pools, no fancy rec rooms. Beth Havlicek, his college sweetheart, is a pretty girl with cornsilk hair and startling blue eyes. She has kept her cheerleader's figure through two pregnancies (they have Chris and a daughter, Jill, who is one year old) by engaging John in a continuous round of shared activities. Beth took up tennis and golf for him, John took up skiing and horseback riding for her.

Havlicek made a grocery stop, then drove past the International Manufacturing and Marketing Corporation, a small but growing ($1 million assets) manufacturer's rep of which John is vice-president. Under its aegis there is an expanding Havlicek line of sporting goods—five signatured items to date and, coming soon, a John Havlicek basketball game that is played like darts and will retail for $15. The president of IMM wants John to quit playing basketball and run the business full time. John said he told him that as long as he was in the shape he's in he'd forgo the opportunity for a full-time desk job.

He patted his unabundant stomach. "I'm down to 193 now, but it's not unusual," he said. "I always lose in the off-season. I don't go for sweets, and I don't drink much, and in the off-season I run around so much that I don't pay much attention to eating. Once we go to camp I'll go to four meals a day, meat and potatoes, and be up to 205 in no time."

He said he could remember that first Celtic camp as if it were yesterday. "I was absorbed right away. There was no trial period, no feeling out. Red never took a lot of guys to camp, and the old Celtics knew what to expect. All Red did was motivate 'em. They'd all been champions either in college or as pros, and they never thought they should ever lose a game.

"The first year, Frank Ramsey and I divided playing time. Ramsey was near retirement, but he was still great. We were close. That's when I first got to be called the 'sixth man.' Red said, 'It doesn't matter who starts, it's who finishes.' I wanted to finish. I've always taken pride in the ability to play guard *and* forward. No one else has really done it. Ordinarily a sixth man can handle the offense at either position, but the defense gets him. A guard can't always pin a good forward in the corner, a forward can't stay with a guard up and down court. My defensive background made it easier.

"To Red the idea of a team having character was as important as anything else. He was gruff and tough, but he transmitted something. The Celtics have always had a unity, a feeling for each other. On my first day in Boston, Bill Russell took me all over town to help me find a stereo. The biggest name in basketball. And I was a rookie. There were no factions, no personality conflicts that lasted very long. There was no scuttlebutt, no rumors. It must have been rough on the Boston writers."

"When Russell left as coach, I went from being the youth of the Celtics to the old man. K.C. Jones was gone…Sam…the next year, Bailey Howell. Nelson, Satch Sanders and I were the only vets left. People said, 'Are these the Celtics?' For a long while I didn't think so. A lot of young players today don't want to learn fundamentals, they don't want to feed, block out, learn the plays. They have so much physical ability they try to take shortcuts. Well, I don't want to be on a team that is fundamentally unsound. And that's the way we seemed to be heading.

"In one game we set up two out-of-bounds plays, actually called timeout to set them up. On the first one, the in-bounds pass was thrown to the wrong man. On the second the

center lined up wrong. I couldn't believe it. I doubt I'd done it before, but I came back to the bench screaming, and I had more to say in the locker room. Afterward I told a writer it was the dumbest team I'd ever been associated with. I said we had seven simple plays, and if a guy comes into this league making $20,000 and can't learn seven simple plays, then he doesn't deserve to be paid. The funny thing about it was we won the game."

Heinsohn, his old roommate in the '60s, gave Havlicek carte blanche to do and say what he pleased but Havlicek said he'd already figured it out. "I had a responsibility to pass on the Celtic tradition, to instill it if I could. I didn't have to be told.

"The difference on the floor, compared with the old Celtics, is that we've shifted the emphasis from defense to offense. Russell was the greatest defensive center the game has ever known. Dave Cowens can't be a Russell, but he's a better shooter. K.C. was a great defensive player. Jo Jo's a better shooter. I'm counted on now more for scoring than I was. Sure, I want the ball in a tight situation. I feel I know more what I can do, and I'm not bothered if I miss. As long as you know it's the best you could have done, you should not second-guess a shot.

"The maturity we reached last year was remarkable considering how short a time we had had to rebuild. I could see it in the playoff series with Milwaukee, the very first game. We knew what we had to do, we did it. We played tough defense, made Oscar [Robertson] keep the ball as long as possible, get the time down to 18 seconds or so before he could get the ball to Jabbar. *Let* Jabbar have his 50 points. One guy won't beat us."

Havlicek steered the Jeep back into his driveway, turned off the key and settled back in the seat. "I've got two years on my contract," he said. "You never know how you're going to feel, so I'm not ruling out anything. This is a good business and I like it, but I'm going to play as long as I can play well. I'll know. I'm not as fast as I was. I'm not as reckless on defense, partly because I'm smarter, partly because I'm called on more offensively. Partly because I'm older."

That afternoon Havlicek drove his Jeep to play golf with his old Ohio State teammates Bobby Knight, now head coach at Indiana, and Gary Gearhart, who sells class rings in Columbus. Since Havlicek has not yet taken golf seriously, he suffered what would have been damage to his ego had he not been having so much fun. Only Knight really suffered. On the 12th hole he hit nine consecutive balls into the water. Havlicek and Gearhart tried to stifle their giggles.

"No wonder you can't do anything," said Havlicek, hefting a club from Knight's bag. "These look like the covers of Mason jars."

"My salary," said Knight acidly, "is not dependent on my parring this hole."

Their carts side by side on the next fairway, Knight looked over at the grinning Havlicek and shook his head.

"Greatest guy in the world. And he's always been the same, from the beginning. Except now he's rich."

"You'd be surprised how naive we were," said Gearhart. "John especially. Didn't smoke, barely drank, probably never cut a class."

"I had to study," said Havlicek. "There were so many of you smart guys around I sure didn't want to be the dumb one."

"The wildest thing we did was go to the movies on Saturday night and throw peanuts around," said Gearhart. "Lucas wouldn't go with us. Havlicek would, but once inside he'd move away."

"It would be embarrassing to get arrested for throwing peanuts," said Havlicek.

"The fact is you were too cheap to buy them," said Knight.

"Thrifty," said Havlicek.

Havlicek's next tee shot, a resounding *whack*, split the fairway and was past them all.

"Watch how I did that," he said. "I never hit it the same way twice."

Clank. Havlicek's second shot, like a stricken toy plane, dived erratically into the left rough. John waved at it.

"In my opinion," said Knight, "John Havlicek is the greatest basketball player who ever lived, bar none. I'm not saying he has more ability, I'm saying he's the greatest *player*, because he can beat you so many ways, and nobody, *nobody* goes as hard for as long as he does."

Bonk. Havlicek's third shot, struggling to get airborne and out of the rough, hit a tree and caromed off into a sand trap. "My game," said Havlicek, "has gotten itself together."

"How can the world's greatest athlete be so bad at golf?" asked Gearhart.

Schlump. Kerplop. Havlicek's sand shot took off nicely but landed in a pond by the green. Havlicek raised his club into the air as if it were a standard.

"I'll tell you a story," said Knight. "At Indiana we were playing Providence after we'd lost in the NCAA semifinals. Playing for third place. John suddenly appeared at our team meal. He went around introducing himself, as if my players did not know who he was. Then he told them, 'You have to play for third place tonight. It's the best you can do. So you should do your best.' Later, after we won easily, a writer asked me how I got 'em so keyed up for a third-place game. I said *I* hadn't."

At the Havlicek banquet that night the menu included Boston Celtic parfait, and a group of ladies in green and white uniforms who called themselves the "Havlicettes" sang a medley of "Havlicek," "Super Celtic Handy" and "Give John's Regards to the Buckeyes." There were film clips of key games and TV commercials John had made—Diet Rite among them—and a nostalgic reel or two of his wedding. Perhaps accidentally, the pictures of his high school football games came on the screen upside down.

People influential in Havlicek's life got up to pay him tribute. His old high school coach told the audience that whenever he sees John on TV "I tell my son, 'That's John Havlicek. I coached him.' It's the greatest honor I could have." Fred Taylor said that Havlicek was probably the only man in Ohio who could bring such a crowd together "on the eve of oblong ball season." Bobby Knight said he wished he had Havlicek's money. When John's mother was called on to be recognized from the floor, John, on the podium, stood up and the audience followed. Mrs. Havlicek's blush could be seen across the room.

Then the occasion himself came to the microphone. He said in his familiar, pleasing baritone that it was "hard for me to accept compliments very well," and that the only reason he was there was that there were children who needed help. After that he and Beth passed out the door prizes—balls, posters, etc.—that John himself had donated.

When it was over and the dance band was whipping up a rock tune, Knight and a small knot of old Ohio State players and friends gathered around Fred Taylor near the podium. Taylor said he had called Havlicek after the final NBA championship game with Milwaukee. "I got him out of the shower. He said, 'Fred, it's the only time I ever won anything by myself,' meaning without a Lucas or a Russell to take the spotlight. I said, 'John, you've been winning all your life.'

"You know, I had a call just the other day, one that I seem to get all the time. The guy said, 'Fred, I have a prospect for you. He's another John Havlicek.' I stopped him right there. I said, 'Don't ever tell me that. There's no such thing. There's only one.'" ●

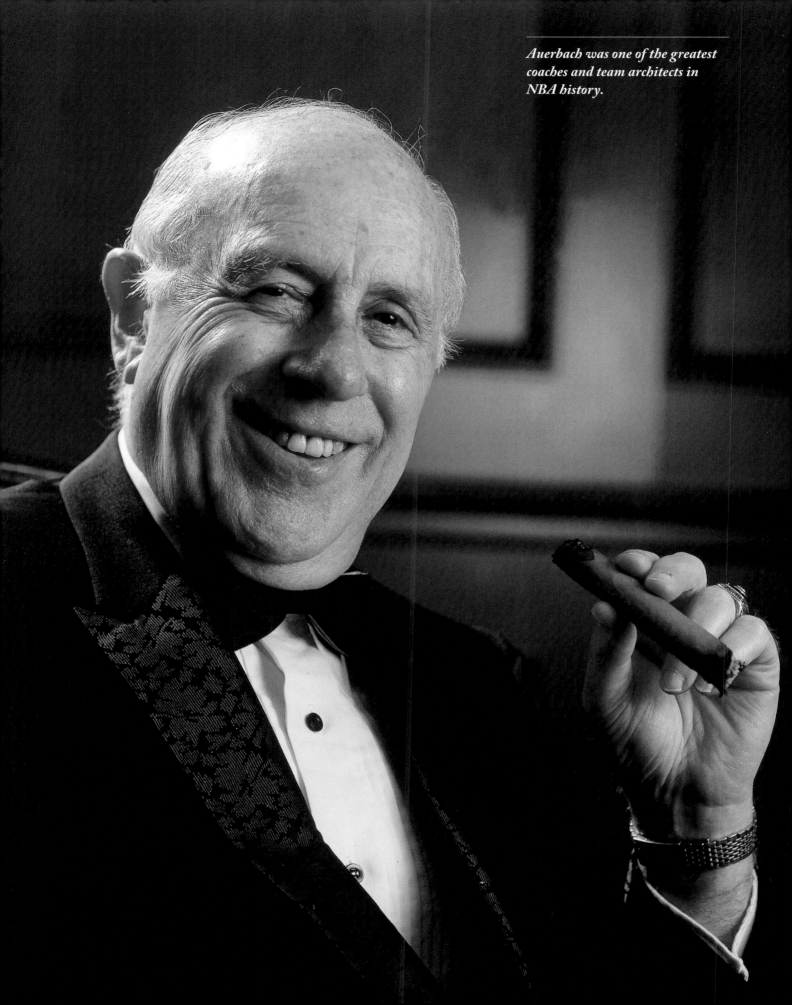

Auerbach was one of the greatest coaches and team architects in NBA history.

A MAN FOR ALL SEASONS

Red Auerbach and Celtic green are the most successful blend in the history of pro sports BY Frank Deford

THE CELTICS HAVE BANGED OUT BOSTON GARDEN THEIR LAST 52 HOME DATES. FIFTEEN THREE TWENTY. AS they would say in Boston, you could charm a dog off a meat wagon with a Celtic ducat. It's ironic, isn't it? Here's Red Auerbach—64 years of age, 30-odd years in the Hub, 13 in the Hall of Fame, 14 world championships as the Celtic coach and/or general manager— thinking about retiring after next season, and only now, right at the end of the line, Boston finally appreciates what it had all along. The Celtics were champions, heroes, legends, and at last, holy of holies, they're even a hot ticket. Red, you can hang it up now.

Of course, he says it didn't bother him all that much. "My players know what I did. I know what I did," he says. Naturally, he is chomping on a cigar. He's sitting in his office, surrounded by all manner of the most incredible bric-a-brac—photos and cartoons, handmade presents, the letter openers he collects, citations, cigars, gadgets and gizmos, all the effluvia of a long life in the public eye. And, in a way, Auerbach looks like a larger prop. After all, he does blend in. Red? What a laugh, red. Har de har har. Red? Always your browns and grays, your tans, your basic blacks. Maroon or forest green are flaming autumn leaves upon Auerbach. If they put out a new paint color named Auerbach Red it would be a dull brown, the shade of a well-used basketball.

He hangs up the phone and says: "Where was I? Oh yeah, Bill Sharman comes up to me in practice, and he says we got to change the numbers of the plays. We only had seven, you know, and even the opponents knew them. So he says, can we change the numbers? I say, no. He says, why? I say, because you're all too dumb." Of course, this may have been the 1960–61 team, all 11 members of which became pro or college coaches and the trainer a major league baseball owner. "You can't have a debating society," Red goes on. "But Sharman keeps after me, so I say, O.K., we'll do it for you dummies the easiest way possible. Number One becomes Number Two, Number Two Three, and on like that, with Number Seven becoming Number One. So the next night, Cousy comes

down, calls out Number Three or something, and half of 'em go one way, half the other. This goes on a while, and I call timeout and bring 'em into the huddle, and I say, stick your heads in here close, and they do, and I take my hand and slap 'em one after one like this—bap, bap, bap, bap, bap—and say, all right, it's all wiped out of your minds. From now on, Number One is Number One again, and Number Two Number Two and so on. And then they were fine again. You see, you got to have a dictator." Then he pauses. "I got to stop this reminiscing. You got to make them think you're very modern." He draws on his cigar. There is a constant battle of the senses played out in Red's office between the smell of cigar smoke and the noise of vigorous conversation.

Even getting to the office is something of an adventure. Nowhere on the ground floor of North Station–Boston Garden—they're both located in the same scuzzy old building—is there a clue as to where the world champions' office may be. Only insiders know that you go past The Horse, the old "drinking parlor" on the street, turn down the musty corridor where the vagrant adolescents of Boston are ODing on video games and then weave up the steps where the winos are sitting, brown-bagging it. Turn left at the dark at the top of the stairs.

It was always thus. It wasn't only the citizens of Boston who didn't care for the Celtics, even when the Celtics had the greatest player and the greatest coach and the greatest teams of all time. The Celtics' landlords hated the Celtics. For that matter, one couldn't be sure whose side some of the Celtics' owners were on. Auerbach alone was the Celtics—substance and continuity, heart and soul.

The Garden was jealous because the Garden is also the Bruins, but the Bruins were stiffs until Bobby Orr arrived. The Celtics' success made the Bruins look even worse. Still, Boston had a great hockey tradition, and even if the Bruins finished last every year, they could count on big crowds, while the Celtics couldn't draw flies until the playoffs.

After the Celtics' original owner, the sainted Walter Brown, died in 1964, the team switched bosses as regularly as a banana republic. At the height of the glorious Russell run, the Celtics went seven straight seasons, 1963–64 through 1969–70, with different ownership every year. From Brown's death until 1979 when Harry Mangurian—"My best owner since Walter," says Auerbach—assumed full control, there were 11 different ownerships. No wonder Red can play owners every bit as well as he worked the refs. But it wasn't mere personalities he had to juggle. Paychecks sometimes were late. One year, Auerbach had to pledge his personal credit to keep the phones in. Once he had to write a personal check for $9,000 so the fabled Celtics could make a road trip by air. Even when they were in proximate solvency, the Celts had the shorts.

"We did everything right, but without money," Auerbach says. "I'm very proud of that. But it was so frustrating." The famous Celtic black basketball shoes were chosen simply because white shoes got dirtier faster and had to be replaced sooner. During much of the dynasty, the front office consisted of only two full-time employees, P.R. man Howie McHugh and a secretary. Then there was a part-time secretary, a gofer and the coach, who moonlighted as the administrative majordomo.

Nobody so successful in sports ever had to learn more angles. Is it possible there are only seven basic plays to life itself? Recently, on a local radio salute to Auerbach, Bill Fitch, the present Celtic coach, told Bruce Cornblatt of WHDH about a State Department tour

of the Far East he and Auerbach made a few years ago. In one store, Fitch spotted some beautiful jade at a good price. He pointed it out, but Auerbach just said, "Naw, let's get out of here."

Fitch was unbelieving: "Red, at that price, you've got to look at it."

"It couldn't be any good," Auerbach replied as they walked on, looking for a new store. "Too close to the door." Though no sports executive has ever been shrewder than Auerbach, none has ever been so much a prophet without honor, either as a coach or a general manager. Auerbach won eight NBA championships before he was voted Coach of the Year. The main knock against him was that any rumbum could have won with Bill Russell. And there's some truth in that; probably any competent coach would have won once or twice, maybe three times. Even Russell won two out of three seasons coaching Russell. And Russell has a view: "Red Auerbach is the best coach in the history of professional sports, period."

Dick O'Connell, who ran the Red Sox for many years, was once asked whom he would pick if he could choose any man he wanted to manage the Sox. In a flash O'Connell replied that he would choose Auerbach, and never mind if he knew beans about baseball. Gene Conley, who played for the Sox and Celtics, and Eddie Andelman, who runs Foxboro Raceway, the local trotting track, decided once that they would try to get a state law passed, requiring Auerbach to run the Sox and the Patriots as well as the Celtics. Says Dick Vertlieb, who has been general manager of the Sonics, Warriors and Pacers, "When I came into the league I figured the guy had to be overrated. By the time I left, I wanted him to be commissioner. I started to call Red 'Stradivarius' because he played us all like a fiddle."

As coach and/or general manager, Auerbach won 11 NBA titles between 1957 and 1969. That last club collapsed, but within five years, with only two holdovers, he had built a new championship squad, good enough to win in '74 and '76. By 1978–79 the Celtics had faded again, to a 29–53 record, second worst in the league; only two years after that, the Celtics, 100% overhauled from the last title team, were champions once more.

Who could challenge Auerbach's record? John McGraw, who managed the old Orioles and Giants, would be a good candidate; still, his record of three world championships pales before Auerbach's. Even with a lot more time in grade, George Halas and Connie Mack, who like Auerbach were on-the-field and off-the-field bosses, can't approach Red. Branch Rickey created the farm system and built Cardinal and Dodger champions; George Weiss with the Yankees and Sam Pollock with the Canadiens had long-running championship acts. But Auerbach can match them all with the Russell teams and then top them with what he has accomplished since.

Make no mistake, though: The reason the Celtics have kept winning, the reason Auerbach has never let up on them, has been that there have been more than natural enemies aligned against his team. There were his owners, his building, his city, and that kept him meaner and leaner. It was Auerbach and his Celtics—"the Guys" was all Russell ever called them—against the world. Auerbach is a Russian immigrant's son, propelled by conflicting amounts of Jewish angst and Brooklyn feistiness. Lighting the famous victory cigar when a win was assured was a message to a much larger world than the one that sat on the opposition's bench. And triumph only fed upon itself. "It's easy to get people to commiserate with you when you're

finishing third or fourth all the time," Fitch says (probably holding up a shiny new mirror to his own face as he talks about Auerbach), "but when Red was first every year, there was no one there to care about him."

When those who know Auerbach at all well talk of him, they first cite his loyalty. It is fierce. The tales are legion. The hardest thing he ever had to do was to fire Tommy Heinsohn, one of his son figures, as coach. Who, after Auerbach (938–479, .662), has the best coaching record—using the NBA's standard of 420 or more victories—in history? Heinsohn (427–263, .619). Just this year Red yanked the Celtics' radio rights from a clear-channel station in favor of a lesser outlet, partly because of what he felt was mistreatment by that station of members of the Celtic family. Old Celtics are never forgotten. Red gets them jobs, saves their jobs, loans them money. Beneath that gruff exterior....

One recent day John Havlicek's wife was in Florida, his kids were in school, so Havlicek just came by to shoot the breeze and show Auerbach a new remote control telephone that he'd bought. Red said a) he must have gotten beaten on the price, and b) who but an atomic scientist could learn to operate it? Havlicek protested in vain and left shaking his head. As soon as he was gone, Red beamed: "They come by all the time." In his playing days, Russell was never more than "cordial" with Auerbach, but once, when Wilt Chamberlain went after Red, Russell jumped in front of Wilt and snarled: "You've got to get through me to get him."

And yet, loyalty is often a curious quality when it is the prime one. Then it can have an edge to it. Jeff Cohen, 39, the general manager of the Kansas City Kings, is a lifelong friend of Auerbach's and worked for him in the Celtics' front office for 16 years. "Red's first reaction to almost anything is to

be self-protective, even suspicious," Cohen says. "If I came to him with any new idea, his immediate response was not, how can this help us, but, what are they getting out of us?" Red makes the rules. Whenever he shot baskets with his players, he determined the spot—the handicap. Protests to no avail. It's no different in negotiations. Says Bob Woolf, Larry Bird's agent, "Negotiating with Red is so hard because he starts off with a figure, which he thinks is fair, and then he's hurt if you dare think otherwise. And worse, for me, I always believe that he's completely sincere." And as might be expected of a man of such strong loyalty, Auerbach has a long memory.

A scene from the mid-'60s: The Celtics have just won another title from the Lakers—Red's fourth or fifth or seventh in a row, one of them—and the sunshine fans, momentarily adoring their Celtics, are swarming onto the court. A young network television producer (the league would have killed for network exposure in those days) finds Auerbach. Red doesn't recognize him. The young man touches Auerbach's arm and tells him: "We need you up in the booth right away, Red."

Auerbach brushes the fellow's hand off his jacket, as he might flick away cigar ash. Then he looks the producer in the face. "Where were you guys in February?" he says. The TV man stutters. Auerbach tells him he'll be with his February people, the Guys and his writers.

A few years later, Auerbach was invited to address the Greater Boston Chamber of Commerce at a fancy luncheon. "Let me start by saying this is not quite an honor my being here," he began his speech. "I haven't had too much regard for the Chamber of Commerce over my years in Boston. When the Celtics won 11 championships in 13 years, it was promptly ignored in their own town."

And then, what the hell, just to twist the knife: "The Bruins…a household word around Greater Boston, but mention Bruins 50 miles from this city and people immediately think of UCLA."

And yet, as blunt as Auerbach can be, he's ever careful, he's always on guard. What so often appeared as mad, spontaneous behavior was, in fact, calculated. And maybe it's his fault that he spawned a whole generation of ref-baiting coaches, but don't blame Red for their not getting it right. "They saw all the ranting and raving, but they didn't understand how I picked my spots," he says.

One night several weeks ago Fitch apologized to Auerbach for doing a rotten job of coaching. Fitch had blown a home game to the Bulls. Auerbach liked that; it showed Fitch's self-security and candor and intelligence. "I wasn't going to say anything," Red said after he left Fitch, "but he's right: He was terrible tonight. But I'm realistic enough to know that coaches will have bad days just like anybody else. Now, if I had been Fitch tonight, I would have got thrown out. Maybe it would've got the team mad. But I would've just turned it over to somebody—anybody— and said, hey, it's yours. You've got to do better than me."

For all his renowned brusqueness, Auerbach has always been a closet diplomat; he never puts all his eggs in one basket. At a certain point in every game he coached, he

Briefly suspended in 1961, Auerbach could only wait in the dressing room.

would start thinking about the next game. "It's like they say at the track," he says. "Anybody can beat a race, but beat the races? There's a big difference between winning a game and winning games." Even now, Auerbach tiptoes around the subject of John Y. Brown, who was briefly the owner of the Celtics, and who treated Auerbach with less respect and more mean-spiritedness than anyone ever has.

When Brown bought the club in 1978 (with Mangurian as his quiet partner), he ran roughshod over Auerbach, dealing on his own, even trading precious first-round draft choices to obtain a player that the new Mrs. Brown was partial to. One day when Brown was in Boston, he appropriated Auerbach's desk, in Red's presence, and then he looked up and said condescendingly, "Red, why don't you leave so I can go to work?" On another occasion, after a Celtic loss, a crowd of old friends gathered in Auerbach's office, as is the case following every home game. Brown, who had come along too, was whining "like a little boy who couldn't have his ice cream," according to a former Celtic who was there. And then, when he saw Auerbach, Brown sneered and said, "Well, here comes the living legend now. Say something smart for us, living legend."

The room fell silent; no one could even look at Auerbach. But Red bit his lip. It was one game; there would be other games. Says the old player who was there, "I know

it's hard to feel sorry for Red Auerbach, but you couldn't help but want to cry for that man."

Still, when Brown ran for governor in 1979 and the press in Kentucky besieged Auerbach with inquiries, Red's policy was to reply politely that he had no interest in politics.

By that time, though, Auerbach had revived an old standing offer to take over the Knicks, and used it to back Brown into a corner. "If I had left Boston because of him, they'd have run John Y out of town on a rail, and he knew it," Auerbach says. At last, in the spring of 1979, Red delivered an ultimatum to Mangurian: Buy Brown out by Monday or Auerbach was gone to Gotham. Brown sold. Having done his turn with the Boston Celtics, who were 29–53 during his ownership, Brown returned to the Bluegrass to take care of Kentucky; now, it's said, he has his eye on the United States of America.

When Brown left, the Celtics were in disarray. Auerbach had made a succession of abominable first-round draft choices— Steve Downing, Glenn McDonald, Tom Boswell, Norm Cook; Heinsohn, worn out, in aimless retreat, had at last been fired; what was left, a ragtag troop of unlikely Celtics, sulked and smelled of mutiny. Bob Ryan, the much-respected pro basketball writer for the *Globe*, wrote, "For 20 years the Celtics stood for something. The only thing they stand for now is the anthem."

There would be some backing and filling for another season—as Boston awaited the arrival of Larry Bird, the Hoosier messiah, whom Auerbach had picked as a junior-eligible draftee in '78. Meanwhile, Red did some revamping and, for the first time, went outside the Celtic family for a coach. "It was time for new ideas," he admits. Two college guys—Bobby Knight and Hugh Durham— turned him down, so he went to Fitch, who

had been coaching the Cleveland Cavaliers. Then, in the fall of 1979, came Bird and victory. The people of Boston at last saw the light and began lining up for tickets down in the dark and dirty shadows outside The Horse drinking parlor. The Celtics could sell out with season tickets now. But Auerbach won't permit that. He cuts the season sale off so there are about 2,500 tickets available for each game. He remembers that when the Bruins owned the winter in Boston, they practically sold out every summer. At least the kids can get to see the Celts.

"All those kids we gave clinics for finally grew up," Auerbach says. "It's just like anything. People made such a big deal out of us using a first-round choice for Bird and having to wait a year until we got anything to show for it. But I've found time goes by quickly. I admit, I never was super at running the office. I figured, if I just ran the ball club right, it would all take care of itself."

In a way, it took Boston as long to learn about basketball as it did Auerbach to learn about promotion. But then: "Promotion. I remember in St. Louis, Benny Kerner [the owner of the Hawks] used to have those big bands all the time at the Hawks games. Duke Ellington, the big names. And he got good crowds. But then they got to expect the big bands, and when Benny didn't have one, they wouldn't come out just to see the basketball. Promotion? If I had played dull ball, basketball would've died here. What about that? Isn't that promotion? It was close enough." If the merchandise is good, don't put it by the door.

In his 65th year, Arnold Jacob Auerbach's personal habits are as peculiar as ever. At the age of one, his mother gave him an egg. Didn't like it, thank you. Hasn't had an egg since. A few years later, mother gave him a sip of coffee. Didn't like it. Coffee hasn't touched his lips since. Subsists mostly on

Chinese food, heavy on the black bean sauce. Breakfast, more often than not, consists of leftovers he took home in a Pekingese bag the night before. And crack another Coke. For variety, a little deli.

And Auerbach has maintained a complete separation between family and work. "When I go home, I go home," he says. Home isn't Boston; never has been. Home is Washington; has been since he left Brooklyn—where he was a second-team All-Borough guard—to attend George Washington University. He and Dorothy have been married for nearly 41 years and have a lovely condominium on Massachusetts Avenue (a coincidence). One of his two grown daughters, who's divorced, lives almost next door with his only grandchild, another girl. The Guys have always been in Boston.

Up there, for years, Auerbach kept a drab suite at The Lenox Hotel. Now he lives, hardly more opulently, at the Pru Center, in an apartment large enough for a bed and a bath and a refrigerator for the chicken wings and Cokes. "What else do I need?" he asks. "It's like a lot of these general managers. When I travel, I get a simple hotel room. I don't need a suite. I wouldn't have the nerve. Besides, what the hell did I ever have to do to impress anybody?"

It's a special point of pride with Auerbach that he has wasted little money over the years. "Having money is easy. Knowing how to spend it is the trick," he says. "And therein lies the difference between a good businessman and an ego." He estimates the Celtics have spent about one-tenth as much on scouting as virtually all of their competitors. "So, sure, you might miss one guy occasionally out in Texas, but it's not how many players you see, it's making the right decisions on the ones you do see."

Of course, Auerbach has made some concessions to the here and now. Fitch is permitted to have two assistants, just like losing teams do. When Red was coaching, he, like most of his NBA colleagues, worked as a single; he still prides himself that he could remember the number of fouls that all players on both teams had.

"The key to coaching is not what you tell 'em, it's what they absorb. Too many coaches today overcoach. They have to make it more complicated to justify all the assistants. And none of 'em know change of pace. They think they have to yell all the time. But you got to vary it.

"And then, almost every team convinces itself that each new player is the millennium —and pays him like that, too. But the chemistry is more important than a man. You get enough intangibles, they become a tangible and put points on the board. When I scout, I scout the player; I don't care what patterns and plays his team has. Everybody in the league knew the Celtic plays, and what good did that do them?

"It's amazing how much people don't see. Near the end of his career Russell asked me one time what percentage of rebounds did I think were taken beneath the rim. You know the answer? Ninety percent. I watched. Russell was right. Why do you think relatively short guys like [Paul] Silas and [Wes] Unseld who couldn't jump much got so many rebounds? Timing, position, reaction, anticipation. Also, they should measure guys with their arms over their head. A 6'10" guy with short arms isn't 6'10"."

A couple of weeks ago, Auerbach was sitting in his office, blending into his chair, when the phone rang. It was one of his old players calling, needing two for Friday, for the Sixers. Red gave him a little obligatory grief and told him the pair would be waiting. Then he reached into his sport jacket for another cigar. He's a sport jacket guy, heavy

on the Windsor knot. He bought a bunch of suits when he gave up coaching, to look more like an executive, but it didn't take. He tried a pipe, once, too, but that didn't fly either. And now, Celtic fans, Red Auerbach is lighting up his victory pipe! No: Put it over there with the eggs and coffee.

But Auerbach has never lost a step. The ones who lose a step with age are the ones who had been a step ahead. Those steps you can lose. But Red was always more a step to the side and up a little riser. Those steps you can keep. Auerbach's first full-time job was as a physical-education teacher at Washington's Roosevelt High, where he cut Bowie Kuhn from the basketball team. He found that kids kept bringing in doctor's notes,

Basketball Association of America in 1946; Philadelphia publicist Harvey Pollack is the only other survivor. By his measure, this means Auerbach has lasted through almost six generations of pro ball, because he believes a basketball generation spans six years and to survive as a coach or a player you must appreciate that.

"By the time that many seasons pass, you've got to change some of your philosophy," he says. "Now, I'm not saying that if they go in for disco dancing you have to go in for disco dancing. But you must adjust. Check a lot of good coaches around six years or so. They have a tendency to go down the tube for a while. Then the smart ones change.

> ## Auerbach has never lost a step. The ones who lose a step with age are the ones who had been a step ahead. Those steps you can lose. But Red was always more a step to the side and up a little riser. Those steps you can keep.

testifying that they didn't have to take PE, but could take the period off and hang out. Auerbach knew he was being snookered, so he made a rule that even if a kid had a note from the director of the National Institutes of Health, he at least had to suit up and take a shower at the end of the period. Pretty soon, every kid was working out the whole period, because if you had to take a stupid shower, you might as well work up a sweat. "It's all just like basketball," he says. "They'll challenge you and you got to find ways to get back at them."

Auerbach was a pro coach at 29, barely older than many of his players. Except for a few months in 1949 when he was an assistant at Duke, he has been with the league since its inception, as the

"The players I had for six years, I could detect changes in them, too, at that point. A lot of people think that the veterans influence the rookies. But not necessarily. The smart pros will pick up something from the new kids. You don't think [Isiah] Thomas and [Kelly] Tripucka aren't showing the Pistons something new? Think about that: If it wasn't the case, we'd still be playing like 40 years ago.

"But that doesn't mean people can be done over. The one thing I've learned is that the problem guys will revert. They'll appear to change if they have to, but as soon as they're secure, they'll revert. The next day, they'll revert. People are people. That's why I'm so careful when I sign a player to a new contract. I'll say: You really happy with this?

Think about it. Because don't come back to me to renegotiate. We live with this.

"You used to have to earn your wings every day. But not anymore—I mean basketball or anywhere. But it used to be: No matter how good you'd been, you had to earn your wings every day."

Whatever accommodations Auerbach has made aren't readily apparent. It's surely instructive, though, that he always had great success with older players. He got a few more years out of them, and he never coddled the geezers; he didn't taper them off into retirement. "The issue is how old they are, not the number of minutes they play," he says. It would appear that this maxim is still being applied to the key senior personnel on the Celtic office staff.

"Red is always going to be very jealous of his stature," Jeff Cohen says. "He needs to be in control. Don't think that just because he's older, he'll release his grip on things. He doesn't like being older, either. That's tough for him to accept, especially since no one else will grant the fact that Red Auerbach can possibly be old. Red could never gracefully become an éminence grise."

Auerbach allows that for him the fun is disappearing, but the love is still there. The other day, after a practice that he came by to see, to enjoy, Auerbach stood for a long time watching Tiny Archibald go one-on-one with a rookie. Auerbach seemed to draw something from that; all the time he talked about how much Archibald loved the game; one could quite feel the love going around the place. Still....

"So much of it's changed," Auerbach said. "The writers are all new, and the owners—a good percentage of them. The game was what was fun, but they won't let you enjoy it anymore. They all bring lawyers to the league meetings and then we have to have debates. We used to come by ourselves and talk basketball. But the last time, I even had to make an impassioned plea: Can't we ever come to a meeting and talk about the game? And the way these new faces look at me—like I'm out to get 'em."

Well?

"Hey, I don't make that many deals!" He whined that, for effect.

"He's still the best G.M. in sports," says Woolf—and, understand, this is an agent talking. "He's three years in front of everybody else in the game. If Red had accomplished in New York only half of what he has in Boston, they'd have renamed Fifth Avenue after him." If Auerbach does indeed call it quits after next season, if he doesn't renegotiate with himself, he will have to come back to one game in the fall of '83 so they can retire his number. Eighteen of the 188 men who have worn the Celtic green played with the team for at least a generation—six seasons or more. Thirteen of those have had their numbers retired. They are listed on two big banners that hang above the court. Also retired is No. 1, which was assigned, symbolically, to Walter Brown, the team's first owner. Auerbach would be No. 2.

The Boston Garden is packed to the rafters for the ceremony. Auerbach is called out, and here he comes, dressed in seven shades of tan, and the white banner with the big green No. 2 on it starts to rise, and throughout the place, everybody takes out a cigar. Everybody: the fans, of all ages, and the ushers, the press, the referees, the TV cameramen. The present Celtics, and their opponents, too, and all the Guys who have come back, 6 and 14, 15, 16, 17, the two 18s, 19, 21, 22, 23, 24 and 25. Everybody in the old joint holds up a cigar for the man who has been the most successful at running a professional sports team. There are still a few people left who earn their wings every day. ●

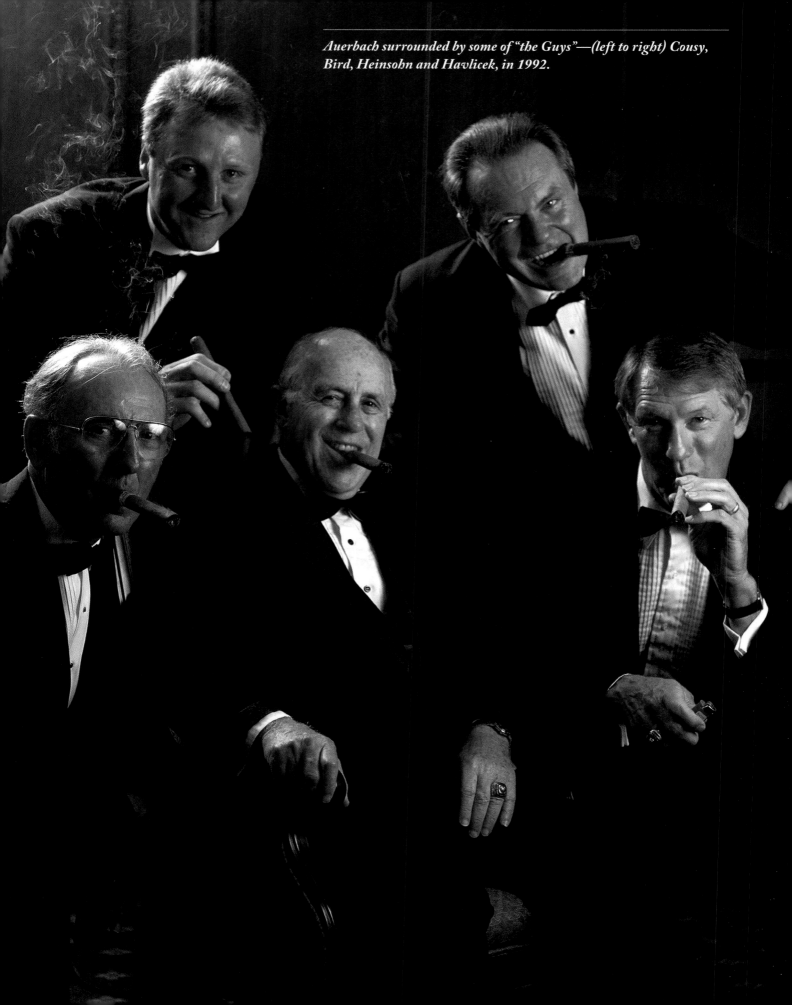

Auerbach surrounded by some of "the Guys"—(left to right) Cousy, Bird, Heinsohn and Havlicek, in 1992.

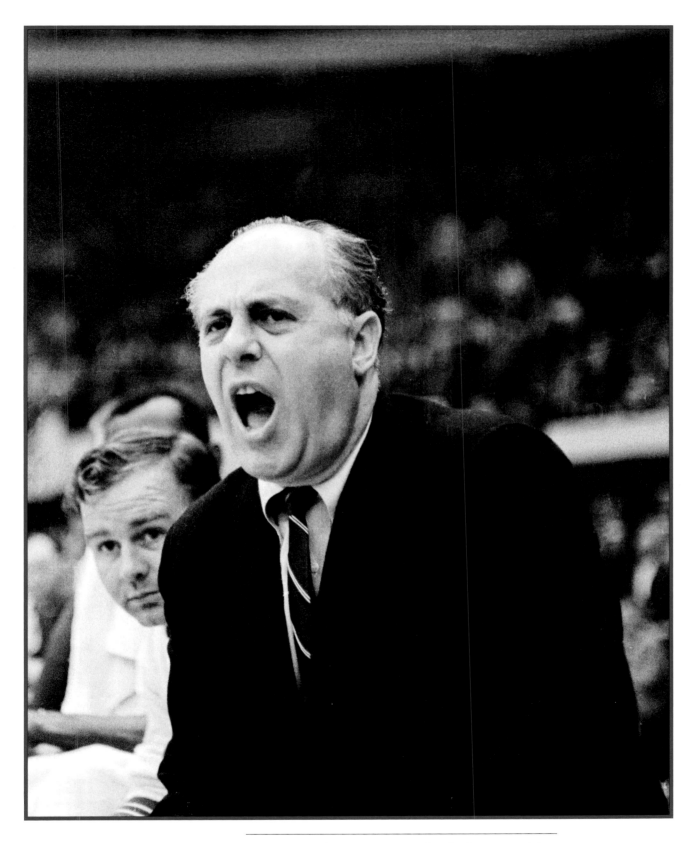

*As a coach and team executive, Auerbach won 16 titles
in 29 years in Boston.*

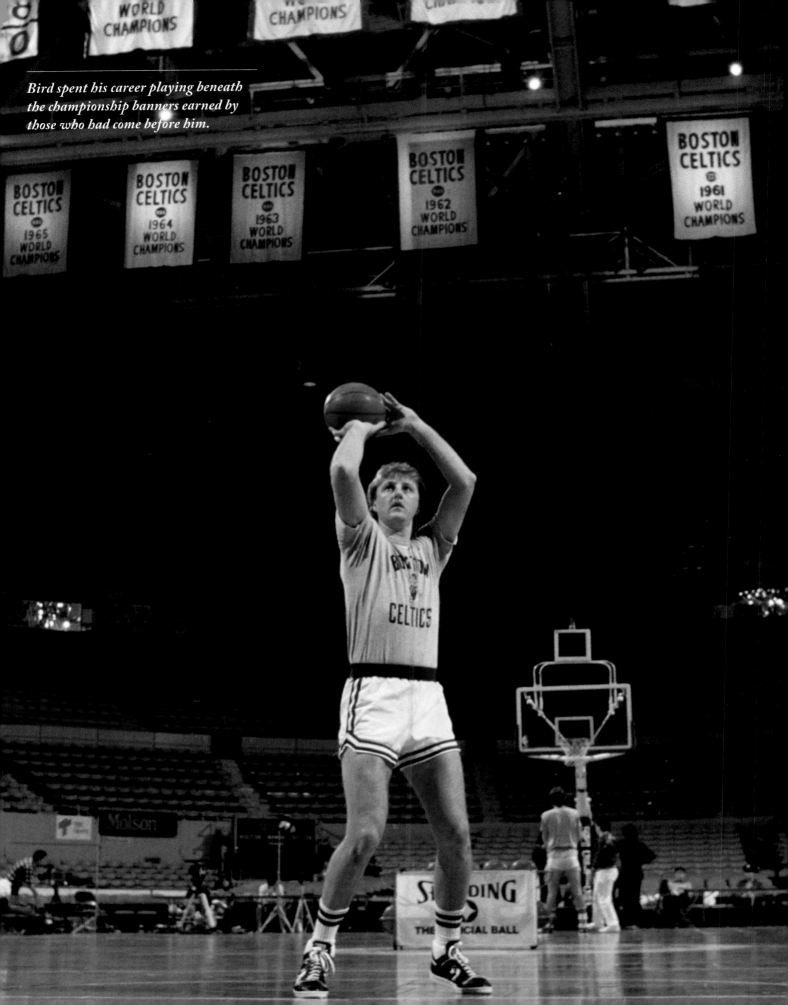

Bird spent his career playing beneath the championship banners earned by those who had come before him.

A PLAYER FOR THE AGES

Larry Bird, in what may be his finest season, gets Red Auerbach's vote—over Bill Russell—as the best ever BY FRANK DEFORD

THE LITTLE COUNTRY BOY IN INDIANA HAD A RECURRING DREAM. IN IT, HE HAS FOUND A MILLION DOLLARS CASH, and he has dug a hole for it under the front porch, and he is hiding there with it. His older brothers walk up and down the steps just above him, but he stays so quiet, they don't have an inkling that their kid brother is down there with a million dollars cash. "I had that same dream all the time—over and over and over and over," says the man who was the little boy.

A lot of grown men have another dream. In it, they're Larry Bird. It's just as reasonable to imagine you're Larry Bird as to imagine you've found a million dollars.

Sure, Larry Bird is 6'9", but he doesn't look particularly tall, no taller than the other tall men out there on the court. And he doesn't appear to be fantastic. He isn't sleek. He isn't fast. It seems that he can barely get his feet off the floor. He essays push shots, from another era. He's white, from another era.

Little boys today would much prefer to grow up to be Michael Jordan or Dominique Wilkins, for however clever and hardworking, they're also truly spectacular players. They can fly. But when kids imitate Larry Bird, mostly what they do, so humdrum, is reach down and rub their hands on the bottoms of their sneakers. Even with a last name that cries out for a sassy nickname, Larry Bird remains, simply, Larry. He seems merely the sum of little bits—a bit more clever than you and me, a bit more dedicated, a bit better on his shooting touch, a bit better with… but certainly nothing out of the ordinary. Larry Bird is like when you first learn fractions and you have to change everything to 12ths—12ths!—to make it possible to add up the thirds and fourths and sixths and stuff. All the other great players are so obviously whole numbers.

And so, as improbable a basketball star as Bird is, he's tantalizingly possible. Bird is simply one of those grown-up daydreams: I wish I could be pretty; I wish I could be back in high school and know what I know now; I wish I could be king of the world; I wish I could find a million dollars; I wish I could be Larry Bird.

He looks up, chuckling at how the little boy got his dream right after all. "Well, I guess I

found the million," Larry Bird says. "Even found a little more to go with it."

Bob Woolf, Bird's attorney, brings out a hotel bill dated April 6, 1979. It was for Bird and his girlfriend, Dinah Mattingly, at the Parker House, when Bird first visited Boston. Bird inspected the city, met Red Auerbach and went to a Celtics' game, wearing a hideous tan sport shirt. He watched as the home team lost its seventh in a row before 7,831 fans. That season the Celtics finished last in their division and sold out the Garden exactly once. Auerbach had sagely drafted Bird the year before, as a junior eligible, but Boston would lose the exclusive rights to him if he didn't sign soon, before the next draft. Woolf suggested a million a year, and Auerbach, apoplectic at that, countered with half a million, maybe, if you counted the perks. He said, "It's been proven. A cornerman can't dominate the game. A big man, occasionally even a guard. But one man playing a corner can't turn a franchise around."

Larry said, "I'm just from a small town, and it don't make no difference where I play at."

Boston stood solidly with Auerbach. The *Globe* editorialized that pro basketball had "achieved the ultimate and the ultimate appears to have limited appeal." For that matter, America appeared to stand solidly with the *Globe*. Bird himself said, "I can see why the fans don't like to watch pro basketball. I don't either. It's not exciting."

So Bird went back to Terre Haute, where he was finishing up at Indiana State, and played softball and hung around with Dinah. One day on the diamond he broke the index finger on his shooting hand. He ambled over to a teammate, a fellow named Danny Miracle, and shoved the twisted digit toward him. "Pull it out, Dan," Bird said. "Pull it out."

Miracle, looking at a minimum $500,000-a-year hand, recoiled in horror. "I can't do

that, Larry," he said. Irked, Bird moved on to find someone who would straighten the damn thing out so he could play some more ball.

Back in Boston, Woolf stood by his demands, and his children were hounded and threatened in school. Finally Auerbach and Woolf settled on a $650,000-a-year deal, which made Bird the highest paid rookie ever. Now the pressure was squarely on Bird. He shrugged and said, "If I fail, I fail. I've failed classes before. I know the feeling."

But the Celtics were saved. Within a year, not a seat was available in Boston Garden, and one hasn't been for going on nine seasons. The Celtics went from 29–53 in 1978–79 to 61–21 in '79–80, best in the league, and they've never had a losing month since the cornerman, who couldn't possibly turn a franchise around, joined them.

Several weeks ago, at a $1,500-a-couple dinner honoring Bird, with the proceeds going to the New England Sports Museum, a $250,000 statue of Bird by Armand LaMontagne was unveiled. Auerbach stood up that night and said, "If I had to start a team, the one guy in all history I would take would be Larry Bird. This is the greatest ballplayer who ever played the game." To say this took an extraordinary amount of "soul-searching" on Auerbach's part. It meant that Bill Russell was No. 2.

Today the Celtics are in first place, as usual, and Bird, at the age of 31, is enjoying what may well be his finest season in spite of a broken nose and a fractured bone under his left eye, which has forced him to wear protective goggles. He has even slimmed down some, and not long ago, driving along in his Ford Bronco with Dinah, he put out his hand to her. Larry has been in love with Dinah for 12 years, and she in love with him. In his hand was a big diamond ring. He said, "You can wear this if you want to." She opted to.

Now, the most illuminating thing in this whole saga is that hotel bill from 1979. You

see, except for the basic room charge and the tax, there was nothing else on it. No room service, no restaurant charge, no long-distance phone calls, no nothing. Having dealt with many other athletes, Woolf naturally assumed that the kid would charge at will. But that wasn't how Larry Joe Bird was raised back in French Lick, Indiana.

"Larry has a way of making everybody he comes into contact with a better person," Woolf says. "If you think the Larry Bird on the court has character and is unselfish—well, off the court he's even more so." Among those who know Bird well, the same catalog of qualities is cited again and again: honest, loyal, steadfast, dependable— his existence shaped by the contradictory, almost mystical ability to be the cynosure, yet always to contribute to those around him. Mel Daniels, who was an assistant coach at Indiana State when Bird played there, said it best: "It's like a piece of Larry goes to each player by the things he does." Tony Clark, a Terre Haute radio executive who grew up with Bird, says, "Larry epitomizes the word friend. Do you understand that?"

Yes.

"Then you really don't have to know anything else about him."

Evidently what we see of him in public, working at his vocation, is an extension of the person. It hasn't always been easy to understand this, though, because Bird is an exceptionally private man. Of course, every

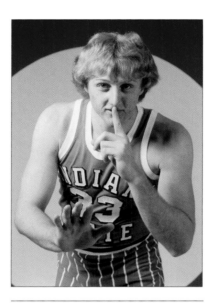

Bird's abilities were no secret at Indiana State.

celebrity loves to swear that he's really very shy. It's an appealing lie. But Bird is shy. Bill Hodges, the coach who helped recruit him for Indiana State, says, "Larry was the most shy and introverted guy I'd ever been around in my life." Bird was so self-conscious in high school that he wouldn't go to watch his older brother Mark—who also wore No. 33 and was a star for Springs Valley High—play basketball until his final varsity game. It ran in the family. "My father was proud of us, but he wouldn't go see us play," Larry says. "Dad didn't like crowds either."

The son's inherited inhibitions were magnified by the fact that he was thrust into the glare as if he were some archeological treasure. Before his junior year at Indiana State, Bird was an unknown quantity on a second-level team. Moreover, even then, a decade ago, there already existed the racial complexities that make basketball cognoscenti chary of any white player.

Basketball had long been the realm of small-town boys—backwater Hoosiers being, in fact, the beau ideal—but by the 1970s the sport had been so completely transformed into a Black urban exercise that Bird might as well have dropped in from Paraguay or Sri Lanka. Ironically, too, for most of the Republic's existence we had reveled in the folk wisdom that country bumpkins were the true brains, certain to get the best of city slickers. Almost overnight, though, the reverse became true; a new myth held that "street

smarts" were the best kind. Bird's utter genius on the court had to be accounted for in some way, however, and so he was explained away as some sort of idiot savant of the hardwood.

Moreover, when he became an overnight sensation in 1979, his shyness was at its most severe because the events of the previous few years had left him hurt and defensive. Bird had left high school for Indiana University as the consummate small-town hero, but he shuffled back to French Lick less than a month later, even before the Hoosiers' preseason practice had begun. Overwhelmed by the huge Bloomington campus, broke, lonely and intimidated by the wardrobe and wherewithal of a more worldly roommate—"a damn mistake I made," says Bobby Knight, who would have been Bird's coach—Bird

Their daughter, Corrie, was born in August 1977, before his junior year. Bird says he isn't allowed to spend much time with his little girl. He and his ex-wife aren't friendly, and however much he loves his child, he still flagellates himself for the youthful union that produced Corrie.

"When I was a kid I thought people who got divorced were the devil," he says, shaking his head. "And then I go out and do it myself right away. Getting married was the worst mistake I ever made. Everything that ever happened to me, I've learned from it, but I'm still scarred by that. That scarred me for life. That and being broke are the two things that influenced me most. Still.

"That dream I told you about—finding the million dollars. I have one other dream,

> *In a way Terre Haute serves as insulation, a halfway house between the French Lick cloister and the city where Bird spends most of the winter working.*

flat out quit. Worse, back in French Lick, he sensed that many of his devoted fans felt that he had let them down, embarrassed the town. To this day Bird remembers who the fair-weather friends were.

Then within the year Larry's father committed suicide. Joe Bird was a laborer who was well liked in the Springs Valley and admired for the work he could do with his hands, but he could never seem to escape creditors and alcohol.

At Indiana State, where Bird matriculated a year after leaving Indiana, his life began to come back together, but then in 1975, at 19, Bird, who had never spent much time with girls, rushed into a disastrous marriage. Within a year they were divorced, but, as a final blow, Bird discovered after the marriage had ended that his former wife was pregnant.

too. The bad dream. I still have it sometimes. My wife is trying to get me to come back to her, but Dinah is there, too, and I keep saying to Dinah, 'I don't want to go with her, I don't want to go.'"

The Birds are known for their tempers, but Larry is so pale—the limpid eyes, the white-on-white mustache—that his face lends itself more to the gentler emotions. He turns almost tender now: "And Dinah was with me through all that stuff. She was there. I don't know how many times that poor girl stood under the basket and passed the ball back to me. Over and over, standing there, throwing it back to me so I could shoot. And then all the time takin' care of my injuries." And a quick broad smile: "Course, we've gotten a lot of beer drinkin' in together, too."

Dinah jokes with friends—well, maybe it's a joke—that Larry finally gave her the engagement ring only after his beloved Doberman, Klinger, died. And Bird still evades the direct question about matrimony: "I've told Dinah, 'Now why get married and ruin a good relationship?' But she really doesn't like it one bit when I say that." She can take some heart when Larry slips a little and says he thinks when he and Dinah get married that they might adopt children rather than have their own.

Anyway, they'll live back in French Lick, where they spend the off-season now, in the house Larry had built with the regulation basketball court and the satellite dish. Lu Meis, a department store executive who befriended Bird in Terre Haute and is now his partner in Larry Bird Ford-Lincoln-Mercury in Martinsville (which boasts a parquet showroom floor), says that once he went with Bird up to Indianapolis to inspect a house Bird was thinking of buying in the big city, but all Bird really seemed interested in was the sprinkler system, which made such a nice lawn. No, Larry Bird will stay in French Lick.

In a way Terre Haute serves as insulation, a halfway house between the French Lick cloister and the city where Bird spends most of the winter working. One almost expects visas for Boston to be distributed in Terre Haute. A radio station brings in Celtics games. The newspapers sometimes feature the Celtics over the Indiana Pacers. Larry Bird memorabilia is a cottage industry. At Larry Bird's Boston Connection hotel, the locals flock to watch Celtics games via satellite on the big screen in the Bird's Nest Sports Lounge—rarely tossing so much as a glance at the Indiana Hoosiers game on the tiny TV screen by the bar. The hallowed MVP Club dining room showcases a photograph of Larry taken by Kenny Rogers. In the coffee shop, also known as the Boston Garden Family Restaurant, miniature Celtics championship banners hang from the ceiling, and the place mats lovingly depict Larry's hands, life-size, complete with his crooked fingers.

Available at this shrine are more than 100 Larry Bird mementos, including Larry Bird golf balls, Larry Bird shower curtains, Larry Bird playing cards (he's the joker), Larry Bird chocolates and Larry Bird clothes for Ken (Barbie's significant other).

Max Gibson, a Terre Haute businessman, is Bird's partner in the hotel venture, and, says Bird, Gibson is the closest thing to a father figure he has had in his life since his own father died. Larry, the fourth in a family of six children, has always gotten along well with older men. But he's zealous in making sure that anyone—of any age—who would cozy up to him is not just poaching on his fame or fortune.

Except for Dinah, an FBI agent's daughter, who was born in New York, and whom he met at Indiana State, all of Bird's best pals go back to French Lick. They were the boys with whom he fished for bluegill or looked for mushrooms under the elm trees or played basketball. "Cars or girls—they didn't interest Larry at all," says Gary Holland, his coach at Springs Valley his senior year. Sundays, for example, Bird would meet up with Tony Clark and maybe another guy or two and they would drive off to some bigger town where there was a Kentucky Fried Chicken franchise, pick up a big bucket, and then come back to the Valley and play ball all day. Nights, Tony says, they would just "cruise around to see who's around."

Essentially, when he's back in French Lick in the off-season, Bird lives much the same life, only Dinah makes a prettier sidekick. They rise when the spirit moves them—Bird is a legendary sleeper—and while she jogs,

he works out at the high school, using the equipment he donated. Then after lunch he'll get in some golf or tennis. Or maybe they'll play tennis together. After dinner Larry and Dinah hang out and have a few beers around the Valley. "We're usually in bed by nine o'clock," he says.

Could he live this sort of existence year-round after he's through playing? Bird shakes his head at this question, and his tiny little mouth drops open in amazement. "Why not?" he says. In the Celtics' media guide, Bird's biography reads "favorite food is steak and potatoes…favorite TV show is *Bonanza*…."

Why not indeed?

————————————

French Lick (pop. 2,265) remains isolated from urbanity, even suburbanity; it's situated approximately in the middle of a rustic triangle formed by Evansville, Ind., and Louisville, Ky., to the south and Bloomington to the north. No interstate reaches French Lick. The houses going up the hill are of white clapboard, and the Lions Club meets the first and third Tuesdays every month at the Villager.

Ah, but there's quite another past to French Lick. It's not just a typical small town in Indiana. Not at all. There are mineral springs in the Valley, and French Lick and its sister town, West Baden (where Bird actually resides now), have long had reputations as Fancy-Dan resorts. Once there was music and dancing, champagne and gambling. Everyone from Al Capone to Franklin Delano Roosevelt holidayed there.

The mineral springs featured Pluto water, a natural—and very powerful—laxative. Indeed for some 75 years one of the largest enterprises in French Lick was the bottling and distribution of the local water, using the slogan: "When nature won't, Pluto will." The locals amended that and yukked: "If nature won't, Pluto will; if Pluto can't, goodbye Bill."

By the time Larry was born on Pearl Harbor Day of 1956, though, most of the Valley's glory was gone. By the early 1970s even the Pluto Corporation had changed from bottling water to household cleaning products. Even though the Springs Hotel in French Lick is still there, many of the younger people, unlike Larry, have cleared out, and Orange County is one of the poorest in the state.

Young Larry knew damn well that he was poor. No, it was not oppressive. But, yes, it was there. The Birds had enough coal to stay warm, but too many nights the old furnace would break down, and the house would fill with black smoke, and they would all have to stand outside, freezing, while Joe Bird tried to fix things. By then it was morning and time to pay the bills.

The creditors never let up on Joe. "I always hear he was the kind of guy would give you the shirt off his back," Larry says. "A lot of people tell me them things now because of who I am, but I know the ones who're tellin' the truth."

His mother, Georgia, was employed mostly as a waitress. "I remember, she worked a hundred hours a week and made a hundred dollars, and then went to the store and had to buy $120 worth of food," Larry says. "If there was a payment to the bank due, and we needed shoes, she'd get the shoes, and then deal with them guys at the bank. I don't mean she wouldn't pay the bank, but the children always came first." Often things were so tough, one way and another, that Larry had to move in with his grandmother, Lizzie Kerns. He adores her. But Grandma Kerns didn't even have a telephone then.

While having been poor—"it motivates me to this day," Bird says—led to his million-dollar dream, it didn't occur to him that basketball would be the thing that would lead him to that cache. "I never once worried

about college when I was in high school, and I never worried about the pros in college," he says. "When it was the Celtics drafted me, I could've cared less."

In fact, once he made up his mind that he just wasn't happy at Indiana and that he was going to quit, once he went back to French Lick and got a maintenance job with the town, he was quite happy. This was the period, ever celebrated (or smirked at), when he worked on a garbage truck. Actually that was Bird's assignment only one day a week, but he enjoyed it immensely, "having a blast," tossing garbage sacks around with his old buddy Bezer Carnes.

"I loved that job," Bird says. "It was outdoors, you were around your friends. Picking up brush, cleaning up. I felt like I was really accomplishing something. How many times are you riding around your town and you say to yourself, Why don't they fix that? Why don't they clean the streets up? And here I had the chance to do that. I had the chance to make my community look better." Bird is a damn sight more impressed with the work he did for French Lick that year than he is with the boulevard named after him that cuts through town.

"I've always enjoyed French Lick, and I could care less what they say about it," he says. "I think maybe if you grow up in a small town you learn better to weed out the good and the bad. There's always going to be a lot of petty jealousy in a small town. If you understand that—and I always have—you can learn better to make your own judgments."

The hard part, Bird seems bent on proving, isn't that you can't go home again. The hard part is showing the ones who never left that the best part of you never left either. Bird will pick up the $17 Thursday night beer tab, until, Clark says, "the minute he senses that you expect him to pick it up." Bird may pull down $2 million or $3 million a year, but

when his little brother Eddie—the best player on the Indiana State team—got a D in one course, Bird took back the Jeep he had given him. "It's damned inconvenient for Eddie." Gibson says, "but Larry won't budge till he gets rid of that D." If money isn't going to change Larry Bird, Larry Bird doesn't see why his money should change anybody else, either.

So Larry goes down to the bait shop, and he goes fishing with Max Pluris, who is fixing up Bird's house, and he paints his grandmother's house, and everybody out of town makes a huge to-do about how everybody in French Lick treats him just like he's normal.

Well, big deal.

He is normal.

––––––––––––––––––

Around his freshman year in high school, when other fires were being lit in most boys his age, Bird's love for basketball began to blossom. He had shot up to just over six feet and a scrawny 135 pounds, and, to his amazement, his father promised him 20 bucks if he made the freshman team.

From a father who didn't shoot around with his boys, this made a real impact. Would your dad be proud of you now? "He was proud," Bird snaps back emphatically. "Even then he was proud of what all his boys had done."

Joe Bird's drinking made it difficult for him to be an idol to his son, but the people who know Larry suspect that many of his strong principles trace back to the man who struggled with his demons. "I remember one time," Larry says. "I was 13, or 14 maybe, and my father came home with an ankle all black and blue and red—out to here." He holds up his hands, almost a foot apart. "He needed me and my brother just to get his boot off, and he was in awful pain, but the next morning we got the boot back on, and he

went to work." Pause. "That really made an impression on me."

From his mother, Larry seems to have drawn a sense of responsibility and determination—what could, in its darkest moments, be called stubbornness. "Oh, I can be moody, like Mom," he says. "One thing can make me mad for two days. Only she'll stay mad over one thing for two months."

This is balanced by a playful, almost childish sense of humor that, even when it verges on meanness, leaves everybody laughing and saying, "Well, that's just Larry." Once he inspected a used car Clark was thinking of buying and told him that the muffler bearings were hopelessly shot. Clark went back to the salesman and accused him of trying to cheat him. "You think I can't tell when the muffler bearings are gone?" Clark screamed. There are no such things as muffler bearings.

Once at a drive-in theater Dinah left the car, heading for the refreshment stand, and Larry drove it to another space. Dinah comes back, loaded up with Cokes and popcorn, and the car isn't there. So Larry toots the horn, and she heads in that direction, and then some other wiseacre toots his horn and she turns that way, and everybody starts tooting, and there's Dinah, standing in the middle, literally holding the bag.

Oh well, that's just Larry.

In basketball this sort of mischievousness takes on the bold edge of bravado. The story of Bird walking into the locker room before the three-point shoot-out at the 1986 All-Star Game and snorting that all the other bozos were playing for second place (which they were) is now a legend. He has said that he wouldn't know half the players in the league if they didn't wear their names on their shirts. Bird has also been known to saunter up behind some poor kid standing at the free-throw line late in a close game

and whisper, "I know you're going to blow these two."

He kids his teammates, too. He regularly rags the other Celtics by telling them that he's writing a book entitled *Game Winners*, and it's almost up to a thousand pages long, but he wishes at least one of them could make it on at least one lousy page.

"Nothing he says is malicious," says Quinn Buckner, who was Bird's teammate for three seasons. "He's certainly not jealous—of your skills or your finances or anything. And everybody who knows Larry understands how well he understands people—so it doesn't take much to appreciate how well intentioned he is."

Bird has always been remarkably honest. He lays it all out plain, and no amount of cajoling will get him to reconsider his priorities. Bird was once offered $25,000 to make a brief appearance at a bar mitzvah being held only a block from his suburban Boston house and rejected it out of hand. One day a couple summers ago Dinah called him inside because Woolf was on the phone with some important business.

"I have three things, Larry," Woolf began. "Derek Bok, the president of Harvard, would like you to address the freshman class this fall."

"No."

"SPORTS ILLUSTRATED wants you to pose for a cover."

"No."

"*Life* magazine wants to do a photo essay on you, but you won't have to pose. The photographer will…."

"No." Pause. "Mr. Woolf, I thought you told me this was an important call."

Invariably too much is made of the fact that the boss or the senator works longer hours than the laborer. Of course, the top dogs do. They also make more money, get more credit and have more fun. Still, the hours that Bird devotes to his job are

astonishing. "I've taken a lot of jump shots in my day," he says. But perhaps even more enlightening is the fact that despite the grind of the NBA, which is accentuated in Bird's case because he gets so much attention, and despite the fact that he's so good that he admits he often gets bored because it's all so easy, despite all that, there have been only two occasions in the more than 800 games he has played in the NBA in which he felt he didn't give an honest day's work for the dollar, when he went home and asked Dinah, "Did it look like I was hustling out there tonight?"

However he performs, Bird is back in spirit, renewed for the next game. At the Boston Garden when the national anthem is played, Bird gazes to the heavens. Everyone assumes that he's looking at the Celtics banners, but ironically, he began to fix his eyes on only one banner—the retired No. 4. But not retired by the Celtics. The No. 4 belonged to the Bruins' Bobby Orr. Bird has stared at the black and gold banner so many times, he can see it in his mind's eye. He knows every stitch,

how many lines pierce the circle around the capital B. "Eight. Don't bet me," he says.

Bird had met Orr only once and had never seen him play, but he had heard how great he was as a player and had learned how much Boston admired Orr as a person. Bird had been too bashful ever to tell Orr this, though, and revealed it only last month in his speech at the Sports Museum dinner, where Orr was on hand for the unveiling of Bird's statue. When Orr heard Bird speak of him, the breath went out of him in a whoosh, and there were tears in his eyes.

"My god," Orr whispered in the dark. "My god."

Bird won't ever reduce his commitment to his sport. "You've got to understand," he says. "My whole life's been basketball. It was never a recreation for me. It was something I fell in love with." The coming irreconcilable conflict in his life is how he can give up this passion while he still has a breath in his pale body. Yet how could he keep playing the game at a less than perfect level? For now, he says he's

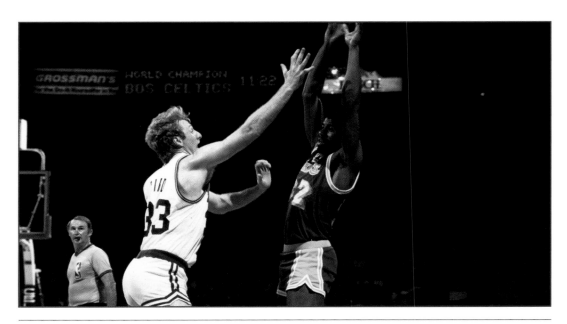

Bird squared off against the Lakers in three NBA Finals during the 1980s.

"95 percent sure" that he will hang up his jock after the 1990 season, when he would be 33½ years old.

For however long he plays, though, Bird will always draw more attention—even suspicion and scrutiny—because he is the Caucasian aberration. This fact bubbled over last May after the Celtics edged the Pistons in the seventh game of the Eastern Conference finals. Emotions were so raw that Chuck Daly, the Detroit coach, shut the door and urged the players to "watch what you say," but shortly after the press flooded in, a distraught young forward, Dennis Rodman, blurted out that Bird was "very overrated," a regular winner of the MVP only because of his race.

Smelling blood, reporters repeated these remarks to Isiah Thomas, who seemed to concur, saying, "If Bird was Black, he'd be just another good guy."

In the brouhaha that followed, only Bird was unflustered. When Thomas called him up shortly thereafter to explain that he had been quoted badly, that his inflection and expression had meant to convey facetious humor, Bird wouldn't even listen to Thomas, because to do so would suggest that he took Thomas's remarks seriously in the first place. Instead he handed the phone to his mother and told Thomas to explain it to her because she liked Isiah, and she was the one who was upset.

Arguments can, of course, go on forever about Bird's superiority. It's common for his teammates to say that playing with Bird reveals him to be even more remarkable than he appears to the naked eye, and there's a tendency among mature observers in the NBA to forgive Rodman for his callow unenlightenment. Bird himself doesn't put any more credence in the other extreme, in the greatest-ever pronouncements of people like Auerbach. "That's nice stuff to hear, but I don't believe it," he says, shrugging and then adding that he'll be quite content if history is only kind enough to speak of him in the same breath as Magic Johnson and John Havlicek. However, it is difficult to believe that any athlete in any sport has demonstrated Bird's instinctive supernatural feel for his game.

But then, as a mere mortal, Bird also possesses touch, strength, stamina, hand-eye coordination, exceptional vision—he is forever spotting friends sitting way back in the bleachers—and overall court ken. This last gift is usually most vividly explained by saying that Bird is able to conduct a game in slow motion that everyone else is playing at breakneck speed.

Yet for all these extraordinary basketball-playing attributes, it is fashionable for observers to say that Bird overcomes not being an athlete. The most amazing thing has happened in America in the past few years. The definition of the word athlete has been narrowed from the dictionary's age-old "one who is trained in exercises, sports, or games requiring physical strength, agility or stamina" to exclusively mean someone who is quick (and, where it applies, can also jump high).

As a consequence, since strength, stamina, hand-eye coordination, etc., are no longer accepted as athletic attributes, when somebody like Bird succeeds in what's accepted to be an athletic endeavor, then it can only be because he's smarter and works harder than all the Black players. In Bird's case, he probably has worked as hard as anybody ever has in sport, and he does possess an incredible sixth sense, but that has no more to do with his race than it does with his Social Security number.

Indeed, the irony of criticizing Bird for taking advantage of his special racial status is that it's difficult to imagine anyone who is so evenhanded, who lives more by the creed of fairness. His best buddies are the same ones he grew up with. He still drives

a Ford Bronco and dresses for it. His best friends on the Celtics fit no type. Buckner might have grown closest to him, and Bird calls former Celtic Cedric Maxwell "my greatest teammate by far."

When the Celtics won the title in 1984, Bird approached Auerbach and said, "I'd like to buy a [championship] ring for Walter." Walter Randall was an old equipment man and sometime trainer who died in '85. "No other player ever thought of that," Auerbach says. Rick Shaw, the team manager at Indiana State, went up to Bird on the sad flight back from the Sycamores' Final Four defeat at the hands of Michigan State in 1979 and handed him a team pennant to sign. Bird didn't just autograph it. He wrote, "Thank you for all the things you've done for me. Love, Larry." When Bird left for the All-Star Game a few years ago, Woolf said he hoped that he could carry Bird's MVP trophy back to Boston again. Bird said, "No, Mr. Woolf, this year I'd like to see Robert [Parish] get it," and in the game he worked toward that end.

From himself on the court he seeks only consistency and considers that the true mark of excellence. "But Larry's so sensitive to what his teammates need that he changes the emphasis of his game to accommodate them," says Jim Rodgers, the Celtics' senior assistant. "It's a unique form of personal consistency, concentrating on the needs of others, isn't it?"

A Celtics teammate, Bill Walton, says: "So much of it—playing, in the locker room, away from basketball—has to do with how much he cares. Larry cares about every element of everything he's involved in. With some people, the sphere of their life is so very small. The sphere of Larry's life is just huge."

And yet these embers of generosity were kindled by the most incendiary competitive fires. Even now in the Valley there's not much amazement that Larry Bird turned out to be the greatest basketball player ever—what the hell, somebody had to, so it might as well be a French Lick boy—but there is some surprise that he could rise above the family temper to reach those heights. In order to win, Bird taught himself not to get angry, rather to gain satisfaction from somebody else's hot blood. "I've learned it's a lot more fun making a shot with a guy hanging on you," he says.

Championships mean ever more to Bird—"His mission," Auerbach calls them. "That's why I play," Bird says. "I'm just greedy on them things. Winning the championship—I've never felt that way any other time no matter how big some other game was. I remember the first time we won, against Houston [in 1981]. We were way ahead at the end, and so I came out with three minutes left, and my heart was pounding so on the bench, I thought it would jump out of my chest. You know what you feel? You just want everything to stop and to stay like that forever."

And that, in his way, is what Larry Bird does for us. He not only slows the world down, but he turns it back. "I've studied it," Woolf says, "and I think, above all, there's just an innocence with him. I think Larry takes anyone who knows him—or sees him playing—back to grammar school. Remember back then? Back then we didn't brag. We dove after the ball. We looked after our friends. I think with Larry we believe he'll save the team. We believe he'll save us somehow. So you follow him."

Look for the open man yourself. Fill the lane. Use the glass. Use the glass! Box out. Make him go to his left. Or just reach down and touch the bottoms of your sneakers. The game is a mile a minute. The world is a mile a minute. Even the memories are a mile a minute these days. But somehow, with Larry Bird, you can see it all before you. So slow. So dreamy. You just want everything to stop and stay like that forever. ●

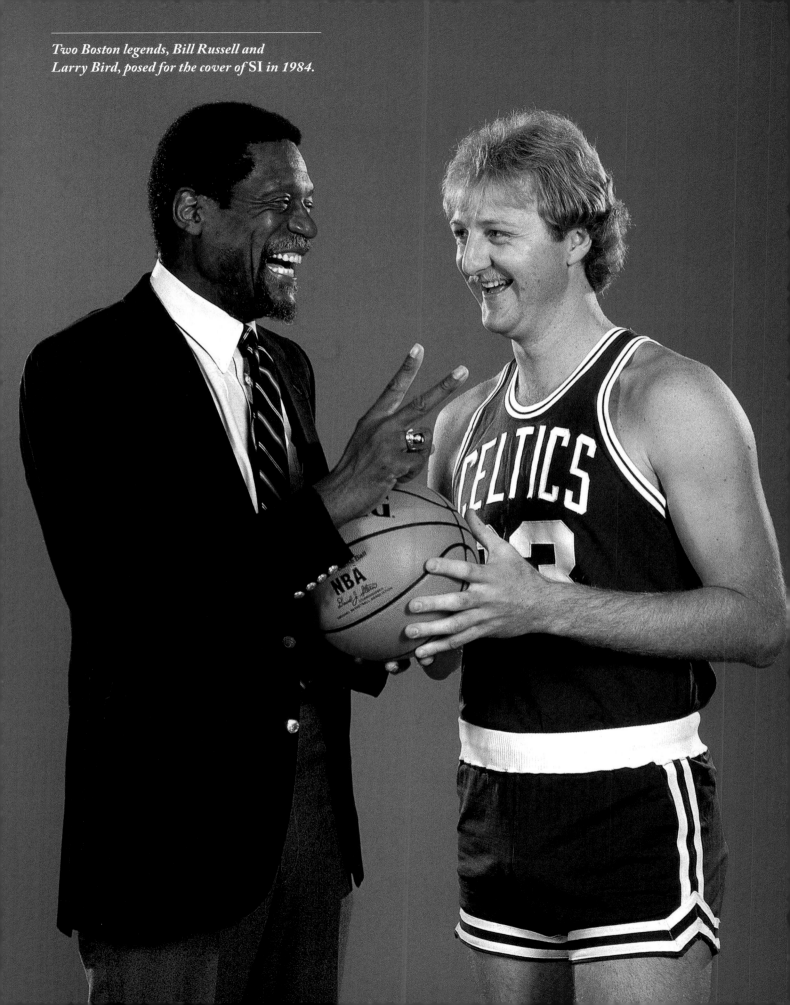

Two Boston legends, Bill Russell and Larry Bird, posed for the cover of SI in 1984.

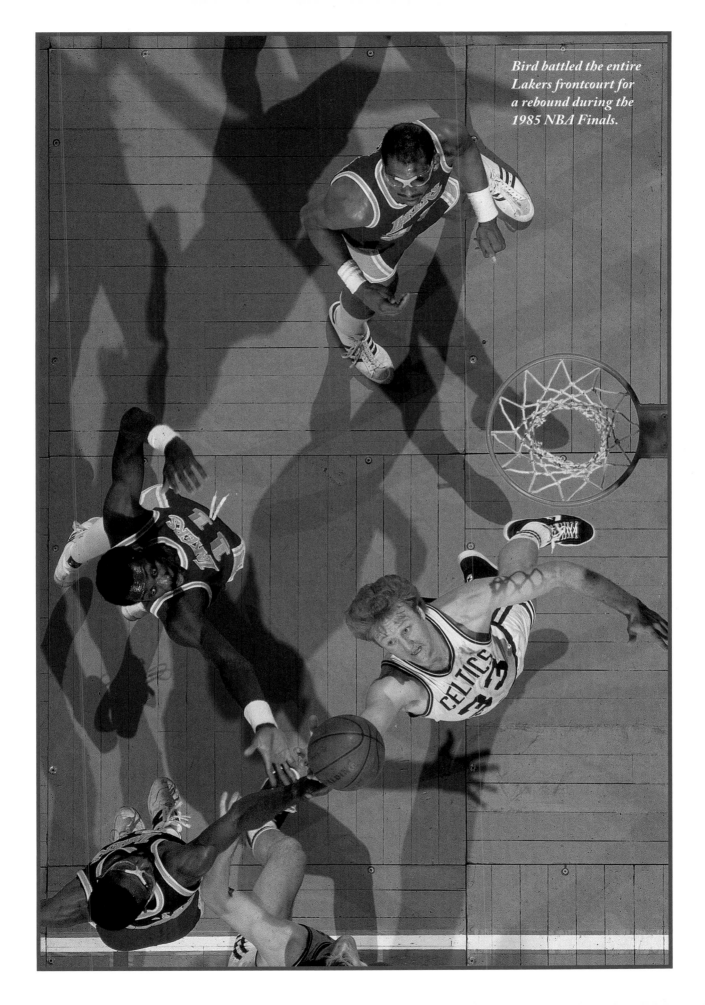

Bird battled the entire Lakers frontcourt for a rebound during the 1985 NBA Finals.

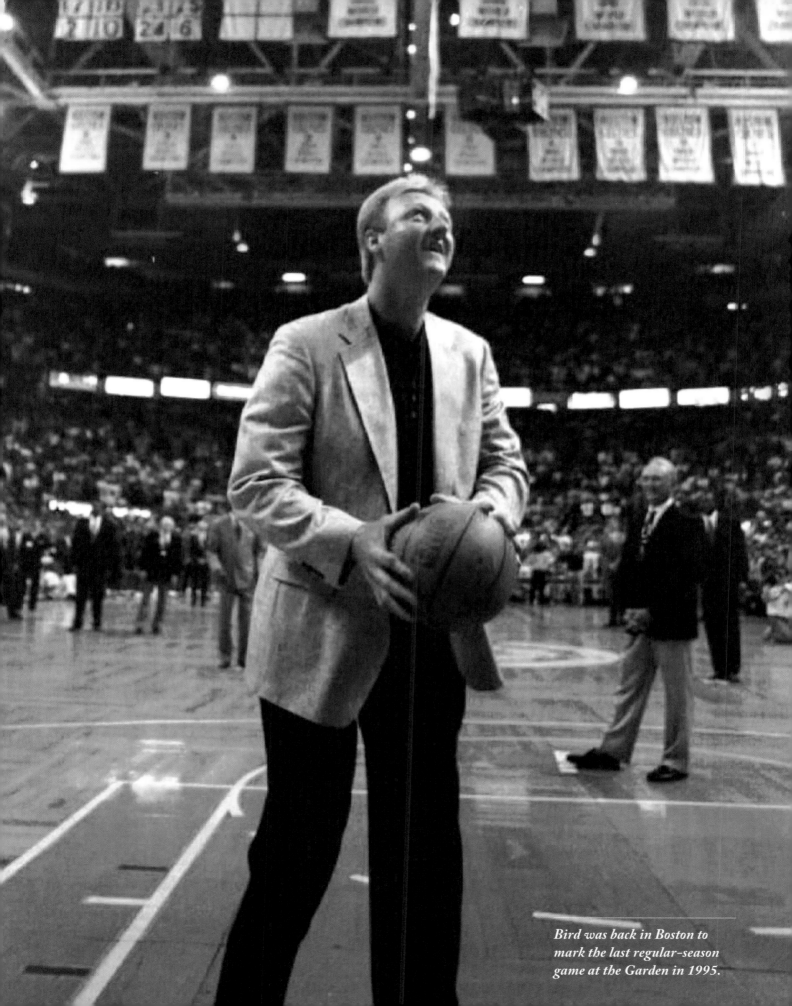

Bird was back in Boston to mark the last regular-season game at the Garden in 1995.

GREEN GHOSTS

Saying goodbye to beloved Boston Garden, old Celtics relive a half century of otherworldly memories BY LEIGH MONTVILLE

THE NIGHT PERHAPS BECOMES DARKER. THE RAIN BECOMES A LITTLE HARDER. THE STREETLIGHTS FOREVER are a washed-out yellow, playing against the thick pillars of the elevated trains of the MBTA's Orange Line above Causeway Street, the metal-on-metal screech of the trains becoming louder and louder. The characters become caricatures.

Memory is the editor. Memory is in control.

"Here was the first look I ever had at the Boston Garden," John Havlicek (Boston Celtics 1962–78) says.

"I came to Boston straight from the [college] East-West All-Star Game in Kansas City. I was the Celtics' first- round draft choice, and I was traveling with Jack [the Shot] Foley, who was the second choice, from Holy Cross. We got into Boston around 11 o'clock on one of those dank, dark, dreary New England nights. We went through the tunnel from the airport into the city, and we arrived outside the Garden, with all the trains and the rain and everything. We checked into the hotel next door, the Manger...."

There is no hesitation in the words. Thirty-three years have passed in the 49-year history of the Celtics at the Garden since this particular March 31 night, in 1962. Thirty-three years and counting. There has been time to polish the story,

to buff away the blemishes, to get everything *right*. There is almost a script.

"I was hungry, so I went back out to get something to eat," Havlicek continues. "The only place open was the Hayes Bickford cafeteria across the street. I went in, and a couple of guys were sitting by themselves, drinking coffee. Another guy was at a table, his head down, sleeping. Everyone was in there to get out from the rain. The counterman had an apron covered with stains from the day. I ordered a couple of eggs that came back filled with all the cholesterol in the world. I sat by myself and said, What have I gotten myself into?"

The particulars are important. The dirt on the apron. The cholesterol in the eggs. Jack (the Shot) was already in bed. The story has been told so

many times now to friends and Rotary Clubs and to sponsors and sportscasters and anyone else that it has become as perfect as a parable, measured out for pauses and appropriate reactions at appropriate places.

"The next day I went to the game," Havlicek says. "They took me to the Celtics' locker room. I was devastated. It was this little room, tucked underneath a stairway. There were no lockers, just nails hammered into these furring strips around the room. The steps cascaded down, so one end of the room had a normal 15-foot ceiling, but the other end was as low as six feet. The shorter guys dressed at that end. The nails for the clothes, it seemed, were based on seniority. If you were a rookie, you were a one-nail guy. I had just finished my four years at Ohio State, which had the best facilities, and to come to this….We went from the locker room to watch the game.

"It was the playoffs. The Celtics were playing [the] Philadelphia [Warriors]. This was the game where Wilt Chamberlain came after Sam Jones, and Sam picked up a wooden stool and said, 'Wilt, I'm not going to fight you fair.' Jim Loscutoff chased Guy Rodgers right into the stands, right into the promenade. I sat there and said, again, What have I gotten myself into?"

Thirty-three years and counting. There are last chances to check out some of the specifics—to walk across from the site of the Hayes Bickford, now a bank, and to enter the 66-year-old arena on top of the train station, to find that little locker room the Celtics once used, to stand at the absolute spot where Jones held that chair above his head—but the story pretty much travels by itself now. Soon there will be nothing to check.

The Celtics will play their final regular-season game at the Garden on Friday night, April 21, against the New York Knicks, ending a tenancy that has included 16 world championships and some of the most

significant moments in NBA history. There is the possibility of one or two more playoff games as this season's team struggles to earn a postseason spot and an overmatched meeting with the Orlando Magic. A final exhibition game will probably be played in the old building next fall before the opening of the $160 million Fleet Center, which already stands next door. But certainly by October or November the wrecking crews will have begun work, and that will be that. The home of the NBA's most successful franchise, home from the moment the league was formed, will be gone.

Memory will be everything. Memory will be all.

———————

Trademark black sneakers ran across a trademark parquet floor. That was what happened at the Boston Garden. The men inside the sneakers were pretty much invincible. Every fall for the longest time there was a ceremony, a ritual, as a banner was raised to the dusty beams at the ceiling of the old building signifying another championship that had been won during the preceding spring. Sixteen banners was the final total, nine of them from the '60s, domination for an entire decade. The black sneakers and the floor and the building were magic. Or was it the men who were the magic?

"There was one game where we wore white sneakers," Bob Brannum (Celtics 1951–55) says. "Walter Brown, the owner [Celtics 1946–64], tried it as an experiment. The same game, he turned the court sideways. He figured that more seats were in the end zones, so this way there would be more seats on the sides of the court. I don't remember the year. He let us wear the white sneakers because we all hated the black ones. No one else was wearing them. We played the game, lost, the court was turned back the original way, and we went back to the black sneakers. We never changed again."

Memory.

The seats hung over the court, two balconies creating a vertical intimacy that architects of modern arenas somehow cannot seem to find. The sellout attendance figure for the longest time was 13,909, a number any Boston schoolchild knew as well as any date of any historical happening. A progression of stars came along, from Bill Russell (Celtics 1956–69) to Dave Cowens (Celtics 1970–80) to Larry Bird (Celtics 1979–92), each starting a new era of success when hope seemed lost. The constants were the building and the presence of Arnold (Red) Auerbach (Celtics 1950–??), who was coach and general manager and, since 1970, has been president of the team. As coach and G.M. he was wily and profane, shrewd and outrageous, a picture to see as he argued a point with the veins popping out of his neck or as he lit a cigar when victory was at hand.

"Red was paranoid," Bob Cousy (Celtics 1950–63 and now one of the team's broadcasters) says. "He always thought everyone was out to get us. Especially the referees. He would start screaming at the referees at the first call, sometimes even if it went for us. He always wanted that edge. He always talked about those s.o.b.'s in New York. That was his thing, that the league wanted New York to win and us to lose. I look at it now, it sounds so silly, but the thing was that when Red was screaming about New York and the referees, we all believed him. Which I suppose is all that mattered."

"I saw him have a fight in the lobby with Sid Borgia, the referee," says Tom Heinsohn (Celtics 1956–65 as a player, 1969–78 as the coach and now Cousy's partner on game telecasts). "They started talking back and forth, and Sid said, 'Yeah, yeah, you can talk. You don't have to worry. Your wife has a lot of money.' Red said, 'My wife doesn't have any money,' and punched him. They started fighting, right there in the lobby."

Memory.

The building was as familiar and comfortable for the home team as could be. The Boston Bruins, the hockey team, were the landlords and, in most years, the more beloved local team, but the Celtics were the team that had magic on its side. No visiting hockey teams complained about the excess heat in their dressing room on hot days and the lack of heat on cold days. Plots abounded in basketball. The floor was supposed to have dead spots where an opposing dribbler would discover that the ball would die as surely as if he had bounced it in a mud puddle. The timekeepers were supposed to have slow fingers when the Celtics needed a few more seconds. The referees were supposed to be intimidated by the fans. A leprechaun supposedly came down from the ceiling at opportune times to knock away important shots.

"Again, all this was important only because other teams believed it," Cousy says. "Think about it, the dead spots. You're telling me that in a game as fast as basketball I could have the presence of mind to push someone over to the fifth board from the right because that's supposed to be a dead spot? Maybe in a slower game like baseball you could use that kind of local knowledge, but basketball? Come on. And the heat in the locker room? We had the same bad heat that they did."

"The heat came from outside the building in a 12-inch pipe," Havlicek says. "I checked this out. The farther along the pipe you were, the less heat you got as it was dispersed. I suppose, because we were about 25 feet closer to the source, we had 25 feet worth of better heat [than the visitors], but that was it. What I think helped us as much as anything was the clock. Not the clock now, the one before it. It had a black minute hand and a red second hand, and it was a hockey clock. Our periods would end at 12-minute marks on the clock,

but the big designations were at 15, 30 and 45. I don't think anybody in the league knew how to read that clock except Red and us. I'd see guys staring at it. Or startled when the buzzer went off at 12 minutes."

"My father did control the water for the referees' locker room," admits Frankie Randall, son of longtime equipment manager Walter Randall. "He loved the Celtics. He started out sitting on the bench, but in 1959 Sid Borgia threatened him with a technical foul, and he left the bench and never again returned. He would sit in the locker room, watching the game on TV. When the referees made some bad calls, well, the knobs for the water in their dressing room were in the Celtics' room. A lot of referees had a lot of cold showers in Boston Garden."

Memory.

The games and the championships were mostly a 49-year blur. Basketball is like that. The action seems to be written on phosphorous paper. Once exposed to the air, there is an exciting flash of fire, and then it is gone. Russell beats Wilt again! Cousy makes big pass! Bird drops three-pointer from heavens to win game! Celtics win! The Cousy one-hander and the Russell block seemed to evolve in an unbroken line into the Cowens dive on the floor and the Robert Parish (Celtics 1980–94) turnaround jumper and the Kevin McHale (Celtics 1980–93) rebound layup. The little oddities seemed to remain longer than the most spectacular moments. The bumps in the line.

"After one of the championships, I'm not sure which one, the crowd ran onto the floor, and a couple of individuals tried to take off my uniform," Tom (Satch) Sanders (Celtics 1960–73 as a player, 1978 as the coach) says. "I was intent on getting off the floor, and the individuals seemed intent on getting a souvenir right there. They were pulling at my shorts, which were kind of loose. My shorts

were coming down to my knees, and I was fighting my way off the floor."

"In 1984, the final game against the Lakers"—the first of three '80s Finals pitting Bird's Celtics against the Magic Johnson/ Kareem Abdul-Jabbar L.A. squads—"we had the game won, and my big idea was that I was going to get the ball at the end of the game," Gerald Henderson (Celtics 1979–84) says. "What I didn't know was that Danny Ainge [Celtics 1981-89] had the same idea. Kareem, I think, took the final shot at the buzzer. The ball went off the rim and straight up in the air. Danny got there first. He just about had the rebound. And I pushed him. The ball came back between his legs and right to me. I still don't think he knows who pushed him. He went down, and the crowd just rolled over him. I still have that ball."

Memory.

The game most often attached to the Garden occurred on April 15, 1965, when Havlicek stole an inbounds pass from the Philadelphia 76ers' Hal Greer to Chet Walker and preserved a 110–109 win in the seventh game of the Eastern finals. While exciting, this game is far from the most significant and not necessarily the most dramatic in the long list of games. The reason it endures is the radio description by announcer Johnny Most, who died in 1993. An unrepentant Celtic booster, with a distinctive croak to his voice that was tuned by four packs of English Ovals cigarettes and countless cups of coffee per day, Most screamed the words, "Havlicek stole the ball!" with an urgency that suggested Martians had landed in the living room.

"Johnny must have had some good coffee that day because he was really excited," Havlicek says. "We had the game won by a point with five seconds left, but Bill Russell's inbounds pass hit the guide wire that went then from the balcony to the basket. Under the rules Philadelphia got the ball back.

Russell said, 'Somebody has to help me out,' in the huddle during the timeout. They tried to in-bound the ball. I was playing defense, counting to myself, 'One-thousand-one, one-thousand-two,' and when I got to 'one-thousand-three,' I knew I could sneak a peek. I saw Greer pass the ball, and I got my hands on it, and that was the game. I didn't know until a few days later about Johnny's call.

"Since then, it's never left. Just a few days ago I was at the Final Four and [CBS sportscaster] Pat O'Brien was doing his Johnny impression: 'Havlicek stole the ball! Havlicek stole the ball!' Everyone seems to have a Johnny impression. He was the one who made that play different."

Eastern Coat of Watertown.' Johnny said, 'Not today he won't. I need new pants.' We started howling again. The whole thing is on some underground blooper tapes now."

Memory.

The building was filled with characters. Howie McHugh, the Celtics' publicity man with the restrained look of a parish priest, sat on a folding chair at the edge of the parquet floor, center court, and quietly pronounced a string of the most vile curses imaginable on all referees. John Kiley, the organist, the one man who could make "Eleanor Rigby" sound no different than "The Stars and Stripes Forever," hated basketball. He played with his back to the action and never cared what

The games and the championships were mostly a 49-year blur. Basketball is like that.

The action seems to be written on phosphorous paper.

Once exposed to the air, there is an exciting flash of fire, and then it is gone.

"My favorite Johnny Most story is when his pants caught on fire," current radio announcer Glenn Ordway says. "I was doing color, and I'm sitting next to him, and I smelled something burning. I said, 'Johnny, do you smell smoke?' He said, 'My pants are on fire.' He was always smoking, and he'd had a stroke, paralyzing him on one side, so it was hard for him to do some things, and his cigarette had dropped onto his polyester pants, and they'd caught on fire. He always wore that polyester. The fire was right at his crotch, and he poured coffee on it and I helped beat the flame out. It was funny, really. We came back on the air, and neither of us could stop laughing for maybe 45 seconds. We couldn't talk. The first promo I had to read turned out to be, 'Our guest today at halftime will receive a gift certificate from

happened. He quit one day when his parking pass was revoked. The members of the bull gang—responsible for putting the court over the ice surface—were characters. The ball boys. The original owner, Brown, the founder of the team, was followed after his death by a string of venture capitalists and eccentrics, all the way to the present owner, who was given the team by his father and is known in the local newspapers as Paul (Thanks, Dad) Gaston. Characters. Buddy LeRoux, the trainer for eight early championship teams, parlayed his playoff shares into a string of investments that included hospitals, apartment houses, hotels and substantial pieces of the Boston Red Sox and Suffolk Downs racetrack.

"There were so many people around the building, if I saw them 20 years from now, I'd

recognize them," McHale says. "I'd say, 'Fella, I don't know your name, but for an important stretch of my life I know I saw you every day.'"

"Marvin Kratter was a guy who owned the team for a year in the '60s," Havlicek says. "He had gone to the Wailing Wall in Jerusalem and come back with a stone that he found there. He said it was the lucky stone. Before games he would stand under the basket and hold out the stone so each of us could touch it for luck as we went past after layups. The first time I touched it, we lost, so I refused to touch it again. He would hold out the stone, and everyone would touch it, but when I came by, he would drop his hand because he knew I wouldn't touch it. He always sat next to our bench. After he owned the team a month or two, I would hear him saying, 'Run the 2 play.'"

Memory.

The greatest game in NBA history was played in the building. The only problem is picking the game. The general choice is the Celtics' 128–126 triple-overtime victory over the Phoenix Suns in the fifth game of the Finals, on June 4, 1976. The highlight was a 22-foot heave by the Suns' Garfield Heard to tie the score at 112–112 at the end of the second overtime. Havlicek had scored on a running bank shot to give Boston a one-point lead with one second remaining. Phoenix's Paul Westphal (Celtics 1972–75) called timeout, even though the Suns did not have any timeouts left. This gave the Celtics a technical foul shot, which Jo Jo White (Celtics 1969–79) converted but which also allowed the Suns the chance to throw the ball inbounds from center court, which set up Heard's shot. Boston rolled away in the third overtime.

"The league changed the rule after that game," Havlicek says. (Indeed, today the ball would go to the Celtics.) "We had all run into the locker room after my shot, thinking

the game was over. If the play happened now, Phoenix would have won because that would have been a three-point shot by Heard. Then again, we had hit some long shots too during the game that would have been three-pointers."

The win gave Boston a three-games-to-two lead. "After we won, the series was finished," Havlicek says. "We went out to Phoenix for the sixth game, but right away you could see those guys were done. That game took everything out of them."

"I was the coach and everyone says that was the greatest game, but I don't think so," Heinsohn says. "To me, the greatest game ever was when we won our first title, in 1957, against [the] St. Louis [Hawks]. That was the seventh game, the Finals, and we won by two points [125–123] in two overtimes. I saw the two greatest plays I've ever seen in basketball in that game. The first was when Bill Russell ran the length of the floor faster—faster!—than it took for St. Louis to pass the ball the length of the floor and for a guy to take one dribble and a layup. Russell was there to block the shot. The second play was at the end of the game. [Hawk] Alex Hannum threw the ball inbounds off the backboard from half-court. It was a designed play with one second left. He threw the ball off the backboard, straight to Bob Pettit. Pettit, I think, was so amazed the play worked he missed the shot. If that game had been played today, with television and all the replays, it would be called the best game ever. Now, nobody even knows about it."

Memory.

There were other grand nights, of course, dozens of them in 49 years. Besides Havlicek's, there were other grand steals: Henderson's against James Worthy and the Lakers in '84, Bird's against Isiah Thomas and the Detroit Pistons in '87. In the '80s there was Bird's succession of *mano a mano*

duels in playoff matchups with the Sixers' Julius Erving and the Knicks' Bernard King and the Atlanta Hawks' Dominique Wilkins (now a Celtic). There was Russell versus Wilt. Forever. There was Frank Selvy's shot that missed for the Lakers in the 1962 Finals. There was Michael Jordan's coming-out party when he scored 63 in 1986 in double-overtime.

Tree Rollins of Atlanta bit Ainge's finger in 1983. ("Thirty seconds after it happened the story became that I had bitten *his* finger," Ainge says. "And that's the way it's stayed.") Bird returned from the locker room after taking a face-first tumble and led a first-round, series-clinching win over the Indiana Pacers in '91. Sam Jones made last-second jumpers, against the Warriors in '62 and against the Lakers in '69. Russell had 35 rebounds in one title game, 34 in another and was a player for nine titles, a player-coach for two. There was the hot (100-plus degrees in the building) night in the '84 Finals, Game 5, when the Lakers were informed that the air conditioners they had brought for their dressing room were not compatible with the Garden's electricity. The next year Jack Nicholson, the actor and fan, mooned the crowd from a skybox when the Lakers finally won a title in Boston. There was the suspended game against the Hawks in 1990, when condensation from the ice seeped through the floor.

Cousy retired in '63 and Russell retired in '69 and Hondo Havlicek retired in '78 and other standouts retired, and ceremonies were held for all of them except Russell, who hated that stuff and quietly pulled the banner with his number 6 to the ceiling before the paying customers were admitted. A fan yelled, "We love ya, Cooz," at Cousy's retirement ceremony. Havlicek planned his own event, bowing to all four corners of the building and ordering that the organ be abandoned for the afternoon, replaced by recorded rock-and-roll

music. Bird's night, in '93, was not even the night of a game, but instead a special evening of videotaped highlights and visits from former teammates and opponents. There was the saddest night of all, when Reggie Lewis fell down against the Charlotte Hornets in 1993 and never returned, dead within three months.

Memory.

The soul of the building remained its old-time quirkiness, its unpreserved preservation, nobody ever caring enough to really fix it up, but also no one ever caring enough to tear it down. The best seats were the best in basketball, closer than anywhere else. The worst seats were behind poles, the absolute worst. The smell was different from the new arenas, a combination of all the popcorn and hot dogs and spilled beer and smoke and perspiration and circus visits. The lack of air conditioning did not hurt the smell at all. There were stories of rats that roamed the building, large as house pets. There were stories of things that happened long ago matched against stories that happened yesterday. Stories were the soul of the building.

"We played doubleheaders a lot," Heinsohn says. "We played doubleheaders with the Globetrotters, with the ice shows.... We played doubleheaders with the rodeo. The dirt would be spread on the cement for the rodeo, and they would brush it all back and lay down the floor. You'd go running off the court and go straight into this big mound of dirt."

"One day I was recovering from a knee injury, running the stairs all alone," Sanders says. "I guess no one knew I was there, because they released the guard dogs. I wound up staring at this German shepherd at the top of the stairs, him staring at me and me staring at him and neither of us moving for a long time. Finally the guard came."

"I saw a rat that was so large, I should have shot it and stuffed it," McHale says. "I was walking across the court, and I saw this thing at the stairs that went to the exit. He was standing on his hind legs. I said, What's a rabbit doing in here? That's how large he was. I thought he was a rabbit.

"There were only two stalls in the bathroom in our locker room," McHale continues. "No matter how early I got there, someone else always would have been there before me. I finally found an answer. I got a ball boy to let me into the officials' locker room before they got there. I did that every night. It was perfect. Quiet. I could read the paper. It was my little secret. Somehow I thought it was justice. I was making a statement."

Memory.

The future will be all mind. There will be pictures of the Garden and the events, of course, better pictures from each succeeding year, but cameras cannot capture day-to-day existence. Cameras cannot record smells and all sounds. There will be numbers, records, the Celtics with 1,287 wins in 1,709 home games (a handful in the smaller Boston Arena) as of Sunday, but numbers are not descriptions of people and places and situations and emotions. The building and the things that happened in it will exist primarily in the minds of the people who were there. Truth will be carried in a fragile envelope.

"Memory is a strange thing," Cousy says. "I went out to dinner with Tommy Heinsohn the other night with some advertising clients. We sat there for two hours, 2½ hours, telling all the old stories. Tommy was going on and on, telling these stories, and half of them I'd never heard before. Or didn't remember. I mean I was there when these things happened, and I didn't remember any of them the same way. Time passes, you know, and you can say anything, and it can sound right.

"With any successful business, any successful person, you can pick out reasons for the success that have nothing to do with it but sound as good as anything else. Do you know what I mean? The Celtic mystique. The Garden. I hear so many things that are ridiculous, yet they have been repeated so many times they sound true. Everything sounds true now."

There will be a ceremony to mark the final regular-season Garden game. A last ceremony. The plan is for 28 Celtic heroes to return, as many as possible. At halftime they will pass a ball back and forth.

Bird will stand in the corner. Three-point territory.

He will take a pass and raise the ball as if to shoot. Suddenly, visitors from all of NBA history will come flying in an imaginary pack, all of them, Wilt and Kareem and Magic and Dr. J and Senator Bill Bradley and World B. Free and Walter (Big Bells) Bellamy and Moses and Oscar and Jerry West and Isiah and Elgin and Air Jordan, himself. All of them. Bird will pull the ball back down.

Russell will walk to a spot underneath the basket. All alone.

He will take the pass from Bird and make the easy layup, and the doors will close on an era. Not only will the Garden era, the Celtic era, be gone, but also the era of old-time arenas, the cramped and crowded, working-class, big-city athletic showplaces. The oldest building in the NBA will become the Los Angeles Sports Arena, built in 1959. The L.A. Sports Arena?

Ten years from now, no more than 15, the final shot will become a dunk. Russell dunked and the backboard shattered and everyone left and the Boston Garden was closed and the rats ran into the sea. That was the way it was. ●

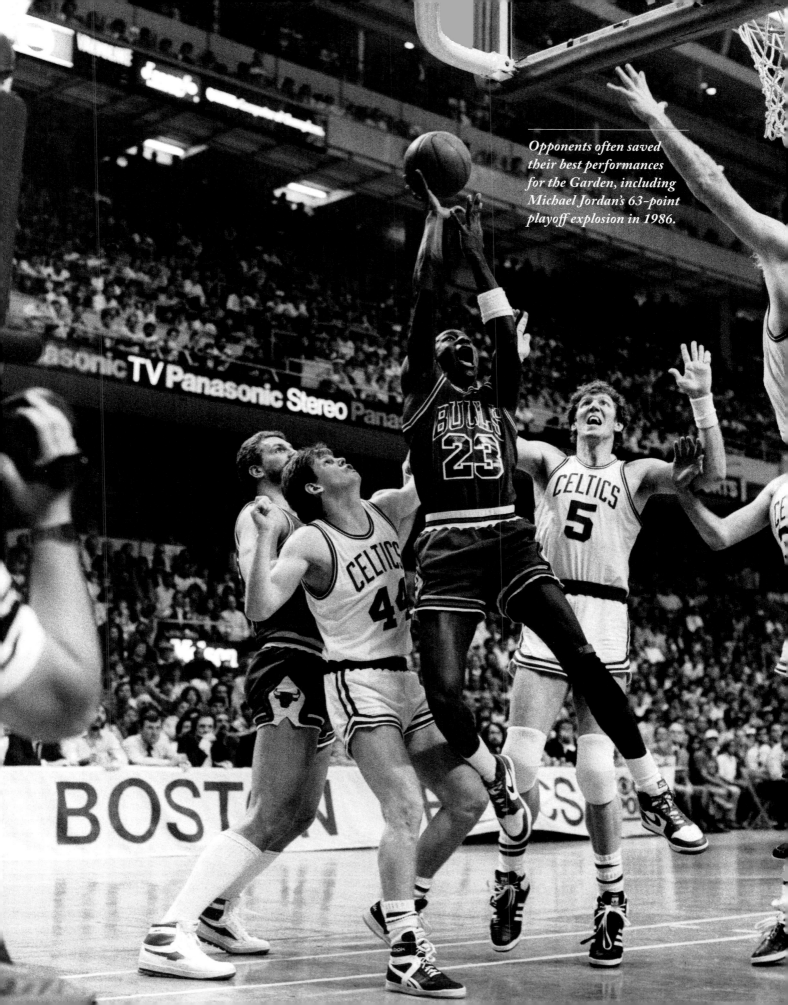

Opponents often saved their best performances for the Garden, including Michael Jordan's 63-point playoff explosion in 1986.

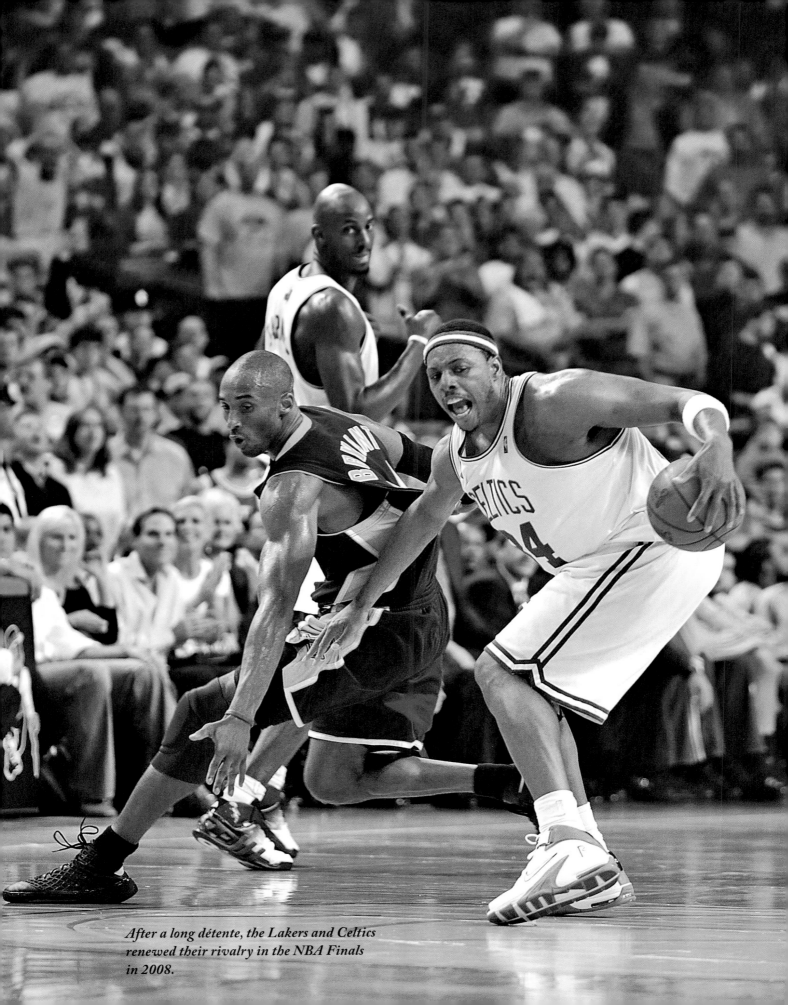

After a long détente, the Lakers and Celtics renewed their rivalry in the NBA Finals in 2008.

SEEMS LIKE OLD TIMES

Twenty-two years after their last NBA title the Celtics earned their 17th, as G.M. Danny Ainge reconnected the franchise (and this author) to a storied past of retired numbers, Hall of Famers and one-namers BY JACK MCCALLUM

WENT FOR A LONG, LONG WALK AND CAME BACK TO THE SAME PLACE, A 360-DEGREE JOURNEY TO FIND DANNY AINGE, 27 years later.

"My first story after I started working for SI was on you," I tell him.

"I remember," Ainge says. "Dunedin, Florida."

Dunedin was and still is the spring training site of the Toronto Blue Jays. The 22-year-old Ainge, a third baseman, was trying to establish himself as a big league starter. He ended up batting .187 in 86 games that season and abandoned baseball for the NBA.

Ainge was also a starting guard on the first championship team I covered as SI's NBA writer, the 1985–86 Boston Celtics, so to an extent our careers have run on parallel tracks, though I am far more aware of that than he is. "That was a special team," Ainge says. "Larry was lucky he had so many great players around him. Kevin was lucky he got to play with Larry. Chief was lucky to be there, considering he started with Golden State. DJ wasn't always happy with his teams [Seattle and Phoenix] before he got to Boston. It was a magical time."

You knew those Celtics stars by one name. Larry stood for Bird, Kevin for McHale, Chief for Robert Parish, DJ for Dennis Johnson.

Now it's another magical time in Boston, the anti-Cleveland, the city of Williams and Yaz, of Shore and Orr, of Russell and Cousy, of Manny and Big Papi, of Brady and Belichick. Ainge was born in 1959, three weeks before the Celtics won the second of 11 championships they would earn in a 13-year stretch. Ainge's shooting and hustle contributed to two of the franchise's three titles in the '80s; he and DJ represent one of the last backcourt combos that didn't need to be differentiated as point and shooting guards. Ainge returned to Boston in 2003 as executive director of basketball operations and general manager, eventually building a championship team for the new millennium, erasing memories

of the fallow decade of the '90s with the best single-season turnaround (a 42-win swing) in NBA history.

The 2007–08 Celtics still have work to do before they can claim a special spot in the high-bar history of the franchise—before Paul is strong enough to identify Paul Pierce, before KG (Kevin is taken) suffices for Kevin Garnett, before Ray instantly conjures up Ray Allen. Will Pierce's nothing-gets-in-my-way aggressiveness stand up to Bird's? Will Garnett's 5 and Pierce's 34 join the 22 retired numbers that already hang from the TD Banknorth Garden rafters?

No pro franchise is as obsessed with jersey numbers as the Celtics. Bird's 33, McHale's 32, Parish's 00 and the late

now part of the continuum. Danny is a one-namer.

It is 11 a.m. on June 18. Ainge has come to the Celtics' training center in Waltham, a suburb 12 miles west of Boston, to work out potential draft prospects. Dave Wohl, his assistant G.M., is also here, but they are almost alone in their section of the sprawling complex. Only hours earlier the Celtics had trounced the Los Angeles Lakers 131–92 at the Garden in Game 6 to win their 17th championship, the first since that memorable '85–86 team. Some of Ainge's players and employees are sleeping off the celebration; others have yet to get to bed. Ainge himself left the deliriously happy Garden just eight hours before.

In six third quarters—the period that some say is the most important, when a team can build a lead and crush the opposition's spirit or render its strong first-half effort meaningless—Boston outscored L.A. by an average of 7.2 points.

Johnson's 3 are up there, but Ainge's 44 remains available; little-used forward Brian Scalabrine has worn it for the last three seasons. When Ainge was hired to run the team, managing partner Wyc Grousbeck lightheartedly told Ainge he would retire his jersey if he could produce a winner. Ainge, mindful of his own limitations as a player, may not take Grousbeck up on the offer should he make it again. But if he says yes, it's a safe bet that McHale, VP of basketball operations for the Minnesota Timberwolves and still a close friend, would issue a mock protest. "We shouldn't be retiring Danny's shoelaces, much less his jersey," McHale might say. "If Danny's jersey goes up, mine comes down." But Danny—championship player, championship exec—is

I feel like a zombie (deadline writing and a few cold ones in the hospitality suite will do that to a man) sitting in Ainge's office, but he looks as he always does—wide-eyed and fresh-scrubbed. A devout Mormon, he avoided the celebratory champagne the way Californians are avoiding plum tomatoes. I try to match the mug I saw in 1981 to the one I see now, and after adding a frown line or two, I'm done. Ainge is a 49-year-old whose Facebook page, if he had one, would earn approval from the LDS elders. It would highlight his six children and six grandchildren, his avoidance of profanity, his going to church every Sunday unless an early tip-off gets in the way.

Family photos are scattered across his orderly desk, but an image on the wall draws

my eye: It is an autographed shot of Ainge and the other four starters (Larry, Kevin, Chief and DJ) from the '86 championship team. "I got them all to sign it," says Ainge.

History is always the subject for the Boston Celtics. It's always about history.

———————————

At a press conference before Game 4, in which the Celtics would overcome a 24-point deficit to win 97–91, the biggest comeback in Finals history, Boston coach Doc Rivers was asked a question about his father, Grady, a Chicago police lieutenant who had died suddenly last November at age 74. There was a long silence. "He's just very important in my life," Rivers finally said. "It's still very difficult for me to talk about because I haven't had a lot of time, really, to reflect on it." Rivers had told stories about Grady before, how he would show up at his son's basketball games in his police uniform and take a seat in the first row. He also coached Doc's childhood baseball teams, keeping the police scanner on at full volume. There's a thin-blue-line sensibility about Rivers, too, a no-bull orderliness, even though he has a delightful sense of humor.

I caught Rivers's eye as he left the podium. "I bring greetings from the citizens of Tbilisi," I said.

Rivers laughed. "Thank you, comrade," he said.

In July 1988 I covered the Atlanta Hawks on a 13-day, three-game "goodwill tour" of the Soviet Union that was really a poorly disguised business trip for the NBA and Turner Broadcasting. The Hawks schlepped from Tbilisi to Vilnius to Moscow, a trip that still provides conversational fodder two decades later for all who were on it because it was so bad it was good. Bad food, bad rides on Aeroflot, bad accommodations, bad organization, bad refereeing, bad basketball. Rivers, then the Hawks' point guard, and his

wife, Kris, were among those who made it good. A smile Krazy-glued to his face, Rivers shook every hand, slapped every back, signed every autograph and generally made it seem as if he were having the time of his life. "I don't know how we would've gotten through this without Doc," Atlanta coach Mike Fratello would say.

Rivers is one of numerous former players from the 1970s and '80s who are now head coaches in the league, just as Ainge is a member of the player-turned-G.M. club. It's one of the reasons I keep covering the NBA: Its legs keep getting younger, but its head, like mine, is old. As long as coaches such as the Lakers' Phil Jackson and the Utah Jazz's Jerry Sloan continue to communicate with their players, and executives such as Ainge, McHale, the Indiana Pacers' Bird, the Lakers' Mitch Kupchak and the Detroit Pistons' Joe Dumars stay relevant enough to have their bosses' ears, I figure there is hope for me.

It is simplistic to conclude, as many did, that Rivers outcoached Jackson in the series, thus preventing Jackson from earning his 10th ring and surpassing the total of Red Auerbach, the Celtics' patriarch, who died in 2006. Outcoached is one of the most overused words in our sporting lexicon. Good coaching (and bad) manifests itself over time. Rivers juggled his backup guards (Eddie House, Sam Cassell and Tony Allen) according to no formula that I could discern, yet got strong performances out of all of them at one time or another; Jackson, meanwhile, had no idea what he was going to get from his bench and ultimately got very little. So is that one guy outcoaching the other?

But there is this: In six third quarters— the period that some say is the most important, when a team can build a lead and crush the opposition's spirit or render

its strong first-half effort meaningless—Boston outscored L.A. by an average of 7.2 points. Let's put it this way: In these Finals, the Rivers way was superior to the Jackson way. Rivers roamed, Jackson sat. Rivers lit a fire under his players, Jackson asked his to figure it out on their own. Rivers acted glad-to-be-here, Jackson came across as this-is-my-11th-time-here.

When Rivers got the Boston job in April 2004, he embraced the burden of history, inviting every living former Celtic to attend practice. He also consulted with Auerbach, who gave him two pieces of advice: "Be the agitators; don't be the retaliators" and "Get the ball; don't give up the ball."

Frankly, that sounds like a bunch of useless pap—but there's been a lot of that over the years in Boston, where the older generation is always hoops-whispering to the younger. When Russell and Garnett got together in March to tape a conversation for ESPN, I thought, What do they have to talk about? Russell won 11 championships and Garnett hasn't even played a postseason game in a Celtics uniform. Still, Garnett was moved when Russell said he would share one of his 11 rings with Garnett if the team didn't bring home the title this season. Those old Celtics cast long shadows; accepting that is just part of the deal in Boston.

Rivers connected his players to the franchise's illustrious past while keeping them in the present. Something that backup big man P.J. Brown told me during the Finals stuck with me. Ainge signed Brown in late February—it was P.J.'s fifth stop in a 15-year career—to provide maturity and toughness. I asked if he had made an immediate assessment of Rivers when he came to the team.

"Most definitely," said Brown. "Doc had the team. You can always tell that right away. He just had the team."

After the Celtics failed to close out in Game 5 in L.A., losing 103–98, much of the criticism centered on Garnett for his lack of aggressiveness around the basket on offense, a rap he has dealt with for years. I thought it understandable but unfair. Garnett has never been an in-traffic scorer; he's a jump-shooter in a 7-foot package. He makes his bones with rebounding and never-take-a-play-off defense—which describes Russell. The Celtics of the 1950s and '60s never went into an important game expecting Russell to lead them in scoring. That was for Bob Cousy, Bill Sharman, Tommy Heinsohn, Frank Ramsey, Sam Jones and John Havlicek. Russell's job was to be the spiritual leader, the rock, more immovable object than irresistible force. Same for Garnett.

So when KG got off early in Game 6, hitting a layup, an alley-oop dunk and three jumpers in the first quarter—his offensive effort matching his primal scream played on the scoreboard before every home game—Boston was off and running. After one quarter it was 24–20; after two it was 58–35 and so over. All of Russell's rings would remain with him. (Later, Garnett would tearfully tell the goateed éminence grise, "I got my own.") The TV cameras could afford to spend time panning for Celtics legends in the stands—Russell, Havlicek, Heinsohn, Cedric Maxwell and Jo Jo White among them. With Boston up 89–60 at the end of the third quarter, Ainge's BlackBerry blipped, and up flashed a text message: GREAT JOB, DANNY, I'M REALLY HAPPY FOR YOU. LARRY.

Although they occupy different galaxies in the basketball universe, Bird and Ainge were a lot alike two decades ago: monumental pains in the ass to friend and foe. As with Bird, feisty didn't begin to

describe Ainge. He claims he never finished a game of backyard one-on-one with Dave, one of his two older brothers, because they would get into fistfights. "I remember a Little League game when a kid stole a base on us," says Ainge, who was playing shortstop, "so I told him there was a foul ball and he had to go back to first. He stepped off the bag, and I tagged him out. He started crying, and their coach called me a dirty player. It didn't bother me. We got the out."

During the time I covered Ainge in the '80s, I always saw him as a little brother to Bird and McHale. (He was two years younger than the former and 15 months younger than the latter.) In effect, he took on the same position he held in his own family under Doug (four years older) and Dave (three years older). McHale could goof off with the best of them—from time to time he would sneak a snack on the bench—but it was Ainge who acted as if he were 10, showing up at practice wearing goofy headbands and adhesive-taped names on his jersey. Lamar Mundane, a fictional playground legend who was the subject of a Reebok commercial at the time, was one of Ainge's favorites. Bird and McHale ragged him for his boyish enthusiasm and I-got-screwed whining during games. Only when Bill Walton came to the Celtics in 1985, giving Bird and McHale a new target, did Ainge slither off the hook.

Ainge looked on as Pierce bathed coach Doc Rivers in celebratory Gatorade.

Still, Ainge was the player most plugged into the complex Bird-McHale dynamic. "Larry would always come to me and say, 'Hey, go tell Kevin this,' and Kevin would come to me and say, 'Go tell Larry that.' They were such great players, but sometimes they didn't know how to talk to each other and how to yell at each other. But they knew how to yell at me."

With such a distinctive team imprinted on his memory, I wondered if Ainge tried to consciously model this club on his old one.

"It would be impossible," says Ainge. "The game is different. Players are different."

But doesn't Garnett, in his legendary intensity, compare to Bird?

"They're completely different," says Ainge. "KG is more of a sentimental guy, more feeling, kinder. Larry was not kind. Larry was grouchy. That's how he was born, that's how he competed. He would bust everybody's chops, get angry and frustrated.

"But here's what KG is like: We're in training camp in Rome [last October], and I see him in the weight room. Then he goes to practice, works his butt off and gets his shots up after practice. Then, for the next 45 minutes, KG is running around the gym rebounding for [point guard] Rajon Rondo. Let me tell you something: In a million years Larry Bird would never do that. He might make me rebound for him, but not the other way around. KG is focused and intense like Larry, but he really cares about the feelings

of his teammates, cares that he's perceived as almost the team mother."

Ainge is rolling now.

"As for Paul, he's a very determined player, like Larry, but he reminds me of DJ. Like DJ, Paul can get a little salty. He's up and down moodwise. And on the court he's kind of an energy conserver. He doesn't play all out all the time. That used to drive me nuts about DJ because I was the other guard and I'd think, This guy is so gifted. What's he doing coasting? But then, like with DJ, Paul has stretches that are unbelievably special. You need something to happen, whatever it is—a blocked shot, winning a jump ball, a steal, a rebound, a pass, a shot—and Paul supplies it. That's how DJ was.

"As for Ray, he is just an amazing

is Heinsohn, cocky and offensive-minded. Allen is Sharman, fluid and fundamental, drop-dead accurate from the free-throw line. Kendrick Perkins is Jim Loscutoff, the basher, the enforcer. (Rondo, however, is not Cousy.)

Such comparisons are, in the end, weaker than dishwater. But they are inevitable, for it is almost impossible to find a fan who will talk about the Celtics of the present without referencing the Celtics of the past. That's how it is and how it will remain.

"They're here," says Ainge, peering out of his second-floor office window into the weight room below.

"Who?" I ask.

"The guys we're trying out," he says.

> ## "KG is focused and intense like Larry, but he really cares about the feelings of his teammates, cares that he's perceived as almost the team mother."

basketball player. We didn't have anybody as cool and poised and who could shoot the ball like him."

Is there anybody like you? Rondo, perhaps, somewhat the helter-skelter guard? Cassell, the chattering, in-everybody's-face veteran?

"No," says Ainge, "nobody matches."

It's easier to compare the current Celtics with the franchise's 1974 and '76 championship teams: KG is Dave Cowens, a relentless, take-no-prisoners, two-way board banger with an outside touch. Pierce is a better offensive version of Havlicek (though not as good all-around). Allen is White in his silky smoothness. Even Boston's earliest NBA champions of the late '50s and early '60s are a better fit: Garnett is Russell. Pierce

"Do you know all of them by sight?" I ask.

"Of course," he answers, looking at me like I'm nuts. "There's Joe Crawford, shooting guard from Kentucky. There's Sean Singletary, point guard, Virginia. There's…."

There is no Russell, no Bird, no Pierce, no Garnett in that group. Barring a trade, the Celtics have only their two picks for Thursday's draft, at the end of the first round and the end of the second. Picking so low, they can only hope to find a role player or two. Still, Ainge is eager to see these prospects in action, eager to begin the next season just hours after the old season has ended. I envy him. He never seemed younger than he does right now, so much a part of a golden past, living a blissful present, looking ahead to a sparkling future. ●

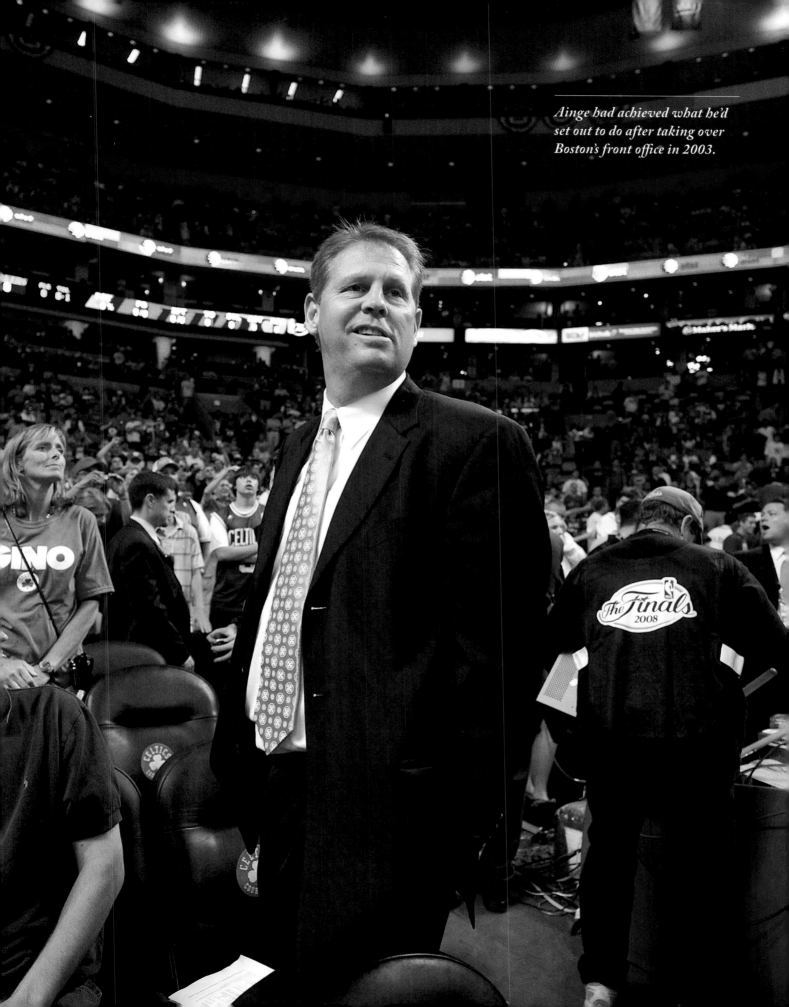

Ainge had achieved what he'd set out to do after taking over Boston's front office in 2003.

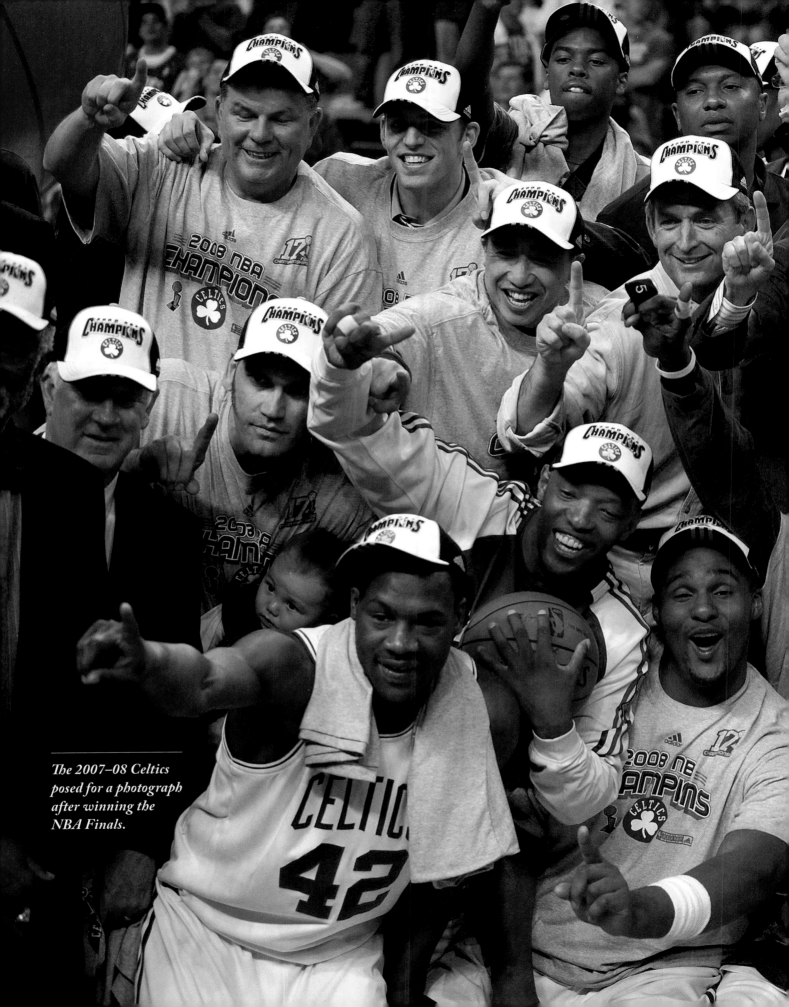

The 2007–08 Celtics posed for a photograph after winning the NBA Finals.

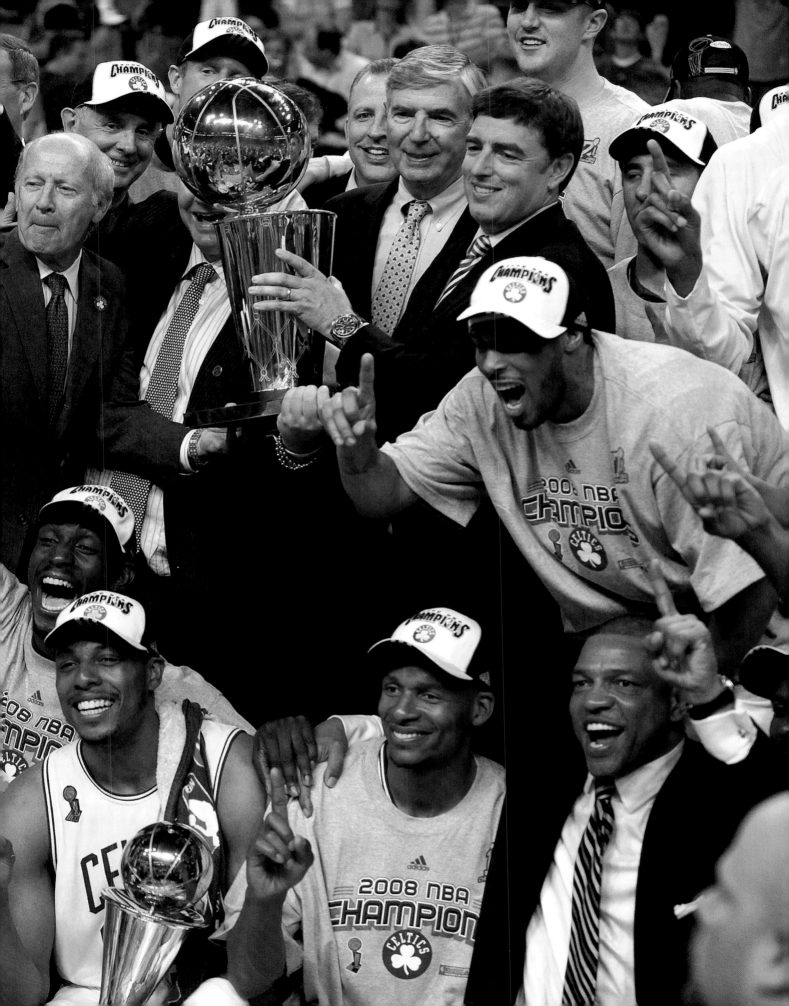

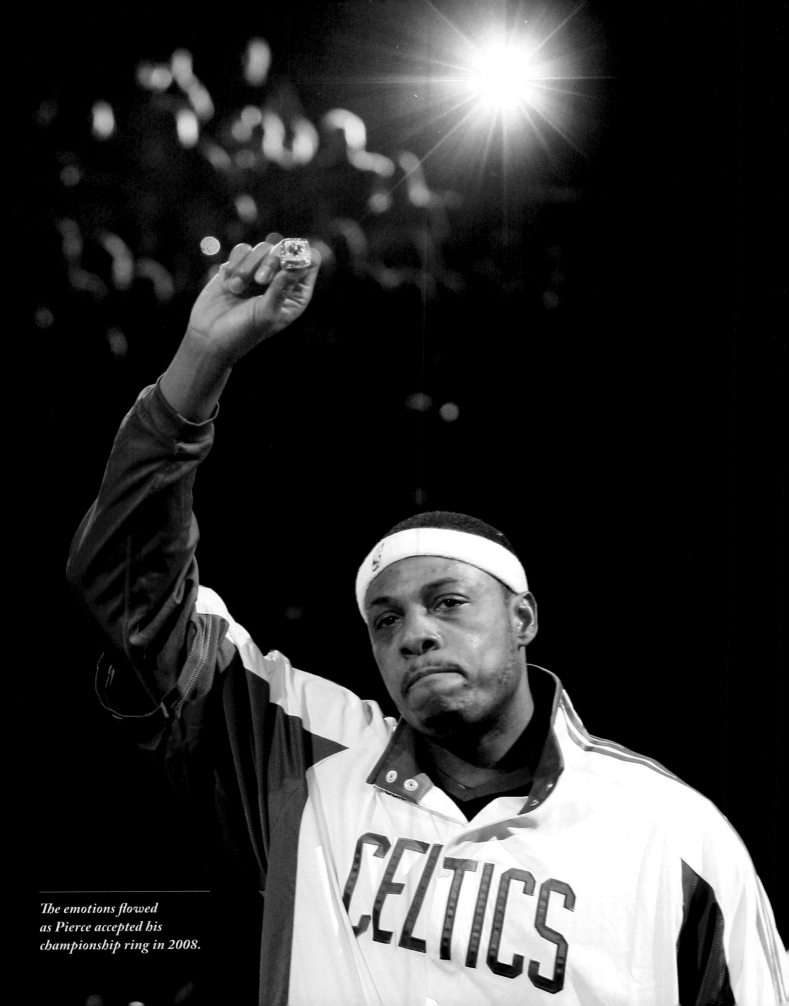

The emotions flowed as Pierce accepted his championship ring in 2008.

THE TRUTH REVEALED

*Even after earning a title, there's something
bothering Paul Pierce* BY S.L. PRICE

DOES WINNING MATTER ANYMORE? WHEN SPORTS ARE CONSIDERED MORE ENTERTAINMENT THAN COMPETITION; when seasons and playoffs stretch for so long in so naked a grab for revenue that the off-season feels like a week; when players make so much money that one game lost, one or two or three seasons lost, can't affect the way they live…can winning a championship possibly have the same power?

It's impossible to avoid thinking like this whenever you walk into a sports palace like Boston's TD Banknorth Garden.

With plush carpets and a spread fit for Nero in the locker room, 104 luxury suites with whispering waiters and state-of-the-art, high-def scoreboards, it's not like the old Garden, smelling as it did like piss, smoke or your grandfather's shoes. Each detail declares its high-tech worth; you find yourself constantly thinking, That must've cost a ton. It all smells like money.

Especially tonight, opening night 2008. In minutes they'll be handing out the championship rings and hoisting the 17th championship banner for the Boston Celtics, but…

I've paid my dues…
(No, please. Not *We Are the Champions*.)
Time after time…
…much has changed since the 16th went up in 1986. The league, remember, was the hot young thing then. The commissioner, the dynamic stars, the young-turk execs, all were riding a phenomenon, a game that could displace baseball and threaten football in the national conversation. Then came the pop-culture breakout: Michael Jordan won his first title in 1991 with the Chicago Bulls, wept uncontrollably—charisma finding greatness finding humanity—and pro basketball had its unstoppable Elvis.

*…I've done my sentence
But committed no crime.*
As ticket prices climbed, though, so did the need for distraction, a sleight of hand to cover up how few players like Jordan there really were. NBA arenas became an even greater bombardment of spectacle after he quit: dancers,

endless noise, pyrotechnics. Confirmation that the hoopla had consumed the hoops came in 2006, when the defending champion Miami Heat staged an over-the-top opening night celebration and lost to Chicago by 42 points. Now it looks as though even the venerable Celtics, one of the greatest franchises in sports history, will launch their own bit of wretched excess with Queen's schlock anthem.

But then something odd occurs. As Freddie Mercury starts his shriek, old Celtics faces—calm, composed as if they hear no music at all—march in, single file. There's John Havlicek holding the Larry O'Brien Championship Trophy, trailed by Bob Cousy, Jo Jo White, Tom Heinsohn, M.L. Carr, Satch Sanders and Cedric Maxwell. "Like the ghosts of Celtics past had been summoned," guard Ray Allen says later. And it's true: Each championship era is represented, and the representatives beam as they close in on the 31-year-old man at center court.

There stands Paul Pierce. The Celtics forward, once the seeming embodiment of what Jordan sneeringly called "New Jack players"—underachieving and self-involved, persona non grata with the national team after leading it to its implosion in 2002, bearer of a contract that will pay him $18,077,903 this season—is hunched over. He's a wreck. Havlicek hands him the trophy, and Pierce dips his head onto the legend's right shoulder. Pierce lifts his head, tears streaming down his cheeks, and it suddenly becomes clear that we're witnessing a rare moment in modern sports: not market-tested, not spun, close to pure.

The greats circle Pierce, hugging the captain who erased 10 years of questions by leading Boston over its archrival, the Los Angeles Lakers, in the 2008 Finals, the man who went head-to-head with LeBron James and Kobe Bryant and outplayed

them, revealing himself as a winner. It is a welcome. "For Havlicek to pass that to him?" says Celtics forward Kevin Garnett. "That was a generation passing it down, saying, 'You're finally one of us. You're a made person.'" Pierce raises the golden prize above his head and shakes it at the crowd: 19,000 throats bellow. He glances at the trophy, shakes it again, cheeks shiny and wet, mouth gaping; the man can barely breathe. He sets the trophy down on a table and staggers off.

But it's not over. When Pierce walks back out minutes later to receive his ring, he's still weeping, and he files down the line of league and team execs saying "Thank you, thank you" to each. He hugs his coach, Doc Rivers, and general manager Danny Ainge and, after helping raise the banner, turns on his heel and burrows into the crowd. He finds his mother, the woman who raised him alone, and gives the ring to her.

Lorraine Hosey kisses her son. "You've waited your whole life for this," she says.

And maybe that's it, why Pierce is carrying on in a way his family and friends have never seen before. Jason Crowe, his best friend for 17 years, had never seen him cry, not after heartbreaking high school losses, not after one of their teammates was murdered, not even after Paul himself almost died.

So many of the important people in Pierce's life are here tonight: Uncle Mike, who raised the basket in the driveway where he learned to play; his idol and half brother Steve Hosey; the high school coaches who served as the father he never had. Even that man—the dad—he's here, too, though he's not, his absence the same massive presence it has been since Pierce was very young.

This can't be real, Pierce thinks as he makes his way to the bench. His teammates are on the court, shooting warmups, but he sinks into a chair. He blows out his cheeks. "Get it together," Pierce says out loud, and then a

fan yells, "Do it again, Paul!" and he drops his head into his hands. *No: It happened. It really happened.* When Pierce looks up, his eyes are red. He tugs on his right knee brace. He rubs his hands into his face.

And that's when you know: yes. Winning can still matter, still trump coin, comfort and cheap fame. The next question is *why*.

Twice in his life, men have left Paul Pierce in profound pain. It's too glib to say that's the reason he is a champion today, but being a victim has provided him a unique fuel. He's also been given great ability, especially to probe other men for weaknesses and beat them in a very public way—victimizing *them*, no less—and the tricky part is figuring out which is more important, the ability or the fuel. Pierce doesn't give a lot of clues. He's about as easy to read as an Easter Island monument. "There can be a fire going on all around him," Crowe says, "and if you look at his face? You won't know."

But Pierce may not know either; pain can breed complications, a lifetime of inner conflict. That's why, though stunned to see him so emotional, those in his camp understood. He is a basketball player, after all, whose ambivalence toward his sport can be summed up by the tattoo he commissioned two years ago for his left forearm, the one depicting a knife plunging into a basketball and framed by the words MY GIFT, MY CURSE. Pierce keeps that covered on the court with a sweatband, but if

Pierce went head-to-head against James 69 times during his career.

you're looking—and he wants you to look—know that in what should be his season of supreme contentment, of peace at last, Pierce has a miniature version emblazoned on the side of his game sneakers, complete with the initials MG/MC. Whenever he hits the court, Pierce is literally a walking contradiction.

So, yes, it makes perfect sense that in an era when stars bounce city to city, Pierce emerged in the Celtics' shakiest era as their one constant. It makes sense that his college coach, Roy Williams, can speak about Pierce's ferocious desire and then talk of throwing him out of practice for wearing "that casual, careless, it-doesn't-mean-that-much kind of look." Or that Pierce, who early on undermined Rivers by snarling, "Why the hell'd you take me out of the game?" for all of Boston to hear, revered Red Auerbach, treasuring each foul cigar the Celtics patriarch slipped him as if it were made of gold.

And that, of course, may be the most delicious contradiction: Paul Pierce sitting with Red, beginning a career that now ranks as one of the greatest in the franchise's history. Because growing up in Los Angeles, Pierce hated the Boston Celtics.

For the longest time his vision of the future was tinted purple-and-gold, and it wasn't just a dream of basketball. It was the dream NBA life that a 14-year-old boy saw when he'd sneak into games at the Forum in Inglewood or see the players' sweet rides parked outside the gym at Inglewood High,

where they sometimes practiced and where Paul would become a star. Paul would worm his way into some of those practices, too, trying to glimpse the collective spark igniting that high-octane offense, the blinding passes. Magic, Kareem, Worthy: They were winners, those men, deep-voiced and cocky. They had such a *presence.*

Pierce didn't have that at home. As a kid growing up in Oakland, he had Steve Hosey and another half brother, Jamal Hosey, eight and 14 years older, respectively, and for a time they filled the dad role. Chubby and feisty, Paul hated to lose any game. In kindergarten, he'd survey their awards and declare, "I'm going to have more trophies than both of you guys put together."

But when Paul was eight, Steve got a scholarship to play baseball at Fresno State, and Lorraine moved to L.A. with her youngest son to be near her ailing mother. There she scouted out coaches and pastors who could make good role models, and made sure Paul became more than just another kid to them. There was an uncle who kept him in line, and another to take him to play in the grown-men games on Saturdays at Athens Park. But Lorraine worked as a nurse and, though she made sure to drive her son to every practice, when extra shifts came open, she'd grab them, and at dinnertime Paul would be making noodles in an empty house. He was on his own. You could feel the longing.

George Pierce never lived with Lorraine. Paul was no more than six the last time he saw his dad.

Cornelia Pierce, George's wife, answers the phone at their home. She's cordial but has little desire to open old wounds. "I'm a strong woman," she says. "I've prayed over it and I've accepted the whole situation; in fact, I watch many of Paul's games. I feel that Paul is an innocent bystander, as well as I am. I'm a Christian woman, so I look at things from the positive side and I don't have any regrets, or any attitude or anything. George and I have been married for 45 years."

Paul and Lorraine moved to Inglewood in 1988, and that year Jamal Hosey saw George Pierce one last time. "I yelled at him, 'You know, you got a great kid! You at least could call him, you bum!'" Jamal says. "Then my wife pulled me, and I walked away."

Sprawled beneath the jet paths of the L.A. airport, hardscrabble Inglewood didn't expect much of Paul Pierce. When at 13 he announced that he wanted to be a garbageman, his middle-school teacher replied, "That's pretty good." But he was also studying those Lakers and playing ball every chance he got.

Briefly sent down to junior varsity in his sophomore year at Inglewood High, Pierce was the team's star by season's end. The next year he was one of California's top recruits, turning up for classes still sweaty from the 5:30 a.m. sessions run by assistant coach Scott Collins, a local policeman. "If it was making a pass, getting a rebound, the last-second shot? Whatever it took to win, that was Paul Pierce in high school," says Inglewood High coach Patrick Roy. "He was everywhere."

Pierce went off to Kansas in 1995 and led a talent-rich team that went 69–6 in his final two seasons. Now that NBA dream life was close. He left school after his junior year, sailed into the 1998 draft hearing talk that he could go as high as No. 3, yet when the day came, Paul sat unpicked as future journeymen Michael Olowokandi, Raef LaFrentz, Robert Traylor and Jason Williams skipped up to the podium. The Celtics snapped him up at No. 10: more fuel for the furnace. That fall Pierce practiced jumpers while shouting out the names of every player taken ahead of him.

"I've always been the Rodney Dangerfield of this game," he says. "Maybe it was meant

to be that way, but that always drove me. If somebody said, 'You're going to be the Number 1 pick, you're going to have a great team around you all these years'? It would've been too easy."

It didn't take long to prove himself. He and Antoine Walker became one of the league's top-scoring tandems, and if the 6'7" Pierce was not your classic aerodynamic swingman, opponents still found his first step impossible to stop, his shot nearly unblockable. He rebounded, swatted away shots; by his second season Pierce was among the league leaders in steals. But most unusual, perhaps, was his sense of calm. Pierce never seemed rushed, no matter how frenetic the pace. "One of the best tempo scorers I've ever seen," says Rivers. "He just puts the defender on a string all night. They're dropping, off-

first one in the gym in the morning, talking smack. You'd get in at 9 o'clock and think you're early, but Paul was there at 7:30. He'd out-party you, then get his lift in while you were still sleeping off the night before."

On Sunday night, Sept. 24, 2000, Pierce had just returned home from dinner with Steve Hosey in Boston when Battie called. Paul hung up and told his brother he'd be back soon. Steve was in town from California; the two would be playing in a golf tournament the next day. Hosey went to his room, began sorting through the clothes he'd wear on the course, when a voice shot through his head: *You're not golfing tomorrow.*

Hosey shrugged it off. The feeling rolled through him again. He looked out the window, checking for snow or rain: nothing. He got into bed, turned off the light. Twenty

> If the 6'7" Pierce was not your classic aerodynamic swingman, opponents still found his first step impossible to stop, his shot nearly unblockable.

balance…but he's always balanced."

After the games he could play too. Pierce liked bars and clubs; he was known to get together with friends and have a time, and off-season nights in L.A. could stretch till dawn. In his early college years it wasn't unusual for him and Crowe to bolt a club at 3 a.m., grab a bite and then head to Manhattan Beach to sprint the sand hills. "Play basketball, chase girls and have fun," Crowe says. "And do each with the same aggression."

It didn't let up when Pierce moved to Boston. "He was competitive in everything: a game of H-O-R-S-E, a game of cards, an evening out," says Orlando Magic forward Tony Battie, a former Celtics teammate. "We'd get together and hang pretty rough and party pretty hard, but he would be the

minutes later he sat up, unable to shake the sense that something was wrong. Such a thing had never happened before, so he got on his knees to pray. He didn't know why.

Then the phone rang.

It was just past 1 a.m. on Sept. 25 when Pierce, along with Battie and Battie's brother, Derrick, arrived at Boston's Buzz Club. What happened next took mere minutes: The Batties veered off for the men's room, Pierce strolled through the pool room. When he leaned down to talk to two women, a man stepped forward and said, "That's my sister." Pierce said, "No disrespect," and tried to backpedal. "Next thing you know," he says, "all hell breaks loose."

A champagne bottle crashed against the side of his head, and a swarm of men descended, punching, stabbing, windmilling blows from all angles. At least two blades flashed. One sliced three times into Pierce's abdomen, with one jab slicing his diaphragm, puncturing a lung and plunging to within a half-inch of his heart.

By the time the Batties emerged from the men's room, security guards had dragged Pierce to a stairwell. Blood streamed from six gashes on his face. He noticed his shirt was wet, peeled it back and saw his wounds, put his hands on them "to hold the blood," he says. He had been stabbed five times between his shoulder blades, too. He didn't know that, though, until the Batties had gotten him into their car and were weaving through traffic to get him to a nearby hospital. In the emergency room, Pierce kept asking, "Am I going to live?"

He was extraordinarily lucky. The surgeons were able to operate using minimally invasive instruments and didn't have to open up Pierce's chest. But for the once-mighty Celtics it still felt like another bewildering blow; the sudden deaths of Len Bias in 1986 and Reggie Lewis in '93 had crippled efforts to rebuild in the post–Larry Bird era.

Pierce stayed just four days in the hospital and was back playing three weeks later, but some of the wounds weren't physical. Once an outgoing, almost clownish presence, Pierce kept to himself at home; the Celtics arranged for a 24-hour guard there. He talked with fewer and fewer friends and family members as the months wore on. "It really messed me up in the head," he says. "I saw a shrink, a psychiatrist, a couple of times and I was like, 'You know what, man? I don't want to talk to you no more; this is bothering me.' I didn't feel comfortable."

A year after the stabbing, Pierce went to a tattoo parlor in Venice Beach and tried to reclaim his body his way: with a massive ink job across his back, over the five purplish wounds. It was his own design—the hands of God holding his heart, with wings and a halo and the words CHOSEN ONE unrolling below. Pierce removes his shirt, steps under a spotlight in his living room, points. "When they were going over all my scars, some of the marks right here?" Pierce says. "They were hurting still."

But when, in September 2002, it came time for the trial, Pierce was not the star witness the prosecution had hoped for. By the time Pierce took the stand, two key witnesses had already recanted their grand-jury testimony. Pierce had identified one of the three defendants—William Ragland, Trevor Watson and Anthony Hurston—while in the hospital, and ID'd another two weeks later, both through photographs. But at the trial assistant district attorney John Pappas lost confidence that Pierce could provide a positive identification of his assailants on the witness stand. So Pappas didn't ask.

It wasn't a total flip, says former Boston federal prosecutor Paul Kelly, now the NHL Players' Association head, but "anybody with a sense of the system—lawyers, police officers, court officials—we all knew somebody either got to these witnesses or fear overtook them and, frankly, Paul Pierce."

Pierce laughs at the idea, pointing to the six-year contract extension he agreed to as he awaited the start of the trial. "If I was scared," he says, "why would I re-sign with Boston?" He says that he simply couldn't be sure the men in court were the same ones who stabbed him. The club was dark, the attack fast and furious. The jury acquitted all three men on the charge of armed assault with intent to murder; Ragland was convicted of assault and battery by means of a dangerous weapon and sentenced to a seven-to-10-year prison term, Watson was convicted of assault

and battery and sentenced to one year, and Hurston was acquitted of all charges. Pierce declined to make a victim-impact statement at sentencing. He was alive. He just wanted it all to go away.

Still, one memory remains vivid. In the days and weeks after the stabbing, Pierce wondered if the gruesome news might finally be enough to flush his father out. Each day Paul would sift through the messages and supportive letters from strangers, fans, friends. "I'm here: I could've died," Pierce says. "And to never get a phone call or a letter from him? That really hurt me for a long time. I was like, *Man, he didn't even reach out or nothing.* That hurt me to where I was, like, If he dies? I don't even care."

And that NBA dream life: Where was that, anyway? Winning titles like Magic's Lakers? Pierce had three straight losing seasons in Boston, and his own slick-haired coach, Rick Pitino, scurried back to college a failure. Hitting clubs? Being famous? It had nearly killed him, and it laid bare in nightmarish relief the flip side of being a pro athlete, what Pierce calls his "curse." Riches and adulation, of course, he had figured on. But with it came a new responsibility to care for family and friends, "all the stress that comes with you finally having money," he says. Pierce was sure his stabbing had grown out of "the jealousy, the envy" that comes with celebrity.

All that was puzzling enough, but now, after his best season yet, after Pierce had led the Celtics to the 2002 Eastern Conference finals, even his game was being called into question.

It's not that Pierce didn't work. He'd show up to practice at all hours, even on off days. One night during the 2001–02 season then Celtics coach Jim O'Brien looked down from his office and saw Pierce on a treadmill, "and I don't mean jogging: I mean sprints," O'Brien

says. "He's completely drenched. I said, 'What the hell you doing?' And he said, 'There are no days off.' That's who Paul Pierce is."

It's not that he lacked toughness, either. No one could scoff when Shaquille O'Neal dubbed Pierce the Truth. New Celtics CEO Wyc Grousbeck knew that in 2002, when he saw Pierce play on after the Phoenix Suns' Amaré Stoudemire knocked out two of his teeth and the bloody pieces slid across the Garden floor and stopped at Grousbeck's feet.

But when measuring greatness, it all came down to the word *win*. Celtics great Kevin McHale sniffed that Pierce "couldn't carry Larry Bird's jock," and after Pierce led the U.S. to a sixth-place finish at the 2002 world championships—with coach George Karl benching him against Argentina and sitting him in the fourth quarter of the final game against Spain—the notion gained currency. Suddenly Pierce was tagged as selfish.

"Paul and I? It was obvious at the end that we were battling," Karl says. He'll say only that Pierce wasn't always "committed" to areas beyond scoring and tended to force "his personality on the game. And when that happens, the game has a way of slapping you."

The slaps kept coming. In 2003 Pierce had his first playoff triple-double in the second round against New Jersey and led Boston in postseason assists and scoring. But the Celts lost to the Nets, and when Ainge took over as general manager that May, he unloaded Walker. "He didn't think highly of me and Antoine at all, and I knew this," Pierce says. "So I'm already thinking, He's not feeling my game; I don't need to try to build a relationship because he already doesn't like me and just traded Antoine. Maybe I'm next."

Pierce wanted to play for the U.S. again at the 2004 Olympics, but his reputation was in tatters. Roy Williams, an assistant on the U.S. staff for those Games, tried for two

years to convince his colleagues that everyone had gotten Pierce wrong. "I was the only guy bringing his name up," Williams says, "and it wasn't getting anywhere."

His sell wasn't made any easier by Pierce's demeanor. The stabbing, the trial, the losses, the selfish label—all of it combined to drive Pierce further into a shell. There were times, Battie says, when he'd see his friend sink into "his own zone, his own little space" where no one was welcome. Paul stopped calling everyone in the family except Lorraine; his mother would implore him to phone his brothers, and Paul would say yes. But six more months could pass without a call.

After the stabbing, Pierce was warming up for a game against the Golden State Warriors in Oakland when someone from the stands called, "Hey Paul! I'm Billy!" Pierce glanced up. It was his half brother Billy Pierce. And Billy is certain that he heard Paul call back, "My brother?" Then George and Cornelia's son came down courtside.

The two men had never met. Billy told Paul that he had called the hospital when Paul was convalescing. He asked if they could speak after the game.

Paul says the pregame meeting "could've happened," but he doesn't remember. Maybe Billy misheard, or Paul was distracted or inclined back then to write off anyone named Pierce. But when the horn sounded at game's end, Paul ran into the locker room without looking back. Billy says he wants no money. He has a good life as a truck driver, and his kids' favorite player is Paul Pierce.

"I'm the only child," Billy says. "I had a sister who passed away as a baby, and the whole time Paul was in Oakland, I was like, I wish I could see my brother. But...bad situation, I guess.

"I love my brother. I would love to know my brother. If he doesn't want to know me? O.K. I would wish at least he and our father can sit down and have some closure. Because I have kids, by two different mothers, and one thing I have learned? I will not allow my kids

Pierce grew more comfortable over time as both a leader and a facilitator of the offense.

to grow up the way me and Paul grew up—not knowing each other."

Doc Rivers took over as Boston coach in 2004, and for half of that season he and Pierce clashed. The Celtics were rebuilding and had used three first-round picks to bring in Al Jefferson, Delonte West and Tony Allen. Rivers wanted Pierce to trust his young teammates more and stop playing his ponderous isolation game. Trust? With a championship looking ever more distant, Pierce didn't trust Ainge to get the winning players the team needed and didn't trust Rivers's approach. Boston's first-round playoff loss to Indiana in 2005 put another dent in Pierce's image. After getting ejected from Game 6 for throwing a retaliatory elbow with 12.9 seconds left in regulation, he peeled off his jersey and walked off the court at Conseco Fieldhouse waving it. Auerbach, the Celtics' eminence, called the display "embarrassing." It came as no shock to hear, on draft night two months later, that Ainge was close to dealing Pierce for the rights to rookie guard Chris Paul.

When that deal fell through, it looked like star and team would be stuck in one of those bad NBA marriages. But during the two awful seasons following 2005, Pierce never tuned the coach out. Rivers kept waiting for Pierce's supposed selfishness to kick in, but "even though it wasn't working—and he was fighting it—he was still trying to do [what was needed]," Rivers says. "That's not a selfish person."

The team won just 24 games in 2006–07, and late in the season Pierce told a Boston reporter, "I'm the classic case of a great player on a bad team, and it stinks." Yet such foot-stomping had become more exception than rule; Ainge, Rivers, his brothers Jamal and Steve had noticed that, as Pierce says, "my spirits really changed." He had been seeing a woman named Julie Landrum since '05, and Pierce credits her with teaching him to think more positively and "keeping me happy." Out for nearly half the '06–07 season with injuries, Pierce watched Boston lose a record 18 straight. He realized that, at 29, he was as far as ever from winning a title, and his first impulse was to publicly demand a trade. Landrum talked him out of it.

Instead, in a midseason meeting with Ainge, Grousbeck and managing partner Stephen Pagliuca, Pierce calmly ran through the options: trading him to a veteran team, rebuilding around young talent. Grousbeck insisted he wanted Pierce to retire a Celtic and would pay to build a winner. "I believed them this time," Pierce says. "I thought, All right. I finally heard it from the horse's mouth."

Proof came only when Ainge engineered the trades, in June and July 2007, for perennial All-Stars Garnett and Allen. *This is your opportunity,* Pierce thought. *Don't let it go to waste.* Any fear that he wouldn't be able to share the ball, the stage, dissolved. "First day of camp, you knew: He wanted to win so bad," Rivers says.

When George Pierce returns the call, he speaks briefly, says he has watched his son play on TV. He has just one photograph, taken when Paul was four or five. George remembers that he was supposed to pick Paul up once, but he had to work and didn't show. George says he's had his ups and downs, and "some things that shouldn't have happened did." It's not clear if he's talking about his relationship with Lorraine or Paul or the fact that he never spoke to his son again.

"Why don't you do this," George says. "Why don't you get ahold of him and have him call me?"

The Celtics bolted to a 30–4 start, and anyone could see that Garnett and Allen had freed Pierce. He had carried the scoring load

for so long that his all-around game now came as a revelation. With Garnett's presence enabling him to gamble on the defensive end, and Allen's outside shooting providing a payoff for his passes, Pierce took the fewest shots of his career and had the season of his life. He averaged 19.6 points, 5.1 rebounds, 4.5 assists and 1.26 steals. He made the All-Star team for the sixth time. He began changing minds.

"What I saw was commitment," Karl says. "If the game said, 'Be a defender'? He was a defender. If the game said, 'Be a rebounder'? He was a rebounder. If the game said, 'Be an orchestrator'? He was an orchestrator. He made his career scoring points, but last year? What the game asked him to do, he did."

Pierce missed his first game of the season on April 4, when Landrum, now his fiancée, gave birth to their daughter, Prianna Lee. He cut the umbilical cord, changed diapers and came back even more motivated. Boston struggled to eliminate the Atlanta Hawks in the first round of the playoffs, and the pressure mounted as Cleveland came next. Pierce and Garnett shared the scoring burden as the Celtics and the Cavaliers split the first six games, but the plan for Game 7, Garnett says, was: Get the ball to Paul Pierce and get the hell out of the way.

Pierce didn't wait. He stole the ball from LeBron James on Cleveland's first possession, setting the tone. The two traded impossible baskets all afternoon—James scoring 45, Pierce 41—but it was Pierce's dive to beat James to the tip of a jump ball with one minute left that sparked visions of Bird's 1987 pickoff against Detroit. It was Pierce's killer free throws with 7.9 seconds left—the first one bouncing high off the back of the rim like Don Nelson's prayer in 1969—that sent James home.

Then, in the deciding Game 6 of the Eastern Conference finals against the Pistons,

Pierce scored 12 of his 27 points in the fourth quarter at Auburn Hills, and Boston came back to win, and the whole time he looked more alive than anyone had ever seen him. Pierce grabbed Rivers in a hug at series' end. "Thanks for sticking with me," he said.

Pierce's performance in the Celtics' dismantling of the Lakers in the Finals sealed the transformation. In Game 1 he left the court with a knee injury, but he returned to hit two three-pointers and give Boston the lead for good. In Game 2 he led the Celtics in scoring and held off L.A.'s desperate comeback with two key free throws and a block on Sasha Vujacic's three-pointer. With Boston down 18 at the half of Game 4, Pierce demanded that Rivers let him guard Bryant, then dogged the Lakers guard relentlessly, blocked one of his jumpers and held him to 6-of-15 shooting, and the Celtics fought all the way back to win and take a 3–1 series lead.

Pierce, the Finals MVP, would outplay Bryant again in the next game and Boston would win in six, but the championship—and Pierce's legacy—was secured in Game 4. George Karl is 57 and has seen the greatest, from Russell to Jordan, produce the kind of basketball that can make a coach swoon. He was in the building for the Celts' miraculous comeback and saw it up close.

"Probably the best half of basketball I can remember one player playing," Karl says.

Paul Pierce knew that many observers figured he would spend the off-season celebrating in Vegas, getting fat and happy with last summer's win. And yes, he did his share of partying. But despite Rivers's orders not to come back to town till camp opened, Pierce returned a month early, nine pounds lighter, his body more toned. "He came in the first day," Garnett says, "and the man looked like he was on steroids or something. You

know what I'm saying? He's committed. He was telling me, 'I'm ready.'"

The night before the opener, Pierce drove the seven minutes from his house to the team's empty training center and spent an hour drilling alone. "My time to zone in and see the game the way I picture it," he says. "My way." Then he went to dinner with the dozen or so people he had flown in for the ceremony, and Steve Hosey saw him hovering over his baby and fiancée, and edged over to hug him and tell Paul how he couldn't feel prouder of the journey he had made.

But it wasn't over. Pierce has proven himself, and he's enough of a player to pound his chest about it; when people asked this summer about Kobe, he would say, "I think *I'm* the best player in the world." But somewhere along the way, he felt this… shift. A championship had always been the goal, the way to quiet critics and tell others they'd only made him stronger and, maybe, show that man what he had missed out on. But in the months after, Pierce found that he enjoyed how others—his brothers, cousins and uncles—enjoyed his success more than he did. He found himself feeling that his time in the delivery room, seeing his daughter born, was better than winning it all. "It was unreal," he whispers. It made him decide some things.

"I don't want to be the dad that my father was," Pierce says. "I want to see my child grow. Who knows if I would've made it if he had been involved? Who knows if I would've been that much better? Who *knows*? But I'm sure his influence wouldn't have hurt those times I fell off my bike or didn't have nobody to rebound for me. I want to be there for my daughter—when she falls, to pick her up. When she needs help with homework."

For the first time, too, Pierce feels ready to reach out to his father. "I want to at least contact him and talk to him," he says. "I think

now, as a man, I can swallow whatever his reason was to not be there. Right now, I feel like talking to him and asking him, *Why?*"

Told that George Pierce had asked him to call, Pierce pauses, says, "Oh, yeah? Did he really?" Offered the number, he says, "Sure…I do want it. I do," and then he repeats the digits back, slowly, to make certain he's gotten them right. Then he takes Billy's number.

When Pierce arrived at the Garden for the opener, he carried with him one of Auerbach's cigars. He placed it in his locker, where he plans to leave it until the season's last day, when he'll smoke it after Boston wins title number 18. Then he walked out and received the trophy crying and gave a speech to thank the people who raised him, and all the coaches and relatives and friends cried, too. It made the long wait seem right. "Because we know he can appreciate it," Steve said moments later. "Sometimes young guys can't. But he can; he's *there*. It's the right time. It doesn't get any better than this."

But down on the floor, the ceremonies were over and LeBron James and the Cavaliers were trying to spoil everything. Emotions spent, Pierce and the Celtics trailed by seven at the half, and who would've blamed them for losing? Then Pierce snapped his team to life, starting the third period with a three-pointer, hitting another to answer a James jumper, scoring 11 to spark a 24–13 run that put Boston up for good. The Truth had beaten King James again: That's how the sports shows would play it.

But something about the comeback, the whole night, resisted the usual reductive hokum. Nicknames are kids' stuff, really, and aren't much good at summing up complicated struggle. The truth? He swallowed his tears and got to work. Paul Pierce got through another hard night, and he's had enough of those to be called a man at last. Some would call that winning, too. ●

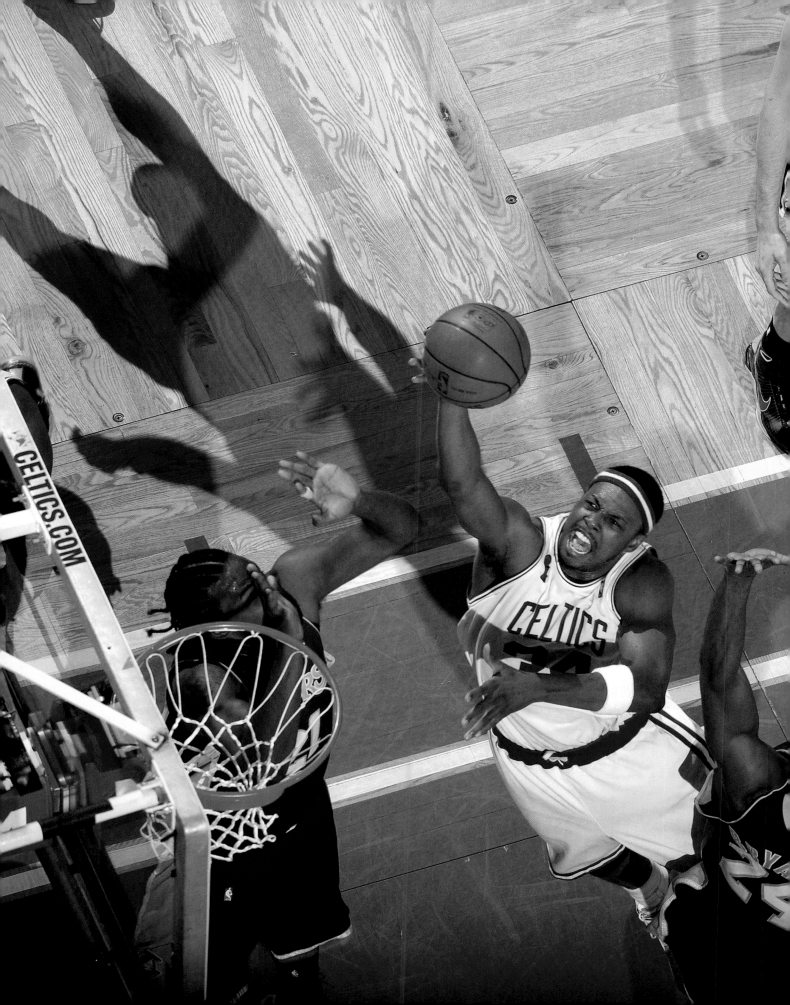

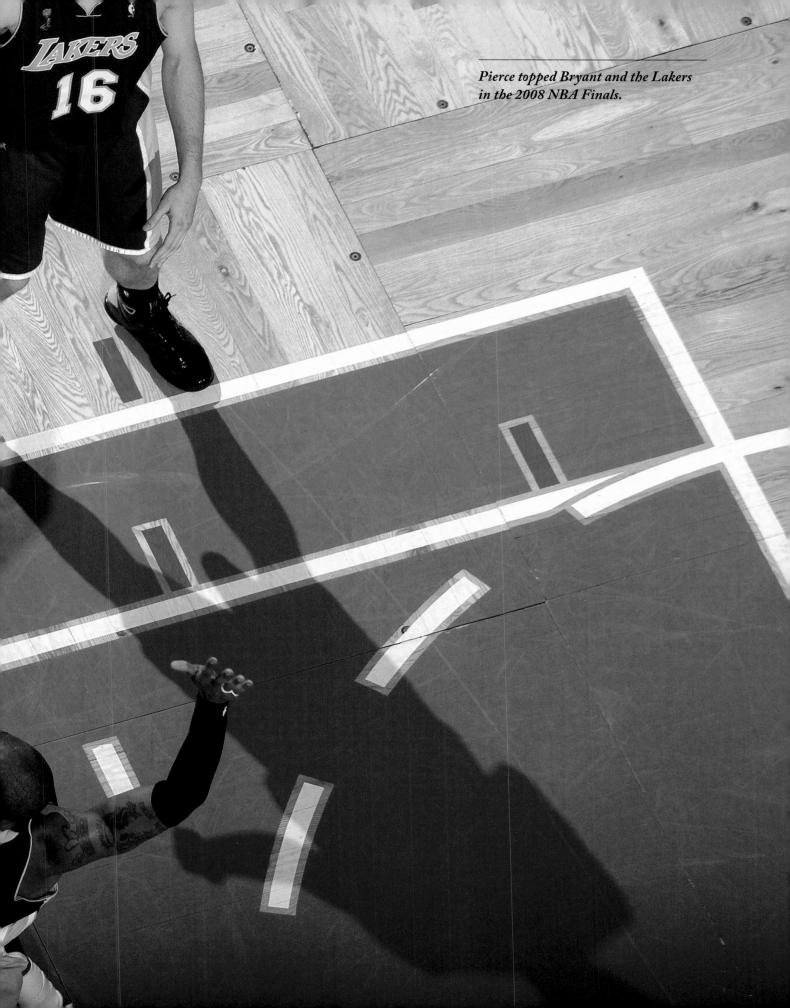

Pierce topped Bryant and the Lakers in the 2008 NBA Finals.

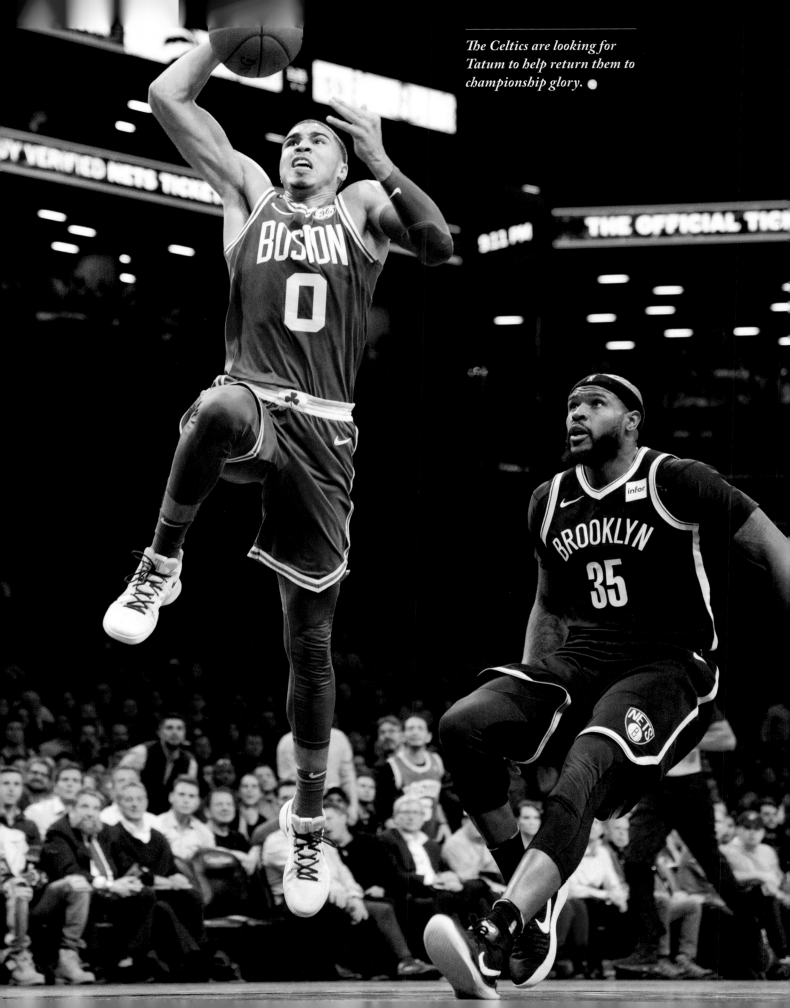

FAMILY GUY

Set on the road to the NBA by the sacrifices made by his mother, Jayson Tatum is evolving into one of the league's most dangerous players—as his son becomes one of its youngest social media stars BY CHRIS MANNIX

T'S GOD, THEN MOM—OR AT LEAST THAT'S THE RUNNING ORDER OF MOST ACCEPTANCE SPEECHES. AFTER THE MAN upstairs, Kevin Durant thanked his mother when receiving his MVP award in 2014, a powerful moment that, naturally, later evolved into an Internet meme. Ditto Giannis Antetokounmpo, who had tears in his eyes when he paid tribute to his mom at the NBA awards show in 2019, while Mrs. Antetokounmpo, seated in the gallery, brushed away a few of her own. Jayson Tatum isn't an MVP (yet) but if (when) that day comes, God's likely to get second billing.

Who knows where Brandy Cole would be if 22 years ago her world didn't change forever? Class president, a hotly recruited volleyball player at University City High in suburban St. Louis, Cole toyed with the idea of applying to MIT, with an eye toward becoming a biomedical engineer. A relationship with Justin Tatum, a Saint Louis University basketball player, led to an unexpected pregnancy the summer after she graduated. A positive test confirmed it. Then another. Then another. For weeks, Cole was in denial. She didn't tell her mother, Kristie, who had been a teenage mother herself. Early in the pregnancy, while working at a Walgreens, Cole collapsed. "I was anemic," she says, "and didn't know it." She was taken to the hospital, where a nurse, phone in hand, came into the room and said she had a call from Brandy Cole's mom. When she asked for Brandy, Cole told the nurse she had never heard of her.

Soon, though, reality would set in. And so would Cole's focus. She wouldn't put her life on hold. While raising Jayson, Cole earned a bachelor's degree from Missouri–St. Louis, then a master's and a law degree—but he would come first. Her son would go to private schools, even if it meant frequent visits to predatory payday lenders to make ends meet. It meant humbling experiences. When food was scarce, Cole would send Jayson to a neighbor's to pick up leftovers. "Chicken pot pie was the go-to," says Tatum. He would eat the filling. Cole would make do with the crust.

It meant supporting her son's dream. Cole sold cellphones, worked in an office at UPS, underwrote workman's comp policies for Travelers, did grant writing for nonprofits—anything to make ends meet. In between she kept up a full class schedule. Often, Jayson would tag along, fiddling with a Game Boy or sleeping

next to her in a lecture hall. "He should have college credit hours," says Cole.

That dream was basketball. In second grade, his teacher asked the class what they wanted to be when they got older. There were doctors, lawyers, veterinarians. Jayson said he wanted to play in the NBA. The teacher told him to choose something more realistic. His mother believed it was. When Jayson was 13, she called Drew Hanlen, a skills trainer who worked with prominent NBA players. "I want you to train Jayson," Cole said. "I'll take out a loan to pay you if I have to."

Initially, Hanlen declined. Cole rang Besta Beal, her former high school volleyball coach—and mother of Bradley Beal, a Hanlen client and a Florida-bound star. Soon after, Hanlen got a call from Bradley. "J is like a little brother to me," Beal said. "Can you help him out?"

Hanlen relented—but remained skeptical. "A lot of kids want to be great," says Hanlen. "But most aren't willing to do the work." The first workout was grueling. Cardio drills, five minutes each, nonstop. "I basically tried to kill him," jokes Hanlen.

Afterward, Jayson called his mom. "He said he thought he was going to pass out," says Cole. "But [also] that you were going to have to carry him off that court." The next day, Hanlen brought in Scott Suggs, then a sharpshooting guard at Washington. Hanlen pointed to different spots on the floor—the wings, the top of the key, two mid-post spots, seven in all—and directed Suggs and Jayson to go one-on-one. Jayson lost all seven times. "He just got worked," Hanlen said. "But he kept coming back."

And working. Through Chaminade Prep, where Tatum emerged as National Player of the Year in 2016. At Duke, where he overcame an early foot injury to earn All-ACC honors in his lone season. And in the NBA. At 22, Tatum got his first All-NBA nod last season, his third, and picked up right where he left off in this one. Before he was placed in the league's COVID-19 protocol, the 6'8", 210-pound forward was averaging career highs in scoring (26.9) and rebounding (7.1) through the first 10 games. "His ceiling is really high," says Hanlen. "And he's just getting started."

———————

The education of Jayson Tatum began in an unsurprising place: on YouTube. Justin Tatum's basketball career ended in 2005. He had always supported Jayson financially as best he could, and when he returned from overseas, he took on a prominent role in coaching Jayson. His early instructions: Watch how the pros score. Not *when* they score. *How* they do it. "He didn't want me looking at the end result," says Jayson. "He wanted me looking at their footwork and how they got open, how they came off the pin-down, how they came off the screen. To look at all the things before the shot."

Justin was tough. "Early on," says Cole, "I thought Justin was insane." (The two never married but have maintained a cordial relationship.) Jayson recalls a middle school game he was struggling in. At halftime, Justin burst into the locker room. "He grabbed me by my jersey and literally picked me up and put me against the wall," says Jayson. "And I just remember, everybody was just watching it like, *Damn, is this really happening?* And I had tears coming down my eyes the whole second half." The result? "I had like 25 straight after that."

When Justin began coaching high school ball he would bring Jayson to practice, sticking him in drills with kids six or seven years older. "It was a struggle for him," Justin said in an interview with NBC Sports Boston last February. "Jayson probably cried a couple of times, but he always came back. He always wanted the challenge."

Justin's coaching proved revealing. "Jayson plays better mad," says Cole. Normally, though, angering Tatum is difficult. He routinely shrugs off criticism, and Cole will often check his arm, asking whether he has a pulse. "He's very logical," says Cole. "When there is adversity, he doesn't think crying about it will fix anything." At Duke, following a close loss to N.C. State, Cole was incensed by criticisms she read on social media. Tatum's response: *Mom, you don't know any of those people—why are you reading it?*

"Nothing becomes personal to him," says Duke coach Mike Krzyzewski. "He has great humility. I like to say that in any environment, his boat still has oars." But when Tatum does get angry— look out. After Tatum scored seven points in the first half against Virginia, Krzyzewski jumped on Tatum in the locker room, calling him a "soft-ass St. Louis kid." Tatum erupted for 21 in the second half.

Talent can breed arrogance. Tatum, though, has always been coachable. Hanlen saw it early. Video of Kobe Bryant, Michael Jordan and Tracy McGrady helped Tatum absorb the nuances of a jab step. In high school, Tatum would occasionally shoot from only certain areas. "He'd basically be using other teams for practice," says Hanlen. At Duke, Tatum struggled early with his shot. Following the loss to N.C. State, Hanlen flew to Durham. At the time, Tatum's three-point percentage was 29.5%. The next day, the two drove to a nearby high school. Over

Tatum posed with his son, Deuce, and his mother, Brandy, in 2019.

two hours, Hanlen altered Tatum's arm angle by 30 degrees. "Basically lowered his shot pocket," says Hanlen. Tatum shot 41.2% from three the rest of the way.

Absorbing coaching is one thing. But Tatum also implements it quickly. "Share something with Jayson once," says Celtics coach Brad Stevens, "and he usually does it the next time down the floor." Stevens recalls a sequence during an exhibition game in Charlotte in Tatum's rookie season. The Hornets ran a play the Celtics hadn't worked on defending. Tatum got lost the first time. When Charlotte ran the same play a few possessions later, Tatum broke it up. Last season Celtics assistant Jay Larranaga showed Tatum a clip of Kemba Walker getting to the rim with an in-and-out dribble. The next night Tatum scored on a similar move. "His brain never gets sped up," says Larranaga. "You tell him something in a game and he is able to immediately apply it."

As Tatum blossoms into one of the game's elite all-around players, it's easy to forget that drafting him was considered a risky proposition for Boston. In 2017, the Celtics, thanks to a fruitful trade with Brooklyn four years earlier, owned the first pick. Washington's Markelle Fultz was widely projected as the top player. A few weeks before the draft, Boston's brass flew to Los Angeles to watch Tatum work out. Krzyzewski was already in the Celtics' ear, insisting Tatum was "by far" the best offensive

player in the draft. In an empty gym at St. Bernard's High, Tatum shot 275 threes. He made 83% of them. "He shot 34% from three in college," says Stevens. "But that wasn't real. That ball hit the net like it was supposed to."

The Celtics were sold. Boston flipped spots with Philadelphia, which had the third pick. The Sixers took Fultz. (Boston officials insist that Fultz's subsequent shooting woes were not apparent in his workout.) As expected, Lonzo Ball went next to the Lakers, leaving Tatum sitting at No. 3.

Confirmation that it was a wise move came quickly. "His skill level for such a young kid was so impressive," says former Celtics assistant Micah Shrewsberry, who left in 2019 to become an assistant at Purdue. "He was fluid

Memphis, when Tatum, on a play run for Jaylen Brown, made a hard cut that sprung Brown for a shot. "A play like that," says Stevens, "is just as good."

Tatum's rise hasn't been without rocky moments. After a breakout rookie season, Tatum entered his second year with high expectations. So, too, did Boston, which had pushed LeBron James's Cavaliers to seven games in the conference finals without Kyrie Irving and Hayward, and would welcome the two stars back. But chemistry issues plagued the 2018–19 Celtics, and the team fizzled out in the second round of the playoffs. Tatum, who had been a focal point of the offense during Boston's '18 playoff run, struggled to adapt to a new role, and

A roster shake-up before last season saw Irving exit and Tatum return to a leading role.

Presented with opportunity, Tatum seized it, averaging 23.4 points. His three-point percentage

jumped back above 40%. His playmaking, something Tatum has worked diligently on, improved.

in everything he did for a guy his size." Tatum averaged 17.7 points in Summer League. At his first practice, he grabbed every rebound and deflected a handful of passes. "None of us knew how good a defender he was," says Stevens. At an open workout in the fall, Tatum knocked off Gordon Hayward in a shooting contest. "There's a swagger to him," says Shrewsberry. "He didn't want to be an NBA player. He wanted to be a great NBA player."

It's a chilly evening in Detroit in early January when Stevens boards a bus to the airport after a win over the Pistons. Tatum scored 24 points, the last two on a game-winning jumper in the closing seconds. Stevens praises the shot, but quickly shifts the discussion to two games earlier, against

his shooting percentages dipped. His shot selection, particularly an affinity for midrange jumpers, drew criticism. Faced with failure for the first time, Tatum blamed himself. "He took a lot on," says Shrewsberry. "He has such high expectations for where he wants to be." Adds Hanlen, "He was overthinking. He took [Boston's struggles] really personal. He wasn't living up to his own expectations."

Tatum's takeaway from that snakebit season? "Don't take anything for granted," says Tatum. "The year before when we went to the Eastern Conference finals, I thought that s--- was normal. That this was just how it was supposed to be. And then the next year I realized things can go south. And it made me really appreciate the year before and just how valuable things like that are."

A roster shake-up before last season saw Irving exit and Tatum return to a leading role. Presented with opportunity, Tatum seized it, averaging 23.4 points. His three-point percentage jumped back above 40%. His playmaking, something Tatum has worked diligently on, improved. Last summer, in the NBA bubble, Boston faced Oklahoma City in an early scrimmage. During one sequence, a Thunder defender drifted away to defend the pass on a Tatum drive. Chris Paul, loud enough for many in the quiet arena to hear, barked that Tatum wasn't going to pass. Enter Playmaker Tatum. In the Celtics' second seeding game, Tatum handed out a career-high eight assists in a win over Portland; a few games later, he dished out six against Orlando. This season coaches say his passing out of double teams has improved.

Leadership, at least the vocal kind, doesn't come naturally to Tatum, but there have been strides there, too. After his rookie season, Tatum worked out with Bryant. Growing up, Tatum idolized Bryant. He studied his game religiously. (Celtics coaches privately grumbled that when ESPN released an episode of *Details*, a Bryant-helmed show that took a deep dive into players, during the 2018 conference finals against the Cavs, Tatum attempted to implement Bryant's suggestions mid-series.) But the thing that really stuck with Tatum was a conversation. Bryant recalled how San Antonio had created a special trap to flummox him in the mid-post. To beat it, Bryant would reposition the Lakers' big men so they would be open when the Spurs deployed the defense. The lesson: *Good players can beat their man. The best beat the other team.*

That's the kind of leadership Boston is looking for. "We're asking him to share what he sees," says Stevens. The rest is by example. As much as Tatum has accomplished, there is more to unlock. After the 2018–19 season,

Tatum worked on adding a side-step three; he shot 43.0% on those last season, an NBA best. Analytics suggest his best shots come off isolations, slot drives and post-ups. But Tatum is growing more comfortable with downhill pick-and-roll threes, while Boston envisions him eventually thriving in catch-and-shoot situations. Hanlen says that a focus during the brief off-season was getting to the free-throw line more. "He'll lead the NBA in scoring someday," says Hanlen. "You will be able to run a championship offense through him."

Basketball, though, is no longer Tatum's singular focus. His son, Jayson Jr.—Deuce, as he is known—was born during Tatum's rookie season. Cole recalls the early-morning phone call in 2017 when an 18-year-old Tatum told her that he was going to be a father. "I think he expected me to go crazy," says Cole. But Cole flashed back to her own experience, how the support of her family helped her through it. "The last thing he needed was for me to go off," says Cole. "I told him it would all work out."

And it has. Deuce is a fixture at Celtics games. (Tatum and Deuce's mother, Toriah Lachell, maintain a healthy coparenting relationship.) A video of the two celebrating Tatum's first All-Star selection went viral last January, as did footage of the two reuniting in the NBA bubble after Brandy brought him to Florida. When Tatum agreed to a five-year, $195 million extension in November, Deuce was there to watch him sign the contract. He's become an inspiration. "[Jayson] says all the time, when Deuce gets older, he wants him to say, 'My dad is cold,'" says Hanlen.

He's his motivation, just like Jayson was to Brandy. Around the house, Brandy likes to grumble that Jayson cost her a college experience. Tatum's favorite punch line: "I think it all worked out."

It did. Thanks, Mom. ●

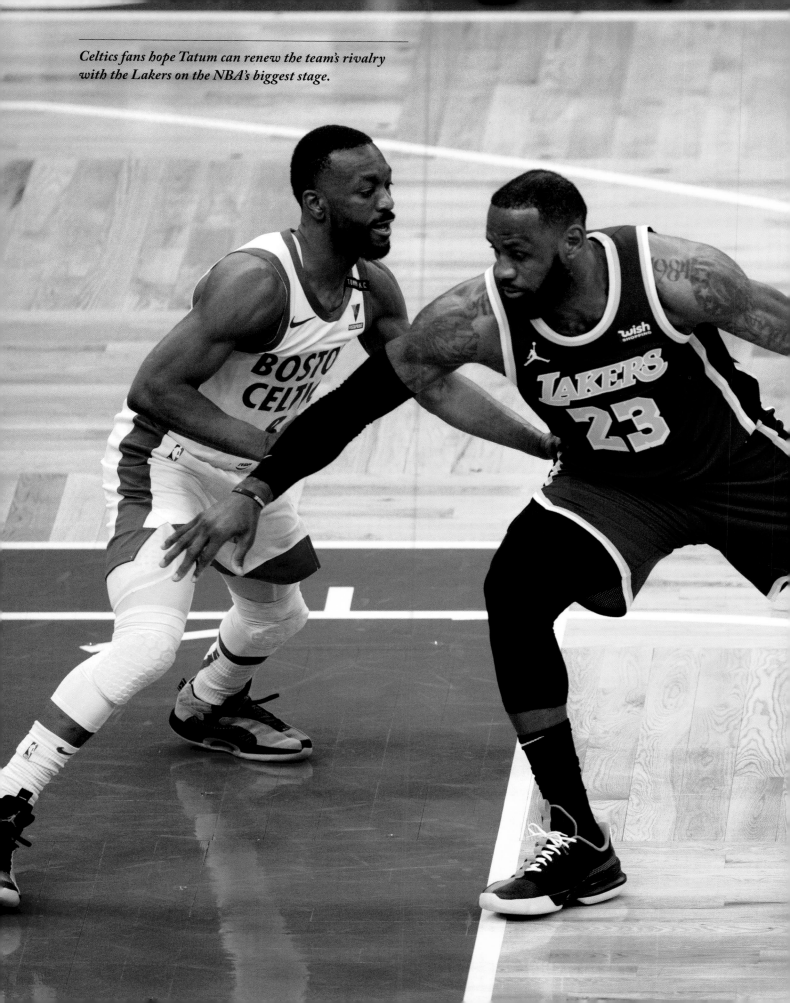

Celtics fans hope Tatum can renew the team's rivalry with the Lakers on the NBA's biggest stage.

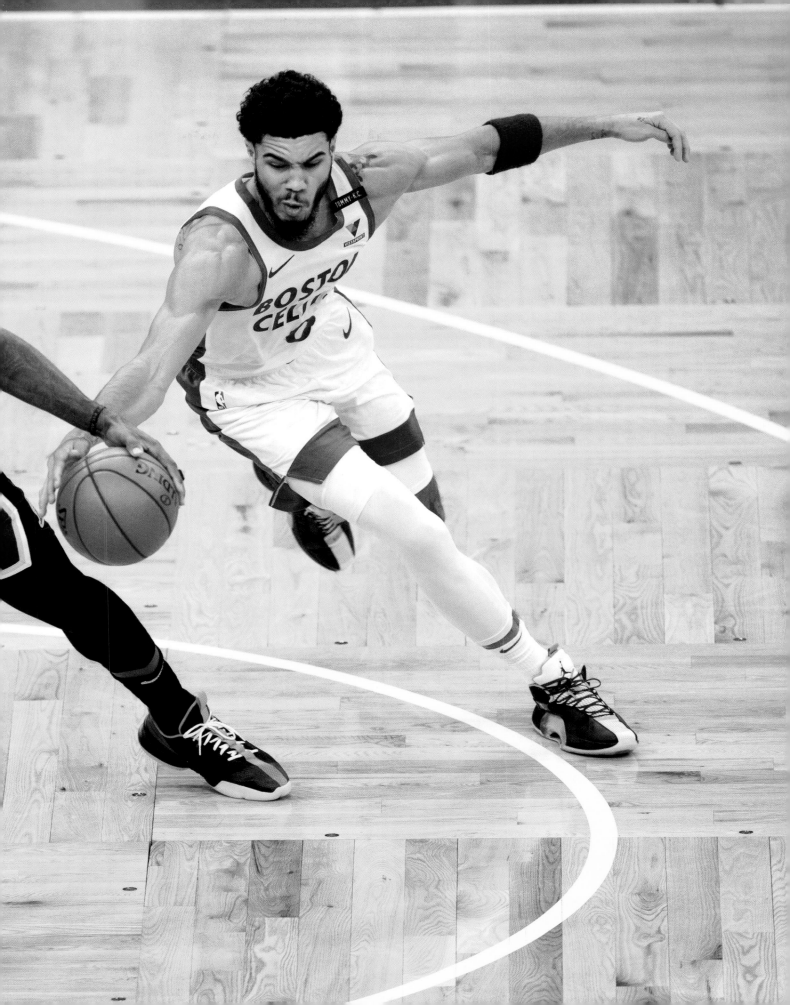

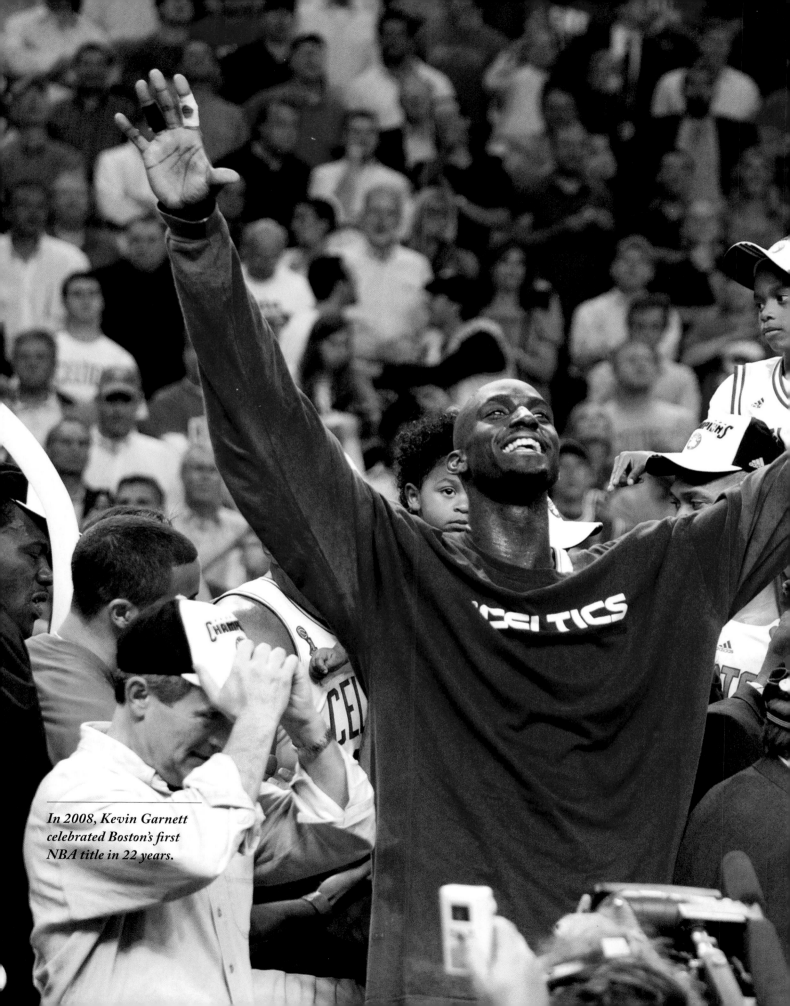

In 2008, Kevin Garnett celebrated Boston's first NBA title in 22 years.

THE CHAMPIONSHIPS

No team has won more NBA titles than the Celtics' total of 17. Those championship runs have been full of memorable moments

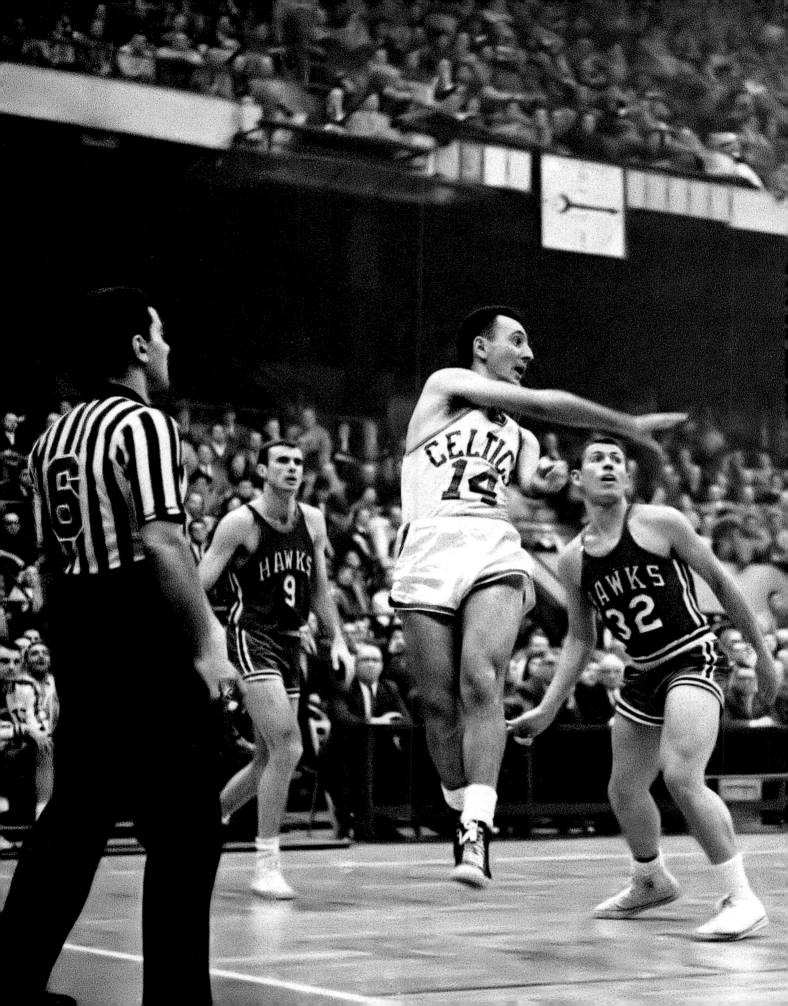

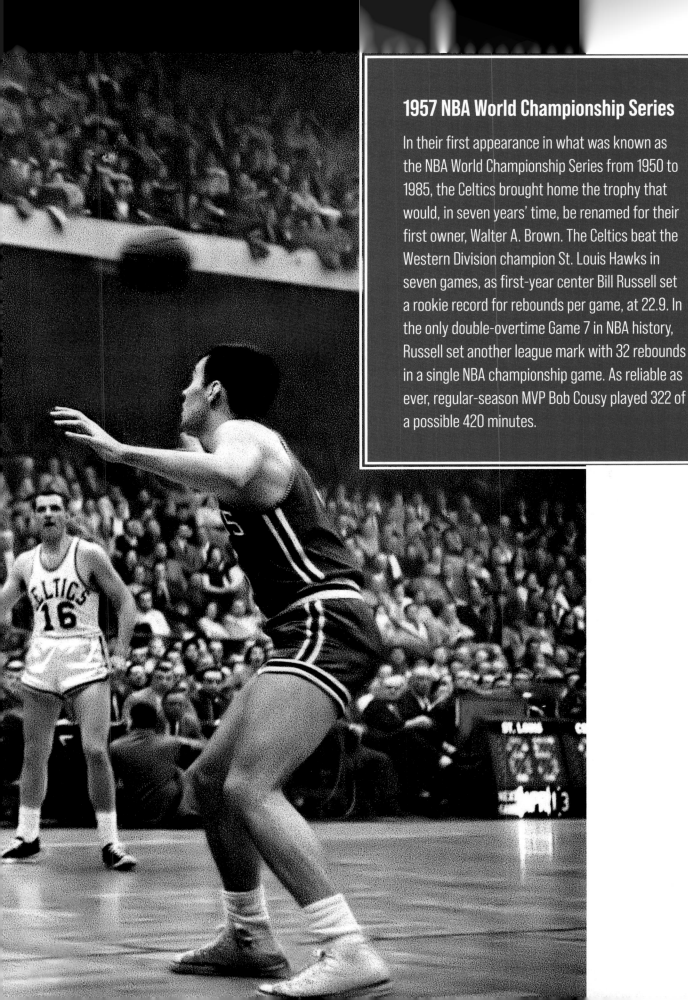

1957 NBA World Championship Series

In their first appearance in what was known as the NBA World Championship Series from 1950 to 1985, the Celtics brought home the trophy that would, in seven years' time, be renamed for their first owner, Walter A. Brown. The Celtics beat the Western Division champion St. Louis Hawks in seven games, as first-year center Bill Russell set a rookie record for rebounds per game, at 22.9. In the only double-overtime Game 7 in NBA history, Russell set another league mark with 32 rebounds in a single NBA championship game. As reliable as ever, regular-season MVP Bob Cousy played 322 of a possible 420 minutes.

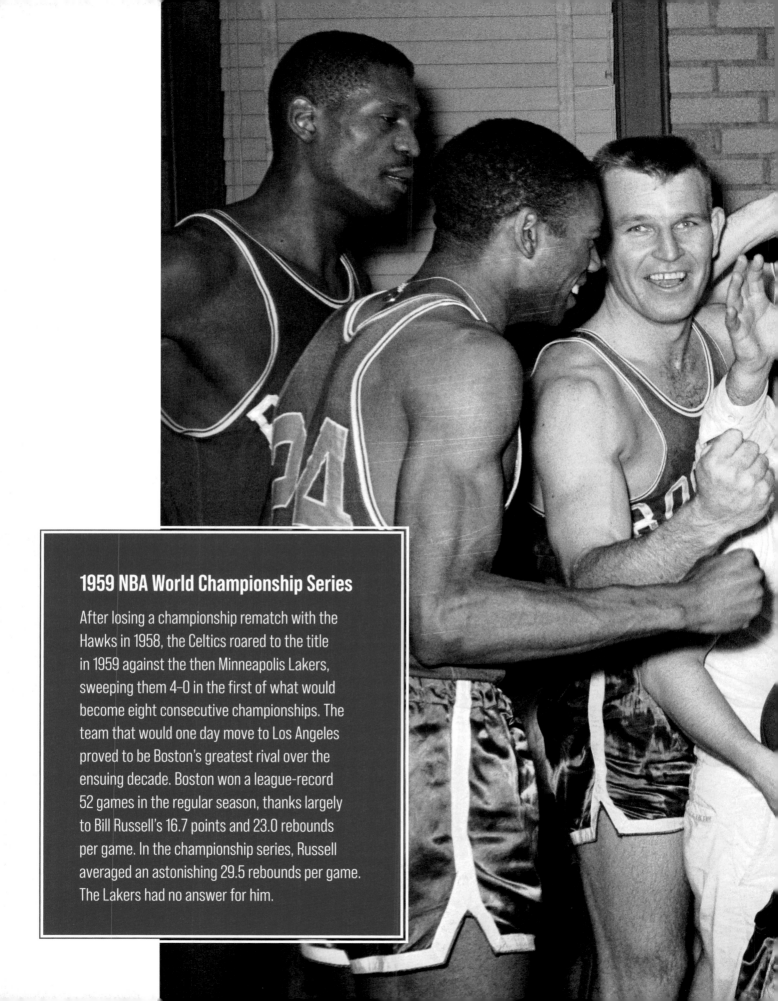

1959 NBA World Championship Series

After losing a championship rematch with the Hawks in 1958, the Celtics roared to the title in 1959 against the then Minneapolis Lakers, sweeping them 4–0 in the first of what would become eight consecutive championships. The team that would one day move to Los Angeles proved to be Boston's greatest rival over the ensuing decade. Boston won a league-record 52 games in the regular season, thanks largely to Bill Russell's 16.7 points and 23.0 rebounds per game. In the championship series, Russell averaged an astonishing 29.5 rebounds per game. The Lakers had no answer for him.

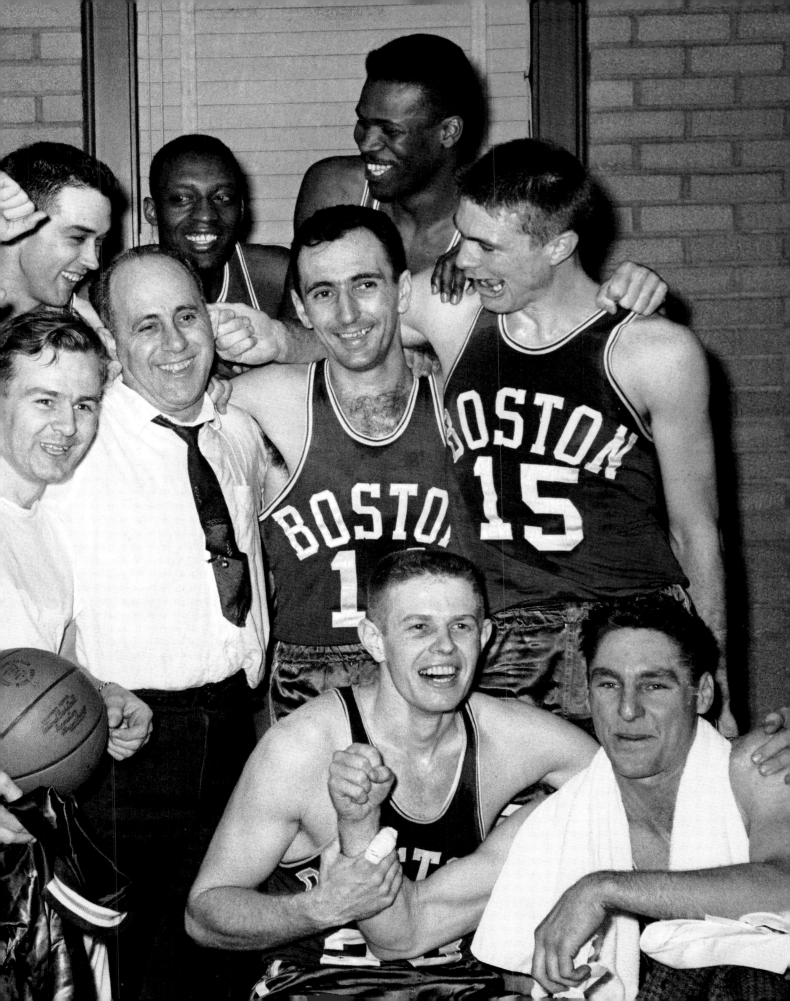

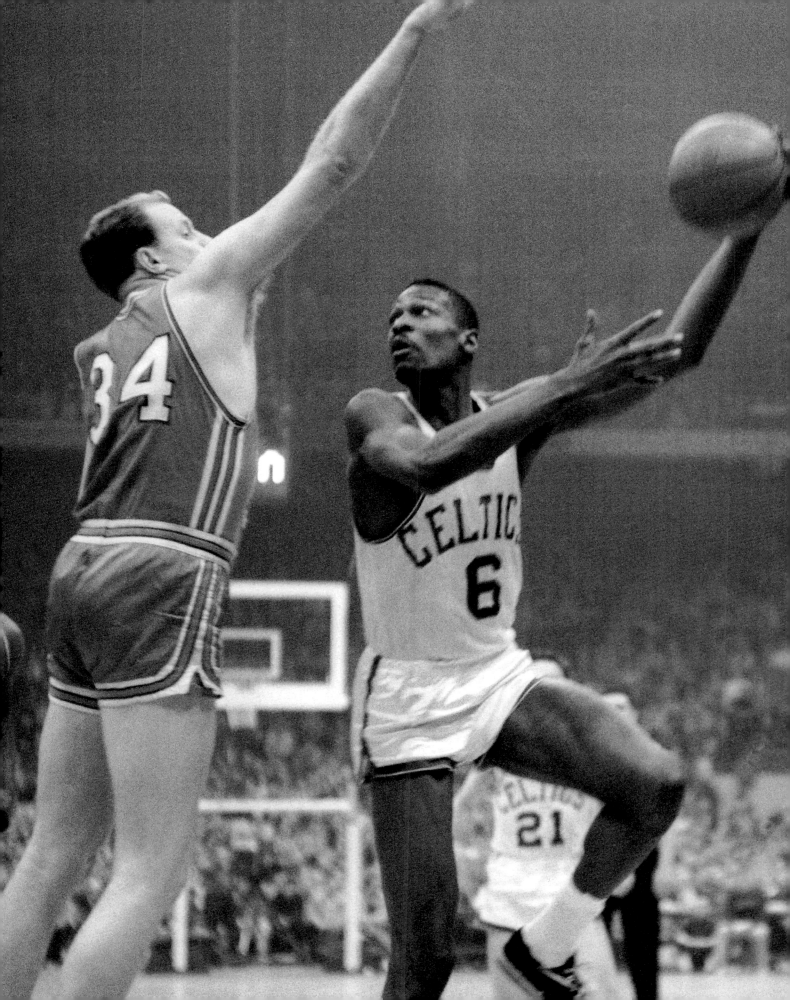

1960 NBA World Championship Series

In another championship showdown with the St. Louis Hawks, the Celtics exacted their revenge for their loss in 1958. The series featured 13 future Hall of Fame members in all. Boston had bested its own regular-season wins record from 1959, this time boasting 59, including a run of 17 straight. Bill Russell continued to push the limits of what the league thought was possible in rebounding, grabbing a final-series-record 40 rebounds in Game 2, a feat he would repeat in 1962. In the deciding Game 7, which Boston won 122–103, Russell scored 22 points and brought down 35 rebounds.

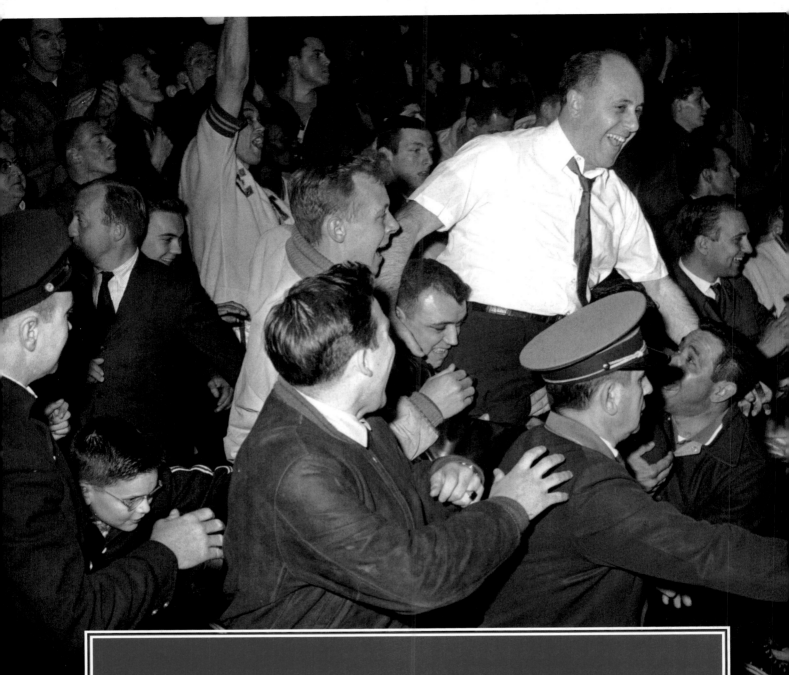

1961 NBA World Championship Series

The Celtics met the St. Louis Hawks in the championship series for the fourth and final time in 1961. Winning the series in five, Boston improved its championship record against the Hawks to 3–1. Unlike the Hawks, who saw more than half of their 543 total points come from two players—Cliff Hagan and Bob Pettit—four Celtics players had 75 or more points in the series. Bill Russell totaled his highest career postseason rebounding average, with 29.9 per game. With their third straight NBA title and fourth overall, the Celtics announced to the rest of the league that a dynasty had arrived.

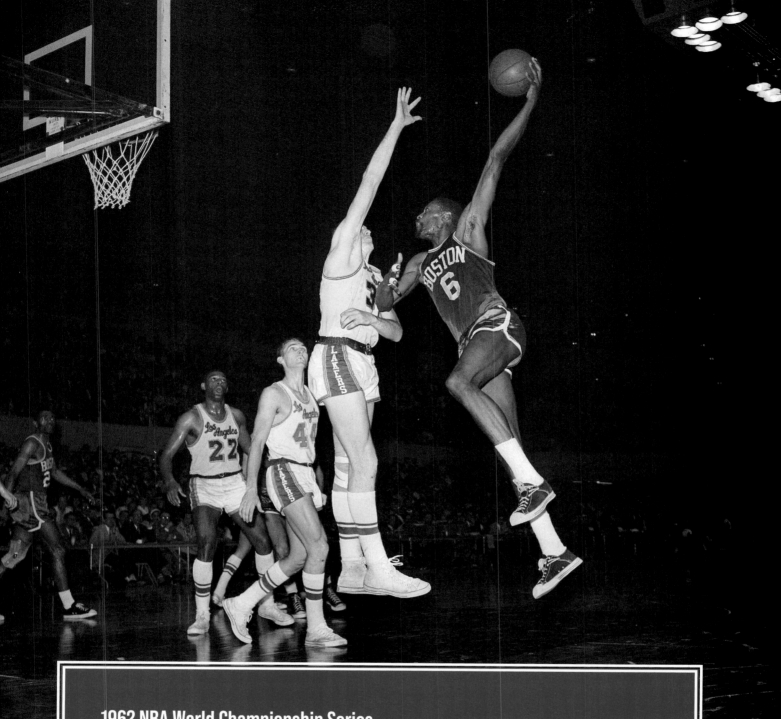

1962 NBA World Championship Series

In 1962, the Celtics faced the Los Angeles Lakers for the first of six championship meetings in the '60s alone. Boston's sixth straight trip to the final series went to seven games, a common result when these two vied for a title. For the second time in NBA—and Celtics franchise—history, the series was decided by overtime in Game 7. (Boston went to double-overtime against St. Louis in 1957.) After forwards Jim Loscutoff, Tom Heinsohn, Tom "Satch" Sanders and Frank Ramsey fouled out, Bill Russell got the job done in the 110–107 clincher, tallying 30 points and tying his own rebounds record, with 40.

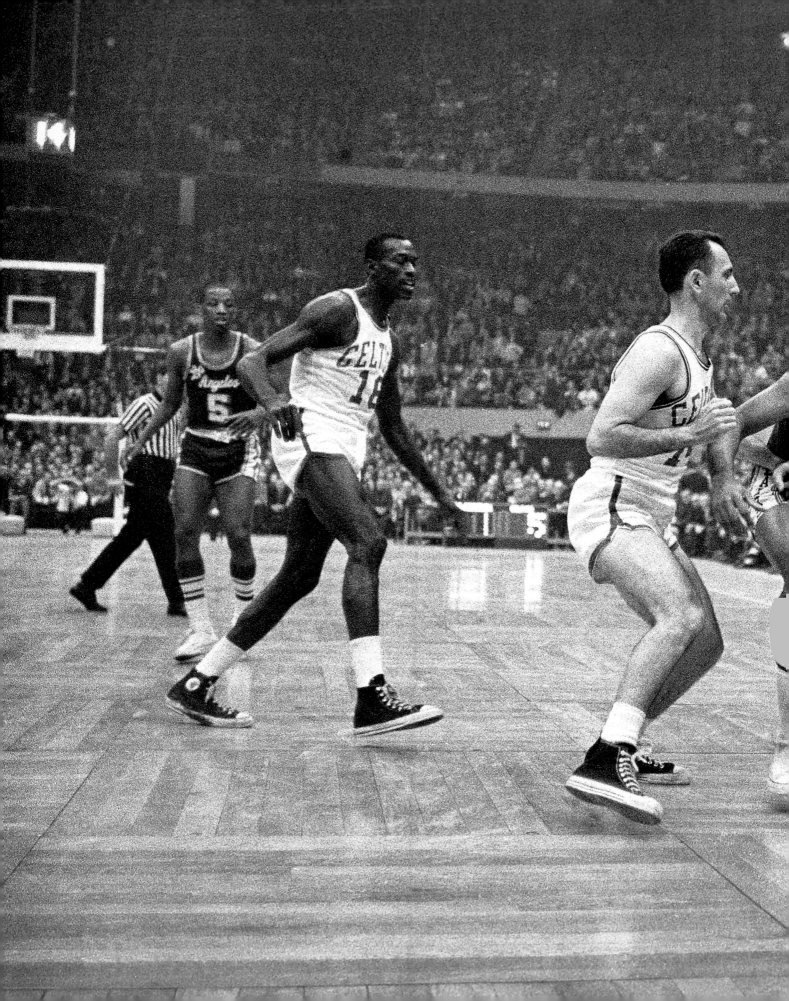

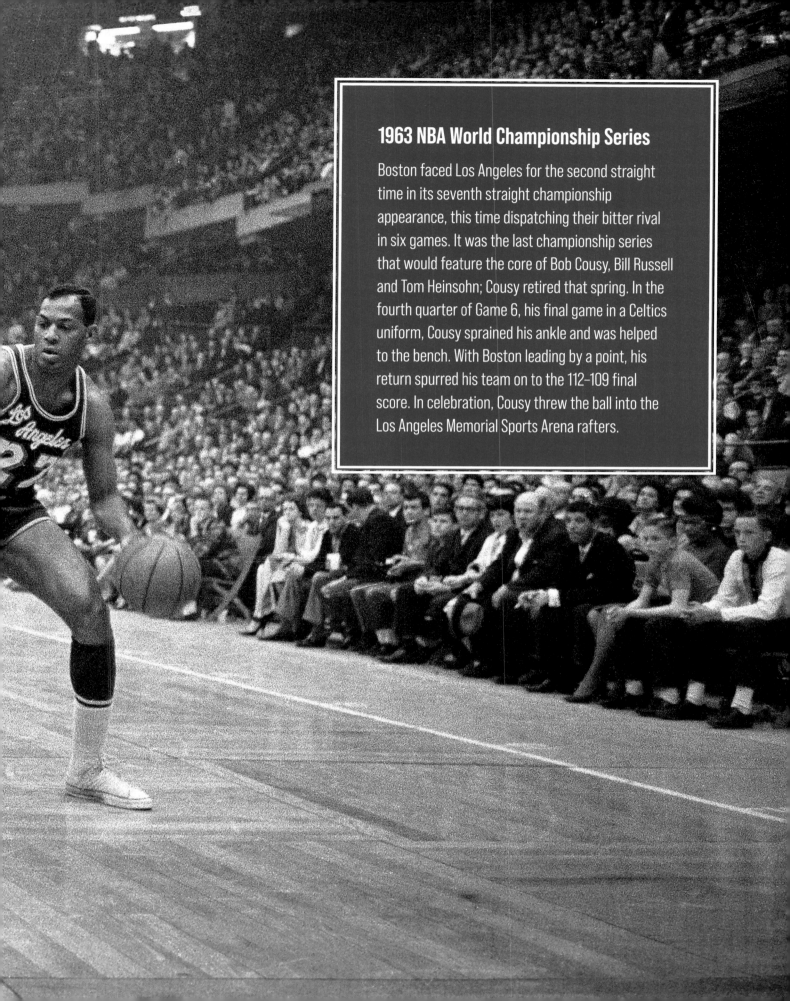

1963 NBA World Championship Series

Boston faced Los Angeles for the second straight time in its seventh straight championship appearance, this time dispatching their bitter rival in six games. It was the last championship series that would feature the core of Bob Cousy, Bill Russell and Tom Heinsohn; Cousy retired that spring. In the fourth quarter of Game 6, his final game in a Celtics uniform, Cousy sprained his ankle and was helped to the bench. With Boston leading by a point, his return spurred his team on to the 112–109 final score. In celebration, Cousy threw the ball into the Los Angeles Memorial Sports Arena rafters.

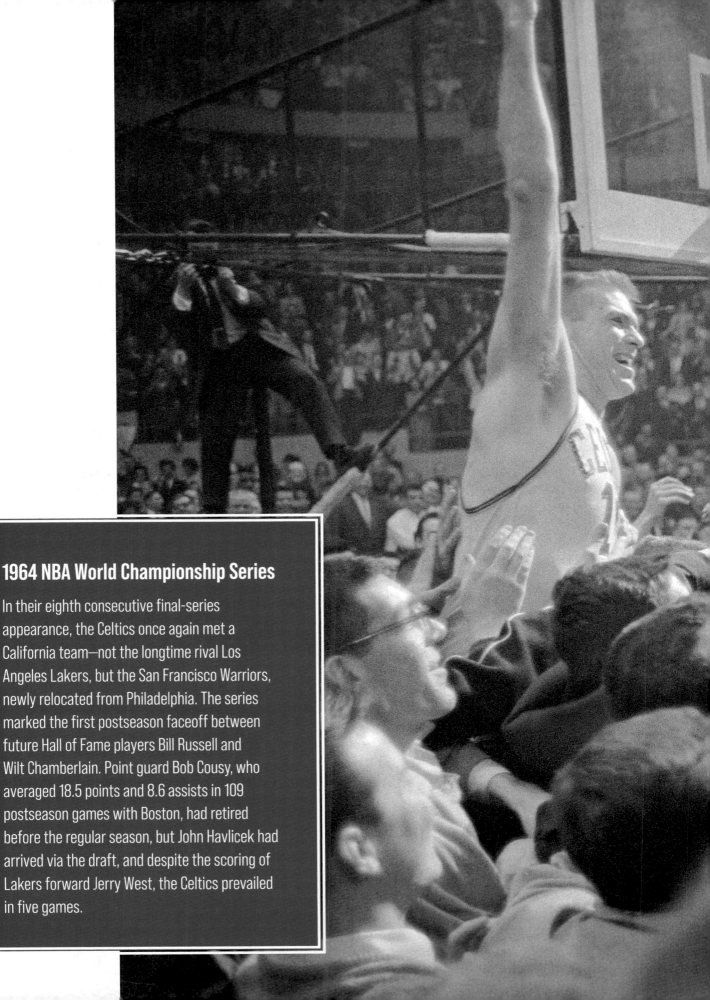

1964 NBA World Championship Series

In their eighth consecutive final-series appearance, the Celtics once again met a California team—not the longtime rival Los Angeles Lakers, but the San Francisco Warriors, newly relocated from Philadelphia. The series marked the first postseason faceoff between future Hall of Fame players Bill Russell and Wilt Chamberlain. Point guard Bob Cousy, who averaged 18.5 points and 8.6 assists in 109 postseason games with Boston, had retired before the regular season, but John Havlicek had arrived via the draft, and despite the scoring of Lakers forward Jerry West, the Celtics prevailed in five games.

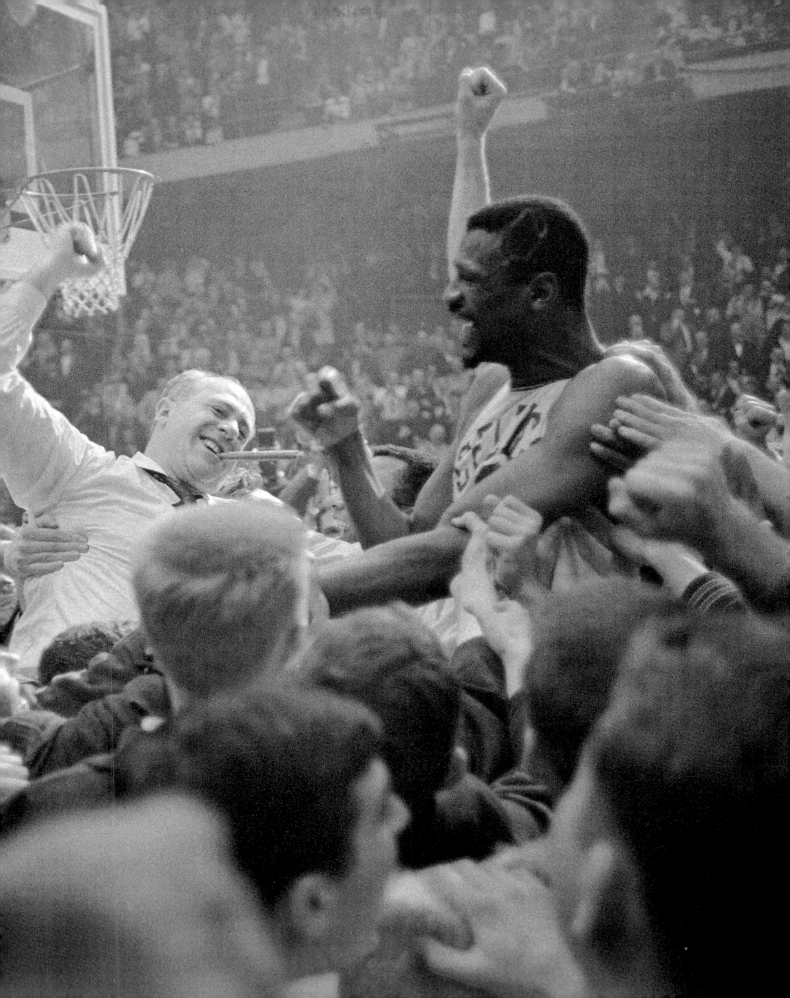

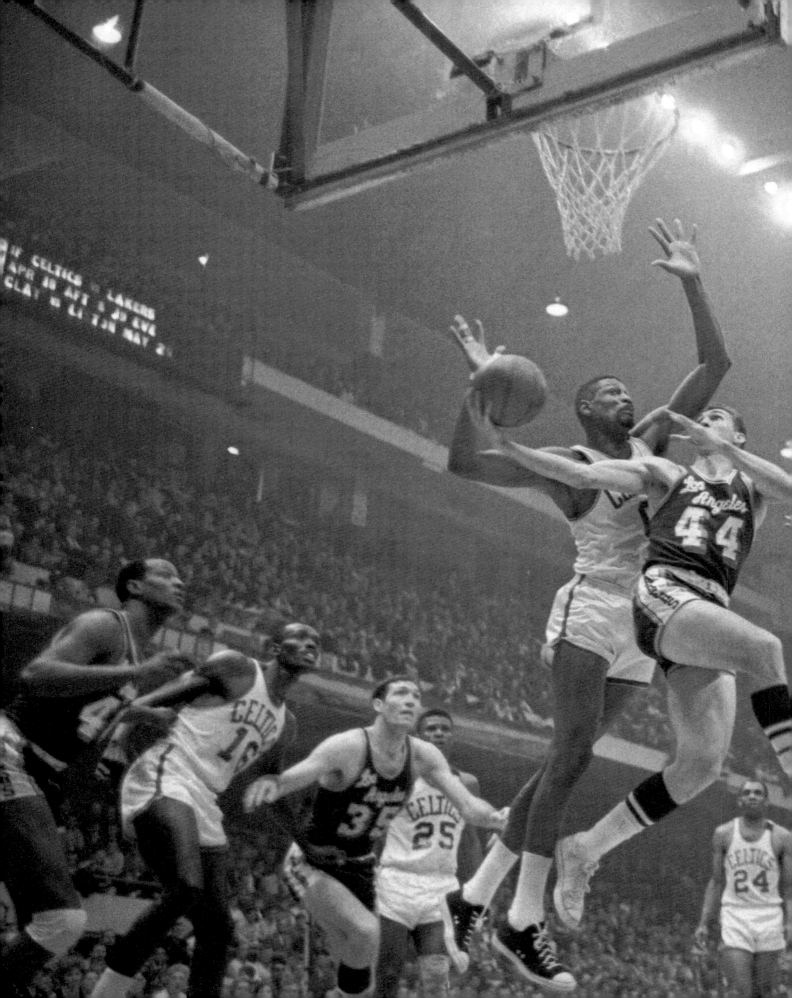

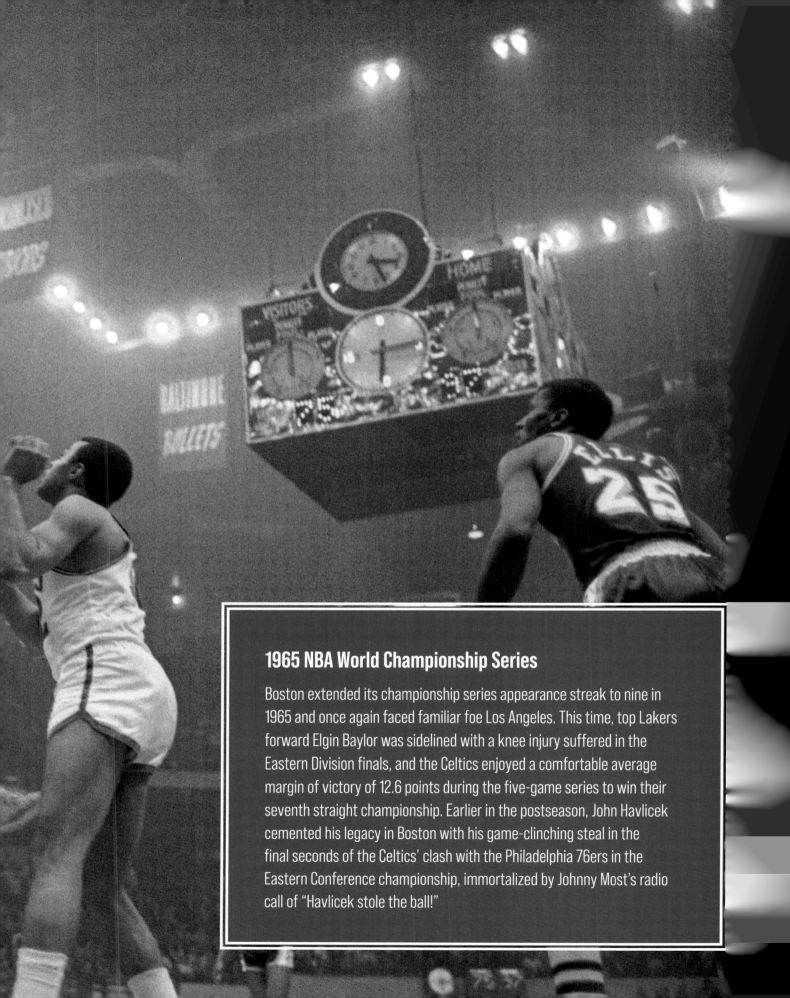

1965 NBA World Championship Series

Boston extended its championship series appearance streak to nine in 1965 and once again faced familiar foe Los Angeles. This time, top Lakers forward Elgin Baylor was sidelined with a knee injury suffered in the Eastern Division finals, and the Celtics enjoyed a comfortable average margin of victory of 12.6 points during the five-game series to win their seventh straight championship. Earlier in the postseason, John Havlicek cemented his legacy in Boston with his game-clinching steal in the final seconds of the Celtics' clash with the Philadelphia 76ers in the Eastern Conference championship, immortalized by Johnny Most's radio call of "Havlicek stole the ball!"

1966 NBA World Championship Series

The Celtics notched their 10th consecutive final-series appearance in 1966, tying a North American professional sports record. In yet another showdown against the Lakers, the Celtics were ready to close out the series in Game 5. However, the Lakers rallied and took the Celtics all the way to Game 7; no NBA team would overcome a series deficit that large again until the Cleveland Cavaliers in 2016. The series marked Red Auerbach's last as the head coach in Boston before handing the team over to newly announced player-coach Bill Russell. It was Boston's eighth consecutive NBA title; to this day, no other North American sports team has matched that feat.

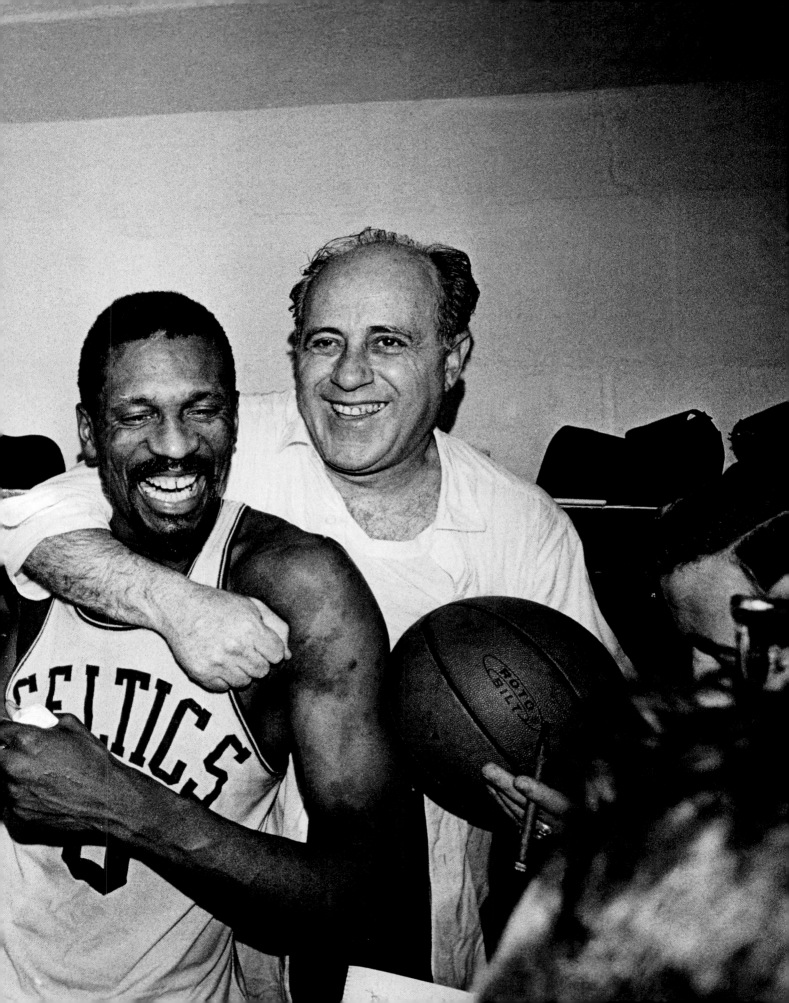

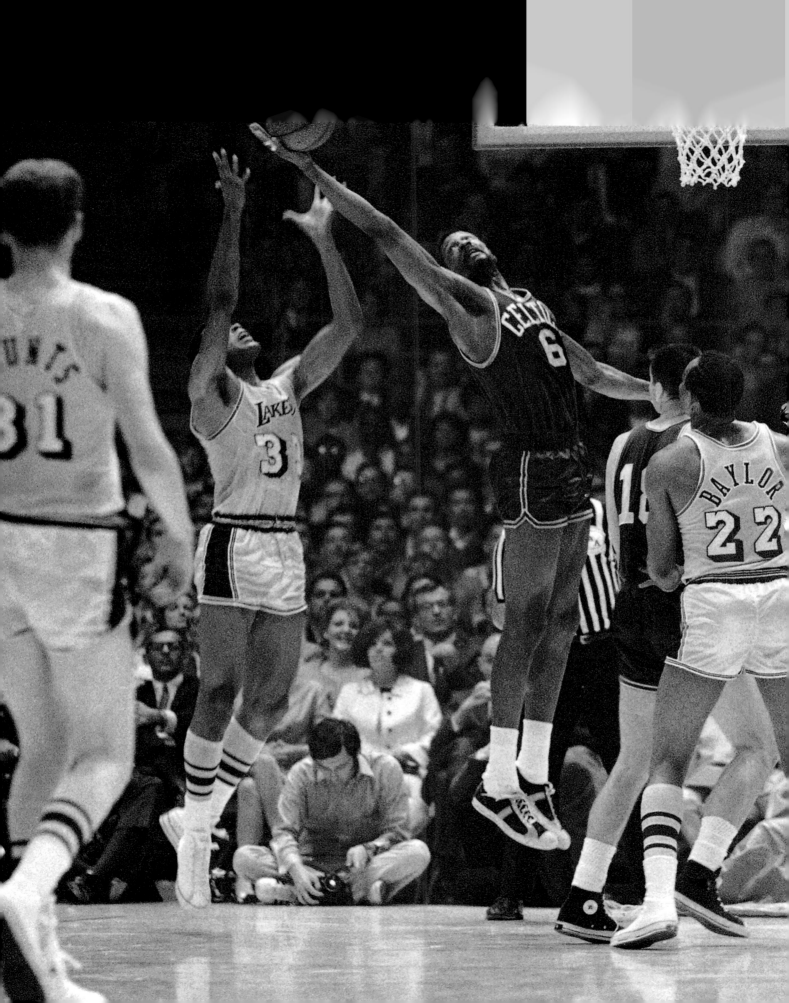

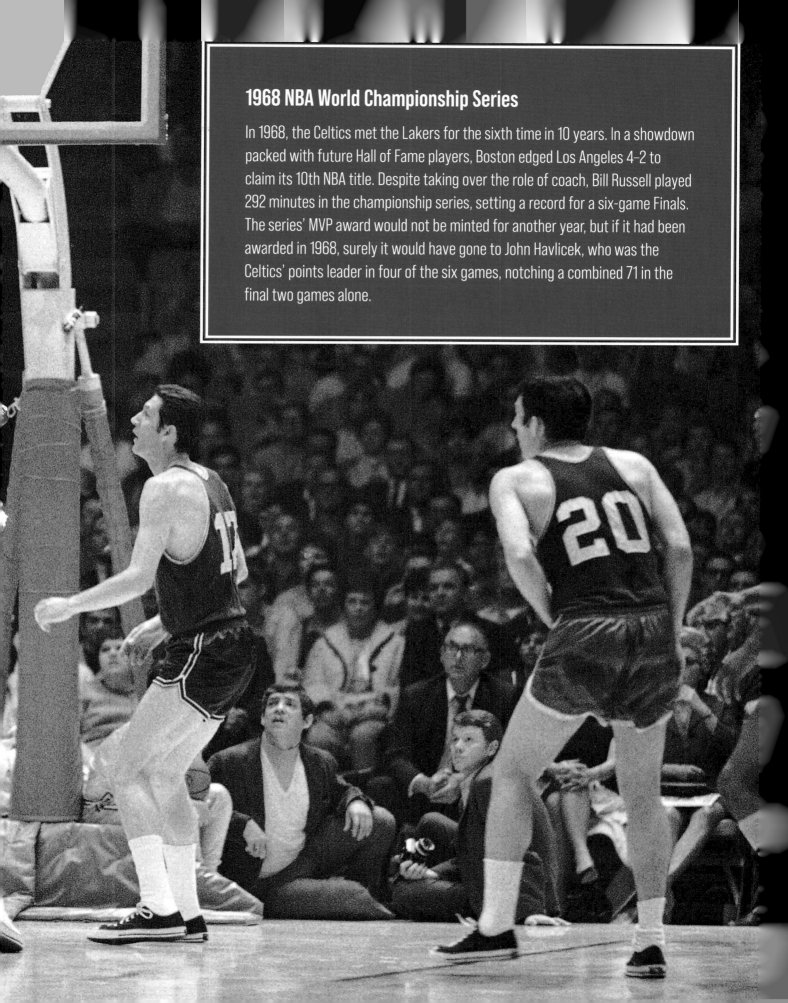

1968 NBA World Championship Series

In 1968, the Celtics met the Lakers for the sixth time in 10 years. In a showdown packed with future Hall of Fame players, Boston edged Los Angeles 4–2 to claim its 10th NBA title. Despite taking over the role of coach, Bill Russell played 292 minutes in the championship series, setting a record for a six-game Finals. The series' MVP award would not be minted for another year, but if it had been awarded in 1968, surely it would have gone to John Havlicek, who was the Celtics' points leader in four of the six games, notching a combined 71 in the final two games alone.

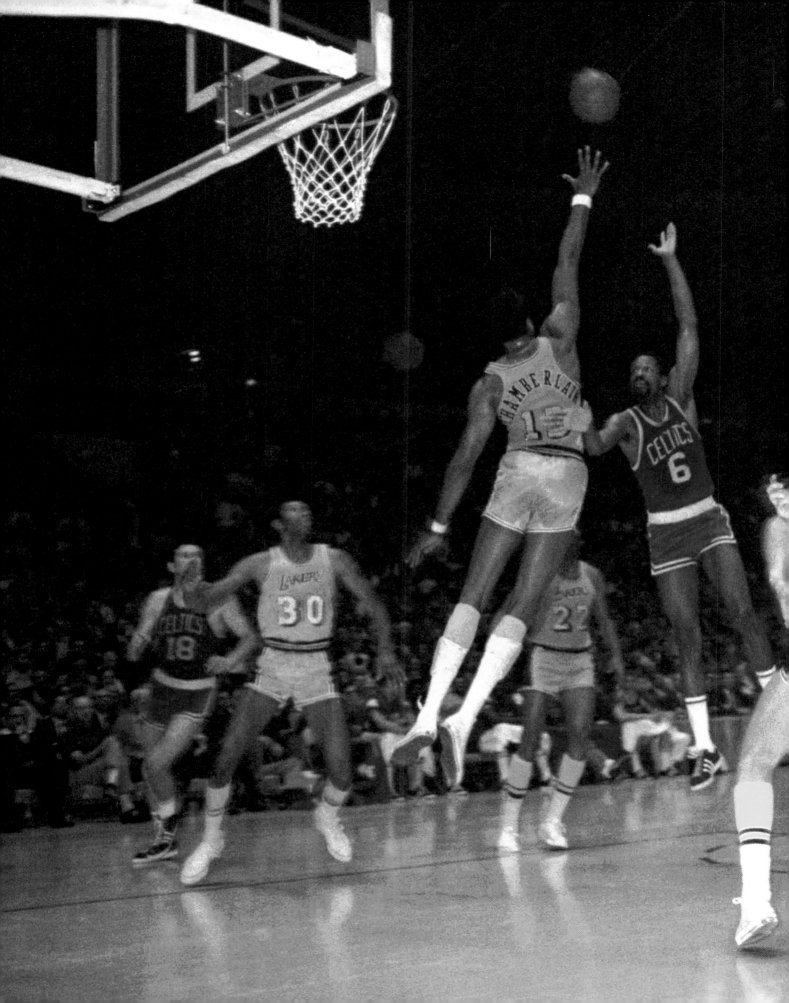

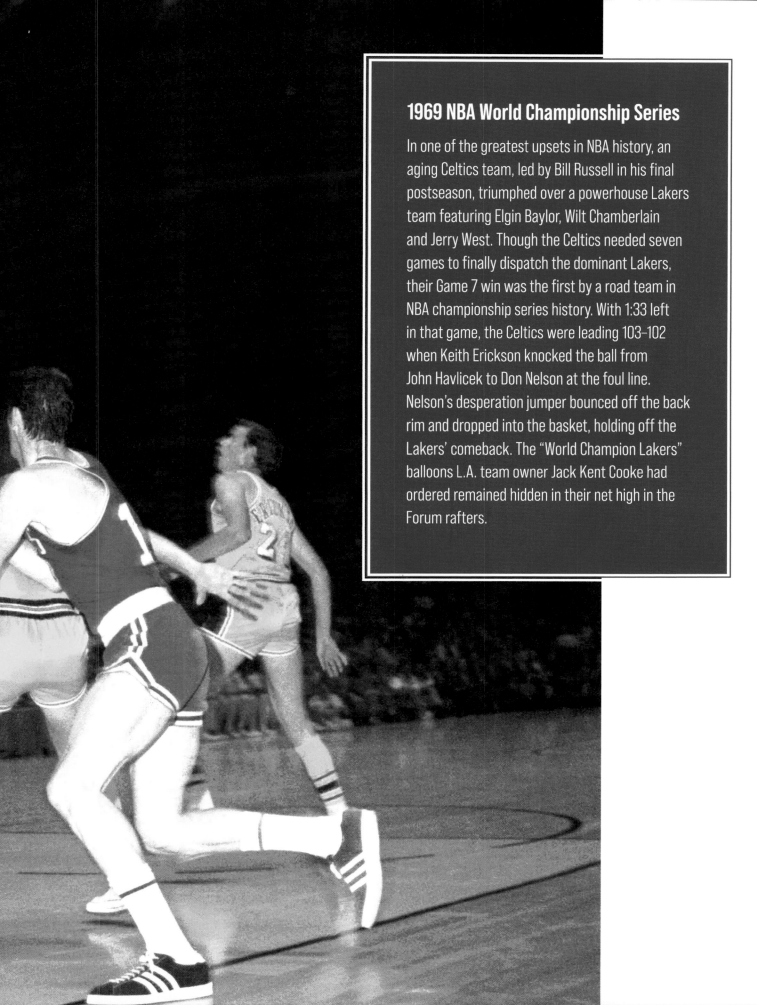

1969 NBA World Championship Series

In one of the greatest upsets in NBA history, an aging Celtics team, led by Bill Russell in his final postseason, triumphed over a powerhouse Lakers team featuring Elgin Baylor, Wilt Chamberlain and Jerry West. Though the Celtics needed seven games to finally dispatch the dominant Lakers, their Game 7 win was the first by a road team in NBA championship series history. With 1:33 left in that game, the Celtics were leading 103–102 when Keith Erickson knocked the ball from John Havlicek to Don Nelson at the foul line. Nelson's desperation jumper bounced off the back rim and dropped into the basket, holding off the Lakers' comeback. The "World Champion Lakers" balloons L.A. team owner Jack Kent Cooke had ordered remained hidden in their net high in the Forum rafters.

1974 NBA World Championship Series

The Celtics failed to capitalize on a title in 1973 after winning a franchise-record 68 games in the regular season, largely due to a John Havlicek shoulder injury. But in 1974, a healthy Havlicek, along with future Hall of Fame players Dave Cowens and Jo Jo White, dispatched the Buffalo Braves and New York Knicks en route to a championship meeting with Kareem Abdul-Jabbar and the Milwaukee Bucks. Though the Bucks took the Celtics to seven games, Boston prevailed for its first championship in the post–Bill Russell era. Havlicek was indeed the missing piece, scoring 185 points and earning series MVP honors.

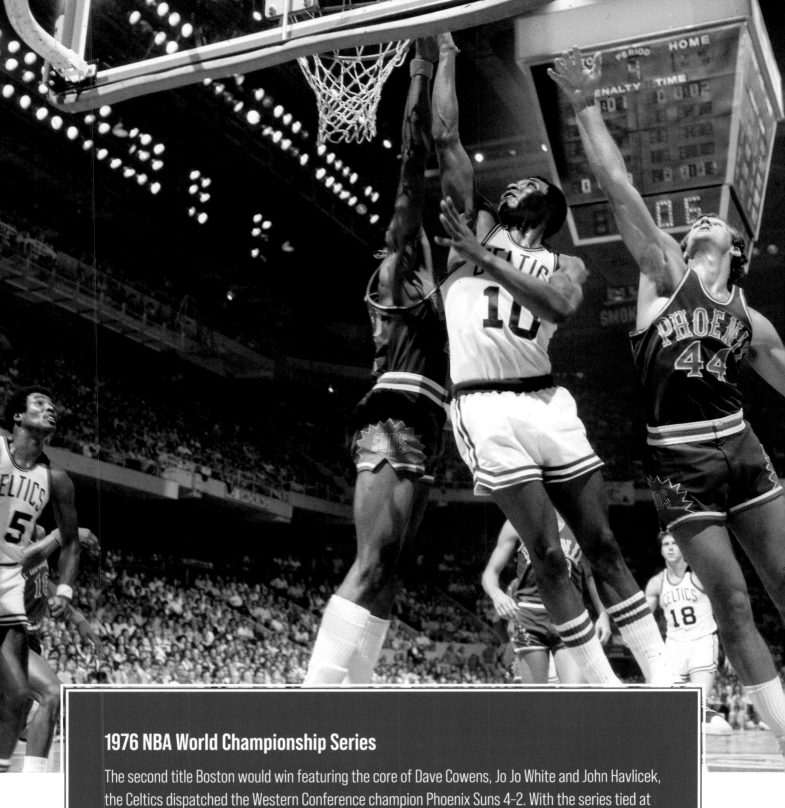

1976 NBA World Championship Series

The second title Boston would win featuring the core of Dave Cowens, Jo Jo White and John Havlicek, the Celtics dispatched the Western Conference champion Phoenix Suns 4–2. With the series tied at two apiece, Boston edged Phoenix 128–126 in triple-overtime in Game 5, a contest often referred to as the "Greatest Game Ever Played." Series MVP White led Boston to its 13th NBA title with 130 points in six games, and the Celtics became the last team to win the original Walter A. Brown trophy prior to the introduction of the Larry O'Brien Championship Trophy.

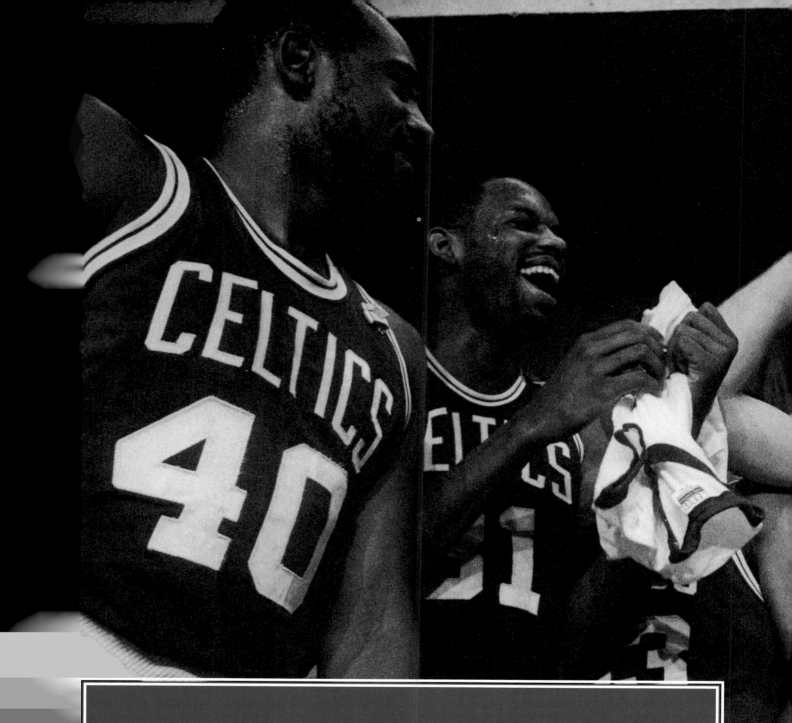

1981 NBA World Championship Series

The Celtics, led by the "Big Three" of Larry Bird, Robert Parish and Kevin McHale, embarked upon a new era of postseason success in 1981 following the retirement of Dave Cowens and Jo Jo White, who helped lead the team to its last title in 1976. In the first of two championship meetings with the Houston Rockets in the 1980s, Boston figured as a heavy favorite, having defeated Houston in 12 straight, including sweeping them 4–0 in the previous postseason. However, the Rockets forced the Celtics to six games as Bird struggled offensively after Game 1. In the end, series MVP Cedric Maxwell stepped up and brought the title back to Boston.

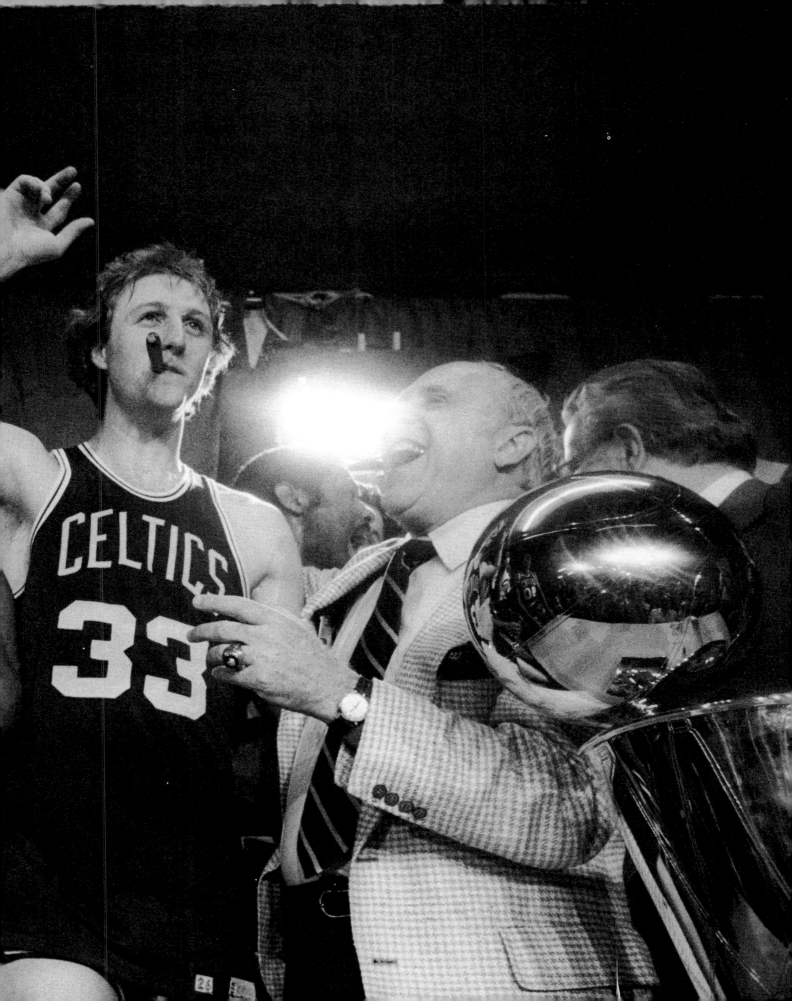

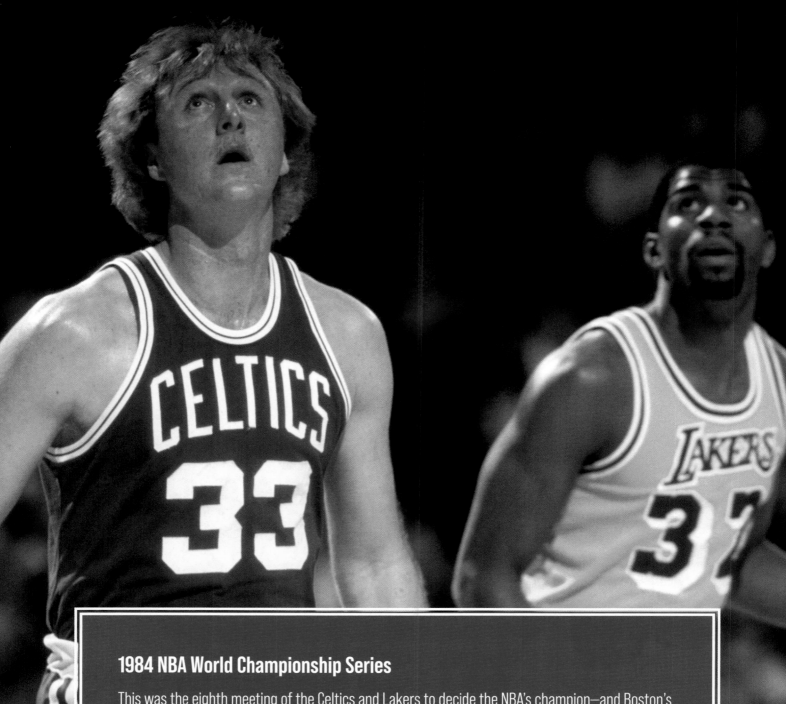

1984 NBA World Championship Series

This was the eighth meeting of the Celtics and Lakers to decide the NBA's champion—and Boston's eighth consecutive victory. Larry Bird, who averaged 27 points and 14 rebounds per game during the series, became the third player in NBA history to be named regular-season MVP and Finals MVP in the same season. After Los Angeles trounced Boston 137–104 in Game 3—the worst playoff loss in franchise history to that point, prompting Bird to publicly call out his teammates—the Celtics roared back to win the next two, persevering through 97-degree temps at a sweltering Boston Garden in Game 5. In Game 7, with the Lakers knocking on the door, Cedric Maxwell knocked the ball away from Magic Johnson in the final minute to seal the championship.

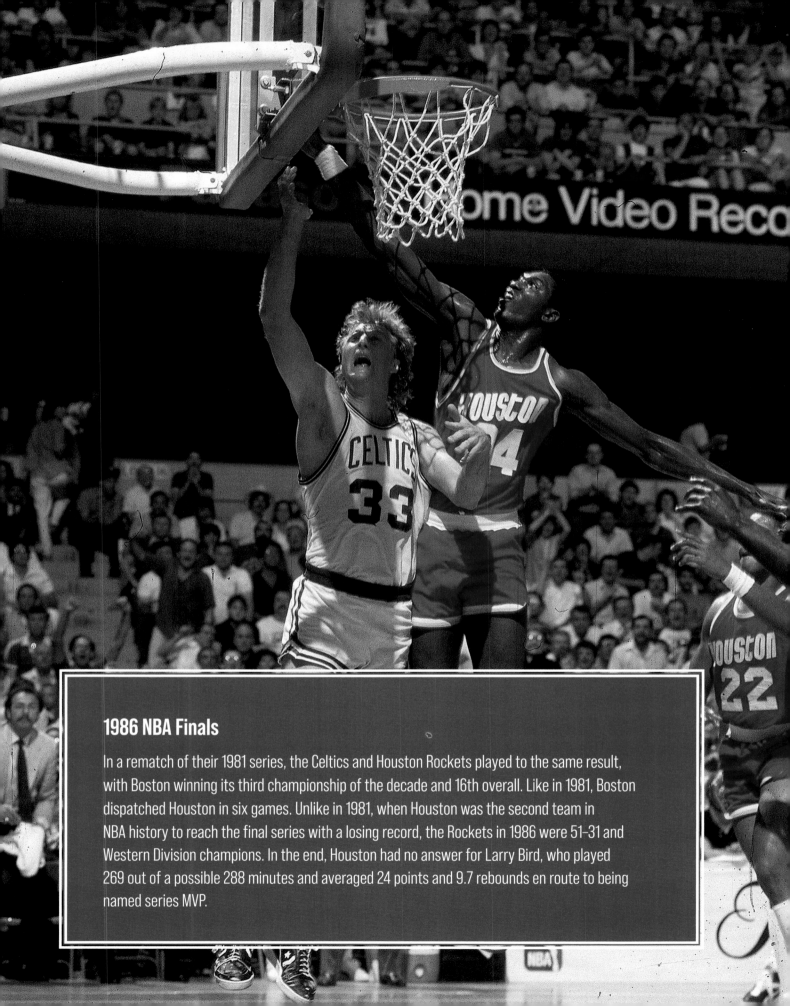

1986 NBA Finals

In a rematch of their 1981 series, the Celtics and Houston Rockets played to the same result, with Boston winning its third championship of the decade and 16th overall. Like in 1981, Boston dispatched Houston in six games. Unlike in 1981, when Houston was the second team in NBA history to reach the final series with a losing record, the Rockets in 1986 were 51–31 and Western Division champions. In the end, Houston had no answer for Larry Bird, who played 269 out of a possible 288 minutes and averaged 24 points and 9.7 rebounds en route to being named series MVP.

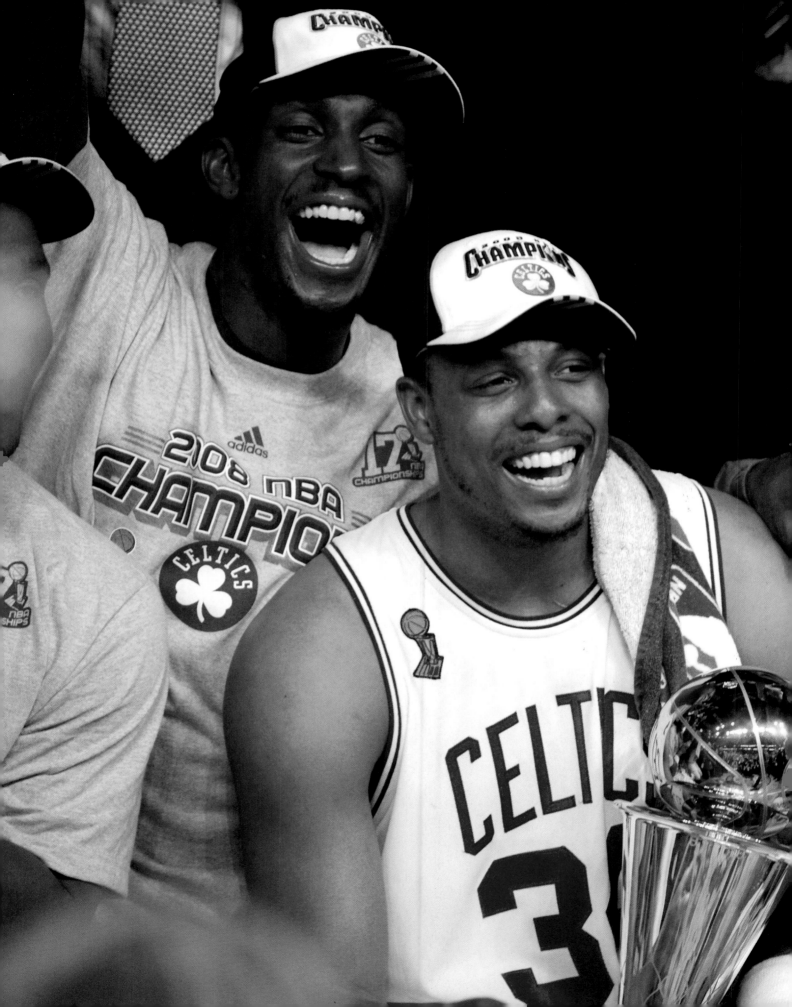

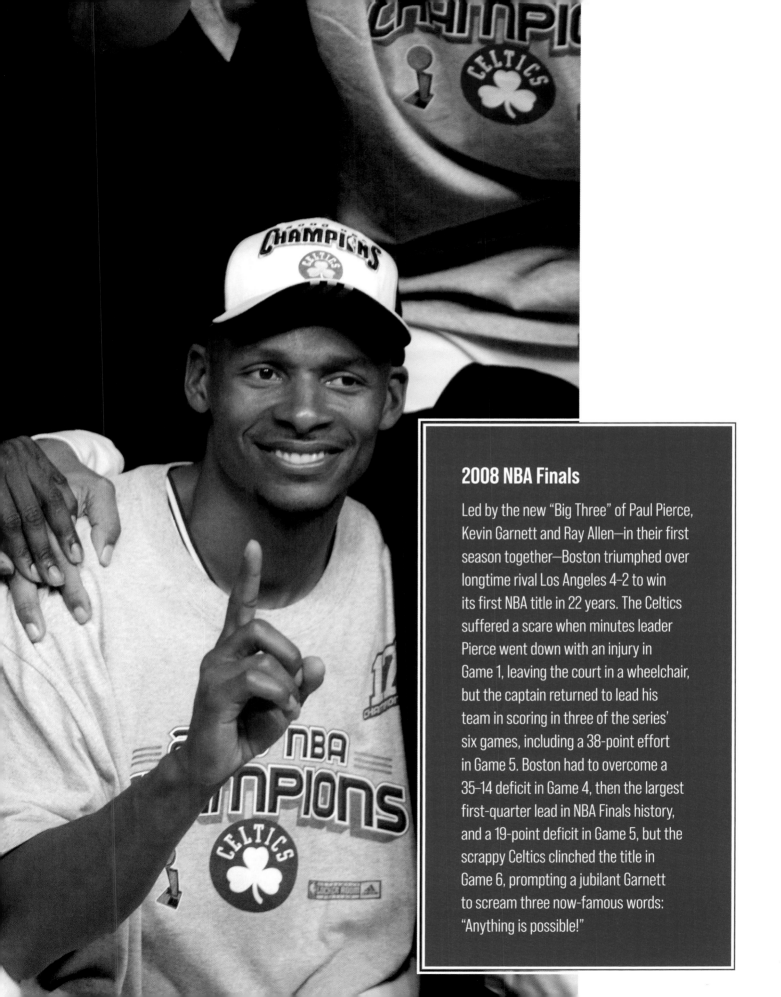

2008 NBA Finals

Led by the new "Big Three" of Paul Pierce, Kevin Garnett and Ray Allen—in their first season together—Boston triumphed over longtime rival Los Angeles 4–2 to win its first NBA title in 22 years. The Celtics suffered a scare when minutes leader Pierce went down with an injury in Game 1, leaving the court in a wheelchair, but the captain returned to lead his team in scoring in three of the series' six games, including a 38-point effort in Game 5. Boston had to overcome a 35–14 deficit in Game 4, then the largest first-quarter lead in NBA Finals history, and a 19-point deficit in Game 5, but the scrappy Celtics clinched the title in Game 6, prompting a jubilant Garnett to scream three now-famous words: "Anything is possible!"

CELTICS BY THE NUMBERS

HEAD-TO-HEAD RECORD

Rk	Franchise	Games	Wins	Losses	W/L%
1	New York Knicks	481	297	184	0.617
2	Philadelphia 76ers	455	262	193	0.576
3	Atlanta Hawks	382	237	145	0.62
4	Detroit Pistons	382	243	139	0.636
5	Golden State Warriors	344	207	137	0.602
6	Washington Wizards	311	194	117	0.624
7	Sacramento Kings	305	186	119	0.61
8	Los Angeles Lakers	294	162	132	0.551
9	Chicago Bulls	233	127	106	0.545
10	Milwaukee Bucks	219	112	107	0.511

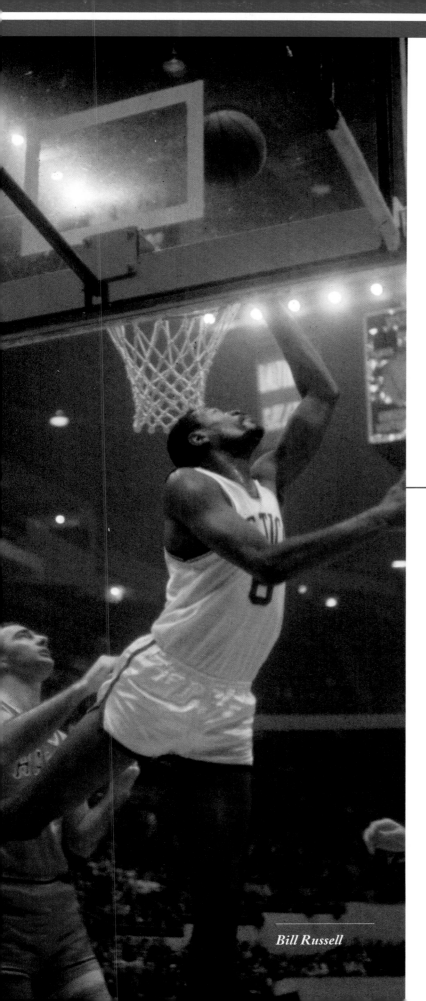

Bill Russell

CAREER POINTS

1. John Havlicek **26,395**
2. Paul Pierce **24,021**
3. Larry Bird **21,791**
4. Robert Parish **18,245**
5. Kevin McHale **17,335**
6. Bob Cousy **16,955**
7. Sam Jones **15,411**
8. Bill Russell **14,522**
9. Dave Cowens **13,192**
10. Jo Jo White **13,188**

CAREER REBOUNDS

1. Bill Russell **21,620**
2. Robert Parish **11,051**
3. Dave Cowens **10,170**
4. Larry Bird **8,974**
5. John Havlicek **8,007**
6. Kevin McHale **7,122**
7. Paul Pierce **6,651**
8. Tom Sanders **5,798**
9. Tom Heinsohn **5,749**
10. Antoine Walker **4,782**

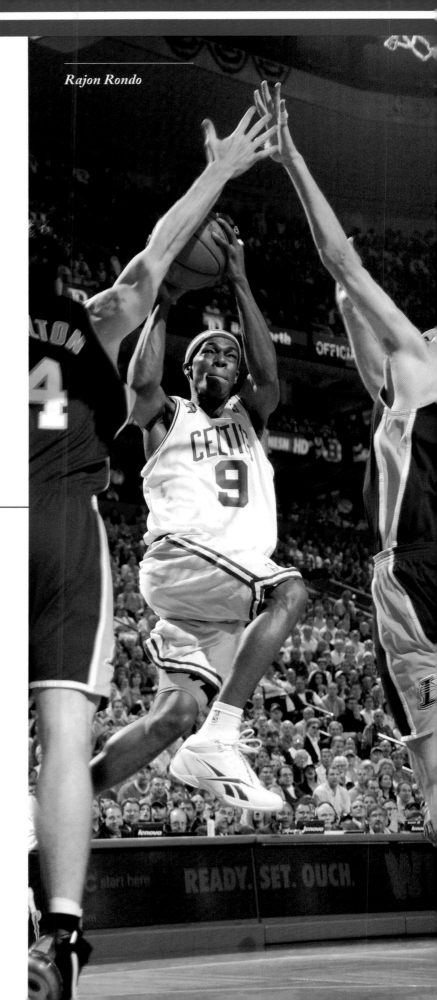

Rajon Rondo

CAREER ASSISTS

1. Bob Cousy **6,945**
2. John Havlicek **6,114**
3. Larry Bird **5,695**
4. Rajon Rondo **4,474**
5. Paul Pierce **4,305**
6. Bill Russell **4,100**
7. Jo Jo White **3,686**
8. Dennis Johnson **3,486**
9. K.C. Jones **2,908**
10. Dave Cowens **2,828**

CAREER GAMES

1. John Havlicek **1,270**
2. Robert Parish **1,106**
3. Paul Pierce **1,102**
4. Kevin McHale **971**
5. Bill Russell **963**
6. Bob Cousy **917**
7. Tom Sanders **916**
8. Larry Bird **897**
9. Don Nelson **872**
10. Sam Jones **871**

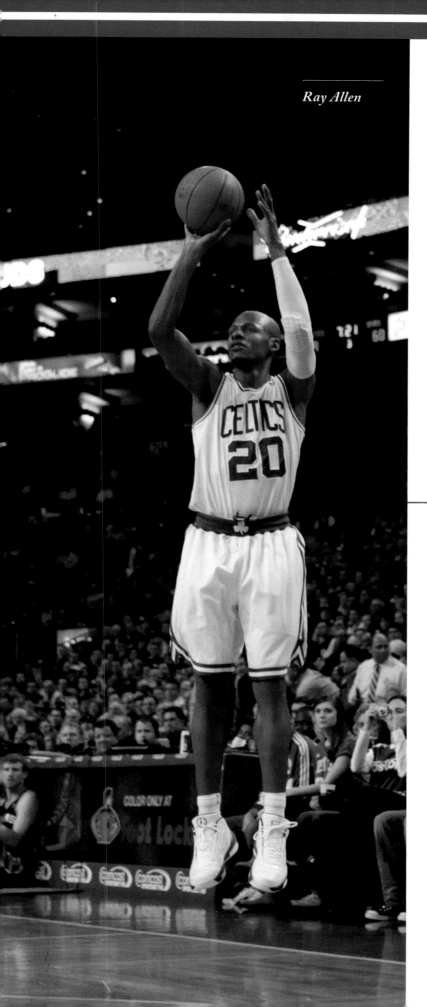

Ray Allen

CAREER THREE-POINTERS

1. Paul Pierce **1,823**
2. Antoine Walker **937**
3. Ray Allen **798**
4. Marcus Smart **677**
5. Larry Bird **649**
6. Jayson Tatum **597**
7. Jaylen Brown **554**
8. Avery Bradley **520**
9. Isaiah Thomas **460**
10. Walter McCarty **41**

CAREER STEALS

1. Paul Pierce **1,583**
2. Larry Bird **1,556**
3. Rajon Rondo **990**
4. Robert Parish **873**
5. Antoine Walker **828**
6. Marcus Smart **702**
7. Dee Brown **675**
8. Danny Ainge **671**
9. Dennis Johnson **654**
10. Dave Cowens **569**

 Reggie Lewis **569**

CAREER COACHING WINS

1. Red Auerbach **795**
2. Tom Heinsohn **427**
3. Doc Rivers **416**
4. Brad Stevens **354**
5. K.C. Jones **308**
6. Bill Fitch **242**
7. Chris Ford **222**
8. Bill Russell **162**
9. Jim O'Brien **139**
10. Rick Pitino **102**

CAREER BLOCKS

1. Robert Parish **1,703**
2. Kevin McHale **1,690**
3. Larry Bird **755**
4. Paul Pierce **668**
5. Kendrick Perkins **646**
6. Dave Cowens **473**
7. Reggie Lewis **417**
8. Kevin Garnett **394**
9. Cedric Maxwell **378**
10. Tony Battie **369**

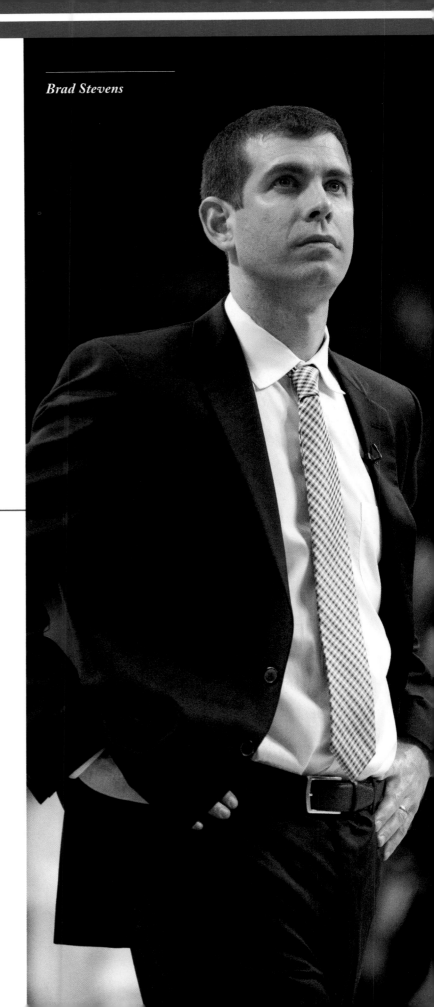

Brad Stevens

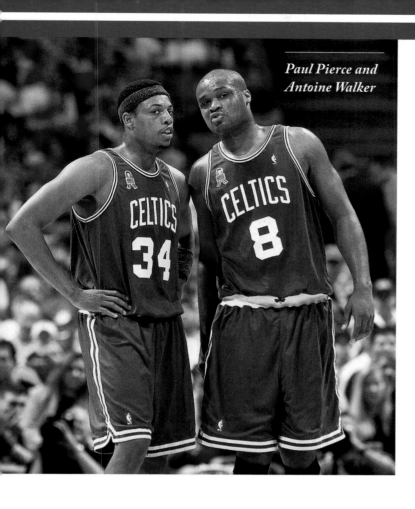

Paul Pierce and Antoine Walker

CAREER TRIPLE-DOUBLES

1. Larry Bird **59**
2. Bob Cousy **33**
3. John Havlicek **31**
4. Rajon Rondo **22**
5. Bill Russell **18**
6. Antoine Walker **13**
7. Paul Pierce **9**
8. Dave Cowens **6**
9. Evan Turner **3**
10. Ed Macauley **2**

MOST NBA CHAMPIONSHIPS

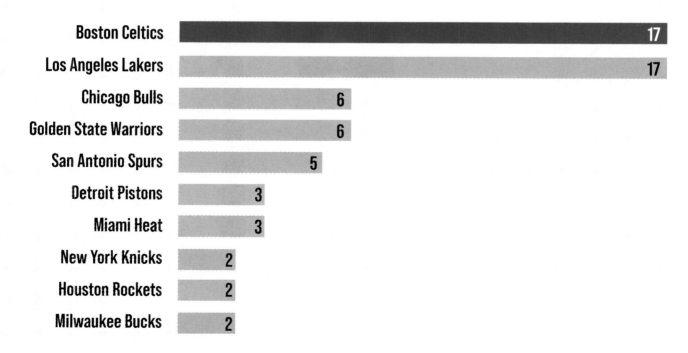

Team	Championships
Boston Celtics	17
Los Angeles Lakers	17
Chicago Bulls	6
Golden State Warriors	6
San Antonio Spurs	5
Detroit Pistons	3
Miami Heat	3
New York Knicks	2
Houston Rockets	2
Milwaukee Bucks	2

THE COVERS

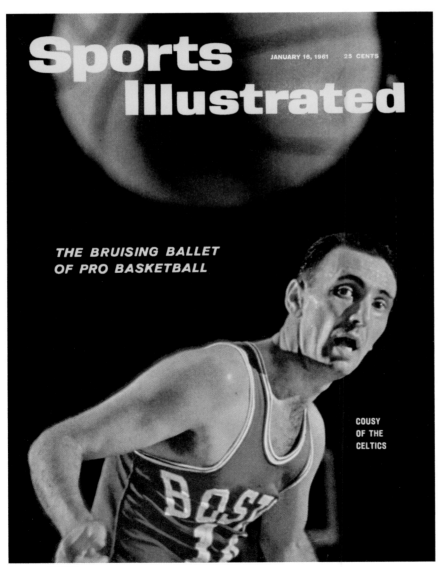

January 16, 1961

December 9, 1963

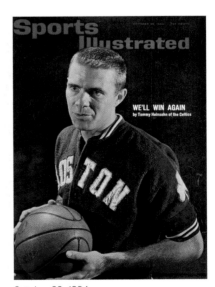

October 26, 1964

Sports Illustrated

MAY 9, 1966 35 CENTS

BOSTON CELTICS 19 WORLD CHAMPIONS

JOHN HAVLICEK

Sports Illustrated

OCTOBER 25, 1965 35 CENTS

PRO BASKETBALL

'How I Psych Them'
by BOSTON'S BILL RUSSELL

October 25, 1965

May 9, 1966

PRO FOOTBALL SHOWDOWNS / COLLEGES – THE BOWLS

Sports Illustrated

DECEMBER 23, 1968 35 CENTS

SPORTSMAN OF THE YEAR
BILL RUSSELL

December 23, 1968

Sports Illustrated

BOSTON'S OLD GUARD | THE LAST STAND

April 28, 1969

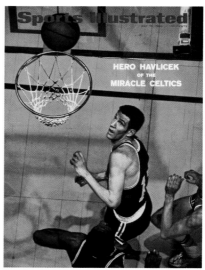

Sports Illustrated

HERO HAVLICEK
OF THE MIRACLE CELTICS

May 12, 1969

| 227

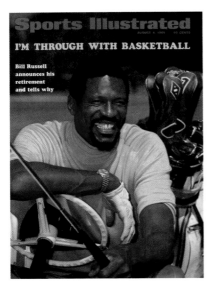

August 4, 1969

February 7, 1972

February 18, 1974

May 20, 1974

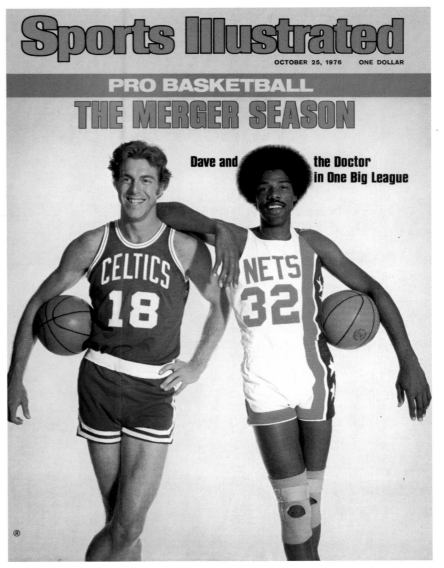

October 25, 1976

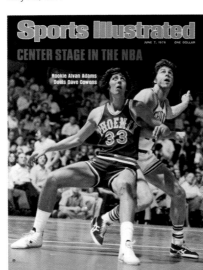

June 7, 1976

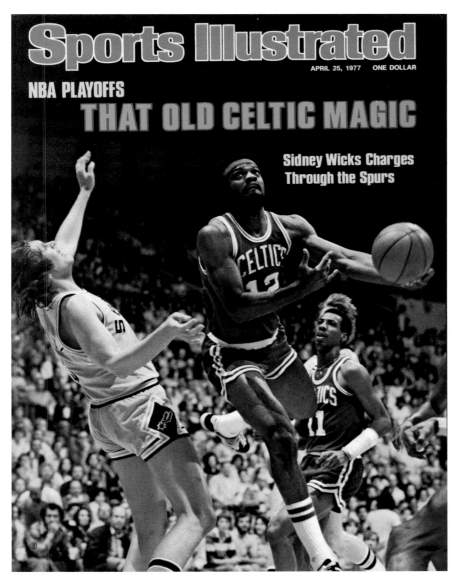

April 25, 1977

May 11, 1981

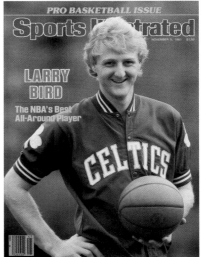

November 9, 1981

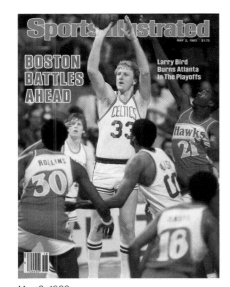

May 2, 1983

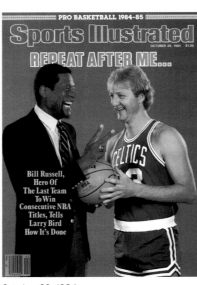

October 29, 1984

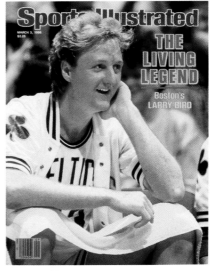

March 3, 1986

June 9, 1986

June 16, 1986

June 8, 1987

March 21, 1988

December 11, 1989

March 23, 1992

August 31, 1992

August 9, 1993

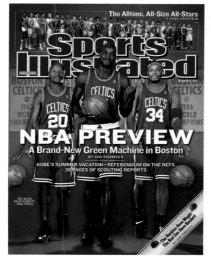

October 29, 2007

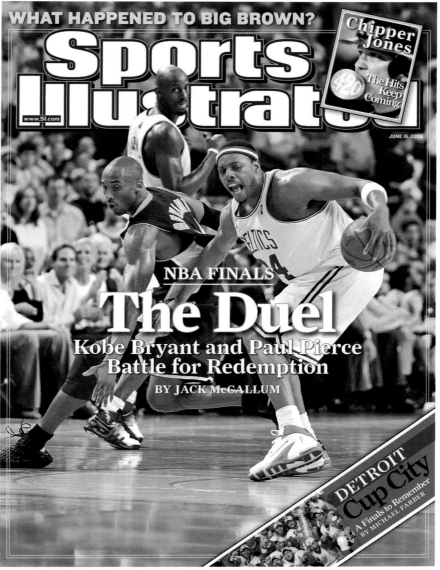

June 16, 2008

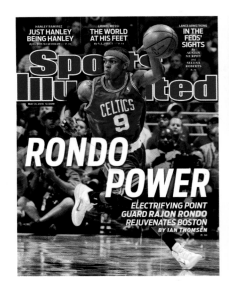

May 31, 2010

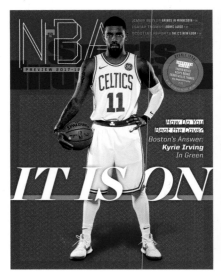

October 16–23, 2017

October 22–29, 2018

Photo Credits

Andy Hayt: Pages 76, 146, 216; Bill Frakes: Page 82; Bob Rosato: Pages 10, 158, 165, 180, 190, 218; Damian Strohmeyer: Pages 8, 84, 171, 223; Erick W. Rasco: Pages 182, 188, 224; Hy Peskin: Pages 4, 34, 35, 58, 90, 94, 98; John Biever: Pages 22, 176; John G. Zimmerman: Pages 27, 100; John Iacano: Page 217; John W. McDonough: Pages 24, 85, 163, 166; Lane Stewart: Page 137; Manny Millan: Pages 16, 17, 20, 21, 57, 77, 78, 88, 122, 132, 143, 147, 213, 225; Neil Leifer: Pages 6, 12, 28, 29, 38, 41, 46, 52, 60, 102, 105, 106, 109, 112, 221; Richard Meek: Pages 2, 192; Tony Triolo: Page 116; Walter Iooss Jr.: Pages 1, 30, 32, 33, 47, 51, 53, 56, 81, 212, 220.

Additional photography: AP Photos: Pages 66, 198, 208, 210; Bettman: Pages 40, 44, 48, 54, 63, 65, 69, 80, 110, 127, 133, 157, 194, 196, 200, 202, 204, 206, 214; Casey Athena/Getty Images: Page 185; Focus on Sport: Pages 19, 43, 73, 86; Gabriel Bouys/AFP: Page 25; Harold P. Matosian/AP Photos: Page 199; Mike Kullen/AP Photos: Page 75; Robert Houston/AP Photos: Page 70; Ronald C. Modra/Getty Images: Page 134; Stuart Cahill/AFP: Page 148; Winslow Townson/AP Photos: Page 168; Wirelmage: Page 14.

Library of Congress Cataloging-in-Publication Data available upon request.

This book is available in quantity at special discounts for your group or organization.
For further information, contact:
Triumph Books LLC
814 North Franklin Street, Chicago, Illinois 60610
(312) 337-0747
www.triumphbooks.com

Printed in U.S.A.
ISBN: 978-1-62937-955-5